John Mundy

Popular music on screen

From the Hollywood musical to music video

Manchester University Press

Manchester and New York

distributed exclusively in the USA by St. Martin's Press

Copyright © John Mundy 1999

The right of John Mundy to be identified as the author of this work has been asserted by him in accordance with the Copyright, Designs and Patents Act 1988.

Published by Manchester University Press
Oxford Road, Manchester M13 9NR, UK
and Room 400, 175 Fifth Avenue, New York, NY 10010, USA
http://www.man.ac.uk/mup

Distributed exclusively in the USA by
St. Martin's Press, Inc.,
175 Fifth Avenue, New York, NY 10010, USA

Distributed exclusively in Canada by
UBC Press, University of British Columbia,
6344 Memorial Road, Vancouver, BC, Canada V6T 1Z2

British Library Cataloguing-in-Publication Data
A catalogue record for this book is available from the British Library

Library of Congress Cataloging-in-Publication Data applied for

ISBN 0 7190 4028 0 *hardback*
 0 7190 4029 9 *paperback*

First published 1999

06 05 04 03 02 01 00 99 10 9 8 7 6 5 4 3 2 1

Typeset
by Helen Skelton Publishing, London
Printed in Great Britain
by Bell and Bain Ltd, Glasgow

For Karen, Ellyn and Alice

Contents

Acknowledgements

I would like to thank all the students at University College Warrington who, over the years, have taken my course on popular music and moving image culture. Too numerous to mention by name, I have learnt as much from them as they have from me and I am grateful. I am also grateful to students within the Drama Department at Manchester University who took my sessions on the Hollywood musical and for the way their initial laughter at the films we saw turned to passionate enthusiasm. I am especially indebted to Professor David Mayer of the Drama Department for all his wisdom and encouragement. I would like to thank my colleagues within the Department of Media and Performing Arts at Warrington for their help, interest and encouragement and to thank University College for a period of study leave which enabled me to finish my writing. Thanks to Matthew Frost and Lauren McAllister at Manchester University Press for their patience and support and, above all, to my wife, Karen, for so much more of those same precious commodities.

Introduction

The alliance between popular music and the screen media – cinema, television and video – sits at the heart of contemporary popular culture. By looking at the historical development of the relationship between popular music and moving image culture, this book aims to examine some important developments in the ways in which popular music has been mediated commercially, ideologically and aesthetically through the screen media throughout the twentieth century, to examine what I want to call the visual economy of popular music.

In trying to understand popular music in its specific relationship with the screen media, this book attempts a kind of academic 'mission impossible'. It undertakes specific analysis of individual texts, examines their ideological determinants and effects, emphasises the importance of economics – of business and commerce – in both their production and consumption, points to the crucial importance of technology in shaping and determining film, television and music video as both commodity and cultural form, and examines the pleasures which audiences have experienced – and continue to experience.

Not surprisingly, this is a book of, and about, contradictions and tensions, about connections and discontinuities. In some senses, it can be seen as flying in the face of current critical orthodoxy for, whilst acknowledging the influence of contemporary postmodernist and poststructuralist theory, as well as the specific differences which mark out contemporary music video from earlier cultural forms such as the Hollywood musical, it wants to argue that similarity, continuity and a sense of connectedness

remain important elements in any attempt to understand the development and significance of popular music and the screen media.

Some years ago, when writing this book first seemed a good idea, my interest in music video seemed boundless. Like many lecturers in higher education, I was lucky enough to be able to package my interest and enthusiasm into an undergraduate teaching programme. Though gratified by the shared enthusiasm shown by scores of students and stimulated by the ideas we exchanged, I soon realized that there were some issues and debates which music video raised, but which were not being addressed.

Like many people teaching and writing about music video in the mid- and late 1980s, much of what we discussed was heavily influenced by debates about postmodernism. Within the richness of poststructuralist theory, the work of Foucault on discourse and power and his concern with 'the politics of the personal', of Lacan and his emphasis on the instability of the subject, the insistence by Baudrillard on the power of the simulacra, the hyperreal, the 'political economy of the sign', the subversion by Lyotard of the hegemony of metanarratives, all presented a dense heady mix which seemed to provide a relevant context for thinking productively about music video. If, as Gitlin put it, 'modernism tore up unity and postmodernism has been enjoying the threads',[1] music videos seemed the purest, most pleasureable of threads.

Within this wider concern about the postmodern moment and its aesthetic articulation, important debates about the relationship between texts and audiences have assumed additional prominence. Though the concept of viewers, listeners and readers as passive recipients of mass media messages had long been discredited, the growth of cultural studies and, in particular, the interest in popular music, has given additional impetus to new ways of thinking about the consumption of popular culture including, importantly, neglected issues of gender.[2] Much of this new thinking has stressed the power of individuals to make their own meanings from cultural commodities, through what Willis terms 'symbolic creativity'[3] and Fiske calls 'semiotic productivity'.[4] At its extreme, this thinking ascribes a degree of autonomy to active readers which makes the power of those corporations and institutions which produce textual commodities seemingly irrelevant.

Yet, in teaching and learning about music video, it has always been important to emphasise the determining role played by corporations and institutions in the production of cultural goods. Primarily this is because of Music TeleVision (MTV) which, launched in 1981, rapidly assumed a significance beyond its capability to attract a mass audience. MTV signified important changes in a new deregulated broadcasting landscape in the United States and in Britain, where cable and satellite channels began to have an impact. At the same time, there was a resurgence of interest in Hollywood and, to a lesser extent, in British cinema. The creation of new multiplexes saw ever-larger numbers of young people queueing to see films which increasingly featured rock and pop soundtracks that, as singles or albums, often found their way into the charts.

Any emphasis on the political economy of the media will invariably draw upon Adorno's critique of capitalist cultural production and his analyses of popular music in particular.[5] Yet, whilst the evident value of his notion of the importance of the market in creating demand for products was recognized, his unfavourable comparison between 'serious' and 'popular' music and his cultural pessimism seemed at odds with the evident pleasures young people themselves experienced when watching and listening to music and music video,[6] and with more contemporary theoretical perspectives on audiences and consumption. Writing in the 1930s and 1940s, Adorno could not have anticipated the extent to which elements of post-World War Two popular music came to be used by its consumers to connote rebellion, opposition, authenticity.

Though, like postmodernism and new models of active consumption, Adorno's critique has much to offer, like them it increasingly seems inadequate. What seems to be lacking is any sense of the historical and material context from which music video as cultural and commodity form has developed and a methodology which, whilst recognizing music video as 'different', also allowed for an understanding of the ways in which popular music has been mediated by the screen media over a considerable period of time. Such an approach requires, it seems to me, not just a sense of the history of popular music and its long relationship with moving image culture, but also an awareness of the determining influence of technology and economics, of those institutions and organizations whose business it is to provide

entertainment and of the people who work within those institu-
tions and who contribute, in highly complex ways, to the ideology
of 'entertainment'. Such an approach also needs to take into
account the quite extraordinary levels of investment – financial,
physical and emotional – which we all make in popular culture,
particularly music, film and television.

Though we can begin to see similar processes at work around
certain films and television programmes which attain cult status,
popular music in particular seems to invite levels of emotional
investment and engagement in ways which enable individuals to
construct and register difference. Though remaining deeply ideo-
logical, it seems that popular culture and its commodified prod-
ucts can be fully understood only when we begin to take into
account the pleasures, the fun, the emotion and the passion they
engender. Nowhere is this clearer than with music video whose
dense, compact, highly stylized form engenders so many and so
varied pleasures. Yet this very strength is also a weakness, since
emotional investment often induces critical myopia towards other
types or genres of popular music.

Studying music video reminds us that rock or pop music
cannot be reduced to a single primary text, but needs to be under-
stood as a highly mediated form, its meanings dependent on a
variety of media including 'live' performance itself, television and
film soundtracks and 'promotional' video'.[7] It ought also to
remind us that the relationship between popular music and the
screen is a long one and that debates about the relationship
between image and sound are not new, even though they may have
taken on an urgency and significance which characterizes contem-
porary concern with the politics of the cultural.

Lawrence Grossberg, in a book which ought to be required
reading for anyone interested in contemporary culture, reminds
us of the importance that popular culture has for our daily lives,
in 'effectively shaping the possibilities of our existence'.[8] He also
reminds us that the 'fact that people appropriate texts, or find
pleasure in them, does not erase the reality of dominant,
"preferred", readings'.[9] This book acknowledges the importance
of popular music in the daily lives of all of us and recognizes the
specific pleasures that popular music on screen has always made
available. But it also argues that, whatever readings we may nego-
tiate, as a product of capitalist corporate production, popular

music on screen comes ideologically pre-loaded. In reflecting on the importance of contemporary popular music – 'rock' – in the politics of the everyday, Grossberg argues,

> The political possibilities of rock are not inscribed within its musical forms and social relationships. The politics of rock cannot be read off the surface of its texts, or from the economics of its production, or from the social position of its fans. There is nothing intrinsic to its practices ... that guarantees that it delivers its audience to a specific political position. This does not mean that rock, or specific practices, cannot be articulated to political positions and struggles.[10]

The argument in this book is that popular music on the screen represents just such a set of 'specific practices', carrying with them implicit ideological positions which we may – or may not – reject.

In suggesting that popular music on the screen is marked by some significant continuities, I have been influenced by some recent developments in studies of the history of film and media and, in particular, by those who reject the notion of sudden rupture between one cultural form and another, favouring instead a historical model which sees a process of 'layering' of cultural practices. This process of cultural interconnectedness is evident in early cinema's relationship both with the stage and the range of screen practices which existed in the late nineteenth century. Work by film historians such as Charles Musser and Tom Gunning[11] and theatre historians such as David Mayer[12] suggest that the relationship between live theatrical entertainment and early cinema is more complex than was previously thought. Equally important, the book suggests that the spectacular remains an important aspect of the representational regime of texts which combine popular musical performance with moving images, from Hollywood musical to music video.

In this and other ways, the view here is that music video is less a rupture with earlier cultural forms than is often suggested. Precisely because it is concerned with the representation of music on screen, music video draws upon the same representational strategies as the musical genre and television shows featuring popular music. Of course, the repertoire has been extended, but not in the uniquely innovative way that is sometimes claimed. Indeed, just as research shows a more complex relation-ship between early cinema and the stage, so research into the

pment and consumption of filmed clips such as the
dies' in the 1940s and film clips in the 1960s suggests that
we may need to revise opinions about the originations of music
video.

This emphasis on the continuity of cultural practices is
supported by the continuity in the organizations and processes
responsible for cultural production. True, Warner Communica-
tions in the 1990s is a different organization from Warner Broth-
ers of the 1920s, but there are evident continuities. Even where
the corporate players have changed, corporate processes have not.
The desire to integrate software with hardware in the effort to
exploit the potential of new technologies, the need to restructure
and reposition in order to exploit market potential, or to respond
to perceived market demand; these may have changed in scale, but
not in any essential terms.

A comprehensive history of popular music on the screen would
be a much bigger undertaking than this volume. This book does
not attempt to look at wider questions of film music. In the same
way, the book does not attempt in any way to replicate the number
of good books on popular music which are appearing each year,
nor does it attempt to emulate seminal studies of particular
aspects of popular music.[13] No pretence is made to offer a
comprehensive critical view of the Hollywood musical, though in
common with a number of useful books on the musical it regards
the genre as seriously neglected within media and cultural
studies.[14] Readers interested in dance, whether within the musical
genre, on television or within contemporary pop music, will be
disappointed to find that its importance is entirely neglected. The
justification for this, in a study concerned with the industrial and
commercial determinants of twentieth-century cultural produc-
tion, is that dance lacks such an industrial structure. Though radio
has exercised enormous influence on the production, dissemina-
tion and consumption of pop music, it is discussed here only in
the context of ways in which star personas were constructed
across a range of media and in terms of corporate ownership. In
the concluding chapter, some general critical statements about
music video far outweigh textual analysis of individual texts.
Nothing is said about popular music and the Internet, despite the
fact that an enormous amount of material is already available and
being used. It is more than conceivable that his latest development

in the relationship between popular music and the screen will prove to be the most significant of all, deserving of a study of its own.

At one level, then, what this book does aim to do is examine representations of popular music on the screen from the 1920s to the 1990s. In ranging from the developments in the early twentieth century which led to the newly emergent musical genre in the late 1920s to contemporary developments in music television and music video, we take account of both the differences and similarities which they reveal. Arguably, part of what links these developments together is the formation of representational strategies specific to musical performance on screen.

At another level, whilst acknowledging the implications of postmodernism and contemporary theories of reception, the book examines the suggestion that what most characterizes the relationship between popular music and the screen media from Hollywood musical to music video is a strong sense of continuity. This continuity exists, and finds expression, through the institutional structures, the economics, the technology, the aesthetics and the ideologies – in particular the ideology of 'entertainment' and 'showbiz' – which are under scrutiny in the pages that follow.

Chapter 1 looks briefly at some of the earliest developments in the relationship between recorded music and the screen, suggesting reasons as to why available technologies failed to develop into fully social technologies. An overview of some of the major subsequent developments offers a rationale for the importance of studying popular music and moving image culture.

Chapter 2 examines the development of the technologies of sound recording in early cinema and analyses its successful application within a restructured American film industry through an examination of the 1927 film *The Jazz Singer*. The development of a commercial popular music tradition within what became known as Tin Pan Alley and its relationship with a maturing film industry forms the basis of Chapter 3, which undertakes specific analysis of a number of classical Hollywood musicals from the early 1930s to the mid-1950s and examines its role in the construction of the ideology of entertainment.

Chapter 4 examines Hollywood's response to the challenge of rock'n'roll and the development of a youth market in the 1950s. Hollywood's supremacy as the entertainment medium was under

threat from both record sales and the burgeoning television industry; the impact of a differentiated market and the challenge to conventional 'adult' values represented a crisis in sociocultural attitudes which Hollywood found hard to deal with. After consideration of both the film and the music industries at this period, detailed analysis of a number of films, including the early films of Elvis Presley, suggests that the screen industries successfully incorporated the challenges of the new music, arguing that Presley's films, far from representing a radical departure in the way popular music was 'pictured', perpetuate ideological and aesthetic concerns established in the classical Hollywood musical.

Chapter 5 undertakes an analysis of the British contribution to popular music and moving image culture through an examination of British film musicals from the 1930s to the 1960s. The relationship between British and American popular culture is shown to be both competitive and complex. British musicals, or at least some of them it is argued, have been the subject of serious and unjustified neglect, though reasons for this are examined within the overall context of British film production and the influence of class-based social attitudes towards popular culture.

Chapter 6 looks at the relationship between popular music and television and charts the development of rock and pop on both British and American television from the 1950s onwards. Limited as it was, technically and aesthetically, in its early years, television nonetheless engaged with youth culture and the growing cultural influence of the music business with an immediacy which cinema found difficult to match. Even so, what most characterizes television's relationship with the new youth music and culture is its insistence on rendering it safe and comprehensible to the mixed audiences which watched the limited number of available television channels. There were, as we shall see, important differences between shows, but essentially television, whilst recognizing the growing importance of popular music for young people, undertook a policy of cultural containment. The growing convergence between the record industry and television, the place of television in youth culture and the power of televisual images to determine the meanings of popular music, are examined through consideration of a number of specific programmes.

The concluding chapter takes issue with much of the recent writing about music video, though argues that the development of

a 'music video aesthetic' pervades the contemporary media land-scape, including Hollywood cinema.

Finally, a note about nomenclature. It is usual in writing about twentieth-century popular music to reserve that term for music characterized by Tin Pan Alley up until the 1950s, and to use 'pop' to describe the new youth-orientated music which emerged in that decade, 'Rock'n'roll' is generally seen, like 'punk' and 'indie', as genres within 'pop'. 'Rock' music is generally used to suggest a less specific youth-orientated culture which is different from 'folk', 'adult' or 'art' music. Given that one of the central arguments in this book is that cinema, TV and music video trans-form all music into popular entertainment commodity, and given that 'rock' is enjoyed by people well into their forties, the term 'popular' will be used more often than some people may find justi-fiable.

Notes

1 T. Gitlin, 'Postmodernism: roots and politics', in I. Angus and S. Jhally (eds), *Cultural Politics in Contemporary America* (New York, Routledge, 1989), p. 351.

2 For a useful overview, see B. Longhurst, *Popular Music and Society* (Cambridge, Polity Press, 1995), pp. 195–248.

3 P. Willis with S. Jones, J. Canaan and G. Hurd, *Common Culture: Symbolic Work at Play in the Everyday Cultures of the Young* (Milton Keynes, Open University Press, 1990).

4 J. Fiske, 'The cultural economy of fandom', in L. A. Lewis (ed.), *The Adoring Audience: Fan Culture and Popular Media* (London, Routledge, 1992), pp. 30–49. See also J. Fiske, *Television Culture* (London, Methuen, 1987).

5 T. W. Adorno with G. Simpson, 'On popular music', in S. Frith and A. Goodwin (eds), *On Record: Rock, Pop and the Written Word* (London, Routledge, 1990), pp. 301–14.

6 B. Gendron, 'Theodore Adorno meets the Cadillacs', in T. Modleski (ed.), *Studies in Entertainment: Critical Approaches to Mass Culture* (Bloomington IN, Indiana University Press, 1986), pp. 272–308.

7 A. Durant, *Conditions of Music* (London, Macmillan, 1984), p. 168.

8 L. Grossberg, *We Gotta Get Out of This Place: Popular Conservatism and Postmodern Culture* (New York, Routledge, 1992), p. 69.

9 Grossberg, *We Gotta Get Out*, p. 95.

10 Grossberg, *We Gotta Get Out*, p. 137.

11 C. Musser, *The Emergence of Cinema: The American Screen to 1907*
 (Berkeley CA, University of California Press, 1994); T. Gunning,
 'The cinema of attractions: early film, its spectator, and the avant
 garde', in T. Elsaesser and A. Barker (eds), *Early Cinema: Space,
 Frame, Narrative* (London, British Film Institute, 1990).

12 D. Mayer, 'Learning to see in the dark', *Nineteenth Century Theatre*,
 25: 2 (Winter 1997) 92–114.

13 Such as C. Gillett, *The Sound of the City* (London, Sphere, 1971).

14 See, for example, R. Altman, *The American Film Musical* (London,
 British Film Institute, 1989) and J. Feuer, *The Hollywood Musical*
 (London, British Film Institute, 1982).

1

Overtones and undertones

I was very alienated, but isn't every teenager? The TV and everything would like the teenager to feel that he's part of the same world, buying the same things, and listening to the same records, but it isn't like that.

T. V. Smith in J. Savage, *England's Dreaming*, 1991

Pop is music that gets into the charts. Pop stands for popular in my eyes.

Gordan McNamee, Kiss FM

Pop music is rock music without the sex or the soul.

Mark Fisher, MP

There is absolutely no difference. Rock is Pop and Pop is Rock, with or without a guitar solo.

Anthony Wilson, Factory Records

An explosive twenty seconds of television on 1 December 1976 revealed something of the structural and cultural dissonances that exist in contemporary capitalist society, and the extent to which corporate cultural production successfully erases them – most of the time. When the Sex Pistols, hastily arranged last-minute substitutes for Freddy Mercury and Queen, were interviewed by Bill Grundy on Thames Television's *Today* programme, two issues became apparent. In the first place, during the brief but inflammatory collision of cultures, it was clear that the meaning and significance of popular music is something to be contested. In the second place, here was further evidence that the meaning of popular music is inextricably linked to those media that give visual

expression to it, that film, television and music video are all-important sites where meanings are constructed and, sometimes, resisted.

Behind this twenty seconds of television lies a whole history of the representation of popular music in the visual media, and of the struggles for cultural meaning which are involved. Some twenty years later, popular music is firmly entrenched as an integral element of TV programming, whether through dedicated music channels such as MTV and VH-1, teen- or youth-orientated series such as *Fully Booked* and *The Chart Show* on terrestrial TV, through TV specials such as *MTV Unplugged*, through live concerts, and through guest appearances of 'stars' on chat shows. Music video, purchased for private consumption on domestic VCRs, and readily available at a growing number of retail outlets, and the near-ubiquitous pop soundtrack in contemporary Hollywood films, are both essential elements of the popular cultural landscape in the 1990s. I want to ask, simply, why; how come; and so what?

Contemporary wisdom amongst media analysts stresses the growing convergence of the visual and audio industries, whether through conglomerate ownership and control, or through the increasingly self-referential world of album, compact disc (CD), television, music video and style magazine. Integrated corporations such as Time-Warner in the USA, Bertelsmann A.G. in Germany, Hachette S.A. in France and Australian-based News Corporation combine their interests in the music industry with other interests such as cable, satellite and broadcast television, magazine and book publishing, film and television programming.[1] All operate a global distribution system, and their products surround us. In the late 1980s and early 1990s, Jason Donovan starred in an Australian soap opera, had hit records, produced music videos, appeared in West End theatre productions, acted as a guest DJ on Radio 1, and beamed from countless pages in numerous magazines, even if, as in the case of *The Face*, he later took them to court. In the early and mid-1990s George Michael was better known for his much-publicized dispute with Sony than for his music itself. In the late 1990s, CDs by Oasis and the Spice Girls outsell all previous best-selling albums and the artists find themselves and the phenomenon they represent suitable fodder for serious newspaper journalists. Bands such as these are

available for consumption on a truly global scale in an industry which in 1996 was estimated to be worth $36 billion. Perhaps more important, the exploitation of songs for film soundtracks and television productions, including those in the back catalogue, forms a major element of corporate profits.

Early attempts to combine sound and vision

Whilst it is true that as we reach the millennium the scale is different and the consumption more pervasive, there is nothing new about this relationship between the visual and audio industries, and especially between the screen media and popular music. Sound effects were used to accompany projected images as early as the beginning of the nineteenth century. In the last quarter of that century, it was common for lantern slide shows of travellers' journeys to be accompanied by spoken narration. For a brief period in the late 1880s and early 1890s, popular music publishers attempted to exploit new songs by having them performed against a background of specially painted curtains or, at considerably greater cost, using a series of photographic slides. Exceptionally, some songs were accompanied by over a thousand slides. At an average cost of between five and ten dollars, the illustrated song-slide was a major expense in a publisher's promotion campaign, but was testimony to the importance of visual images in the commercial exploitation of popular song. For example, in her study of Scandinavian immigrant stereotypes in the early film musical, Harvey notes the influence of songs such as 'Christina Swanson', originally conceived by music publishers to be accompanied by pre-cinematic illustrated slide shows.[2]

During the same period, Thomas Edison's interests in developing a coin-operated entertainment machine encompassed both the kinetoscope and the phonograph. Edison was an important figure in the development of early cinema as much for his commercial awareness as for his ability to gather technical innovators around him. On one occasion, he expressed his frustration with traditional nineteenth-century scientific methods of inquiry with their lack of commercial urgency: 'We can't be spending time that way! We have got to keep working up things of commercial value – that is what this laboratory is for.'[3] For a short while at

least, Edison's primary interest was in sound recording, with
moving pictures being regarded as an ancillary extra. However, he
told the world's press in 1891:

> I hope to be able by the invention to throw upon a canvas a perfect
> picture of anybody, and reproduce his words. Thus, should Patti be
> singing somewhere, this invention will put her full-length picture upon
> the canvas so perfectly as to enable one to distinguish every feature
> and expression of her face, see all her actions and listen to the
> entrancing melody of her peerless voice I have already perfected the
> invention so far as to be able to picture a prize fight – the two men, the
> ring, the intensely interested faces of those surrounding it – and you
> can hear the sound of the blows.[4]

In 1895, Edison introduced the kinetophone which combined the
moving images of his kinetoscope with the phonograph. Individ-
ual spectators were able to watch a brief film accompanied by
synchronized sound heard through earphones. The most famous
surviving example of sound pictures made especially for the kine-
tophone is that of two men dancing whilst another, W. K. L.
Dickson, plays the violin. Partly because of the high cost of the
hardware – the kinetophone was more than twice the price of a
kinetoscope – demand for syncronized films remained low and
only forty-five kinetophones had been made by 1900.[5] As we shall
see, this relationship between hardware and software has
remained a crucial factor throughout all the technological devel-
opments which have made an impact upon popular music and the
screen media.

 Though Edison's commercial concern with combining sound
and image faltered, with moving pictures assuming primacy as
their business potential was translated into commercial reality,
what is clear is that the emerging film industry was as much
concerned with sound – music, dialogue and effects – as it was
with visual images. One of Edison's commercial rivals, Philadel-
phia-based Sigmund Lubin, marketed a series of 'song films' in
1903, marking a development from his earlier lantern slides
designed to illustrate songs.[6] In 1904, Lubin marketed his cine-
phone which offered a 'Combination of Instrumental Music, Song
and Speech with Life Motion Pictures ... see the Black-Faced
Comedian ... and hear him talk and sing at the same time.'[7]
Played with Victor Monarch disks not specifically designed for the

purpose, Lubin's cinephone provided only primitive synchroniza-
tion and proved a commercial failure. The challenge that lay
ahead was in the development and commercial exploitation of
systems which synchronized moving pictures with sound.

The myth of 'silent' cinema

Not that the so-called 'silent' cinema was ever silent. Just as earlier
Victorian entertainments using magic lanterns were accompanied
by piano music, sound effects and, sometimes, an 'elocutionist',
the earliest moving picture shows used live music and, though less
often, live off-screen commentary, to reinforce dramatic, poignant
or comic moods. Not only was musical accompaniment important
in the film production process, with solo pianists, violinists, trios
and even small orchestras employed in the studio to help create
moods for actors, it was equally important when films were
screened before audiences.

Arguing that the content of early film music was far from
arbitrary and irrelevant, Marks suggests that both the function
and conventions of early cinema music were influenced by tradi-
tions established in nineteenth-century theatrical melodrama.
Inevitably, however, the quality and often even the length of this
accompanying music varied greatly, for reasons explained by
Marks:

> The tens of thousands of theatres across Europe and America varied
> enormously in size and decor, and in the number and types of musi-
> cians employed. There were amateurs and professionals, pianists,
> organists, small ensembles, and orchestras ... these silent film players
> enjoyed a great deal of freedom to realise their music according to
> talent and circumstance.[8]

Much of the musical accompaniment in the early nickelodeons
was initially provided by a pianist who 'accompanied' the events
on screen. However, in the search to cut costs, many nickelodeon
owners bought automatic instruments which, by using a piano
roll, did away with the pianist. Some of these instruments, such
as the orchestrion, played rolls which had a range of instrumental
effects, but not, sadly, in any order related to the film on screen.
The Wurlitzer company, based initially in North Tonawanda,
New York, was soon producing a range of more sophisticated

instruments, including its photoplayers that, controlled by an operator, played music and special effects which matched the action on the screen and, as a result, was felt to justify the wages of what was in fact quite a skilled operator.[9] As late as 1909 an editorial in *Moving Picture World* complained that in too many exhibition outlets pianos were old and out of tune and begged theatre managers to 'tune the pianos or burn them'.[10] It was not unknown for the music either to bear little relation to the events on screen or to finish before the end of the film, the musicians leaving before the film had finished.

That this was possible was due in large part to the fact that, in the early years of the twentieth century, film production and film exhibition were separate commercial entities. Whilst a production company might have clear ideas as how best to present their film, the decision as to how this was to be done, including musical accompaniment, rested with the exhibitor. As early as 1909, film production companies prepared standardized sheet music to accompany specific films and, as Marks shows, film scores were being written well in advance of Breil's score for *The Birth of a Nation* in 1915.[11] However, independent exhibitors often resisted these, and other, pressures from the production companies to conform precisely in an attempt to assert their independence. They were fighting a losing battle, not simply because the growing complexity of narrative film form – and the audiences – demanded appropriate musical accompaniment, but also because the economic drift towards merger and integration was proving too strong. The impact of the film score for *Quo Vadis* (1914) written by Samuel Rothapfel, that written by Joseph Carl Breil for *Cabiria* (1914), together with the score for *The Birth of a Nation* marked what was described by contemporary reviewers as 'the marriage of music and spectacle'.[12] Writing about the score for *The Birth of a Nation* which he unproblematically ascribes to Breil and Griffith himself, Prendergast comments that it

> is of little musical significance, but is of considerable historical inter-est. It is a pastiche of original compositions, quotes from Liszt, Verdi, Beethoven, Wagner, Tchaikovsksy, as well as a number of well-known traditional tunes from the United States such as 'Dixie' and 'The Star-Spangled Banner'. Despite the score's lack of musical value, it did set standards of orchestration and cuing techniques that remained throughout the silent era.[13]

Perceived at first as one potentially profitable popular entertain-
ment amongst several competing for consumers' disposable
income, the films were exhibited at vaudeville houses, fair-
grounds, circuses, music halls. Technological inventiveness, busi-
ness profitability, and an aesthetic mimicry based initially upon
other entertainment forms such as open-air spectaculars, popular
theatre and literature, propelled film into a regular and highly
lucrative form of entertainment. The rapid aesthetic development
of film as a complex narrative medium was coterminous with its
equally rapid development as industrial and commodity form,
with its own quite specific production, distribution and exhibition
practices.[14]

Unfortunately, many of those writing about the first twenty-five
years in the development of cinema treat it as if it were silent,
imputing a double negative to sound in the cinema. Too many
writers who are interested in the relationship between film
style and technology in early cinema ignore the fact that audi-
ences, whether in the early nickleodeons or in the purpose-built
'dream-palaces' that were replacing them from 1914 onwards,
experienced film as moving pictures with sound accompani-
ment.[15] The plush gilt and marbled 3300-seat Strand Cinema
which opened in Manhattan in 1914 had its own thirty-piece
orchestra and a huge Wurlitzer organ, clear evidence of the impor-
tance of musical accompaniment to 'silent' film. Music, and the
architectural environment of the movie theatre, were essential
elements of a complete reception experience which went beyond
simply watching what was on the screen.[16] The impact of a live
orchestra such as the seventy-six-piece Los Angeles Philharmonic
which accompanied the premiere of Griffith's *The Clansman* in
1915 (subsequently known as *The Birth of a Nation*) could have an
emotional effect even on those who had been involved in making
the film, as Karl Brown, the assistant camerman, testified.[17]

Though much more research remains to be done into music in
early cinema, it is clear that the emerging technique of film
scoring for 'silent' films relied upon mixing original composition
with compilations from existing, often classical, music. This meant
that film scores, though they might include segments from what
were then regarded as 'popular' light classics, were not 'popular
music' in the sense that we understand it today. Despite the emer-
gence of a commercial music industry in both the United States

and Britain, based upon the creation of songs often written for vaudeville or music-hall performers or designed to be played by people in their own homes, cinematic film scores largely ignored such material. One of the consequences was that 'film music', that is music composed and scored specifically for films, remained in a largely subordinate relationship to the narrative demands of the film itself. As late as 1936, the composer Maurice Jaubert could state that 'We do not go to the cinema to hear music'.[18] However, in her study of narrative film music, Gorbman makes the point that whilst most music in film scores is non-diegetic, the music can also be part of the diegesis, part of that 'implied spatiotemporal world of the actions and characters'.[19] As such, film music can operate as a 'suturing device of capital importance'.[20]

In questioning the assumption that film music necessarily remains subordinate to filmic narrative demands and suggesting that a more complex dynamic between music and image exists, Gorbman cites two areas where these traditional assumptions about the sound/image hierarchy are clearly called into question. One of these is melodrama, where music can be used to 'mark entrances of characters, to provide interludes, and to give emotional coloring to dramatic climaxes and to scenes with rapid physical action'.[21] The other, of crucial concern to this study, is where the film score includes songs with lyrics. Recognizing that a different relationship exists between music and images when a character in the film breaks into song, Gorbman writes that 'the action necessarily freezes for the duration of that song. Songs require narrative to cede to spectacle, for it seems that lyrics and action compete for attention.'[22] Though Gorbman fails to recognize that action and song are not necessarily mutually exclusive, as we shall see when looking at examples of the classical Hollywood musical, she does draw attention to the way in which the relationship of sound and image becomes more complex when songs are performed on screen. Her use of the term spectacle is also important. As we shall see, these are issues which remain important from the commercially successful introduction of synchronized sound film in the mid-1920s, to contemporary Hollywood films which make use of pop music, to current music videos, where in all of them the performance of song is a central concern in representational strategy.

The commercial exploitation of sound and vision

Of course, the emerging American film industry was developing within the economic system of capitalism, and the drive towards standardized industrial production processes was intended to maximize profits for film manufacturers. For capitalism, technology has an economic value and its utilization makes sense primarily as a business strategy in the pursuit of profit. Yet, as the role of sound within early cinema suggests, technological innovation is subject to considerations which include, but also go beyond, the economic and material. What is striking about the development of Hollywood is that at times it adopted film-making practices which were by no means the cheapest, whilst at other times it seemed almost wilfully to neglect innovations which clearly promised to be economically beneficial. Moreover, before the late 1920s, when full vertical integration of production, distribution and exhibition within the industry was achieved, the interests of producers and exhibitors did not always automatically coincide, and this had important consequences for the development of sound in the cinema.[23]

For these reasons, it makes more sense to talk not of a history of Hollywood or of the commercial music industry, but of a series of histories, socioeconomic, political, technological, ideological, which not only have a complex inter-relationship, but which exist within, and are influenced by, other social and cultural institutions and practices. Early cinema developed within a complex commercial, technological and ideological context, a context which also witnessed the development, at around the same time, of recorded music. There is a curious and important paradox here, for, just at the time that the cultural circulation of moving visual images was in its ascendancy, music, hitherto a highly visible performance medium, was being rendered invisible. Recorded music, whether recorded initially on Edison's cylinder phonograph, or subsequently on Emile Berliner's technically superior flat shellac disc gramophone, invented in 1887, widened the availability of a range of music and singers to a mass audience, consumed in the privacy of their own homes. An American music critic wrote some years later: 'at last it is possible ... to sit at home and get the thrill of the real thing as ... in the music hall.'[24] Whatever the technical limitations of early sound recording – and these were considerable

prior to the development of electrical recording and amplification in the 1920s – its capacity to challenge the dominance of music experienced as both direct auditory and visual performance was remarkable.

As always, once there was a degree of standardized compatibility between the hardware and the software, together with legislation which encouraged and enabled commercial dominance, record sales became big business, dominated in the United States by Victor and Columbia. Originally operating as franchise of the North American Phonograph Company, manufacturing and selling office dictating machines, Columbia quickly moved into the entertainment media and, by the end of the nineteenth century, had a catalogue of over 5,000 recordings. Between 1901, when it offered its first discs, and 1912, when the production of cylinders was discontinued, the company developed its catalogue of both popular and classical music. Sales flourished through the second decade of the century as popular ragtime and other dance-craze music was recorded and by 1919 Americans were buying more than twenty-five million 78 r.p.m. records a year as the record industry as a whole reported sales of $150 million.

William Owen's Gramophone Company, later to become Electrical and Musical Industries Ltd (EMI), established in London in 1898 with start-up capital of £15,000, found an early and prestigious niche in the booming market for recorded music with its specialist Red Label operatic recordings of singers such as Chaliapin, Caruso and Melba. However, like the company's counterparts in America, it was the exploitation of a wide range of popular music which contributed most to the rapid increase in profits, from £79,348 in 1901 to £252,285 in 1903.[25] Music-hall and musical-comedy stars such as Dan Leno and Edna May consolidated and extended their popularity through sound recordings. The connection between popularity and profits, as well as between hardware and software sales, was clear and the important commercial lessons learnt were to be rigorously applied in the years that followed.

Musicologists rightly claim that these early sound recordings, whether of operatic arias or of music-hall comedy numbers, made musical talents available to wider audiences. In doing so, however, they were eroding popular music traditions in two important ways, first by rendering it invisible, and then by establishing the

consumption of musical stars at the expense of making music within the community. Professional musical performers had been in existence as part of an oral popular entertainment tradition since the Middle Ages. As Russell reminds us, in late Victorian and Edwardian Britain, the domestic house, the street, and arenas such as the public house and municipal park, were centres for musical performance and consumption.[26] When other nineteenth-century popular musical traditions such as choral societies, brass bands and street buskers are taken into account, it is clear that recorded music represents a discontinuity in what had always been a visual as well as an auditory experience.

In this sense, the restoration of visible musical performance on the cinema screen which became commercially viable from the mid-1920s onwards can be seen as the resurrection of the norm, a process which has continued with television and music video. The brief period of recorded music's invisibility represents, in many respects, the aberration. Of course, the market for 'invisible' music grew and remains significant, whether on the radio, on cassette, CD or rapidly disappearing vinyl, but from the mid-1920s onwards, it is clear that the meanings of popular music, its consumption and reception, have increasingly been mediated by the screen media.

In turn, the presence of performers and popular music has inflected upon cinema. Whilst it is true that commercial cinema in both the United States and Britain has conventionally by judged by the standards of a realist aesthetic, this is currently undergoing some critical reassessment. Curiously, to date the musical genre has not featured highly in this reassessment in spite of the fact that, even at its most naturalistic in what is often termed the 'classical' Hollywood musical, it renders many assumptions about the hegemony of realist narrational modes deeply problematic through creating space for the spectacle of performance.

The visual economy of popular music

The commercial exploitation of the technologies of synchronized sound was to give an importance to the visual economy of popular music in unprecedented ways. As we shall see in the following chapter, the extent to which synchronized sound was sold to the

public on the basis of short clips of popular musical entertainers has been neglected, as has the use of shorts by studios to test potential of new artists. Nevertheless, the development of the musical genre in Hollywood and elsewhere from the late 1920s constitutes a significant element in the history of popular film and represents the most significant development in the visual economy of popular music. Refined and developed through the 1930s, the American musical film aimed for and established a broad popular appeal, sustained in part by the marginalization of musical styles such as jazz, and rural blues with their perceived ethnic, ideological and commercial limitations. Where such 'marginal' musics were employed in musicals, they were filtered through studio concern not to alienate broad popular appeal, which in the 1930s largely meant white audiences. As a result, with a few notable exceptions, the visual economy of popular music at that time was coded as essentially white.

In Britain during the 1930s, there was some success in representing indigenous popular musical talent and styles in a series of musicals which played well to British audiences, but which were largely incomprehensible elsewhere. Ultimately, the economic power and aesthetic appeal of the American product proved too strong and popular music in Britain at this period was increasingly influenced by American stars or by British artists and dance bands adopting their style.

Through the 1940s and into the mid-1950s, musicals constituted an important staple element in Hollywood studio production, particularly at MGM where production budgets and values were especially lavish. Though MGM had created its own music department within the studio as early as 1929, with the other major studios doing the same in the early 1930s,[27] the relationship with the music industry was essentially with songwriters, with Tin Pan Alley and with Broadway. Songwriters such as Irving Berlin, George Gershwin, Richard Rodgers, Harry Warren and Cole Porter, as well as a host of less well-known talents, were essential to the success of musicals. In turn the musical proved a highly effective form for recycling popular music, as the 1929, 1936 and 1951 film versions of *Show Boat*, with music by Jerome Kern and lyrics by Oscar Hammerstein II, illustrate. Though there is still much work to be done on the reasons why musicals were so popular for the twenty-five years up to the mid-1950s and on their

reception and on the pleasures they delivered, it is also interesting to speculate on their effect on music policy and practice within the studios. For much of that period, music written for the sound-tracks of films other than musicals tended to be regarded as distinct and separate from the popular music being written for, or recycled within, musicals. However, as Leo Shuken, a leading Hollywood orchestrator, remarked, 'the big difference in the middle fifties was that you found yourself much more with the popular idiom rather than a symphonic idiom'.[28] Of course, this shift was also undoubtedly influenced by the growing significance of pop music and the rise of pop record consumption in the 1950s. The trend towards 'pop stuff' and the desire of the studios to make money on the sales of records was resisted by many screen composers. Elmer Bernstein regarded the trend as 'absolutely ruinous of the art of film music'.[29] This was not an untypical sentiment amongst those working within Hollywood, though it failed to recognize the important structural realign-ments taking place between Hollywood and the music industry in the 1950s and the reasons for them.

The economic challenge of television, the emergence of the youth market, the social implications of the civil rights movement and US involvement in Vietnam, rendered the essential optimism of the classical Hollywood musical redundant, but did not damage irreparably the relationship between cinema and popular music. Of course, the market for 'invisible' pop music grew and remains hugely significant, but by the 1950s the visual economy of popular music was firmly established, such that it was impossible to understand popular music without reference to its representation and presence in other media. As Frith puts it: 'Because the meaning of popular music this century is inseparable from its use by the other mass media – radio, cinema, TV, video – so their organisation and regulation shape the possibilities of pop.'[30] And as one British pop musician put it, rather more prosaically: 'pop music fans not only want to hear the hits, they want to see the artists perform them on TV'.[31] Arguably, the implication that a youth-orientated programming policy within 1960s television was stimulated essentially by consumer demand over-simplifies a complex process, but the development and the exploitation of the youth market has been a crucial factor in the history of pop music on the screen since the 1950s.

The huge success of *The Sound of Music* as the highest-grossing film of 1965 was in many senses a musical and commercial aberration, based as it was on the Rodgers and Hammerstein Broadway show, recreating a formula which proved commercially disastrous.[32] However, Hollywood's interest in, and exploitation of, popular music continued unabated through the 1960s. Uncertain at first how to respond to this new music and its youthful adherents, the cinema industry realized the commercial potential of the important changes which had occurred in the music industry. Quite simply, there was too much money at stake for Hollywood to ignore.

The fractures and dislocations associated with the emergence of rock'n'roll and pop in the mid- and late 1950s were commercial, socioeconomic and ideological. Issues of race and class, conflicts of values that existed between generations, suddenly appeared highly visible. Like Hollywood, the popular music industry was initially unsure how to respond to the challenges posed by the new music and its audience. Still dominated by the mentality of Tin Pan Alley, it had relied for its profits on the publication and sales of sheet music written by songwriters who were not themselves performers. As Dranov puts it:

> no longer was the public interested in the products of Tin Pan Alley tunesmiths that had been the staple of the industry. Broadway musicals as a source of hit music were on the decline; and not even motion picture theme music could compete with the new sound from the street.[33]

Rock'n'roll changed all that, at first threatening and then altering the established structures of the industry. Driven by small, independent recording studios such as Sam Phillips' Sun studios in Memphis, and using the newly developed multi-track recording technology, records performed by an identifiable voice – Elvis Presley, Buddy Holly, Chuck Berry – became the commercial nexus of the popular music industry from the late 1950s onwards, as record sales out-grossed sales of sheet music. This fundamental shift, with its emphasis on direct performance, was both stimulated by and reflected in the growing importance of the radio and gramophone industries, and had a profound influence on the ways in which popular music was represented in cinema and, belatedly, television. Of course, it was a two-way street, and

the music industry was quick to appreciate the power of both cinema and television to sell records. The sheer power of cinema and television to render performers visible and therefore 'accessible' was clearly understood by the music industry. Presley's phenomenal success in Britain, even though he never actually made a live appearance here, was bolstered by appearances on film and television.

The challenges posed by rock'n'roll from the mid-1950s went beyond the structural, commercial and aesthetic changes that occurred in the music, radio and cinema industries. As Hatch and Millward remind us, rock'n'roll needs to be seen as a sociomusical phenomenon, one closely associated with specific socioeconomic and ideological shifts that were happening in this period.[34] In particular, the indebtedness of rock'n'roll to hitherto commercially and ideologically marginalized black music, together with its relatively exclusive appeal to youth as a sectionalized audience, confronted the cosy ideological consensus which up to this time had determined and characterized popular entertainment products. The effects on the Hollywood musical of this self-evidently differentiated market for its product were far-reaching, as were their implications, and all this was taking place as cinema's economic and cultural position was being challenged by television. Whatever the merits of a postmodernist view of contemporary media texts as sites of consumer playfulness, operating at the margins of predetermined ideologies, it seems clear that from the late 1950s a degree of slippage in the raw unadulterated power of capitalist cultural production to position audiences monolithically was under way, a situation directly related to developments in technology and cultural form. A clear, if slightly later, example of the ways in which the industrial hegemony of capitalist production could be undermined was the practice of home taping. Though it has proved impossible to eradicate home taping, the practice of persuading us to purchase our music on CD has clearly gone some way to offsetting whatever losses may have occurred. The argument put forward here is that that the entertainment industries have consistently adopted strategies which responded to the growing complexities of audience reception and consumption.

Arguments for an essentially romantic concept of any popular music as 'authentic' subcultural expression, unaffected by the

structures, economics and ideologies of capitalist industrial cultural production, seem difficult to sustain. There is nothing innately 'authentic' about any popular music, though the uses to which it can be put can articulate a range of positions, social attitudes and values and frequently have done so. However, as the development of the rock musical on film and representations of popular music on television and music video show, what remains significant about popular music and its industrial structure is that it is invariably co-opted by the commercial media industries for quite specific purposes. This may be as supposedly 'neutral' as the pursuit of profit, or may involve more explicitly ideologically loaded strategies. The exploitative nature of this process is clearly seen in such 1960s films as *Don't Knock the Twist* (1962), which cashed in on the record chart success of Chubby Checker, and *Dr Goldfoot and the Girl Bombs* (1966), a California beach-party film which responded to the popularity of west-coast surfing. This process of incorporation, with its aesthetic and ideological implications, is nowhere more self-evident than in the career of Elvis Presley, with its discursive trajectory from 'independence' and 'rebellion' in the 1950s to mainstream commercial musical and cinematic production in the 1960s and beyond.

It is possible, of course, to regard the development of certain musical styles within certain specific historical moments as representing challenge and refusal. Rock'n'roll in the mid-1950s and punk in the mid-1970s contested sociocultural and ideological orthodoxies in ways which challenged assumptions about the power of capitalism to dictate social relations, to determine meanings. Musical style, production context, and the evident ability to forge links with the values characteristic of their youthful audience, enabled both rock'n'roll and punk to mark out the limits of commerce and its ideological control. But, in marking out the limits, neither rock'n'roll nor punk were ultimately able to deny the power of the commercial institutions and the ideology of consumption which they promoted. It may be that people create their own meanings, but, as Marx argued, this process does not take place in the conditions of their own choosing.

The argument here is that the meanings which are created and circulated by contemporary popular music are constantly mediated through other powerful textual and institutional practices, not least cinema, television and video. Whatever radical potential

rock music may have within certain historical conditions, it becomes muted as the screen media transform it into a commodity designed to entertain. What characterizes contemporary popular cultural production is the unified and integrated nature of its industrial, commercial and aesthetic practices. Nowhere is this more evident than in the development of music video during the 1980s and 1990s and the current convergence between television and computing, but the process can be seen in operation from the beginnings of the synchronized sound film in the mid-1920s, gaining momentum with the development of television in the 1950s and 1960s.

Disney's *Snow White and the Seven Dwarfs* was the first 78 r.p.m. album from a film, released in 1937. MGM is credited as the company which first used the concept of 'original soundtrack', with the release of the soundtrack album from the Jerome Kern biopic *Till the Clouds Roll By* in 1947. Today, the screen media both feed off and perpetuate the cultural importance of popular music, whether in its use as soundtrack in feature films, in television programmes which relay 'live' concerts and performances, in 'youth' programming or in dedicated TV channels such as MTV aimed at a youth audience, or in the rapid development of music video as both cultural and commodity form. The synergy between the music and screen industries has become part of our everyday experience. The number of chart-topping singles and albums based on, featured in or relating to films is growing and is clear evidence of this contemporary symbiosis between the screen media, popular music and other forms of contemporary entertainment. At the time of writing, the top-selling single in Britain is by Boyzone, with a song from the West End musical based on the 1963 British film *Whistle Down the Wind*. The third best-selling single is from the film *Lost in Space* (1998) – itself based on the 1965–68 television series of the same name – performed by the former indie band Apollo Four Forty. Soundtrack albums are big business. Epic, a division of Sony, paid $700,000 advance for the soundtrack rights for *Dances With Wolves* (1990). The size of the advance is often totally justifed by the return: the $100,000 advance paid by Giant Records for the soundtrack for *New Jack City* (1991) was rewarded with sales of over two million album units. The soundtrack album from *Saturday Night Fever* has, to date, sold in excess of twenty million units.[35]

Postmodernism and its problems

In spite of clear evidence that the relationship between sound and image and, more specifically, popular music and the screen media is a long-standing if dynamic one, the emergence of music video in the early and mid-1980s lead many to argue that it represented a distinct cultural form, epitomizing postmodern culture. In writing about music video little, if any, reference was made either to earlier screen practices which combined popular music and moving images, or to the development of specific representational strategies used to picture music on screen. The rejection of 'history' as ideological category often meant ignoring the quite specific and substantial commercial, ideological and aesthetic history of popular music and its relationship with the screen which, as we have seen, starts in the late nineteenth century.

Important issues are at stake in all this. It is now commonplace to assert that we live in some important sense in a postmodern era. In problematizing the distinction between 'images' and 'reality', in blurring the boundaries between the commercial and the cultural, in rejecting coherence, certainty and authority, post-modernism appears to describe a radical break with previous sociocultural assumptions. It has been argued, for instance, that in the early 1970s when there was still 'some separation between television and rock music', John Lennon's record 'Revolution' could have a meaning set apart from the commercial image system. In the postmodern context, it turns into advertising mate-rial for Nike.[36] Postmodernist culture appears to offer a pick-'n'mix pathway through a shattered culture, celebrating difference, freedom and the power to construct meaning in ways that we wish. For many, music video epitomizes postmodern culture, marked by its 'merging of commercial and artistic image production, an abolition of the traditional boundaries between an image and its real-life referent, between past and present, between character and performance, between mannered art and stylized life'.[37] Above all, it is argued, the very openness of the polysemic music video text enables us to reject ideology and its positionings, and to recognize the range of potential meanings in any one text. We need to take such arguments seriously, but we also need to ask questions about the extent to which postmodern culture – and music video – represent a radical break with what went before.

In differentiating postmodern culture from earlier phases of cultural development, which they characterize as class culture and mass culture, Angus and Jhally argue that we should see postmodern culture as developing from and overlaying these earlier phases.[38] From this perspective, issues of class, power, access to cultural goods and mass homogenization do not disappear or become unimportant, they are simply no longer the most important arena through which cultural dynamics are articulated. In declaring the 'death of history' and in arguing for the end of ideology, it may be that postmodernism wilfully neglects its own position within cultural history.

In looking at the ways in which cinema, television and video engage with popular music and help create the social meanings which surround it, we may begin to make sense of the apparently conflicting claims of continuity and change. To do so, we need to accept that these media work – and impact upon us – at a variety of levels and in a variety of ways. Textual comparison between a 1930s Hollywood musical, a 1960s edition of *Top of the Pops* and the latest music video by Prodigy will lead us into certain evaluative conclusions. A consideration of the economic, institutional and production processes which lie behind such texts may well lead us to different conclusions. An examination of the pleasures which audiences experience when they engage with these commodified entertainments may lead to entirely different conclusions.

That the screen media and the music industry are inextricably linked seems all too evident. There are significant changes which have taken place between the 1920s and the 1990s, and full consideration has been given to these. However, the important economic, corporate and ideological continuities which characterize popular cultural production are re-examined and evaluated, leading to the suggestion that, important though recent sociocultural developments are, they do not in any significant sense represent a shift away from classic patterns of capital accumulation, social relations and social control. In the chapters which follow, we look at a range of particular issues which reflect the complex relationship which exists between popular music and moving image culture, and between all of us who get so much pleasure from it.

Notes

1 For recent comments and analysis of the 'globalization' of the music industry, see D. Robinson, E. Buck and M. Cuthbert, *Music at the Margins: Popular Music and Global Cultural Diversity* (London, Sage, 1991), K. Negus, *Producing Pop: Culture and Conflict in the Popular Music Industry*, (London, Edward Arnold, 1992) and R. Burnett, *The Global Jukebox: The International Music Industry* (London, Routledge, 1996).

2 A. C. H. Harvey, 'Holy yumpin' yiminy: Scandinavian immigrant stereotypes in the early twentieth century American musical', in R. Lawson-Peebles (ed.), *Approaches to the American Musical*, (Exeter, University of Exeter Press, 1996), pp. 55–71.

3 W. Wachhorst, *Thomas Alva Edison: An American Myth*, (Cambridge MA, The MIT Press, 1982), p. 35.

4 K. Brownlow, 'An introduction to silent film: the Peter Le Neve Foster Lecture, 23 November 1983', *Journal of the Royal Society of Arts* (March 1984), 261–70.

5 C. Musser, *The Emergence of Cinema: The American Screen to 1907*, (Berkeley CA, University of California Press, 1994), p. 88.

6 Musser, *The Emergence of Cinema*, p. 363.

7 Musser, *The Emergence of Cinema*, p. 398.

8 M. M. Marks, *Music and the Silent Film: Contexts and Case Studies 1895–1924*, (New York, Oxford University Press, 1997), p. 9.

9 Q. D. Bowers, *Nickelodeon Theatres and Their Music* (New York, Vestal Press, 1986).

10 F. Karlin, *Listening to Movies: The Film Lover's Guide to Film Music* (New York, Schirmer, 1994), p. 154.

11 Marks, *Music and the Silent Film*, pp. 64–108.

12 Marks, *Music and the Silent Film*, p. 108.

13 R. M. Prendergast, *Film Music: A Neglected Art – A Critical Study of Music in Films* (New York, W. W. Norton, 2nd edn 1992), p. 13.

14 D. Bordwell, J. Staiger and K. Thompson, *The Classical Hollywood Cinema: Film Style and Mode of Production to 1960* (London, Routledge, 1985).

15 For example, B. Salt, *Film Style and Technology: History and Analysis* (London, Starword, 1983).

16 R. C. Allen, 'From exhibition to reception: reflections on the audience in film history' *Screen*, 31:4 (Winter 1990), 347–56.

17 K. Brown, *Adventures with D. W. Griffith* (London, Faber and Faber, 1988), p.88.

18 C. Gorbman, *Unheard Melodies: Narrative Film Music* (Bloomington IN, Indiana University Press/British Film Institute, 1987), p. 3.

19 Gorbman, *Unheard Melodies*, p. 21.

20 Gorbman, *Unheard Melodies*, p. 40.
21 Gorbman, *Unheard Melodies*, p. 34.
22 Gorbman, *Unheard Melodies*, p. 20.
23 R. Altman, *Sound Theory Sound Practice* (London, Routledge, 1992), pp. 113–25.
24 R. Gelatt, 'Music on records', in P. H. Lang (ed.), *One Hundred Years of Music in America* (New York, Schirmer, 1961), p. 190.
25 R. Pearsall, *Edwardian Popular Music* (Newton Abbot, David and Charles, 1975), p. 140. For more information on Owen and EMI, see P. Martland, *Since Records Began: EMI, the First 100 Years* (London, Batsford, 1997).
26 D. Russell, *Popular Music in England 1840–1914: A Social History* (Manchester, Manchester University Press, 1987), p. x.
27 Karlin, *Listening to Movies*, pp. 175–95.
28 Karlin, *Listening to Movies*, p. 242.
29 Karlin, *Listening to Movies*, p. 242.
30 S. Frith, *Music For Pleasure: Essays in the Sociology of Pop* (Cambridge, Polity Press, 1988), p. 3.
31 S. Blacknell, *The Story of* Top of the Pops (Wellingborough, Thorsons in association with the BBC, 1985), p. 27.
32 E. Mordden, *The Hollywood Musical* (Newton Abbot, David and Charles, 1982), pp. 203–6.
33 P. Dranov, *Inside the Music Publishing Industry* (New York, Knowledge Industry Publications, 1980), p. 13.
34 D. Hatch and S. Millward, *From Blues to Rock: An Analytical History of Pop Music* (Manchester, Manchester University Press, 1987), p. 69.
35 Karlin, *Listening to Movies*, p. 232.
36 I. Angus and S. Jhally (eds), *Cultural Politics in Contemporary America*, (New York, Routledge, 1989), p. 11.
37 P. Aufderheide, 'The look of the sound', in T. Gitlin (ed.), *Watching Television* (New York, Pantheon, 1986), p.112.
38 I. Angus, 'Circumscribing postmodern culture' in Angus and Jhally (eds), *Cultural Politics in Contemporary America*, pp. 96–110.

2

The emergence of popular music and sound cinema, 1890–1927

Every code of music is rooted in the ideologies and technologies of its age, and at the same time produces them.

Jacques Attali, *Noise: The Political Economy of Music*, 1985

Wait a minute, wait a minute. You ain't heard nothin' yet ...

Al Jolson, *The Jazz Singer*, 1927

Hollywood, Calif. – Motion Picture Producers Announce Only Talking Pictures Will Be Made In Future – Silent Pictures Are Finished

Footlight Parade, 1933

When new technologies emerge and cultural forms collide, there are consequences and casualties. Although details are still a matter of dispute, it seems clear that many people were unable to sustain their jobs and careers in the cinema industry in the late 1920s as both the studios and exhibitors converted to sound. Clearly, major career casualties took place amongst musicians and specialist sound effects operators in cinemas as synchronized sound films replaced the 'silents'. In the same way, the increasing commercialization of the music publishing industry and its convergence with sound cinema produced its own casualties.

Around the turn of the twentieth century in the United States, American popular music had dominated the entertainment industry through sales of sheet music and the live performance of its songs, both by professional artists and by people playing and singing in their own homes. The growing popularity of domestic music-playing in the late nineteenth and early twentieth centuries

is illustrated by the increase in piano sales. Whereas in 1870 only one in 1,540 Americans bought a new piano, that ratio was one in 874 in 1890, and one in 252 in 1910.[1] Between 1890 and 1909 the wholesale value of sheet music printed in the US trebled.[2]

This exponential growth in the demand for popular songs could lead equally to fame, fortune or obscurity for those who attempted to make a living by writing for that demand. After emigrating to the United States in 1897, Polish-born Jack Yellen had made a living within the industry for a number of years. Working with lyricist Milton Ager, a former song-plugger who wrote 'Happy Days are Here Again', Yellen produced popular songs such as 'Happy Feet', 'Hard-Hearted Hannah' and 'Ain't She Sweet'. However, having moved to Hollywood both Yellen and Ager struggled to make a living, and eventually sold their publishing company to Warner Brothers. Although a few of their songs found their way into some early Hollywood musicals, Yellen and Ager simply drifted into obscurity. Yet this narrative of personal decline, which could be retold for countless individuals, contrasts sharply with the wider industrial, commercial and cultural picture, as the various branches of the popular entertainment industries converged and grew, as the popular music industry forged a new and powerful alliance with the film industry. Whatever the personal fate of some individuals, the commercial success of sound cinema and the rise of the Hollywood musical, the convergence between popular music and the moving image, represents one of the most significant developments in capitalist cultural production in the early twentieth century.

Tin Pan Alley

For the first twenty years of the new century, the American music industry had been dominated by Tin Pan Alley, that definable, but shifting, geographic centre for commercial music production and publication clustered around New York's Broadway. Although there had been twenty-five music publishing houses in America as early as 1825,[3] publishing pirated versions of European songs as well as, later in the nineteenth century, the songs of native American composers such as Stephen Foster, Hart Danks and Paul Dresser, the music industry remained until the mid-1890s both

largely disorganized, spread across a number of cities including
Chicago, Baltimore and Philadelphia, and lacking in commercial
drive.

Charles K. Harris's hit 'After the Ball' in 1892 both signalled
and epitomized the changes which affected the American music
industry at the turn of the century, centred in New York and on
what Whitcomb calls assimilation and organization.[4] Commer-
cially orientated, highly organized and effectively marketed,
popular music publishing became industrialized in the early years
of the twentieth century, with the result that, as Middleton points
out, American musical forms began to overshadow national
musics.[5] Unit costs tumbled and sales volumes rocketed; between
1900 and 1910 well over a hundred popular songs each sold a
million copies of sheet music. In addition, the industry prospered
through live performance rights and the royalties on sales of
phonograph records, particularly following the formation of the
American Society of Composers, Authors and Publishers
(ASCAP) in 1914, which enabled the theoretical protection
enshrined into the 1909 Copyright Law to become reality.

Creating and responding to a variety of popular music tastes
and fashions, the core activity of the industry centred on the
production and sale of ballads such as 'In the Shade of the Old
Apple Tree' (1905), 'I Wonder Who's Kissing Her Now' (1909)
and 'Let Me Call You Sweetheart' (1910). Nostalgic and senti-
mental in tone, deeply conservative ideologically, many of the
ballads written during this period were to find their way into
Broadway productions and, subsequently, Hollywood musicals of
the 1930s and 1940s. So too, many of the writers and composers
who began their careers working in Tin Pan Alley, not least Jerome
Kern and Irving Berlin, consolidated them through working in
(and eventually being celebrated by) Hollywood musicals. This
convergence of aesthetics, ideology and personnel was capped by
the economic convergence of Hollywood, Broadway and the
music industry which accelerated in the late 1920s, as the studios
acquired ownership of the music publishing houses and set about
developing their own music departments.[6]

The commercial exploitation of the new technologies

By 1927 cinema audiences in the United States had eagerly embraced the social habits that cinema economics and technology had encouraged them to adopt. Though, as Izod points out, the industry's admission figures need to be treated with caution, the first coherent attempt in 1922 to gather such data suggested that some forty million cinema tickets were sold every week.[7] By 1929, that figure had more than doubled to ninety million. Of course, going to the cinema was only one aspect of leisure consumption which increasingly characterized social life in the early twentieth century. In 1927, the year of Warner Brothers' *The Jazz Singer*, Americans purchased 104 million 78 r.p.m. records[8] as well as the equipment to play them on. The impetus for this consumption was clearly related to the technical developments in electrical recording which had been carried out by, amongst others, the Bell Telephone Laboratories between 1919 and 1924. The striking improvements in the quality of sound reproduction on record, expanding the frequency range by some two and a half octaves, stimulated a vast range of both classical and popular music recording.

In a similar way, the technical development of the audion or vacuum tube and its commercial exploitation by companies such as the Radio Corporation of America (RCA) gave an enormous boost to radio as an entertainment medium in the early 1920s. By 1927 there were some 600 radio stations in the United States broadcasting to an American population who had purchased domestic radio sets to the gross value of $425 million.[9] In 1927 came the establishment of the second and third national radio networks – the American Broadcasting Company (ABC) and Columbia Broadcasting System (CBS) respectively – to add to the National Broadcasting Company (NBC) which RCA had set up a year earlier.

Despite their increasing consumption of radio, records and film, mid-1920s audiences were still fractured into listeners (of radio and records) and viewers (at the cinema), bound to what Armes calls 'amputations of experience'.[10] This separation of experience reflected the ways in which the essentially nineteenth-century technologies had been exploited prior to the 1920s. Although Edison, Pathe, Muybridge, Gaumont, Messter and

others had been interested in developing a range of different
media, the exploitation of their work, as well as the work of a host
of others, tended not to cross over commercially. This was due, in
part, to an embryonic capitalist industrial structure which was not
yet sufficiently developed to realize the potential for commodifi-
cation which these new and various reproduction media offered.
Eyman notes that a Frenchman working in England, Eugene
Lauste, had developed an effective sound-on-film system as early
as 1904, but that development of his system was hindered by the
'traditional indifference of English capital to the economic possi-
bilities of inventions'.[11]

This is not to suggest that early pioneers such as Edison were
uninterested in the commercial exploitation of their work, merely
that they were keen on exploiting what proved to be the the wrong
things. For a long time Edison saw the value of his phonograph as
its ability to preserve the speech of a nationally important politi-
cian, the performance of a classical singer, the voice of a loved one
who had subsequently died. What he seemed unable to conceptu-
alize was the commercial potential and cultural implications of
recorded sound which could be used, not just to preserve,
museum-like, the voices of the exemplary great and the good, but
to offer the mass duplication of music on a commodity basis at a
time when popular music was being organized along commercial
lines. In fact, Edison opposed the use of the phonograph as a type
of early jukebox on the grounds that it trivialized the invention.
In the same way, Charles Sumner Tainter and Chichester A. Bell's
North American Phonograph Company, the forerunner of
what became the Columbia Phonograph Company, manufactured
cylinders for office dictating machines. Though, as we have
seen, Edison was concerned with the commercial exploitation of
technical innovations, he was the product of an essentially late
nineteenth-century cultural politics. Curiously, for all his
dismissal of 'disinterested' science, he and others like him were
concerned to represent and perpetuate existing power relation-
ships, resistant to the changes that their innovations implied.[12]

This cultural blindness to the radical challenge these 'new tech-
nologies' posed was matched by the underdeveloped commercial
and industrial structures which were needed to exploit them.
The first twenty years of the century witnessed a growing aware-
ness of the cultural implications of mass reproduction, and the

development of economic structures able to promote and exploit mass culture. This growing cultural and economic convergence can clearly be seen in the cinema during this period, reducing the independence of exhibitors and their power to control which music accompanied films.

The entrepreneurial values of many of those working within an emerging mass entertainment industry has long been acknowledged.[13] When, in 1916, Adolph Zukor merged the Famous Players production company with the Paramount distribution company, forming the Famous Players-Lasky Corporation, he was able through the system of block-booking to force exhibitors to take the films his company wanted them to. Industrial power was shifting away from the exhibitors to the production companies; five years later, in 1921, Paramount-Famous Players-Lasky actually owned 303 cinemas, and the days of the independent exhibitors were numbered, as was their influence over the music which accompanied films.[14]

This movement towards vertical integration, whereby a company owned and controlled the production, distribution and exhibition arms of the cinema business, was in many respects a prerequisite for the full commercial introduction of synchronized sound in the cinema in the mid- to late 1920s. As we have seen, much earlier attempts at synchronized sound had been made; both Edison and Charles Pathe had developed 'synchronizers' and, in Britain, Cecil Hepworth's company used the vivaphone, a synchronized disc system, as early as 1907. Such attempts were limited not only by the short duration of the gramophone disc, but more importantly by the poor reproduction available through acoustic recording and the inability to amplify the sound adequately in the auditorium. However, the sheer number of patents for sound systems being registered prompted a trade paper editorial to comment in 1910, 'In our opinion the singing and talking moving picture is bound sooner or later to become a permanent feature of the moving picture theatre'.[15] In a technological sense, the way forward lay, not with sound-on-disc, but with optical sound recording, with sound-on-film.

The scientific principle behind the conversion of sound waves into patterns of light had been understood well before 1900, but the first patented attempt to produce an optical sound track on film appeared in 1904. Significantly, a project to produce such a

system in 1910 failed because of a lack of financial backing. The Tri-Ergon system, developed in Germany in 1919, proved more successful, and was the basis of the sound system purchased (illegally as it was later ruled in 1935) by William Fox's Fox film company in 1927.[16] In the United States, Lee De Forest had patented and developed a similar system by 1923. Earlier, De Forest had developed the audion tube, which amplified the sound it received and relayed it through a speaker. Western Electric, a subsidiary of the burgeoning American Telephone and Telegraph Company (AT&T) had been quick to realize the importance of De Forest's solution to the problems of sound amplification; it purchased the telephone rights to the audion tube in 1913 and the radio rights a year later and perfected its application.[17] Western Electric were thus in the position of having developed a potentially successful hardware system for synchronized sound film but were not, of course, in a position to produce software – the films – for it.

In contrast to Western Electric, the Hollywood production companies remained largely uninterested in De Forest's sound-on-film system, and he formed his own Phonofilm company in 1922 to produce a series of short sound films, many of them based upon musical performance and vaudeville acts, including well-known stars such as Eddie Cantor and George Jessel. Though De Forest had hoped to produce enough material to present full-length films, he accepted that there was more commercial potential in using them as short clips before other studio's feature films.

Western Electric, aware of the need for appropriate software to promote their sound system, remained interested in De Forest's phonofilms. An internal company memorandum reported on one of the films, *The Harlequin's Serenade*:

> It was difficult to tell whether the music was furnished by a small orchestra or only two or three musicians … The reproduction … was very far from satisfactory both as regards overloading and frequency characteristics. All of the heavy piano notes showed marked signs of overloading. This effect would have rendered the reproduction very disagreeable had not the volume been held much lower than we would consider necessary for filling a [large] theater.[18]

Despite the limitations to their quality, De Forest produced nearly

1,000 phonofilms between 1923 and 1927, and managed to find sufficient capital to wire thirty-four cinemas to show them. The general response both by the public and by the industry was overwhelmingly apathetic.

Western Electric, however, had improved its sound recording system using wax discs and was eager to interest the film studios in the process, demonstrating it to the 'big three' studios, Paramount, newly created MGM, and First National, as well as some smaller companies. Hollywood remained commercially aloof until Warner Brothers, eager to expand and diversify its activities, and with newly-acquired financial backing from Wall Street, sought ways in which to challenge the market dominance of the 'big three' companies.

Warner Brothers takes the initiative

The view perpetuated by many standard textbooks on Hollywood history that *The Jazz Singer*, the 'first talking picture', was a risky, one-off novelty which restored the fortunes of a near-bankrupt Warner Brothers is not only inaccurate, but disguises the complexities which characterized the commercial introduction of synchronized sound cinema.[19] Incorporated in 1923, a year later Warner Brothers was a successful but still relatively minor production company, lacking both a cohesive distribution network and its own exhibition outlets, and saddled with a system of financing production that was both expensive and unreliable, sometimes costing the studio an effective interest rate of 100 per cent.[20] Arguably, the most significant innovation by Warners was the ability to attract secured and permanent financing through the Wall Street investment bankers Goldman Sachs. Impressed by the tight management structure and cost-effectiveness of Warners' production methods, Goldman Sachs underwrote its takeover of the ailing Vitagraph Company in 1925. As a result, Warner acquired not only two production studios in New York, but, more important, twenty-six distribution offices in the US and a further twenty-four abroad. Backed by secured Wall Street finance, it acquired further distribution outlets both at home and abroad, and, most significantly, bought a number of important cinemas in major cities such as Seattle, Baltimore and New York as well as a

radio station, KFWB, in Los Angeles. By the end of 1925, Warner's expansionist policy had created a company which threatened to match the dominant companies such as Famous Players and Loew's.

Far from struggling, Warner Brothers was in a position by 1925 of actively seeking other strategies which might add to its growing commercial strength. In this sense, having acquired a stake in radio, it was not surprising that the company felt itself financially strong enough to take on board developments with sound film, the 'new' technology which had been in existence for some years. Although *The Jazz Singer* occupies a central place in conventional cinema history as the first talking picture, it actually reflects Warner's initial interest in sound cinema, not to record dialogue, but rather with its ability to present musical and vaudeville performance to cinema audiences. Moreover, though it was to develop synchronized sound as a commercial proposition, Warner did so not with an optical system of the type developed by de Forest and others, but with the technically inferior sound-on-disc system.

It is clear that, when Warner Brothers signed a contract in June 1925 with Western Electric, it they were not primarily interested in recording spoken dialogue, but with recording a range of music, from popular vaudeville musical acts to popular classics. The short-term motivation, driven by the hard-headed financial considerations which were the dominating factors in everything the company did, was to cut the costs involved in providing live musical accompaniment and the live on-stage prologues which characteristically were an important part of the cinema-going experience in the mid-1920s. The first Vitaphone programme, presented at New York's Warner Theater on 6 August 1926, reflected this concern with musical performance.

Don Juan, directed by Alan Crosland and starring John Barrymore, was already in production as a silent film when the decision was made to add a musical score played and recorded by the New York Philharmonic. At the same time, Sam Warner filmed and recorded a number of musical items which were designed to accompany the screening of *Don Juan*. The decision to record these musical items in New York was in part necessitated by technical considerations and in part by logistical and economic reasons. With the exception of the banjo, guitar and harmonica

playing of Roy Smeck, the musical items were all pitched towards an upmarket audience, with the New York Philharmonic and singers and chorus of the Metropolitan Opera performing music by Wagner, Beethoven and Dvorak.

Warner's decision to feature music from the popular classics can be seen as part of that process whereby, during the 1920s, the cinema industry increasingly sought to stimulate a static market for its products, partly by appealing to a more affluent, better-educated, middle-class audience, though it also reflects the music which predominated in most musical film scores during the 1920s. This process had begun earlier, as bigger, more comfortable theatres lured customers with live music to accompany featured films. For Warner Brothers, the prospect of offering exhibitors prerecorded music which would replace increasingly costly live music was a major attraction, as was the prospect of replicating the type of entertainment which live staged prologues offered, again at a fraction of the cost. At the same time, the new sound cinema would combat the growing challenge of both radio and the phonograph as popular entertainment media. Much more significant though was the determination of Western Electric and its parent company AT&T to reap the enormous potential profits that lay in sales of the technical hardware for sound cinema. The cost of equipping a theatre with Vitaphone equipment was high, but at a time when audience figures were stagnating, exhibitors felt the need to invest in novelty. What they and Western Electric needed was what Warner Brothers supplied, an innovatory product that audiences would want to pay to see and hear. In simple terms, Warner was to provide the software to stimulate sales for Western Electric hardware.

In that sense, the early and experimental sound programmes produced by Warner Brothers can be seen as exercises in market testing. Though the critics responded well to the classical music, popular acclaim focused much more on vaudevillian Roy Smeck's number 'His Pastimes', entertainment much more closely related to the live prologues which were popular with audiences. This was not lost on Warner and, not surprisingly, vaudeville acts became much more prominent in subsequent Vitaphone programmes. Whatever the merits of the musical mix, the first Vitaphone show was a huge commercial success; seen by over half a million people, the programme at the Warner Theater ran for nearly eight months

and grossed just short of $800,000. Warner Brothers' share price rocketed.[21]

The enthusiasm of the paying public and the critics was matched by professional musicians and performers. Although established, top-line vaudeville artists were already capable of commanding high salaries for their live performances, the prospect of Hollywood-style salaries and royalties was even more alluring. To some extent, radio had paved the way, paying artists and bandleaders such as Eddie Cantor, Paul Whiteman and Rudy Vallee salaries which rendered most performers deaf to the warnings issued by ASCAP that the phonograph, radio and now sound cinema posed real threats to the continued existence of live vaudeville and live musical performance. For the moment, the lure of sound cinema seemed increasingly irresistible.

The second Vitaphone programme premiered on 5 October 1926. Significantly, the short musical items which accompanied the feature film, *The Better 'Ole*, were much more popular in their appeal. It included established vaudeville acts Eugene and Willy Howard in a comedy sketch, The Four Aristocrats with their 'jazzy songs and melodies', as well as George Jessel, who was then playing to packed houses in the Broadway production of *The Jazz Singer*, a musical based on the short story, 'A day of atonement', by Samson Raphaelson. The turn that made the biggest impact, not least on the reviewer writing for *Variety*, was Al Jolson. Already an established star in the commercially popular tradition of white appropriation of black minstrelsy, Jolson, complete with black face and cotton-field overalls, performed three numbers, 'Red, Red Robin', 'April Showers' and 'Rockabye Baby With a Dixie Melody'.

Both Jolson and Jessel appeared in subsequent Vitaphone programmes in early 1927. Again, Jolson received both popular and critical acclaim, whereas Jessel's popularity was dented by stilted performances. In fact, as both the number and length of Vitaphone programmes increased, it was clear that audiences were becoming disenchanted with what was seen as a rather tired format. Faced with this, and the competition from William Fox's Movietone sound shorts, premiered in May 1927 and greeted with enthusiasm in the trade papers,[22] Warner Brothers made the decision to invest in a synchronized sound feature film. Then, as now, innovations in software production were seen as essential for

the successful commercial promotion of a new technological and cultural form. Significantly, the cinema industry turned to live musical entertainment, to Broadway for an inspirational vehicle, and to top-flight vaudeville for a leading player.

The Jazz Singer: synchronized sound film as software

Though George Jessel was starring in the Broadway production and was originally set to play the lead in the film, it was Al Jolson who was eventually signed by Warner Brothers to star in the film version of *The Jazz Singer*. Though, as Carringer makes clear, several explanations as to why Jolson replaced Jessel were in circulation, Jolson was actually a better box-office attraction. Though he had previously had a disastrous experience working for director D. W. Griffith, when he walked away from the film and into a court case suing him for damages, the public response to the Vitaphone musical 'clips' persuaded Jolson to sign a lucrative contract with Warner.[23] The sound sequences for the production were shot separately and each given a production code number, prompting speculation that, had the film not been commercially successful, then the clips might have been used separately. Given our earlier comments in the previous chapter on the ways in which the relationship between number and narrative remains distinctive, when as Gorbman puts it, 'narrative cedes to spectacle', this seems entirely possible, given that Warner had no way of predicting the success of *The Jazz Singer* and the success of their previous 'promo' clips.

Opening in New York on 6 October 1927, the 'photo-dramatic production' *The Jazz Singer* played to capacity audiences there and in the other one hundred or so 'wired-for-sound' cinemas in big cities such as Baltimore and Philadelphia. In truth, anyone seeing the film for the first time today will probably be disappointed. Apart from one explosive sequence when Jolson improvises dialogue with Eugenie Besserer – 'Mammy' – much of the film relies on intertitles instead of dialogue. The mawkish sentimentality which oozes from the melodramatic acting, not least from Besserer herself, and the ponderous directorial style were at odds with the accepted conventions of realism which were rapidly established by 'talking pictures'. Yet the film remains

significant in a number of ways. From a technological perspective, of course, the film did little more than replicate what the Vitaphone programmes had already achieved and, ultimately, the sound-on-disc system was to give way to the technically superior optical soundtrack system. Yet, the significance of *The Jazz Singer* for Warner Brothers, Western Electric and Goldman Sachs was the confirmation that their investment in synchronized sound seemed justified in commercial terms, a conclusion the rest of the industry also came to. Although silent films were still made in the years following the success of *The Jazz Singer*, partly because of the capital equipment and resource investment which production companies already had in silent production and, more importantly, because of the enormous financial implications for exhibitors, the shift to sound film production gained momentum through 1928 and 1929.

As we saw at the beginning of the chapter, it is not unusual to concentrate on the human casualties involved in the studios' conversion from silent to sound production. Certainly, it is true that some silent screen actors fell by the wayside, either because recorded sound revealed vocal imperfections and unacceptable foreign accents, or – and this was much more common – because studios were unable to cast them in roles which made the best of their talents. There was some feeling amongst studio musicians and composers for silent film scores that the success of *The Jazz Singer* and the spate of musicals it encouraged were in some respects detrimental to the advances they felt had been made in the years up to 1927. This is a view endorsed by some more recent commentators:

> Paradoxically, the advent of sound in the late 1920s momentarily cut into the progress that background music in general and classical music in particular were making. While filmed musicals such as ... *The Jazz Singer* were briefly all the rage, technical considerations, which in turn helped shape a kind of realist aesthetics, by and large cut the use of nondiegetic, incidental music to almost nothing.[24]

In fact, the shift to sound production was neither as difficult nor as significant as is often claimed. After all, for every former silent actor whose film career came to an end, there was a host of hopefuls to replace them who already had careers in other entertainment areas, in vaudeville, radio and the 'legit' theatre.

Actually, the development of sound cinema ended something of the silent cinema industry's insularity, as Hollywood, the theatrical industry, radio and the music industry came to recognize the mutual economic interests they shared. In fact, the key to the successful commercial exploitation of the new technology lay not with production, but with the conversion and re-equipping of cinemas for sound. This, after all, was where the profits lay, and this expectation of profits was what had stimulated investment in the first place. This, then, was the real significance of *The Jazz Singer*, as successful software which would promote the sales of the new technological hardware, cause the stampede towards 'wiring for sound', and, by stimulating cinema attendances, consolidate and increase the film industry's market share in entertainment and leisure consumption.

Not, of course, that cinema audiences who flocked to see the film throughout 1927 and 1928 thought of it in these terms, any more than cinema audiences do today when they go to see *Jurassic Park*, *Independence Day* or *Titanic*. For them, what *The Jazz Singer* offered was novelty, innovation, an exciting development in entertainment. It also meant that popular entertainment was somehow 'democratized'; Jolson, already enormously successful as a live act, was now available to a much wider audience. In retrospect, we can see that the film also represented an important development in cultural form, and the development of a new cinematic genre, the Hollywood musical.

The Jazz Singer and the emergence of the musical as a cultural form

In this sense, *The Jazz Singer* is significant in the way that it articulates both the formal and thematic paradigms which were to remain at the heart of the musical genre, especially during the years of the 'classical' musical, until the mid-1950s. In structural terms, the axis of public and professional success, as Jack Robin (Jolson) makes it from cafe singing through variety and vaudeville on to Broadway, intersects with the axis of romance, with Jack's relationship with Mary Dale (May McAvoy). Typically, as the musical genre develops, these two arenas of success, the public and the private, become evermore inextricably entwined.

Though there are important exceptions, as we shall see later, professional and public success in the Hollywood musical is usually equated with success in showbusiness and the world of entertainment. In *The Jazz Singer*, the self-reflexive, reiterative showbusiness backgrounds, from the young Jakie Rabinowitz's illicit performance in the smoke-filled bar, to the professional grandeur of 'April Follies' at the New York Winter Gardens, make the film *about* entertainment as much *as* entertainment. We are asked to care about the eponymous hero, whilst we also enjoy his music. The emphasis on performance and spectacle, and on the hard work that goes into performance, into musical and theatrical production, is an essential ingredient of this film and the musical genre as a whole. Clearly, for contemporary audiences, much of the pleasure in the film centred on Jolson's performance. The energy and spontaneity of the musical numbers and of the Jolson persona are in marked contrast with the otherwise slow and often rather tedious 'silent' sequences in the film. When Jolson is performing on screen, we get a very real sense of what must have been, for contemporary audiences, a cinema of possibilities.

Of course, though Jolson's performance can be treated as a source of pleasure in its own right, his songs and the other 'showbiz' sequences serve a more complex purpose in both narrative and ideological terms. For example, the sequence showing us the rehearsals for 'April Follies', has several functions. It has a narrative function in the sense that it reunites Jack and Mary Dale, but it also reiterates the ideological significance of 'work' in production, as well as offering the off-screen audience a sense of privileged spectatorship and voyeuristic pleasure. Reiterative images of entertainers and entertainment, and of showbusiness, permeate the film. Even the sacred songs sung by (the real-life) Cantor Rosenblatt are set in the showbiz context of a matinée performance at a Chicago theatre, and a 'serious' moment in the narrative, when the Jewish elders meet to decide who should sing the Kol Nidre, is treated as slapstick comic business.

Significantly, both for *The Jazz Singer* and the musical genre as a whole, much of the film's meaning is encoded in its music which, as Geduld argues, integrates popular songs, Jewish cantorial music and an orchestral score drawing on classics by Debussy, Tchaikovsky and Sibelius.[24] In particular, the contrasts between the musical orthodoxies of Cantor Rabinowitz, the music of the

synagogue, and the up-tempo syncopation of Jolson's ragtime and jazz, are clearly juxtaposed within the film. The ritualistic intonations of the Kol Nidre may have commanded respect from audiences, but it is 'Blue Skies' and 'Toot, Toot, Tootsie' which set the pulses racing and kept the box office busy. Though Cantor Rabinowitz may see the 'new' music as a pollutant – he is affronted that his son 'dares to bring jazz singing into my house' – there is little doubt that, within the film's narrative schema, it emerges triumphant. In so doing, it represents the challenge to, and overthrow of, both religious and cultural conservatism. In freeing himself from the social constraints of religious orthodoxy, and from the literal and symbolic Law of the Father, Jack offers up an image of a new America in which energy, hard work and spontaneity are seen as the democratic antidote to the cloying hypocrisies of religious and social tradition. This rejection of orthodoxy, of the ways of the old world, is registered in numerous ways, such as when we see Jack eating his cafe breakfast of ham and eggs, but most importantly in the ragtime and jazz singing of Jolson.

Cinema audiences in the 1920s were more than familiar with the rebellious connotations of ragtime, though clearly these connotations were different for black audiences than they were for white. As early as 1899, the musicologist and author Rupert Hughes wrote:

> To formulate ragtime is to commit synedoche, to pretend that one tone is the whole gamut, and to pretend that chaos is orderly. The chief law is to be lawless. The ordinary harmonic progressions are not to be respected; the dissonances are hardly to be represented by any conventional notation, because the chords of the accompaniment are not logically related to the bass nor to each other, nor to the air. It is a tripartite agreement to disagree.[26]

They were equally familiar with the music's black origins and its appropriation by white commercial artists, not least by Jolson himself. It is probably true to say that the important musical distinctions which differentiated ragtime from jazz were unimportant to the mass audience who went to see *The Jazz Singer*. What mattered more were the pleasurable sounds and images which accorded with their sense of a newly emerging 'democratic' America, an America in which hard work would render the

experience of the ghetto irrelevant, and where success was achievable by everyman. This sense that ragtime represented the 'new'
music of an increasingly urban, boisterous and thrusting America
was recognized at the time. Hiram K. Motherwell, defending what
someone had called the 'bangs and explosions' of ragtime, argued
that these bangs and explosions were important because this was
the sound of the city, an expression of the new urban 'jerk and
rattle, its restless bustle and motion, its multitude of unrelated
details and its underlying progress towards a vague somewhere'.[27]
 Whilst the coded rebelliousness of ragtime and jazz is seen as
confronting the staid conformities of earlier social traditions, it
would be wrong to suggest that *The Jazz Singer* in any way
exploits the oppositional significance of the music, or offers a
radical critique of American culture and society. On the contrary,
the film's conservative ideology endorses a social perspective in
which ambition and success remain firmly rooted within the
context of family and community. The conflicts which the film
raises are ultimately reconciled. Torn between the competing
demands of his professional career and those put upon him by his
dying father, Jack expresses his dilemma: 'It's a choice between
giving up the biggest chance of my life – and breaking my
mother's heart'. In fact, Jack cancels the opening night performance of 'April Follies', sings the Kol Nidre with enough 'heart'
to enable his reconciled father to die in peace, and then, since
'time heals, and the show goes on', continues his hugely successful showbiz career, watched by his mother and Yodelson in the
front row of the theatre.
 We should not be surprised by this, since the trajectory of
Jack's success leads him back, as the intertitles tell us, to 'New
York, Broadway, HOME, *MOTHER!*'. If Jack's rebellion is
directed literally and symbolically against the Law of the Father,
and even if his talents 'belong to the world', his separation from
his mother remains a temporary, enforced one, something represented as deeply unnatural. In a crucial sequence in the film, Jack,
still working his way to the top, returns home and entrances his
mother not just with a 'jazzy' rendition of Irving Berlin's 'Blue
Skies', but with an extempore vision of all the material benefits his
showbiz success will bring her, not least a move to a 'better' neighbourhood and a new pink dress. Significantly, his mother not only
seems reconciled to Jack's career and his music, but seems

seduced by the prospect of materialistic improvements to her life. This bond between them, musical, familial and materialistic, is disrupted by the father, who again banishes 'the jazz singer' from his home, from, in effect, the old world in which Jack and his music seem to challenge. Of the two parents, it is clear who will have to give way in the face of Jack's textually predetermined success and all it represents.

In fact, the reconciliatory coda at the end of the film has been presaged and encoded within Jack's music, not just through its lyrical fixation with the mother figure, but by the harmonic and melodic structures associated with the commercialism of Tin Pan Alley. Just as mother remains ever-present in Jack's life – her photograph is on his dressing-room table, and she disrupts the dress rehearsal of 'April Follies' – so her presence permeates his music. At the dress rehearsal, the black-faced Jack sings the sentimental ballad 'Mother, I Still Have You', as his mother watches from the wings:

Mother, I'm sorry I wandered away,
Breaking your heart as I did,
Now that I'm grown up,
I've come back to say
Things that I felt as a kid, dear
Mother of mine,
When friends all doubt me,
I still have you ...

Following the final reconciliation, and the death of the father, the culmination of Jack's career is epitomized in an Oedipal musical homage to 'Mammy', a combination of exuberant minstrelsy and pure Tin Pan Alley ballad-orientated schmaltz. It is hard to imagine a greater fudge of visual, musical and narrative compromise, the black-faced Broadway entertainer, transfixed in a proscenium-bound long shot and static mid- and close shots, singing to a rapturous on-screen audience which includes his mother and the former arch-informer Yodelson, and, simultaneously, to an off-screen audience whose spectatorial space is constrained by the colonizing triumphalism of Jolson's 'all-talking, all-singing' cinematic performance. Yet, as we shall see, it is this drive towards the textual representation of success, of energy and abundance, of harmony and reconciliation, of

consensus and community, of private and public utopia, which lies at the heart of the musical genre.

The impact on the entertainment industries

The Jazz Singer, then, is significant in a number of ways. At one level, it represented the transformation of sound cinema technology into a fully social technology, into something that was to become part of people's everyday experience. It also provided, through its popularity with audiences and resultant commercial success, clear evidence that wiring cinemas for sound made business sense, and that the initial investments made by Western Electric, General Electric, RCA, as well as banking houses like Goldman Sachs, were justified. In basic terms, the film acted as successful software in stimulating investment in sound technology hardware, and left the Hollywood studios in no doubt that future productions would be shot for synchronized sound. In 1929, 75 per cent of all films produced in Hollywood were released with some form of prerecorded sound. The cost of converting cinemas for sound was enormous. According to one estimate, the cost amounted to over four times the 1928 market valuation of the entire American film industry. As a consequence, the controlling influence of Wall Street corporate giants Morgan and Rockefeller on the Hollywood industry was beyond dispute, and ushered in a feverish period of mergers and acquisitions both within the film industry and across other sectors of the entertainment and leisure industry.

The move towards vertical integration within the film industry is well documented.[28] In Warner Brothers' case, for example, this was finally achieved through the acquisition of the Stanley theatre chain in 1928. By 1930, American film production was dominated by the five 'major' studios – MGM, Paramount, Warner Brothers, Twentieth-Century Fox and RKO – all of which owned their own exhibition outlets, and the three 'minors' – Universal, Columbia and United Artists. As we have seen, these major structural realignments were financed by Wall Street, most notably by the two biggest corporate conglomerates Morgan and Rockefeller, with the result that representatives of financial institutions increasingly penetrated and dominated company management at

studio level, and exercised a very real, if indirect, influence on the types of film produced by the studios.

Although this convergence between the various branches of the entertainment industry had been gaining pace throughout the second and third decades of the twentieth century, the new technology of the 'talkies' was to provide an even greater stimulus for this economic realignment, particularly between Hollywood, Broadway and the music industry. Significantly, at a time when the structure of the popular music industry was based on sheet music sales, the Hollywood studios bought into the popular music industry. As *Photoplay* put it in 1929: 'It is now a question as to which has absorbed which. Is the motion picture industry a subsidiary of the music publishing business – or have film producers gone into the business of making songs?'[29] The success of *The Jazz Singer* as well as of the Vitaphone and Fox musical shorts, meant not only that the music and film industries were realigned in important new ways, but also that from now on the meaning of popular music would always to some extent be dependent on its visual economy.

Notes

1 N. E. Tawa, *The Way to Tin Pan Alley: American Popular Song 1866–1910* (New York, Schirmer, 1990), p. 12.

2 D. Clarke, *The Rise and Fall of Popular Music* (London, Penguin, 1995), p. 52.

3 P. Dranov, *Inside the Music Publishing Industry* (New York, Knowledge Industry Publications, 1980), p. 12.

4 I. Whitcomb, *Irving Berlin and Ragtime America* (London, Century Hutchinson, 1987), p. 55.

5 R. Middleton, *Studying Popular Music* (Milton Keynes, Open University Press, 1990), p. 14

6 F. Karlin, *Listening to Movies: The Film Lover's Guide to Film Music* (New York, Schirmer, 1994), pp. 175–95.

7 J. Izod, *Hollywood and the Box Office 1895–1986*, (London, Macmillan, 1988), p. 51.

8 R. Gelatt, 'Music on records', in P. H. Lang (ed.), *One Hundred Years of Music in America* (New York, Schirmer, 1961).

9 R. Armes, *On Video* (London, Routledge, 1988), pp. 42–4.

10 Armes, *On Video*, p. 96.

11 S. Eyman, *The Speed of Sound: Hollywood and the Talkie Revolution 1926–1930* (New York, Simon and Schuster, 1997), p. 31.

12 J. Attali, *Noise: The Political Economy of Music* (Manchester, Manchester University Press, 1985), pp. 90–5.

13 P. French, *The Movie Moguls: An Informal History of the Hollywood Tycoons* (London, Penguin, 1971).

14 A. Zukor, *The Public is Never Wrong* (London, Cassell, 1954).

15 R. Altman, *Sound Theory Sound Practice*, (New York, Routledge, 1992), p. 36. See also H. Geduld, *The Birth of the Talkies: From Edison to Jolson* (Bloomington IN, Indiana University Press, 1975).

16 Eyman, *The Speed of Sound*, pp. 112–13.

17 Eyman, *The Speed of Sound*, pp. 40–4.

18 Eyman, *The Speed of Sound*, p. 50.

19 R. Barrios, *A Song in the Dark: The Birth of the Musical Film* (New York, Oxford University Press, 1995).

20 D. Gomery, 'Writing the history of the American film industry: Warner Bros. and sound', *Screen*, 17:1 (Spring 1976) 40–53.

21 For a fuller account of the Vitaphone programmes, see A. Walker, *The Shattered Silents: How the Talkies Came to Stay* (London, Harrap, 1986).

22 Eyman, *The Speed of Sound*, pp. 111–13.

23 R. L. Carringer, *The Jazz Singer* (Madison WI, University of Wisconsin Press, 1979), pp. 16–20.

24 R. S. Brown, *Overtones and Undertones: Reading Film Music* (Berkeley CA, University of California Press, 1994), p. 56.

25 Geduld, *The Birth of the Talkies*, p. 187. The complete listing for the score for the film is in Carringer, *The Jazz Singer*, pp. 182–3.

26 I. Goldberg, *Tin Pan Alley: A Chronicle of American Popular Music* (New York, Frederick Ungar Publishing, 1961), p. 145.

27 I. Whitcomb, *After the Ball* (London, Penguin, 1972), p. 19.

28 D. Gomery, *The Hollywood Studio System* (London, British Film Institute/Macmillan, 1986).

29 Karlin, *Listening to Movies*, p. 221.

3

The popular music tradition and the
classical Hollywood musical, 1926–55

Mr Kern advises me that he is agreeable to grant Metro the exclusive
right to produce a picture involving a cavalcade of his music ... for
which he is to receive $161, 500.
Memo from agent Sam Lyons to Arthur Freed at MGM, 1940

Dear Mr Mayer,
We understand that you are planning a production of *Show Boat*.We
call your attention to the Production Code ... Article 6 – Miscegena-
tion (sex relationship between the white and black races) is forbidden.
Letter from Joseph I. Breen, 1950.

Though Warner Brothers had been largely responsible for initiat-
ing the convergence between a maturing popular music industry
and the film industry, like the other studios it was not always
aware of all of the possibilities it had created. Though it could
claim that 'from now on we can give every small town in America
... its own 110-piece orchestra',[1] Warner initially failed to realize
the importance of structures which would enable it to capitalize
on the opportunities it had helped bring into being. In fact,
Warner had missed out on the exploitation of the music in *The
Jazz Singer*: 'Mother, I Still Have You', written specially for the
film by Jolson and Louis Silvers, only sold 30,000 sheet music
copies.

It was a lesson that Warner Brothers, and the other studios,
learnt quickly. MGM bought up the Robbins Music Corporation,
RKO acquired Leo Feist, Paramount started its own Famous
Music Corporation. Warner Brothers took control of a number of
publishing houses, including Witmarks, and the resultant Music

Publisher's Holding Corporation gave them copyright control over the music of a number of important composers including Jerome Kern, Cole Porter, Victor Herbert, George Gershwin, Sigmund Romberg, Richard Rodgers and Lorenz Hart, all of whom had already been enormously successful on Broadway. Of course, as Saul Chaplin recalls, where they did not hold copyright control, the studios were not above replicating the structure of the most popular tunes in 'new' and 'original' ways, thus avoiding copyright payments.[2]

Viewed as a market testing device, *The Jazz Singer* has to be seen as remarkable successful, not least in helping to stimulate the structural, economic, technological and ideological fusion of the entertainment industry in the late 1920s. The way was open for the development and exploitation of what Altman calls 'the most complex art form ever devised',[3] the Hollywood musical.

Early musicals: narrative, spectacle and commercial success

For a brief period it seemed as if the rush to produce musicals would fail to keep pace with audience demand for the novelty 'all-talking, all-singing, all-dancing' pictures. Desperate for product, the studios turned to Broadway, which, with the success of shows such as Florenz Ziegfeld's *Whoopee*, *Show Boat*, *Rio Rita* and the extravagant *Follies*, was enjoying record business. Throughout 1928 and 1929, train loads of actors, singers, writers and composers, including Ziegfeld himself, made the trip cross-country to Hollywood. By the middle of 1929, songwriters had replaced sound men as the most conspicuous group of newcomers on the studio lots; for some weeks in November 1929, 90 per cent of America's most popular songs were film-related.[4]

The influence of Broadway and of Tin Pan Alley was evident in three quite distinct ways. First, there were those films which, like *Broadway* (Universal 1929), *Rio Rita* (RKO 1929) and *Gold Diggers of Broadway* (Warner Brothers 1929), simply attempted to shoot the original stage show for cinema. Then there those films which, whilst using original songs written especially for the film, replicated the revue structure typical of many Broadway shows. This debt to Broadway was openly acknowledged, as in the

publicity poster for First National's 1929 *Broadway Babies*, which trumpeted 'All the brightest lights of Broadway merged into one ... All Broadway's best stuff stolen for the Talking Screen'. Too often, because they replicated the Broadway revue structure, films such as the *William Fox Movietone Follies of 1929* and MGM's The *Hollywood Revue of 1929*, lacked any cinematic structure, style, purpose or direction, other than to showcase a string of performers, their songs and dancing. Such films clearly relied upon the spectacular at the expense of narrative. Third, and more significantly for the development of the genre, were those films which used originally composed music and lyrics within the framework of a structured narrative, often set within a 'showbiz' context. Perhaps the most significant was *The Broadway Melody* (MGM 1929), with its songs by Arthur Freed and Nacio Herb Brown. Although the film makes use of a Broadway background – a spectacular 'Francis Zanfield' extravaganza – it does so by exploiting the cinematic potential of the film musical genre rather than simply appropriating theatrical form. In every case, however, what was developing was a set of conventions for staging and shooting the musical spectaculars, the beginnings of a specific representational strategy for showing musical performance, singing and dancing on film.

The early years in the development of the Hollywood musical were marked by two inter-related factors, a degree of overproduction which led to temporary audience disenchantment, and the search for an appropriately cinematic form. The speed with which audiences became disenchanted with 'all-singing, all-dancing' revue musicals alarmed the studios, not least because of the enormous investment they had sunk into this particular kind of synchronized sound picture. Of course, this pattern presaged the wider crisis within the industry as, between 1930 and 1933, the consequences of economic depression fed through to peoples' everyday lives. Studio after studio reported financial loss and, as audiences declined, theatres struggled against closure. RKO made a loss of $5.6 million in 1931 and went into receivership in 1933. Warner Brothers announced a loss of $7.9 million in 1931 and undertook a programme of job cuts. Some 5,000 cinemas closed in the US as box-office receipts tumbled by an estimated 60 per cent compared with two years earlier.[5] Though all the studios had come to realize the importance of a marketing strategy based

upon product differentiation, expressed through stars, genres and distinctive studio styles, not even this could protect them from the chill blast of economic recession.

Arguably, however, this drift away from the musical reflected not just economic pressures, but also a growing disenchantment with the overt theatricality of much of the product, with, ironically, precisely that quality which had made the early films so successful.[6] Whilst spectacle and performance were to remain crucially important elements of the genre, audiences by the early 1930s had been schooled to expect what has since been referred to as the 'classical Hollywood style', a realist narrative driven by, and focused upon, the destinies of one or two leading characters.

In fact, the successful development of the musical genre through the 1930s, and its huge popularity with audiences throughout the next two decades, depended precisely on the formal, thematic and ideological fusion of spectacle and narrative, and on the management of the tensions which result. Unlike the plot-orientated conventional linear narrative which characterized most American film genres of the period, the Hollywood musical genre came to rely upon a series of dichotomies for its specific resonance. These dichotomies centre not just around what Altman calls the 'dual-focus' narrative,[7] through which the development and progression of heterosexual romance takes place, but also around the different modes of address and pleasures involved in spectacle and narrative. What we are offered at the deepest structural level are a series of dualities, of contradictions and oppositions, which, within the text, need to be recognized, commented upon, and resolved. Of course, these tensions are frequently articulated and resolved through the music itself, as 'popular' music is pitched against music coded as essentially 'serious' or elitist, in what Feuer characterizes as 'opera vs swing'.[8]

In the so-called 'backstage' musical, tensions exist not only between male and female, but between work and play, between success and failure, between attributions of 'amateur' and 'professional'. All too often, the twin axes of success in romance and success in professional entertainment intertwine, much as they do, embryonically, in *The Jazz Singer*. Above all, the musical presents us with a tension between the real and the ideal, and it does so through the inherent structural tensions between narrative and spectacle. In reconciling all these tensions, the musical genre

appears to offer up visions of entirely sustainable utopias, not least the utopia of heterosexual romantic love.[9]

This reconciliation takes place in the 'classical' musical through the integration of narrative and spectacle, of narrative and numbers. If, put simply, the structure of a realist Hollywood narrative could be schematized thus, where A represents the establishment of plot, character and setting, B represents the disruption to equilibrium or the enigma, and C represents the search for a new equilibrium and resolution:

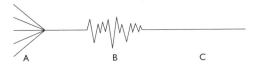

the structure of the fully integrated 'mature' musical could be schematized thus:

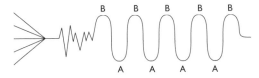

where conventional narration (A) is coded to present the 'real', with all of life's problems, and where the numbers (B), drawing upon the different performative codes of music, song and dance, present an optimistic resolution to those problems. Unlike conventional narration, the numbers often use a direct mode of address and, as a result, implicate us in a space where the ideal appears to triumph over the real. As suggested here, the resolution is frequently temporary, as 'reality' reasserts itself, only to be overcome yet again through another number until, finally and optimistically, we are positioned to accept and believe in the reconciliation of what had previously seemed the irreconcilable.

This structure is so pervasive that it is all too easy to take its significance for granted, and, in so doing, to overlook the crucial importance that music and song have in acting as a formal, ·thematic and ideological 'bridge' which helps reconcile the dichotomies. Though Gorbman argues that, with its ability to cross from diegesis to non-diegesis, all film music undertakes a

suturing function, this process is more complex within the
musical. Just how important the structure is can be usefully illus-
trated by analysing two musicals which, although produced within
two years of each other, are radically different in the way in which
narrative relates to spectacle.

Footlight Parade and the revue structure

Footlight Parade (Warner Brothers 1933), like the enormously
successful *42nd Street* released earlier that year, was directed
by Lloyd Bacon with 'numbers created and directed by' Busby
Berkeley. The film is interesting for a number of reasons, not least
because it offers Hollywood's discursive perspective on the rela-
tionship between live theatrical entertainment and the threat
posed to it by talking pictures. Like *42nd Street* and also *Goldiggers
of 1933*, both of which are ostensibly concerned with staging a
Broadway musical, *Footlight Parade* is set firmly within a showbiz
context, a background which Berkeley knew well, having choreo-
graphed numerous Broadway shows such as *Irene* (1920) and *A
Connecticut Yankee* (1927).

Faced with growing competition from 'talking pictures' – a
passing fad which won't last, according to Chester Kent (James
Cagney) – the live musical comedy shows which Kent produces
are threatened with commercial extinction. After a series of
continuing problems, Kent realizes not only that talking pictures
are here to stay, but that there is a market for the production of
live 'prologues' as part of the package of entertainment offered
to cinema audiences. After a lesson in the capitalist economics
of scale when buying aspirin at a drugstore, Kent persuades
his bosses, Frazer and Gould, to compete for a lucrative contract
to provide these prologues for a big exhibition outlet. Under
pressure from his alimony-seeking wife, a gold-digging blond,
fraudulent accounting by his bosses, and a mole who passes his
ideas to the rival Gladstone Company, Kent bullies his chorus line
and principals into putting together three prologues, 'Honeymoon
Hotel', 'By a Waterfall' and 'Shanghai Lil', in time to be
performed at three different picture houses on one Saturday
night. He is, of course, successful in getting the contract. Kent
also comes to realize that the formerly neglected Nan is the girl

for him, the 'schoolmarmy' secretary Bea becomes a 'real woman' and finds lasting romance with the youthful leading tenor, and the cynical chorus-line director Francis says he knew all along that 'it could be done'.

As with *The Jazz Singer*, *Footlight Parade* presents us with a version of the 'hard work' involved in the business of entertainment. Problems, conflict, self-interest and treachery exist in parallel with solutions, consensus and loyalty, and achieve concordance through the energetic construction of a working community which has an agreed objective. What we are offered finally is a textual representation of personal and professional success, of both private and public utopia, coded through 'putting on the show'. However, all this is achieved through a narrative structure which refuses integration. In many respects, the film is really two films, with the narrative fractured at the point where the dazzling exuberance of the three final numbers takes off. Where there are musical numbers earlier in the film, they remain largely incidental to the narrative, and do little to develop either plot or characterization. 'Ah, the Moon is Here' is merely an undeveloped snatch, used only to audition a singing role which remains narratively redundant and to establish Powell's credibility as a pleasureable lead tenor; 'Sitting on the Backyard Fence' acts as a vehicle to underscore Ruby Keeler's transition from bespectacled secretary to star performer, but has little other direct narrative function. In the same way, the three fully developed numbers at the end of the film are presented as spectacle, and are only related to the narrative concerns raised earlier as confirmation of Kent's success, and of the enduring attractions of heterosexual romance.

Typically of those Warner Brothers musicals involving Busby Berkeley, the final numbers dominate the film, offering distinctive sets of pleasures from those which are associated with the earlier part of the film. Conventionally, the credit for these three numbers belongs entirely to Berkeley's fluid and innovative camera work, but this overlooks the significant contribution of the composers Sammy Fain and Harry Warren, and lyricists Irving Kahal and Al Dubin. Warren and Dubin were responsible for 'Honeymoon Hotel' and 'Shanghai Lil', Fain and Kahal for 'By a Waterfall', as well as the two numbers shown in rehearsal, 'Ah, the Moon is Here' and 'Sitting on a Backyard Fence'.[9] With

the exception of Al Dubin, who had trained and practised as a
lawyer, their backgrounds were firmly within vaudeville and Tin
Pan Alley. Warren, for example, had worked in circus and as a
vaudeville stage-hand before becoming a song-plugger late in the
century's second decade. Throughout the 1920s and 1930s he
wrote numerous popular songs, including 'I Found a Million
Dollar Baby (in a Five- and Ten-Cent Store)' for a Bing Crosby
revue. Dubin's credits included 'Tiptoe Through the Tulips With
Me', Fain and Kahal's hits included 'Let a Smile be Your
Umbrella' and 'You Brought a New Kind of Love to Me'.

The point is that when Hollywood needed songs and music,
it drew inevitably upon existing popular entertainment traditions
and personnel, upon musical luminaries such as Irving Berlin and
George Gershwin, as well as lesser talents such as Bert Kalmar
and Harry Rubin, who had worked as a song-plugger for Harry
Cohn's music company before Cohn was involved with Columbia
Pictures. The merger between Hollywood, radio, theatre and
the music industry was not purely a matter of economics, since
the convergence of institutional policies and practices, of person-
nel and of their shared ideological assumptions were of equal
significance.

Yet, despite this convergence, it is important to recognize
that radical transformations occur when the work of these Tin
Pan Alley stalwarts is visualized on the screen. The problematic
relationship between popular music and the screen, the construc-
tion and contestation of meanings, is a central concern of this
book. However, because of Busby Berkeley's highly idiosyncratic
choreographic and visual style, the transformation here is both
more spectacular and, ironically, more limiting. Because *Footlight
Parade* refuses integration between numbers and narrative,
the final numbers are shot essentially in revue style, though with
a sophistication and panache which earlier revue films had lacked.
It delivers quite specific pleasures, not least as in 'By a Waterfall',
the rich orchestration utilizing lush strings, a melodic saxophone
section, punchy brass and collective female chorus. Berkeley's
imaginative work was – and remains – sufficiently distinctive in
its scope and scale to explain why the films he worked on
were popular with contemporary audiences and retain a cult
status subsequently. Certainly, he imbues all three numbers with
a voyeuristic sexual frisson which both titillates and disturbs,

but the pleasures they deliver are not the more subtle pleasures which come from more mature musicals, where music and song, because they are integrated with the narrative, act as a bridge between the complex dichotomies raised by and represented within the text.

All three numbers have at their centre a concern with romantic love, that ideological bedrock of all popular music, even though this central conceit is challenged and tested by suggestions of illicit flirtations of the kind which were possible before Hollywood's stricter production code took effect in 1934. Dick Powell sings to Ruby Keeler about wedding bells, but a significant number of guests at the 'Honeymoon Hotel' appear to be called 'Mr and Mrs Smith', and the collection of scantily attired wives who give Ruby Keeler advice have to be reminded by the house detectives that they 'are in Jersey City, not in Hollywood'. In 'By a Waterfall', Powell's tenor voice sings the opening verse:

> I appreciate the simple things
> 'Cause I'm awful fond of getting
> Love in a natural setting

As he begins the chorus

> By a waterfall,
> I'm calling you, hoo oo
> We can share it all
> Beneath a ceiling of blue ...

he is joined by Keeler, who echoes his sentiments by repeating it. However, this apparent idyll of heterosexual love is transformed into an extended male masturbatory fantasy. As he falls asleep, Powell dreams – at length – of myriad young women, including a 'naked' Keeler, splashing in waterfalls and swimming pools. The big-band orchestration provides a backcloth for the all-female chorus which takes up the now collectively expressed refrain. This, as much as the explicit voyeurist visual images delivered by Berkeley, implicates the viewing and listening audience in Powell's chauvinist reverie. Again, in 'Shanghai Lil', even if the eponymous lady does finally get her wish to sail away with Cagney courtesy of the US Navy, much is made of her promiscuous sexuality.

It is often argued that no other genre stereotypes women as savagely as the backstage musical does. In particular, it has

become commonplace to accuse Berkeley of transposing voyeur-
istic pleasures into cinematic style, of offering what Lucy Fischer
terms 'the image of woman as image'.[10] As with the video for
Duran Duran's 'Girls on Film' in the early 1980s, the process of
constructing images of women through the imposition of male
fantasy is something which pervades music video as much as
cinema and television. Too often, this process concentrates on
visual imagery, and ignores the important, if less obvious, role that
music and song lyrics play. As *Footlight Parade* reminds us, the
construction of sexual stereotyping is as dependent on the aural
and lyrical imagery of commercial popular music, and the way in
which these address the audience and position the listener, as it is
on visual imagery. Arguably, the pleasures of the spectacle,
whether in Hollywood musical or much contemporary music
video, remain predominantly pleasures constructed for male eyes
and ears.[11]

Footlight Parade essentially retains the structure of a revue
bolted on to a more or less conventional realist narrative. The
distinctive spectacular pleasures of music, song and visual chore-
ography, though impressive, remain essentially detached and
unrelated to the pleasures on offer within the narrative with its
indirect mode of address. In contrast, *Top Hat* (RKO), produced
two years later in 1935, exemplifies the rich aesthetic and ideo-
logical potential when narrative and spectacle become structurally
and ideologically integrated.

In responding to his own question as to why songs have words,
Simon Frith suggests that lyrics give songs their social use, since
they are open to interpretation by audiences as much as by
performers.[12] Whilst he acknowledges the enormous range and
diversity of song lyrics, and the issues of 'authenticity' which
occupy critical debate about specific music genres, it seems self-
evident that notions of love and romance were central concerns of
Tin Pan Alley lyricists. To dismiss these as 'lyrically banal' and
'formulaic' is not only unhelpful, but precludes any understand-
ing of the popular. The point is that these lyrics, these songs and
their sentiments were, and still are, about emotional possibilities.
They are there to be appropriated by listeners. However, when
placed within the context of the Hollywood musical, these possi-
bilities are constrained and determined by the images which
contextualize them, transcoded into the sights and sounds of

sustainable utopias, not least the utopia of romantic love. Arguably, once narrative and numbers become more integrated, the ideological power of both increases.

Top Hat and integrated form

Nowhere is this motif of romantic love more evident than in the cycle of musicals produced by RKO Radio Pictures between 1933 and 1939, starring Fred Astaire and Ginger Rogers. Despite the similarities of plot and structure – Arlene Croce refers to them as 'chapters in a single epic romance'[13] – the films were significant contributors to RKO's struggle to achieve levels of profitability. *Top Hat*, released in August 1935, was second only to *Mutiny on the Bounty* at the box office that year.

Much of this was due, of course, to their importance as dance films, and to the distinctive combined dancing talents of Astaire and Rogers. Of perhaps equal importance was the music and lyrics of Jerome Kern, Irving Berlin, George and Ira Gershwin. Seductively memorable in their own right, the songs sit perfectly within the romantic ideological project which underscores all the films.

Following the success of *Flying Down to Rio* (1933), *The Gay Divorcee* (1934) and *Roberta* (1935), *Top Hat* went into production in early 1935, based on an essentially original screenplay by Dwight Taylor and Allan Scott, and using original music and lyrics by Irving Berlin, though the number 'Top Hat, White Tie and Tails' had been written some years before. The traditions and practices of both Tin Pan Alley and Broadway are clearly in evidence, even in this apparent Hollywood original, and illustrate the ways in which different elements of the entertainment industry were increasingly intertwined.

Astaire and Rogers both began their careers in vaudeville. Astaire, aged seven, appeared with his sister Adele, aged nine, at Keyport, New Jersey, billed as 'Juvenile Artists Presenting an Electrical Musical Toe-dancing Novelty', in a number called the 'Dreamland Waltz'.[14] The two moved to Broadway in 1917, appearing in *Over the Top*, with music by Sigmund Romberg, and went on to do shows such as *Lady be Good* (1924), *Funny Face* (1927), and *The Band Wagon* (1931), featuring songs such as

'Fascinating Rhythm', 'The Babbitt and the Bromide', 'Funny Face' and 'S'Wonderful'. Ginger Rogers moved from singing and dancing in vaudeville to Broadway shows which included *Top Speed* (1929) with music and lyrics by Kalmar and Ruby, and Gershwin's *Girl Crazy* (1930). All of these shows were later to be produced as Hollywood musicals, and the songs were to find their way into numerous films, such as MGM's *Lady be Good* (1941), *Girl Crazy* (1943) and Paramount's *Funny Face* (1957).

Like their companion entertainments on Broadway, the Astaire–Rogers musicals mimic dramatic formulae established in nineteenth-century farce. The plots themselves were flimsy, and usually resolved in a manner which scorned realist demands. *Top Hat*, like *The Gay Divorcee* the year before, relies upon a case of mistaken identity to drive the plot. Jerry Travers (Astaire) is an American professional dancer appearing in a show in London. At the very moment he celebrates his bachelor status, he meets and falls for Dale Tremont (Rogers). Though she is both flattered and interested, she mistakes Travers for Horace Hardwick, the husband of her friend Madge. Despite seeing Travers as some sort of sexual philanderer, Dale allows a courtship to develop, only to marry her costumier Beddini in outraged reaction to Travers' apparent flagrant disregard for his 'wife'. Finally, all's well that ends well, as Dale realizes her mistake, her 'marriage' to Beddini is nullified, and she and Travers are free to consummate their romance in the closing number 'The Piccolino'.

Not that any of this really matters. What does matter is the dancing, the music and singing, the overt stylization of the decor, the opportunities for comic repartee, and the pleasures that come from watching the extra-textually preordained unravel before us. In fact, the very slightness of the plot and the low-key acting performances required, particularly from Astaire and Rogers, only serve to privilege the numbers and the pleasures they deliver. What matters is not plot but character and, in particular, character centred around courtship ritual and the ideology of romantic heterosexual love.

The central dichotomy in *Top Hat* revolves around the desires, expectations and behaviour of the opposing genders. The dual-focus narrative is driven by Jerry Travers' advances and Dale Tremont's reactions, which, initially negative, become more responsive in spite of her view of Travers as a sexual philanderer.

Whilst the problems and misunderstandings are perpetuated within the dialogic narrative, their resolution and the ultimate realization of love and romance is achieved through the numbers, the singing and dancing. What differentiates *Top Hat* from *Footlight Parade* is the degree of integration between the narrative and the numbers. Of course, the numbers do draw upon performance codes in the same way, and much of our pleasure whilst watching them is of the kind that defies rational or intellectual analysis. At the same time, however, they are used to express character and personality, and to develop the romantic relationship between male and female. The one exception is 'Top Hat, White Tie and Tails', which is performed 'on stage' as he 'shoots' his chorus of male dancers in front of the on-screen internal audience The number does have some narrative function; it confirms Travers' professionalism – his successful status has already been established – and, as he 'eliminates' the male chorus, it reinforces his willing rejection of male camaraderie and bachelorhood in readiness for heterosexual romance. However, its primary function is as spectacle, a showcase for the solo talent of Astaire.[15] This is, in a very distinct sense, a cinema of attractions. The other numbers have a function and meaning much more closely related to events in the narrative which surround them, and typify the classic structure of the genre.

Having established that, as the American dancer Jerry Travers, he is in London to star in a show for impresario Horace Hardwick, Astaire performs the number 'No Strings' in Hardwick's hotel room. Horace tells him that Madge, his wife, is expecting them to fly to Italy for the weekend, that she has arranged a meeting with a young friend and that 'something is in the air'. Unsure whether he is expected for a weekend or a wedding, Astaire extols the pleasures and benefits of being single and unattached. We slip from dialogue to song with consummate ease, the orchestration swelling in the background, as he proclaims:

No yens, no yearnings,
No strings, no connections,
No ties to my affections,
I'm fancy free and free for anything fancy.
No dates that can't be broken,
No words that can't be spoken,
Especially when I am feeling romancy.

This celebration of the male refusal of monogamy has a strongly promiscuous tone, as he declares that his 'decks are cleared for action' in anticipation of bringing on 'the main attraction'. This stance is reinforced through Astaire's routine, an aggressive tap dance which colonizes the available physical space. As he kicks and slaps the furniture in Horace's apartment, he acoustically invades the apartment below where Dale Tremont is in bed. She goes up to complain and, at the very moment of its celebration, signals the beginning of the end of his unattached status. As their romance develops, this capitulation of male 'freedoms' and predilections to the power of heterosexual romance becomes complete, so that in the number 'Cheek to Cheek', Astaire acknowledges the superiority of romantic emotions and feelings over tradition male activities:

> Oh, I love to climb a mountain,
> And reach the highest peak,
> But it doesn't thrill me half as much,
> As dancing cheek to cheek.
>
> Oh, I love to go out fishing,
> In a river or a creek,
> But I don't enjoy it half as much,
> As dancing cheek to cheek.
>
> Dance with me,
> I want my arm about you,
>
> The charm about you,
> Will carry me through to
> Heaven, I'm in heaven ...

This expression of male submission to the power of romance is matched by Dale's submission to his advances, even though, at this stage, she still thinks Astaire is already married. The overt sexuality of their relationship is coded through the dance, the finale of which simulates the physical consummation – heaven – of their relationship. The theoretical male promiscuity celebrated in 'No Strings' is matched by apparently equally promiscuous behaviour by the female. This suggestion of sexual frisson is, of course, denied textually as we know what Dale doesn't – that Astaire isn't married as she supposes.

This coded sexual consummation through song and dance

represents the utopian solution to the problems of mistaken identity and the resulting animosity between Dale and Travers which mark the dialogic narration. In an earlier number, 'Isn't This a Lovely Day (to be Caught in the Rain)?', music, song and dance are used to suggest the romantic suitability of the couple, as Dale matches the dance movements that he initiates. Through key changes, two increases of tempo and choreography that brings them from open opposition to symmetrical togetherness, the number suggests sexual awakening and mutual interest, only for this to be frustrated later through the plot mechanisms of mistaken identity. The way this number begins, as rolling drums imitate the rolling thunder on the non-musical soundtrack, introducing and building the orchestration, typifies not just the level of integration between narrative and numbers, but illustrates the way in which the numbers allow a spectatorial slippage by which the audience crosses from the real (the narrative and its problems) to the ideal (the achievable utopias transcoded through music, song and dance). These dual levels and modes of address are central not only to the structure of the 'classical' musical, but to the way in which its ideological project works. Significantly, though *Top Hat* is not a 'backstage' musical, it draws upon all those coded resonances of the world of entertainment. Jerry Travers is a professional dancer, and even when his professional public skills are used to express private emotion, the numbers are 'staged' on a Central Park bandstand or the proscenium space of a Lido dancefloor. This ability to 'stage' solutions and resolutions, to transcend 'reality' and occupy a constructed ideal is crucial to the genre and to its social meanings.

Like the earlier Astaire–Rogers musicals, *Top Hat* finishes with a communal celebration expressed through song and dance, 'The Piccolino'. This closing number serves a range of purposes, textual, ideological and commercial. Like 'The Carioca' in *Flying Down to Rio* and 'The Continental' in *The Gay Divorcee* before it, 'The Piccolino' was designed to be marketed as a dance craze, which itself would mean healthy sales of the sheet music and records. Along with all the other songs in *Top Hat*, it was promoted by Astaire in his radio series, *The Hit Parade*, sponsored by Lucky Strike cigarettes. That the number was less successful commercially than the previous two may well have been due to the fact that the lyrics refer to a song, rather than the dance itself, and to

the self-mocking, introverted quality of these lyrics. However, the number also serves as textual closure, a communal celebration of song and dance, and their role within the regime of romantic love. 'The Piccolino', danced by some score of couples, men and women literally bound to each other with ribbon, acts as ideological reinforcement of the heterosexual romance which has been at the centre of the film. Of course, until Bates the butler reveals that Dale's 'marriage' to Beddini has no legality, the air of promiscuity is prolonged, as Astaire gatecrashes the wedding party. The explanatory denouement is accompanied by a musical soundtrack playing 'The Piccolino', which reprises the celebratory, naturalizing resonance of the dance. Finally, Astaire and Rogers add a brief but sufficient coda, as the film closes.

Top Hat's formulaic quality helps to explain the commercial success of the RKO Astaire–Rogers cycle of films through the 1930s. The film also exemplifies the structural, thematic and ideological preoccupations – as well the central significatory importance of music and song – which characterize the classical musical genre, in all its variety, throughout the late 1930s, the 1940s and the early 1950s.

Of course, such a broad statement is not meant to disguise important differences and distinctions which exist within the musical genre. In his seminal study, Rick Altman argues that we need to accept that not all genre films relate to their genre in the same way. Drawing upon a simultaneous acceptance of semantic and syntactic notions of genre, where the semantic elements are the 'common traits, attitudes, characters, shots, location, sets and the like' and the syntactic are the 'constitutive relationships' between these elements and utilizing the critical potential which this provides, Altman distinguishes between three generic subsets, the 'fairy-tale' musical, the 'folk' musical, and the 'show' musical.[16] Whilst the genre as a whole addresses notions of utopian desire, each subgenre makes its address through distinctive mediatory devices, whether through a visible reification of an ill-defined temporal and geographic space (perhaps 'Ruritania' or the Lido at Venice) which encourages romance to blossom, through a mythologized cultural past constructed by and infused with the vagaries of memory, or through the tensions and energies involved in putting on a show. Between them, Altman argues, the subgenres address those most

fundamental audience desires – 'to be somewhere else, be someone else, at some other time'.[17]

It was argued earlier that the importance of music and song within the Hollywood musical lies, in part, in the way in which they act as a formal, thematic and ideological 'bridge' which helps reconcile tensions and dichotomies inscribed within any one text. Given that Altman locates *Top Hat* as a fairy-tale musical, it will be useful to look at examples from the folk musical and the show musical to see the same process at work.

Meet Me in St Louis: the 'classical' musical and the convergence of the entertainment industries

Produced by MGM's Freed Unit in 1944, directed by Vincente Minnelli and starring Judy Garland, *Meet Me in St Louis* is set in a highly romanticized version of St Louis just after the turn of the century. Like so many folk musicals, the film is suffused with a yearning nostalgia for a cultural past which is both desirable and, the text suggests, attainable. Set in 1903, the Smith family are shown looking forward to 1904, watched, of course, by an audience in 1944 looking backwards. Deeply conservative ideologically, the film endorses the normative values of home, family and heterosexual romance.

The film has received a great deal of critical attention from a variety of critical perspectives. Devoted auteurists are keen to locate the film within the canon of Minnelli's work.[18] Other writers have emphasized its undoubted significance within the history and development of the musical genre, and within MGM in particular. Still others discuss the film within the context of that metatextual construction 'Judy Garland'.[19] Here, I want to concentrate on the film as a further example of those processes of convergence which are central to any understanding of cultural industries under capitalism, and to highlight the significance of music and song in the regime of meaning.

Though this aspect is often overlooked, *Meet Me in St Louis* forcibly illustrates the extent to which the Hollywood product interacted with, and relied upon, the theatre, music and radio industries in a complex web of structural, financial, ideological and creative interdependency. This interdependency was defined

not just by formal, contractual and legal arrangements between different companies and organizations, but crucially depended on individual personnel working across the different branches of the entertainment industry.

Culled from one of a series of Sally Benson short stories which first appeared in *The New Yorker* and which were published in book form in 1942 – at a time when Benson was working at MGM as a treatment writer – the script for *Meet Me in St Louis* was developed by Irving Brecher and Fred Finklehoffe with the active encouragement of Arthur Freed. Though Freed himself had started at MGM as a lyricist where, working with composer Nacio Herb Brown, he had produced a number of songs including, most famously, 'Singin' in the Rain', Freed originally saw the film not as a musical, but as a sentimental drama accompanied by a soundtrack of 'original' Tin Pan Alley music written at the turn of the century. The decision to make the film a musical and to involve Garland and director Minnelli was endorsed reluctantly by Louis B. Mayer, and Ralph Blane and Hugh Martin were asked to produce a score. With the help of Roger Edens, associate producer to Arthur Freed, Blane and Martin produced original numbers – most notably 'The Trolley Song' and 'Have Yourself a Merry Little Christmas' – as well as drawing upon the traditional 'Skip to My Lou', 'Under the Bamboo Tree' (written by J. Rosamund Johnson and Bob Cole), 'You and I' (written by Nacio Herb Brown and Arthur Freed), and the title song 'Meet Me in St Louis' (written by Kerry Mills and Andrew Stirling).

The presence of Minnelli and Garland might be thought indication enough of the industrial and personal convergencies which have characterized the entertainment industries since the 1920s. Minnelli was born into a theatrical family. His father was a composer, a conductor and co-impresario of the Minnelli Brothers' Tent Theater. He built a career as a theatrical costume designer, working first for the Balaban and Katz organization, which merged in 1931 with the Paramount-Publix theatre chain, and then at Radio City Music Hall in New York. Directing Broadway shows such as *At Home Abroad*, *The Ziegfeld Follies of 1936* and *The Show is On*, Minnelli worked with songwriters George and Ira Gershwin, Rodgers and Hart, Dietz and Schwartz, as well as with performers and dancers such as Bert Lahr, Eleanor Powell and Charles Walters. Despite an abortive period in

Hollywood with Paramount in 1936, Minnelli signed with MGM in 1940.

Although not actually 'born in a trunk' in 1922, Garland's theatrical career began in vaudeville when she was only two-and-a-half. Her first radio broadcast was on *The Kiddies Hour* in August 1928 on Santa Monica's local station KFI and, with her sisters, she made consistent appearances on radio shows including the Los Angeles Warner Brothers-owned KFWB *Junior Hi-Jinx Hour* throughout most of 1933. Her screen debut came in a July 1929 'talkie' short produced by Mayfair Pictures, followed by appearances in three First National (a subsidiary of Warner Brothers.) sound shorts. On the basis of this, KFI's *The Kiddies Hour* now billed Garland and her sisters as 'The Hollywood Starlets Trio'.[20] Although she recorded two numbers, 'No Other One' and 'All's Well', for Decca Records in November 1935, they declined to release them. Just over six months later however, Decca did release 'Swing, Mr Charlie' coupled with 'Stomping at the Savoy', recorded with the Bob Crosby Orchestra. By the time Garland signed a seven-year contract with MGM on 27 September 1935, she already had considerable cross-media experience, and this was to continue throughout her life.

This interaction between cultural sites was far from being confined to Minnelli and Garland, however. For example, Blane and Martin had begun their careers in the entertainment industry in live theatre, singing in vocal quartets in Broadway musicals. They had acted as vocal arrangers for numerous Broadway shows, including *Cabin in the Sky* (later to be a MGM film directed by Minnelli) and had written the score for George Abbott's successful show *Best Foot Forward*, itself filmed by MGM in 1943. Conrad Salinger, who orchestrated the score, had worked both as chief musical director for Paramount-Publix and on Broadway. Lemuel Ayers, a Broadway designer who had won acclaim for his sets for the 1943 staging of *Oklahoma*, was brought to MGM by Freed. Freed himself, of course, had been writing songs since 1919 and producing stage shows since 1926.

Though it has become commonplace to recognize the importance of the intertextual construction of star images and the role that their circulation plays, not only in the social production of meaning, but as agencies of pleasure, desire and identification, this has taken place at the neglect of other elements, including

institutional and ideological determinants, which are of funda-
mental significance. A key element of such institutional structures
are the creative and technical personnel who work within and
across them, bring contacts, attitudes and distinctive working
practices with them. Whilst not suggesting that audiences were
either aware of or concerned with the sort of details we have been
examining, the fact remains that the texts they were consuming
were determined in important ways by institutional, cultural and
working practices which were circulated through a range of
cultural sites. In fact, it seems significant that the burgeoning
apparatus of publicity developed by and surrounding early Holly-
wood concentrated on the 'work' of 'players', 'picture personali-
ties' and 'stars', but concealed the range of other industrial
personnel, processes and practices which film production relied
upon. It is clear that the contribution of such personnel remains
an important area for further research.[21] For this reason, and
because of the range of creative and technical expertise involved
in its production, the musical genre is of especial interest in illus-
trating those structural, institutional and ideological convergences
which lie at the heart of capitalist cultural production.

Music, ideology and meaning in the musical

We have seen that the importance of music and song within the
Hollywood musical lies, in part, in the way in which they act as
a formal, thematic and ideological 'bridge', helping to reconcile
tensions and dichotomies inscribed within the text. In *Meet Me
in St Louis*, a film often praised for its 'naturalism',[22] we can see
how music and song serve as a bridge, not just to reconcile
tensions and dichotomies internally within the text, but also
between text and audience. Arguably, Martin and Blane's music
and lyrics serve to implicate the contemporary 1944 audience –
an audience whose location within the 'real' world of global
warfare was in large part characterized by absence and loss – with
the mythologized idyll of a newly emerging democratic America
which, it is suggested at a metatextual level, is still relevant
and sustainable. This attempt to abolish, or at least to render
insignificant, cultural time and space, to elide the utopian and the
real, is driven in large part by the film's numbers, which combine

traditional folk tunes, Tin Pan Alley standards, and Martin and Blane's originals.

As is the convention within the classical musical genre, the opening titles and credits are accompanied by a melange of some of the film's numbers. By matching the fluid camera movements and close matches on action, as the lyrics are passed from one member of the Smith household to another, the opening number, 'Meet Me in St Louis', serves a number of functions. The film's naturalistic visual style is reinforced through the performance of this opening number, with the vocal style and timbres of Agnes and Grandpa, together with the muted underscoring, suggesting an amateurish but authentic exuberance. Interrupted though it is by Garland's more polished performance of 'The Boy Next Door', complete with window-frame proscenium and net curtain which swishes to as the number closes, 'Meet Me in St Louis' serves to introduce the family and to code it as community. The one exception, of course, is father Alonzo Smith who, far from picking up the refrain, puts an end to the 'horrible screeching'. The number acts as a device to establish and delineate character and plot tensions, and also positions us to regard music and music-making as a 'natural' activity at both the intratextual and metatextual levels. With its barrel-piano harmonies and emphatic rhythmic structure, it locates the audience within a nostalgic cultural milieu as surely as the chocolate-box graphics which introduce and delineate the four seasons which serve as the film's ostensible structure.

Garland's 'The Boy Next Door' perfectly illustrates the central importance of music and song as an expressive vehicle, as a means of allowing an audience into the inner emotional life of a character in ways which conventional narration can find difficult. Garland's performance here is, as we should now expect, coded differently from her performance within the conventional narrative. More than one commentator has recognized the function that door and window frames have in *Meet Me in St Louis*, serving to construct a sense of the Smith household as a unified entity, a community from which the outside world is filtered, allowed to enter, or kept at bay. It seems equally important to recognize the way in which these frames are used as, and focus upon, performance space and spectacle. The proscenium-arch framing device is used for 'The Boy Next Door' and again for 'Have Yourself a Merry Little Christmas'. The effect of this is to code

Garland's performances as 'professional', encouraging the audience to make connections with that extratextual construction 'Judy Garland'. Her performances are in marked contrast with the homely amateurishness of, say, 'You and I', where the (over-dubbed) Leon Ames and Mary Astor struggle to find the right key. The connotations of performance are even more explicit in Esther and Tootie's vaudeville-inspired 'Cakewalk' number, 'Under the Bamboo Tree'. The fact that these performance codes are impli-cated within the narrative diegesis so successfully may seem to suggest that the tensions between narrative and spectacle, so evident in a film like *Footlight Parade*, are near to eradication here. In fact, partly because performance space within the film's *mise-en-scène* is so expertly designated and privileged, these tensions are harnessed in a kind of cinematic double-helix, and work upon audiences with a power the earlier film never attains. This can be seen most clearly in what is perhaps the best-known number from the film, 'The Trolley Song'. Here, expressions of heterosexual desire, the importance of community, the energy of youth and the lure of the future are all contained in Garland's driving performance, which simultaneously delivers the distinctive pleasures of music and song.

An analysis of this number would, I suggest, point to the partic-ular power that popular music on the screen possesses, with its combination of the visual and the aural. Whilst it has seemed to some useful to argue for music as a rather mystical non-represen-tational form, whose power lies in its symbolic abstraction, capable, as Suzanne Langer claimed, of 'expressiveness but not expression',[23] this really is to miss music's social function. It certainly is not a fruitful approach to popular music and popular song, especially when contained and contextualized by the regime of the visual. As John Shepherd has argued, in their different ways, sight and sound articulate different aspects of the social process, but both remain resolutely social. Shepherd usefully distinguishes between 'relata' – easily observed elements of the social process – and 'relationships' – elements which underlie social systems, but which are much more difficult to 'see' and analyse.[24] Arguably, whilst the visual regime of screen media articulates relata, the regime of sound (and specifically popular song) within the musical or music video articulates relationships. Despite their distinctive modes of address, it is a tension which is ultimately

harnessed by this specific cultural form to clear aesthetic and ideological purposes. Thus, during 'The Trolley Song', we not only *see* Esther's initial romantic isolation – her disappointment that 'the boy next door' appears to have missed the trolley, the chance to be with her and the community of heterosexual young people – turn into her sense of triumphant expectation as he catches up with the trolley and takes his place beside her, but we *hear* the same scenario through the music and lyrics, as solo voice mixes with chorus, ending with the final flattened chords which deliver that very same sense of expectation for the future.

Whilst a great deal of attention has been paid to notions of cinematic realism, narrative and ideology, much less has been said about the ideological project of popular music. Yet, as Shepherd points out, the functional tonal musical tradition clearly gives expression to ideologies central to industrial capitalist societies. In particular, dominant modes of commercially produced popular song articulate narratives in which personal struggle against forces of opposition consistently culminate in and express individual success and triumph, not least in the arena of romantic desire. This becomes especially significant within the classical Hollywood musical, where marginal musical styles, with their musical inflections, deviations from the mainstream harmonic, rhythmic and melodic structures, and their 'unacceptable' timbres, are either absent or are incorporated within textual strategies which negate whatever opposition potential they may possess. In this way, audiences are allowed some degree of flirtation with these musical styles and their social meanings, before being finally relocated within the cinematic, musical and ideological mainstream.

Summer Stock and the triumph of the 'classical' Hollywood musical

It was argued earlier that the successful development of the musical genre and its popularity with audiences throughout the 1930s and 1940s depended on the formal, thematic and ideological fusion of spectacle and narrative, and on the management of the tensions which result. If, in this sense, *Meet Me in St Louis* represents a triumph of managerialism, we can see the same tensions being put to good use in MGM's 1950 film *Summer*

Stock, directed by Charles Walters, starring Judy Garland and Gene Kelly.

Interestingly, Altman regards *Summer Stock* as a folk musical rather than a show musical. Certainly, many of the characteristics which he sees in the folk musical, not least the restless energy of the male and its counterpoint, the rooted stability of the female, are evident in *Summer Stock*. However, the film is so centrally concerned with 'putting on a show' that its claims as a show musical are every bit as strong. The dual-focus narrative is evident not only in the tensions between male and female, but also between rural and urban, amateur and professional, 'folk' art and 'high' art, the private and the public.

Jane (Judy Garland) struggles to make a living on her New England farm. However, with the help of a new tractor loaned to her as part of a 'contract' designed to bind her matrimonially to the patriarchal Wingait family, mortgage and money problems are overcome and celebrated in the number 'Happy Harvest'. Jane's work-centred existence is interrupted by the arrival of Abigail, her urbanite sister, whose latest foray into the artistic world is marked by the arrival of a theatre company, a group of 'players', led by Joe Ross (Gene Kelly). The coded contrast between Jane's denim farm clothes and Abigail's fashionable dresses serves to highlight the wider contrasts and tensions between the farm folks and the city theatrical people, as the latter celebrate the necessity of farm work in the number 'Dig, Dig, Dig For Your Dinner', but prove comically inept at the rural tasks Jane imposes on them.

These contrasts and tensions established at the beginning of the film are eradicated as Garland is seduced, not only by Kelly, but by the romance of theatrical performance. Jane's undoubted, but amateur, talents are integrated within the company's professional performance, just as other former distinctions, such as between country and city, folk art and industrial art, work and play, are eradicated and denied. These symbiotic twin axes, success in romance and success in putting on the show, serve to deny distinction and 'otherness', to construct community and, by inference, a sense of nationhood unsullied by structural difference.

This denial and accommodation is achieved as much through the music as it is through the dialogic narrative. The tensions between rural and urban are perfectly expressed during the

'Historical Society' barn dance, in which the half-hearted, lifeless rendition of 'The Portland Fancy' is interrupted by the life-affirming outburst of swing and jive. Though the sequence serves to showcase Garland's dancing talents and to bring her and Kelly closer together, it also underscores the friction which, at this stage of the narrative, exists between the natives and the newcomers. Yet, if the music here is used to signify polarities and dichotomies, elsewhere it encodes the process of accommodation. The stilted ballad 'Mem'ry Island' and its equally stilted choreography disappear at rehearsal stage, as do the stuffy lead luvvie and the pretentious Abigail, as the 'professional' world of theatre purges itself of those elements which lack spontaneity. During the final 'performance', of course, the professional players acknowledge, celebrate and privilege the bucolic existence which they have disrupted, and the powerful tradition of folk culture which is coded as somehow more authentic than the shallow insincerities of the 'professional' world. In 'Heavenly Music', Kelly and Phil Silvers, dressed as country hicks, disrupt the urbanite debutantes who offer a paean to 'high society' life:

> We get up each morning at noon,
> and our day is a glorious June.
> Of all things unpleasant, it's free,
> we live it, we love it, mais oui.
> The morning, a scherzo by Brahms or Faure,
> or maybe a a quaint little French rendelais,
> We're cultured, tactful, discrete,
> we're definitely of the elite.

If the urban professionals appear to have made accommodations towards the rural, Garland's transformation in the opposite direction is encoded through her professional performance of 'Get Happy' at the end of the film. Finally, just as urbanite Abigail and small-town Orville discover their love for each other, so too are all distinctions eradicated in the closing reprise of 'Happy Harvest', now incorporated within the show and performed by dressed-alike Kelly and Garland.

Analysis of such films as these illustrates just how central popular song and its performance are to the meanings and ideological project which characterize the Hollywood musical during this period. However, textual analysis of a few musicals made

between the late 1920s and the mid-1950s does nothing to convey
the popularity of the genre, either with the industry and with audi-
ences. Nor can such random analysis give an adequate impression
of the variety of musical styles and performers which range across
the genre. A different book from this one may well have wanted to
concentrate on those film biopics which openly celebrated impor-
tant and influential composers and lyricists such as Jerome Kern
(*Till the Clouds Roll By*, MGM 1946), George Gershwin (*Rhapsody
in Blue*, Warner Bros 1945), Cole Porter (*Night and Day*, Warner
Bros 1946), or those which were based on lesser Tin Pan Alley
luminaries such as composer and ASCAP copyright activist Victor
Herbert (*The Great Victor Herbert*, Paramount 1939), or songwriter
and publisher Fred Fisher (*Oh You Beautiful Doll*, Twentieth-
Century Fox 1949). A significant number of musicals, including
My Gal Sal (1942), *Coney Island* (1943, both Twentieth-Century
Fox) and *By the Light of the Silvery Moon* (1951 Warner Brothers)
openly acknowledged the importance of, and drew upon, turn-of-
the-century Tin Pan Alley. Films such as *Alexander's Ragtime Band*
(1938) and *Tin Pan Alley* (1940, again both Twentieth-Century
Fox) celebrated developments in American popular music
between World War One and the 1930s. Significant shifts in
popular music taste, expressed through the popularity of bands
such as Xavier Cugat, Benny Goodman and Glenn Miller, found
their way into musicals such as *Sun Valley Serenade* (Twentieth-
Century Fox 1941), *Orchestra Wives* (Twentieth-Century Fox,
1942), and *The Glenn Miller Story* (Universal, 1954), as well as the
musicals starring western singers such as Ken Maynard and Gene
Autry. Unimpressive vehicles such as Universal's 1942 offering
Juke Box Jenny served as excuses to jump on board the swing and
jitterbug craze of the early 1940s. With admittedly less frequency,
black American music, its influence and significance, were repre-
sented in films such as *Birth of the Blues* (albeit starring Bing
Crosby, Paramount 1941), *Stormy Weather* (Twentieth-Century
Fox 1943) and Minnelli's *Cabin in the Sky* (MGM 1943).
Homage to specific performers were equally significant in such
films as *Yankee Doodle Dandy* (Warner Brothers 1942) and *The
Jolson Story* (Columbia 1946).[25]
 Again, a history of the genre would want to give consideration
to musicals which were essentially remakes of earlier non-musical
successes such as *State Fair* (Twentieth-Century Fox 1945), to the

popularity of college-campus musicals such as *Sweetheart of the Campus* (Columbia 1941), to hybrid musical westerns and to the long-standing and highly popular traditions of country music, as well as musicals starring established comedy teams such as Laurel and Hardy and Abbott and Costello.[26] Again, a significant number of musicals openly acknowledged the central importance of radio in the development of popular music, and, in so doing, attempted to capitalize on radio's popularity and the popularity of its stars.[27]

Yet whilst recognizing the variety which is contained within the genre, it remains clear that what marks the musical during this so-called classical period is its prevailing conservatism, expressed in large part through the ideologies and meanings encoded in mainstream commercial popular music, the musical values, tastes and practices associated with Tin Pan Alley, with white, reasonably affluent, urban America. This musical, thematic and ideological convergence is matched by convergence at a structural and industrial level. Just as Hollywood had achieved industrial strength through business mergers and acquisitions, and through rigorous concentration on commercial products which expunged risk, so too the popular music industry had, by the beginning of the 1950s, combined concentration of ownership with concentration on avowedly commercial mainstream popular music. By 1951, the year in which the American popular music industry finally relied for the majority of its profits on record sales rather than sales of sheet music, four major companies – RCA Victor, Columbia, Decca and Capitol – dominated the record industry. This dominance, reinforced through their corporate links with radio and cinema, led in the late 1940s and early 1950s to what has been described as the homogeneity of popular music, to music which was written to formula and which 'expressed a quite restricted range of sentiments in conventionalised ways'.[28]

Despite anti-trust legislation, the major players in the American entertainment industry seemed to exercise in the early 1950s an unassailable stranglehold, not just on the structure and practices of the various branches of the industry, but on the type of product they could sell to a seemingly insatiable – and seemingly undifferentiated – audience. If this was the perspective within the corporate boardrooms, it was soon to be challenged, and from a number of directions.

Notes

1 F. Karlin, *Listening to Movies: The Film Lover's Guide to Film Music*, (New York, Schirmer, 1994), p. 175.

2 S. Chaplin, *The Golden Age of Movie Musicals and Me* (Norman OK, University of Oklahoma Press, 1994), p. 32.

3 R. Altman, *The American Film Musical* (London, British Film Institute, 1989), p. xi.

4 R. Barrios, *A Song in the Dark: The Birth of the Musical Film* (New York, Oxford University Press, 1995), p. 108

5 J. Izod, *Hollywood and the Box Office 1895–1986* (London, Macmillan, 1988), p. 96.

6 J. Kobal, *Gotta Sing, Gotta Dance: A History of Movie Musicals* (London, Hamlyn, 1983), p. 9.

7 Altman, *The American Film Musical*, pp. 19–26.

8 J. Feuer, *The Hollywood Musical* (London, British Film Institute, 1982).

9 For more on the films of Busby Berkeley, see M. Rubin *Showstoppers: Busby Berkeley and the Tradition of Spectacle* (New York, Columbia University Press, 1993). For one view of the transmutation of the musical genre and Berkeley's legacy, see Linda Ruth Williams, 'Nothing to find', *Sight and Sound*, 6:1 (January 1996) 28–30, where she comments on Paul Verhoeven's film *Showgirls*.

10 L. Fischer, 'The image of woman as image: the optical politics of *Dames*', in R. Altman (ed.), *Genre: The Musical* (London, British Film Institute, 1981), pp. 70–84.

11 There are important exceptions to this, particularly in some 1980s music videos, where an aural version of the female gaze seem relevant. Songs such as 'It's Raining Men' and 'Sisters are Doing it For Themselves' seem to address similar issues for female ears.

12 S. Frith, 'Why do songs have words?', in S. Frith, *Music For Pleasure: Essays in the Sociology of Pop* (Cambridge, Polity Press, 1986), pp. 105–28.

13 A. Croce, *The Fred Astaire and Ginger Rogers Book* (New York, Dutton, 1987), pp. 7–8.

14 R. Pickard, *Fred Astaire* (London, Deans International Publishing, 1985), p. 9.

15 Astaire had performed a very similar dance routine in a number called 'Say, Young Man of Manhattan' in the 1930 Ziegfeld Broadway show *Smiles*, and persuaded director Mark Sandrich to reprise it for *Top Hat*, albeit to different music.

16 Altman, *The American Film Musical*, p. 95.

17 Altman, *The American Film Musical*, p. 127.

18 J. A. Casper, *Vincente Minnelli and the Film Musical* (Cranbury NJ,

A. C. Barnes and Company, 1977) and S. Harvey, *Directed by Vincente Minnelli* (New York, Museum of Modern Art/Harper and Row, 1989).

19 C. Finch, *Rainbow: The Stormy Life of Judy Garland* (London, Michael Joseph, 1975) and D. Shipman, *Judy Garland* (London, HarperCollins, 1992).

20 Shipman, *Judy Garland*, pp. 30–9.

21 On the construction of 'stars' see J. Staiger, 'Seeing stars' and R. Cordova, 'The emergence of the star system in America', in C. Gledhill, *Stardom: Industry of Desire* (London, Routledge, 1991), pp. 3–16 and 17–29.

22 D. Bordwell and K. Thompson, *Film Art: An Introduction* (New York, Alfred Knopf, 2nd edn 1986), pp. 325–30.

23 S. Langer, *Philosophy in a New Key* (Cambridge MA, Harvard University Press, 1942), p. 240.

24 J. Shepherd, *Music as Social Text*, (Oxford, Polity Press, 1992), pp. 79–80.

25 For an interesting commentary on race and musicals, see Richard Dyer: 'The colour of entertainment', *Sight and Sound*, 5:11 (November 1995) 28–31.

26 For example, Laurel and Hardy's *Jitterbugs* (Twentieth-Century Fox 1943) and Abbott and Costello's *The Naughty Nineties* (Universal 1945).

27 Examples would include *Radio City Revels* (RKO 1938), starring Jackie Oakie and Milton Berle, Republic's *Melody and Moonlight* (1940) which centred around a radio tap-dancing show, *The Great American Broadcast* (Twentieth-Century Fox 1941), the fifth and final film of a series starring Alice Faye, and *Radio Stars on Parade* (RKO 1945).

28 R. A. Peterson and D. G. Berger, 'Cycles in symbol production: the case of popular music', in S. Frith and A. Goodwin (eds), *On Record: Rock, Pop and the Written Word* (London, Routledge, 1990), p.145.

4

Hollywood and the challenge of the youth market, 1955

Popular music during the Fifties was dominated by the so-called 'big beat' of the rock'n'roll craze ... Its performers, even the chief exponent, Elvis Presley, seem remarkably devoid of any singing talent ... Not only are most of the performers of rock'n'roll in their teens (as are their fans), they sing no better than the fans themselves.

> Isaac Goldberg, *Tin Pan Alley:*
> *A Chronicle of American Popular Music*, 1961

Rock'n'roll is the most brutal, ugly, desperate, vicious form of expression it has been my misfortune to hear.

> Frank Sinatra at the US Congress Payola hearings in 1958, in
> Robert Burnett, *The Global Jukebox:*
> *The International Music Industry* 1995

This was ... the kind of show that ... was springing up in one form or another all across the South; black music on a white radio station with a strong Negro audience and a growing, if for the most part unacknowledged, core of young white listeners with a growing, if for the most part unexamined, buying power.

> Peter Guralnick, *Last Train to Memphis:*
> *The Rise of Elvis Presley*, 1994

For the best part of three decades, the classical Hollywood musical helped to construct images of an America in which, if problems and doubts ever arose, they were easily overcome. There may well have been troubles ahead, but whilst there was music and moonlight, energy and optimism, a belief in community and the attainability of love and romance, of personal and public success, nothing was impossible. This powerful hegemonic

perspective, constructed and encoded through the Hollywood musical and its promotion of mainstream popular music, was increasingly under challenge during the 1950s.

In part, of course, this challenge came from sociocultural changes resulting directly from America's changing world position in the years following World War Two. American involvement in the war and its subsequent role as a world power had dramatically ended the isolationism which had characterized prewar America. The fight against the Axis powers had led to internal conflicts which made it hard to sustain a belief in the United States as a 'melting pot' or 'salad bowl' where racial and ethnic difference was discounted. Increasingly, issues of geography, of class, of race, of generation and, though far less visibly at this period, of gender, asserted themselves as problems to be tackled. Above all, the issue of race emerged as the central fault line in American society. The immediate postwar years witnessed the beginnings of an overall increase in affluence for American families, though the distribution of this affluence was woefully unequal, between north and south, black Afro-American and white Caucasian. Even within the powerful hegemonic construction of the United States as defender of world freedom, as the bastion against communist aggression, it became increasingly impossible for the political and cultural agenda to ignore these important structural differences.

At the same time, developments in the technologies of leisure and entertainment coincided with, and reinforced, an increasing domestication of American social life. For affluent white families in the northern states, this was often expressed through the processes of suburbanization, including consumption of 'labour-saving' domestic commodities and of domestic entertainment technologies, notably televisions, gramophones and portable record players, to go alongside the radios which had been purchased in the 1920s, 1930s and 1940s. The growth of television ownership in the United States in the late 1940s and early 1950s was phenomenal, and its initial impact on cinema attendances has been well documented.[1] Hollywood, at this period, regarded television solely as dangerous competition, and with some justification. In 1949, only 2.3 per cent of American households had a television set; in 1954, the percentage had risen to 55.7 per cent, in 1955 to 64.5 per cent.[2]

In Britain too, following the postwar austerity period, the 1950s

were marked by growing affluence, much of it manifested in new
housing estates and the consumption of domestic technologies.
Though structural disparities of class, race and gender remained
deeply engrained in British society and culture, superficially they
appeared less relevant, as more and more families acquired televi-
sions, stereograms and cars. The 'Americanization' of British
culture appeared further to 'democratize' 1950s Britain, though
there was a deep class-based negative consensus about the value
of this process, feared, derided and criticized as it was in many
quarters.[3]

 True, in their infancy, neither British nor American television
acknowledged structurally differentiated audiences and both
remained remarkably naïve about the far-reaching cultural impact
the medium was about to exert. As an agent for and site of
sociocultural change, television during the 1950s became as
significant as radio and as important as the growth of the record
industry, though less so for young people than for the population
at large. With some notable exceptions, American television in the
mid-1950s did little to acknowledge the emergence of a distinctive
youth subculture, and British television did even less. What televi-
sion did do, however, was to facilitate an exponential growth in
communication and information flow, rapidly becoming the
prime site for cultural dissemination and exchange. In the United
States, the fractures and fissures which were beginning to appear
within the social formation, in particular those relating to race,
were soon rendered increasingly visible through the agency of
television. In Britain, though issues of class remained supremely
influential, they were less clearly articulated through televisual
discourse. It is clear that, in both the United States and Britain,
the institutional machinery struggled to set an agenda by which
these fractures and fissures could be interpreted.

 These profound shifts in the sociocultural formation, the
growing awareness of structural problems impacting upon daily
American life, the consequent loss of optimism, together with the
nascent power of new communication technologies, were largely
unacknowledged by Hollywood at the beginning of the 1950s,
preoccupied as the industry was with the major structural changes
it was experiencing and with the legislative challenges it was
facing.

The challenges to Hollywood and the Hollywood musical

As is well known, during the late 1940s and early 1950s, the American film industry underwent a period of major transition, changing the structure of the industry as well as production practices within it.[4] The Supreme Court decision in May 1948 concerning the Paramount case led to far-reaching changes, requiring as it did that the major Hollywood studios divest themselves of some of their production, distribution and exhibition capacity. Though it took some years for the decision to have an impact, it did mean an end both to vertical integration and to many of the restrictive practices, such as block-booking of films, which had flowed from it.[5] Although power was to remain with the majors, the decision signalled the introduction of independent production on an increasingly significant scale. Whereas in 1945 there had been about forty independent producers, in 1948 there were some 165. This shift was to have major repercussions on the number and type of films which were made, not least in creating a structure in which low-budget, niche-market 'quickies', responsive to specific and identifiably different market demands, were to become a significant element within the industry. As we shall see, the creation of a space for smaller independent companies, eager and able to respond to – some would say exploit – cultural trends, was of real significance in the growing convergence which was taking place between the film and the music industries.

The industry was under other, very different, pressures whilst these legal and structural changes were taking place. Although the House Committee on UnAmerican Activities (HUAC) pursued its anti-communist agenda across a wide range of public institutions, it was the hearings into left-wing activities in Hollywood that caught the the public eye and ear.[6] Apart from the very obvious and tangible effects of HUAC's investigations, such as the imprisonment of the so-called 'Hollywood Ten' and the strikes and protests by actors, directors and technicians in their support, perhaps the most important influence the whole process had upon the Hollywood establishment was to make it even more cautious than before. The 'blacklist' – those who were simply barred from working and were told that they were – together with the 'greylist' – those who found work impossible to get, but could never find out why – had a traumatic effect on working practices

and personnel, not least because of studio heads' reluctance to take on any production, or production personnel, considered even marginally risky. It is an interesting question to ask to what extent an established, though atrophied, industry dominated by the majors was offset by the development of a more entrepreneurial and innovative independent production sector. The accepted version of the decline in Hollywood's risk-taking capacity during the late 1940s and early 1950s is actually challenged by the number of films which could be considered as somehow 'radical', though it remains true that the majors were much more inclined to conservatism in production policy.

It was against this background of transition that Hollywood faced up to what it regarded as the main challenge to its primacy as the leading provider of popular entertainment, the challenge of television. In fact, earlier attempts to be involved with a fledgling television industry had failed and, in the late 1940s and early 1950s, Hollywood had used its industrial muscle to restrict the growth and development of a system it failed initially to control.[7] In retrospect, however, this period of apparent rivalry between cinema and television proved short-lived. Accommodations were made at every level, and the two industries rapidly came to see mutual benefits in convergence.

One important strategy for survival was to turn again to Broadway and its proven, successful product. There was nothing new in this, of course, except that too often, rather than reworking the material, Hollywood now adopted the Broadway production in an increasingly uncritical manner. In the opinion of Stephen Harvey, 'Baffled by the ever-more fickle public, Hollywood's musical specialists increasingly sought the security of pre-sold hits from the stage, to the detriment of their own Hollywood originals'.[8] This sometimes had disastrous results, as in Twentieth-Century Fox's 1953 version of Berlin's *Call Me Madam* starring Ethel Merman. Other adaptations were more successful, but still too often revealed their indebtedness to the original stage production. The decision, for example, by MGM to shoot *Brigadoon* (1953) in the studio rather than on location, indicates a new timidity in Hollywood's relationship with Broadway, even though the film still has much to recommend it.

In fact, *Brigadoon* is significant in giving begrudging articulation to the growing sense of unease which was affecting American

society, not least through Tommy Albright's (Gene Kelly) rejec-
tion of noisy, nightmarish Manhattan in favour of the authentici-
ties associated with the village of Brigadoon. Whilst this oscillation
between the dream and reality is standard fare in the Hollywood
musical, the clear rejection, in both spatial and temporal terms, of
contemporary America is here quite stark and pronounced, not
least in the sense that the film positions us in a world where
choices have to be made.

This same sense of unease is pronounced in many of the musi-
cals of the early 1950s, including some of the best known and
most celebrated. In *Singin' in the Rain* (1952), the problematic,
encoded through romance and the coming of the 'talkies', is
resolved and the twin axes of personal and professional success
are rendered triumphant, but not before severe accommodations
have to be endured. In the 1953 version of *The Band Wagon*, a
sense of sociocultural redundancy is perfectly coded through the
fading career of Tony Hunter (Fred Astaire), even if, through the
ideological reassertions of notions of entertainment, that career is
ultimately realigned and revived. In *A Star is Born* (1954), the very
concept of 'stardom', so central to Hollywood cinema, is both
celebrated and interrogated, as jealousy and alcoholism destroy
Norman Maine (James Mason).

It's Always Fair Weather and sociocultural fractures

The musical genre's ability to give expression to these profound
sociocultural shifts, as well as to the specific challenges faced by
the film industry itself, is evident in the 1955 musical *It's Always
Fair Weather* (MGM). Gene Kelly (who co-directed with Stanley
Donen), Dan Dailey and Michael Kidd play three soldiers, Ted,
Doug and Angie, who at the end of the war agree to meet up
in ten years time. When the time comes, they meet up with a
reluctance they could not have imagined, only to find that the
intervening years have treated them very differently. It is not just
that their jobs are different – Dailey works in advertising, Kidd
runs a hamburger joint with pretensions to 'foreign' *haute cuisine*,
and Kelly works within the shady world of boxing promotion –
they have grown apart in their values and beliefs. The three men,
who would have laid down their lives for each other during the

war, are confronted ten years later with the feeling that they have nothing in common. In this sense, the film articulates perfectly the shifts we have been describing, the sense that structural incompatibilities have supplanted a sense of community, of social cohesion.

This shift in values coincides with, the film suggests, the growth of television culture, driven as it is by new-style postwar advertising and sponsored television shows. Even the language seems to have been corrupted by this new regime of consumer materialism, as Fielding, the boss of 'Klenzrite', and fellow sales executives talk of 'situation-wise', 'sales-resistance-wise', 'housewife-wise' and 'consumer-wise'. In an attempt to freshen their television show's formula, improve ratings and sell more product, the producers manipulate the three ex-servicemen into appearing together on the live television broadcast, 'Midnight With Madelaine'. Despite the film's vicious parody of television and its advertising, with its 'H-$_2$O Cola' which is 'as pure as water', its musical homage to 'Klenzrite' products, and its swipe at the insincere sentimentalities of the television business, the live broadcast serves as *deus ex machina*, reconciling the three buddies and exposing the corrupt underworld boss Charley Culloran. What reunites the three is their realignment with traditional American values. Doug is reconciled with his wife and family values; Angie reiterates his status as 'melting-pot' American by dumping his 'pretentious' European restaurant title and opting instead to call it 'Angie and Connie's Roadside Diner', whilst Ted leaves behind his womanizing and the corrupt world of boxing to settle down with Jackie (Cyd Charisse).

If, at its conclusion, *It's Always Fair Weather* positions us within an ideological reassertion of community, of heterosexual romance and family values, and of optimism for an untroubled future, the film is interesting for its grudging recognition and articulation of the fractures and fissures, though not of race, which were growingly evident in American society. Again, although the challenges of television are constrained by textual strategies which position them firmly within the film's own ideological project, the power and significance of television as technology and social institution is openly acknowledged.

Yet, in every other respect, *It's Always Fair Weather* attempts to replicate the formal, structural and thematic conventions of the

'classical' musical genre. With the advantage of critical hindsight, perhaps one of the most significant things about this 1955 film is that, although it acknowledges undefined changes affecting the sociocultural formation, although it hints at the challenge television poses to the primacy of Hollywood itself, it ignores the most significant challenge of all, the emergence in the early and mid-1950s of a youth subculture structured around a reconstituted notion of popular music. As a consequence, it also ignores the implicit, if unacknowledged, importance of racial issues which clustered around popular music at this period. In many respects, *It's Always Fair Weather* signals the end of an era, not just for the classic Hollywood musical, but for Hollywood itself.

Changes in the popular music industry

In a way, a more significant challenge to Hollywood and its view of itself as a prime arena for family-orientated leisure and entertainment consumption came not from the development of television, but from the radical changes which were taking place within the popular music industry, changes which were both reflecting and driving the development of what came to be seen as a distinctive youth subculture.

Like Hollywood, the popular music industry, which by the late 1940s increasingly meant the record industry, was characterized by an oligopolistic dominance over the market through organizational strategies built around the notion of vertical integration. By 1948, following the immediate postwar years, the ending of raw materials shortages for record production, the development of the 45 and 33⅓ r.p.m. record formats (itself a response to the decline in 78 r.p.m. record sales in 1947–8), agreement with the American Federation of Musicians, and radio's increasingly voracious appetite for recorded music, had opened the way for an exponential increase in record sales.[9] At this period, the late 1940s and early 1950s, the record music industry in the United States was dominated by four companies, RCA Victor, Decca, Capitol and Columbia, all of whom had corporate links with Hollywood and the radio industry which enabled them to market their products very effectively:

RCA Victor was linked with the NBC network and a number of radio
stations. In addition, it was corporately affiliated with the RKO film
company. Columbia also had its own network, CBS. Decca was affili-
ated with the Music Corporation of America, a powerful movie and
radio talent agency, and eventually it came to own Universal movie
studios as well. Capitol Records was linked to Paramount Pictures
until 1950.[10]

Two other record labels which appeared at this time, MGM
Records and ABC-Paramount, were branches of established
Hollywood companies. The commercial dominance of these
major labels can be seen by the fact that between 1946 and 1952,
of the 162 million-selling records in the US, only five were
produced by independent companies. By 1957, independents
produced 29 of the top-selling 43 records.[11] In Britain at this
period, the record industry was dominated by EMI, Decca,
Philips and Pye, all with cross-media interests.

Again, like Hollywood, this concentration of ownership within
the record industry tended to create a uniform, homogenous
product, the inevitable consequence of a strategy which aimed to
maximize sales in the mass (at this stage reasonably affluent,
largely white) market. An examination of the most popular
performers on record between 1948 and 1955 reveals a limited
rota of artists, mainly white but some black, whose names domi-
nate over and over again, including Bing Crosby, the Andrews
Sisters, the Mills Brothers, Les Brown, Jo Stafford, Perry Como,
Rosemary Clooney, Frank Sinatra, Patti Page and Doris Day.
Their records reveal a quite remarkable homogeneity in popular
music style, characterized by Peterson and Berger as being
'written by formula' and expressing a 'restricted range of senti-
ments in conventionalized ways'.[12] Like the Hollywood musical
genre, this was a popular music which articulated ideologies
central to industrial capitalist society, which expressed notions of
individual conflict, struggle and success, most often through the
arena of heterosexual romantic desire.

Yet, it is clear that the commercial dominance enjoyed by the
major players in the record industry hid from view demands for
types of music which that very dominance itself rendered
'marginal'. Whilst the major labels catered for classical musical
tastes – music from Broadway shows, commercially orientated
sentimental ballads and, to a lesser extent, country music – they

largely ignored musical styles which were associated with what were perceived of as marginal sectors of the population. Rooted in specific cultural traditions, geographies and ethnicities, jazz, blues, gospel and country and western all had flourishing histories, competent performers and devoted followers, predominantly in the southern states. Significantly, of course, such musics appealed to, catered for and were part of social groups who were essentially denied representation with mainstream American political and cultural discourse. Much of this music was termed 'common-stock material, shared by black and white musicians',[13] but on the whole what most characterized these musical styles and the people who played and listened to them was their marginality from the political, geographic, cultural and commercial centres of power.

Although these 'communal' musics were still largely absent from the main commercial strategies of the northern-based record companies in the early 1950s, their search for new markets had taken them to the southern states as early as the 1920s. The desire to tap into and exploit what was known as the 'race' market prompted companies like Okeh, Victor and Columbia to take the newly available portable recording equipment into states such as Tennessee and Georgia in search of black singers and musicians.[14] Early entrepreneurs such as Perry Bradford used portable equipment to record both black and white rural artists. Ralph Peer, first for Okeh Records from 1923 and then Victor Records from 1927, recorded a significant catalogue of country blues performers. In the same way, Peer and others 'discovered' the rich strain of white country music, not least through the recording and promotion of Jimmie Rodgers and the Carter Family. Through regional record distribution and sales, promotion by local radio stations, as well as touring live performances, important regional markets for both 'race' and white 'folk' musics were developed. So successful was this development that Victor returned to profit following lean years during the early 1930s.[15]

Though it is reasonable to claim, as Hatch and Millward do, that the 'new communications technologies accelerated the musical cross-fertilisation between black and white and between the various regions'[16] from the 1920s, it would be a mistake to think that radio and records had instantaneous impact. In fact, although there was growing awareness of the diversity of

American music throughout the 1930s and 1940s, clear-cut
distinctions between the markets for 'race', country and western
and mainstream popular music still dominated the thinking of the
music, record and radio industries in the late 1940s. Throughout
the 1930s and into the 1940s, these industries remained based in
the northern urban centres such as Chicago. Before the Acuff-
Rose publishing company opened in 1942, there was not one
southern-based music publishing company.[17] As Chambers
comments:

> Between the wars, black music remained largely hidden away in the
> 'race' catalogues of the record companies. It was certainly not heard
> on the radio or in the dance halls. Black music was largely restricted
> to a black audience in bars and 'jukes' along the highway, fish fries and
> picnics in the country, house rent parties in the city ghettos and, in the
> case of gospel music, to the black church.[18]

This lack of recognition by the commercial companies reflected
the inherent racism of southern segregationalist policies, which
maintained spatial separation between the races, a separation
which spilt over into the cultural domain. One consequence of this
commercial neglect by the record industry and the major radio
networks was the significant growth in the 1940s of local and
regional radio stations playing black music, listened to by black
audiences both in the southern states and in the northern cities,
to which huge numbers of black Americans had migrated. This
growth reflected a relative rise in affluence amongst black Ameri-
cans. Clarke estimates that during World War Two, 'the income of
the average white family had doubled, but the income of the
average black family had tripled'.[19] This expansion in the number
of radio stations playing previously neglected music was also a
direct result of the formation of Broadcast Music Inc. (BMI) in
1939, designed to rival ASCAP for a share of lucrative broadcast
music licenses. Throughout the 1930s, as Peterson points out, the
monopolistic tactics of ASCAP had 'effectively controlled access
to exposing new music to the public'.[20] In its desire to generate
repertoire which it could license, BMI turned to the relatively
commercially unexploited black and hillbilly musics, which chal-
lenged the dominant forms of popular, essentially melodic and
harmonic, music promoted by ASCAP. The result was an increase
in the number of dedicated radio stations playing specifically

black music to black audiences and, to a lesser extent, stations dedicated to white hillbilly and country music.[21] This challenge to the dominance of white mainstream music was furthered by the spread of jukeboxes, manufactured by Wurlitzer and Rockola, from the 1930s onwards. As Donald Clarke asserts, 'In many parts of the country hillbillies and blacks were more likely to hear their own recording artists on a jukebox than on the radio'.[22] Clarke argues that jukeboxes were a major factor in the revival of the record industry in the United States following the depression.

'Soundies' and the visual representation of popular music in the 1940s

This 'discovery' and exploitation of black music can be measured by an important, though short-lived, development in the convergence between the audio and visual industries, the so-called Panoram 'Soundies' of the 1940s. Utilizing existing jukebox technology, the Soundies Distributing Corporation of America produced some 2,000 short film clips of a variety of popular musicians and musical acts which were played in the Panoram film jukebox between 1941 and 1947. Ranging across the spectrum of popular music tastes of the late 1930s and 1940s, including big-band swing, jazz, blues, country and western, Latin American, vocal harmony groups, as well as musical comedy and vaudeville acts, Soundies gave exposure to black music in a way which, with few exceptions, the Hollywood musical failed to do. Notable exceptions were Minnelli's 1943 musical *Cabin in the Sky*, with its all-black cast, and Twentieth-Century Fox's *Stormy Weather* in the same year, which featured Duke Ellington, Lena Horne, Cab Calloway and Bill 'Bojangles' Robinson. This is not to discount appearances by black musical groups in Hollywood films such as *The Big Broadcast* (1932), which included the first appearance of the Mills Brothers, and *Twenty Million Sweethearts* (1934), and minor musicals in the 1940s such as *Chatterbox, He's My Guy* and *Reveille With Beverly*. In the same way, the Ink Spots were popular live, on radio, and appeared in musicals such as *Great American Broadcast* (1941) and *Pardon My Sarong* (1942). However, with the Soundies, placed in bars, restaurants and roadside cafes, people were able to hear and see black bandleaders

such as Cab Calloway, Count Basie, the hugely influential Louis
Jordan, as well as black musicians like Fats Waller, Nat 'King'
Cole, Louis Armstrong and Meade Lux Lewis. Combined with
increased radio exposure, black music and black performers of all
types were popularized through the Soundies during the 1940s.

It is difficult to quantify the influence of these Soundies,
though looking at the short clips of ostentatiously attired white
musician Harry Gibson, attacking his boogie piano from all
angles, is like looking at the strident style which Jerry Lee Lewis
'developed' a decade later. What does seem clear is that, whilst
white musicians and singers had consistently appropriated
elements of black Afro-American music since the turn of the
century, in the very late 1940s and early 1950s, a small but
growing number of white musicians began to adopt a more
avowedly mimetic approach to musical performance, drawing
upon both musical and visual codes which were enshrined in
black music and the way it was performed. The influence of the
exuberant 'jump combos' was particularly strong, as Gillett
comments: 'jump blues ... had the most direct impact on the first
singers to become popular with rock'n'roll'.[22] Given the relative
scarcity of visual representations of black musicians in commer-
cial circulation at this period, it seems reasonable to suggest that
the Soundies were a significant influence in paving the way for a
growing acceptance of black music and musicians, as well as the
imitation of black performative codes by white musicians.

Apart from their role in popularizing black musicians, the
Soundies, short-lived as they were, are also of significance in the
development of the representation of popular music on screen. As
well as a range of black artists, the Soundies showcased a variety
of other popular music, including vaudeville, country and
western, comedy groups and Latin American performers. Some of
the clips mark a real innovation in developing the range of repre-
sentational strategies available to show popular music on screen,
often anticipating devices usually thought to have been 'discov-
ered' by music video. For example, 'Pass the Biscuits Mirandy',
performed by Spike Jones and his City Slickers, transgresses
generic boundaries and utilizes spatial and temporal dislocations
in its simple comedic narrative of biscuits which are too hard to
eat but which make wonderful ammunition. The clip explores the
diegetic and non-diegetic relationship as the band members 'play'

jugs, plates, whatever is to hand, in visual accompaniment to the music track. In 'Ho Hum', performed by harmony group the Dinning Sisters, the clip alternates between the singing performance by the three members of the group addressed directly to camera and enacted scenes of a dispeptic office worker which illustrate the number's lyrics. Simplistic though it is in comparison, in terms of its basic representational strategy it is clear that this clip, like other Soundies clips, anticipates later developments usually associated with music video.

New music, new labels:
the rise of independent record production

Thus, at the beginning of the 1950s, there was still a clear separation between the ongoing commercial strategies of the major labels dominating the record industry, strategies which on the whole ignored the proliferation of 'marginal' or 'communal' musics, and the growing audience for these musics which centred around regional and local radio stations, radio stations which were in turn stimulating demand for recordings of precisely those musics ignored by the major labels.

Yet precisely because media technologies create new spaces, and new spatial relationships, this separation, itself an expression of those old spatial geographies which made racial segregation possible, was under attack. For young white adolescents growing up in southern states such as Mississippi or Tennessee in the early 1950s, local radio stations and records offered exposure to what was, for them, new musics and new cultural geographies, which rendered old structural segregations between black and white increasingly questionable. The crossover between musical styles which had been gathering strength was to find commercial expression in the rise of rock'n'roll.

This process of structural and musical desegregation owed much to local radio stations and local DJs such as Dewey Phillips, who broadcast on WHBQ in Memphis from 1950 onwards. It owed just as much to the rise of small independent recording studios and record labels in the late 1940s and early 1950s, such as Atlantic Records founded by Ahmet Ertegun in 1947.[24] One of the most influential, Sun Records, was started by Sam Phillips,

who opened his Memphis Recording Service in January 1950 with the express intention of recording music which the major record labels ignored. It was Phillips' intention to record blues, gospel and white country music which he knew were denied a wider audience in spite of their popularity with live local audiences. Phillips is quoted as saying:

> My aim was to try and record the blues and other music I liked and to prove whether I was right or wrong about this music. I knew, or *felt* I knew, that there was a bigger audience for blues than just the black man of the mid-South. There were city markets to be reached, and I knew that whites listened to blues surreptitiously.[25]

Like other independent labels such as Dot and Aladdin, which were founded at the same period, Sun Records provided a mechanism for local and regional artists, black and white, to reach wider national markets. Phillips' belief in the potential commercial market for 'communal' music was vindicated as early as 1951, when his recording of Ike Turner and Jackie Brenston's 'Rocket 88' was sold to the Chicago-based Chess label and became a national success. Phillips and his Sun label popularized a number of black artists including B. B. King, Chester Burnett (Howlin' Wolf), Rufus Thomas and Bobby Bland, all of whom were hugely influential in later years.

The conventional emphasis placed upon white appropriation of black music through what became known as rock'n'roll tends to neglect precisely the extent to which black artists achieved national prominence and commercial success during this period. Sun Records clearly played a pivotal role in this process, but were far from the only label to do so. For example, in 1953 one of the first R&B hits to cross over to the pop charts, 'Crying in the Chapel' sung by the black doo-wop group the Orioles, had been recorded on the Jubilee label. As the Vibranaires, the group had previously come second to a Swedish soprano in the radio showcase *Arthur Godfrey's Talent Scouts*.[26] Although a cover version of the song by Lee Lawrence on the major Decca label also made the pop chart, the Orioles' success, like that of Fats Domino (who suffered a similar spate of white cover versions of his R&B hits), indicated the growing national commercial acceptance of black musicians and their music.

Unlike the old geographies, where racial segregation was easily

enforced, the new cultural geographies created by radio and record sales made the policing of segregation impossible. Young whites tuned in to radio stations playing the music of black artists such as Sonny Boy Williamson on the KFFN *King Biscuit Show*, bought 'race' records, now marketed as 'rhythm and blues', and – more dangerously since the activity was more visible – sneaked in to see and hear live performances by black artists.

Rock'n'roll and the development of the youth market

For musicologists, the development of rock'n'roll can be understood as this fusion of white country music with black blues, boogie and gospel, underpinned and driven by dominant rhythmic elements. Following Gillett, it has become usual to identify five styles of rock'n'roll, indicating the range of musical influences it drew upon: northern band rock'n'roll; New Orleans dance blues; Memphis country rock or rockabilly; Chicago rhythm and blues; and vocal group rock'n'roll.[27] However, the significance of rock'n'roll goes far beyond musical considerations, crucial though these are. Contemporary studies of peoples' identification with popular music, and of the complexities involved in notions of 'fandom', warn against accepting too uncritically the explanations usually offered up to explain young people's rapid and apparently totalizing embrace of rock'n'roll in the early and mid-1950s.[28] Indeed, even before the commercial advent of rock'n'roll, Riesman, writing in 1950, differentiated between two teenage audience responses to popular music, one characterized by an unquestioning adherence to the mainstream commercial product, the other, more 'rebellious' and resentful of the overtly commercial.[29]

That said, it is clear the emergence of rock'n'roll and the associated youth subculture in the mid-1950s did mark a distinctive moment in the cultural history of the twentieth century. It is equally clear that any understanding of this process needs to be understood through a combination of culturalist and structuralist perspectives. The changing demographics of American society and the emergence of a more affluent, high school- and college-educated young generation, created a demand for new, distinctive cultural spaces where, as Grossberg argues, young people 'could

find some sense of identification and belonging, where they could invest and empower themselves in specific ways'.[30] Increasingly alienated from the cultural experience of domestic suburban existence, young white people forged an identity with a music which seemed to articulate and encapsulate the essence of alienation, that experienced by black Americans. As Wicke argues, what propelled the reorientation of popular music to the traditions of Afro-American music, what made it attractive to young whites, was its perceived expression of a collective and communal experience.[31] Above all, black American music seemed an authentic, deeply emotional, subjective expression of the collective experience of suppression and alienation from the mainstream. Rebels with a cause, albeit an ill-defined one, growing numbers of young whites came to see in rock'n'roll a shared and accessible public arena through which their emotional affective rejection of prevailing sociocultural norms could be expressed.

As films such as *The Blackboard Jungle* (1955) indicate, the focus for this rejection was frequently high school. For many teenagers, the high school experience, its disciplines and conservative values, seemed increasingly irrelevant to their lives. Whilst this rejection focused on what were seen as the petty disciplines of high school life – conflicting attitudes to dress and hairstyles, for example – something more profound was at stake. In both the United States and Britain at this period, the culture and ideology of schooling was conservative and, more importantly, relentlessly anti-materialistic. Values such as obligation, loyalty, and selfless dedication to schoolwork as a means of ensuring later achievement in life, reflected the political and sociocultural imperatives of an era of capitalism which was rapidly passing. Outside of high school, young people were increasingly implicated in a world of materialist consumption, not least the consumption of mass media products which privileged leisure, pleasure and sensuality, values directly at odds with the routine disciplines experienced daily at school. According to one commentator, 'By 1957, the juvenile market was worth over $30 billion a year'.[1]

Of course, in a macroanalytic sense, it is possible to see in all this a massive and necessary realignment of a new phase in capitalism, one in which consumption of the commodity and cultural forms produced by the media and leisure industries gained even greater primacy. This valorization of consumption

and leisure was not new in the 1950s, merely more pronounced, sufficiently so for the phrase 'consumer society' to be coined and take root. The implications of this lurch away from the hegemonic power of a conventional work ethic towards new patterns of socio-cultural validation delivered through processes of consumption were infinite and are, arguably, still unravelling. For young people in the affluent 1950s, however, these shifts implicated them in lived social processes which were confusing and paradoxical. For whilst the attractions of leisure and consumption were over-whelming, and made parental and institutional educational values seem increasingly redundant, the attainment of these pleasures increasingly depended on precisely those objects of derision and rejection, parental power and affluence gained through steady, if 'meaningless', employment and the high school diploma. As the lyrics to the chorus of Eddie Cochran's 1957 hit 'Teenage Heaven' put it:

> I want my own coupe de ville,
> Make my daddy pay the bill,
> Yeh man, that's heaven to me.

This simultaneous desire to be both rebellious and conformist – to reject the trappings of parental existence and high school culture, and at the same time crave the prosperity and affluence which they delivered – lies at the heart of the structural dichotomies experienced by young people in the 1950s. What rock'n'roll created was a cultural space in which these dichotomies could be given expression, explored and, symboli-cally at least, resolved. As Grossberg argues, 'Rock emerged as a way of mapping the specific structures of youth's affective alien-ation on the geographies of everyday life'.[33] Though, as we shall see, the rise of rock'n'roll can only ultimately be understood with reference to changes in the institutional production of popular culture, it seems clear that young people in the mid-1950s were making a personal investment in 'their' music in unprecedented ways.

The commercial music industry, black artists and black music

Of course, the music industry of the 1950s was no less driven by commercial imperatives than Tin Pan Alley had been. However, its products were being used in more complex ways than ever before, involving patterns of consumption which transcended the old geographies of racial segregation. It took some time for the industry to come to terms with this and to realize the commercial potential inherent in this cultural investment young people were making.

Much of this was because the music industry was simply not structured or regulated in a way which enabled it to respond easily or quickly to the rise of the new singer-performers. As we saw earlier, in the late 1940s and early 1950s a growing number of black artists, signed to independent labels, were beginning to achieve greater prominence and commercial success, However, it was still the overwhelmingly common practice for records by black artists to be covered by white singers or groups, who reaped most of the commercial benefit. This process was encouraged by the 1909 Copyright Act, which meant that once a songwriter allowed his or her song to be recorded by one singer, they had no further control over anybody else recording the song. Under the system that became known as compulsory licensing, the sheet music was copyrighted, not the performance of the song. As a result, it was not uncommon for five or six recorded versions of a song to be on sale at the same time, with the majority of sales going to a 'star' – usually white – performer who was under contract to one of the major labels which had the machinery to promote and distribute the product. As Peterson and Berger show, in 1949 there were twenty records which had cover versions in the Top Ten, and twenty-one in 1950. Of all the records to enjoy chart success between 1946 and 1950, 70 per cent had more than one recorded version.[34]

This legislative and regulatory framework actively encouraged and endorsed white appropriation of black music. Elvis Presley's first private recording at the Sun studio, which cost him $3.98 plus tax, was a version of the Ink Spots' 'My Happiness', a cover version of which by Jon and Sandra Steele had made the pop chart in 1948. In fact, what is so noteworthy about Presley's

recordings at Sun is the extent to which they relied on cover versions, whether of numbers like Arthur Crudup's 'That's All Right', Big Mama Thornton's 'Hound Dog', or Bill Monroe's bluegrass "Blue Moon of Kentucky'. Interestingly, when Dewey Phillips interviewed Presley on WHBQ in the summer of 1954, he felt it necessary to reassure his Memphis listeners that Presley was white, a reassurance coded through reference to Humes, the all-white high school Presley had attended.[35] Whilst this coded reference may have offered reassurance to white prejudice in Memphis, it was not always enough once Presley began to enjoy wider regional success. In early 1955, the Houston, Texas, Juvenile Delinquency and Crime Commission published a list of records it wanted banned from all radio play. Of the twenty-six records on the list, all were produced by independent labels, all were published by BMI, and almost all were by black artists. One of the few exceptions to the latter category was Elvis Presley's 'Good Rockin' Tonight'.[36] The significance of Presley's television appearances, which began January 1956, become quite clear in this context of racial discrimination.

Ultimately, the significance of all this lies less in the fact that Presley's early career reflected the then conventional practice of recording cover versions, and much more to the fairly rapid process by which the young record-buying public came to associate particular songs with particular singers and performers. Increasingly, teenagers responded to highly individuated and often innovative *performers* who made particular songs their own, expressed through distinctive musical and performative styles. Many, though of course not all, of these rock'n' roll performers were not much older than the people who were buying their records, a situation which contrasted sharply with the established, older singers whom the majors had locked up in long-term contracts, and from whom most of their profits derived.

It is certainly true, then, that the challenge to hegemonic industrial and aesthetic strategies in popular music, and in radio and cinema, was in part driven by the new and unexpected development in the 1950s of an emerging taste culture amongst young people. It is equally true that these changes reflected, and were made possible by, profound shifts in cultural politics, shifts which made black music both more accessible and more visibly

prominent, and which made youth a prime site for cultural production and consumption.

Although at first the major labels and the people who ran them were dismissive of rock'n'roll, the challenge was not something which the dominant powers in the entertainment industries could ignore, though, at first, opposition to rock'n'roll was extensive and almost a matter of pride amongst those with complex and vested interests at stake. That this commercial opposition was bound up with deep-seated racial antagonism was evident in many of the criticisms of the new youth music. One of the most vocal opponents of the new 'jungle' music was Mitch Miller who, in the early 1950s, was chief A&R man at Columbia Records. Though he was to later to record rock-influenced artists himself, Miller's allegiance both to Broadway and to the prevailing structure of the music industry through ASCAP, undoubtedly drove his opposition to music which he regarded as a 'glorification of monotony'.[37] In much the same vein, Billy Rose, a prominent official at ASCAP, was critical of the 'new' music which BMI were promoting. He was quoted as saying 'Not only are most of the BMI songs junk, but in many cases they are obscene junk, pretty much on a level with dirty comic magazines'.[38] Despite this opposition, the impact on the record industry was all too apparent. In the United States between 1946 and 1952, 157 million-selling records were produced by the major companies, and only five were produced by independents. By 1956, the control exercised by the majors had been seriously eroded, with the independents producing over 50 per cent of the chart hits. In 1957 the independents produced twenty-nine of the top forty-three records.[39] The radio industry also changed. From being dominated by the major networks, which had attempted to gain a share of the national audience, radio became characterized by differentiated local and regional stations aimed at reaching local and regional markets through a greater variety of music on record.

Hollywood attempts to revive its market share

It was a situation which Hollywood could no longer ignore either. As we saw earlier, the American film industry was undergoing unprecedented structural changes, as a result of the legal, political

and economic pressures being put upon it. Bludgeoned by the attentions of HUAC into a mood of caution even more extreme than that which normally governed its executive decisions, the film industry saw its share of the leisure market in the early 1950s decline markedly. Whereas in 1946, $1 out of every $5 Americans spent on their leisure consumption went Hollywood's way, by 1957 only 35 cents of that $5 was being spent on cinema. Significantly, expenditure on television, radio and records was, in that latter year, at unprecedented levels. Though Hollywood viewed this erosion as resulting largely from the rise in the sale of television sets and the consequent loss of audience, it is also clear that they belatedly recognized the competition posed by the record industry.

As with television, Hollywood's initial response to this changing pattern of leisure consumption was to try and buy into it, or to extend the corporate links which already existed. On the whole, the results of this strategy were largely unremarkable from the commercial viewpoint, with only MGM making any significant impact in the music industry between 1956 and 1959, as perhaps befitted the company which had close links with music publishing since the 1930s[40] and which later pioneered the phrase 'original soundtrack'.[41] In much the same way, though each studio had its own distinctive strategy towards coping with the business threat which television presented, the relative failure of these strategies triggered a variety of responses and initiatives designed to promote the attractions of cinema-going itself. Many of these were technologically based, including various wide-screen formats, and increased use of colour photography, using both Technicolor and the new Eastman-Kodak colour film developed in 1949.[42] In 1953, 50 per cent of all features were produced in colour, with the musical genre being a particular beneficiary of the process. These innovations did little to address the surging demands of a new and increasingly important teenage market, which treated much of conventional Hollywood production with the same indifference it increasingly showed to the conventional pop products of the record industry.

Whilst teenagers expressed disenchantment with conventional Hollywood product, Hollywood lost little time in expressing its disenchantment with this new teenage generation. The Hollywood majors proved very responsive to the mounting social concern

about teenagers, a concern which focused predominantly on the supposed surge in juvenile delinquency. Ignoring the structural and institutional determinants which had positioned young adolescents within a burgeoning consumer economy, Hollywood was a powerful contributor to the dominant discourse about teenagers, a discourse which centered on notions of deviancy. J. Edgar Hoover, the influential head of the FBI, saw in juvenile delinquency the same threat to American freedom as that posed by communism. Hoover, like many cultural commentators and leader writers, employed linguistic metaphors which likened young people to savage, dangerous animals. They roved in 'packs' and 'herds', listened to music which sounded 'like the jungle bird house at the zoo', and, revealingly, behaved like 'the heathens of Africa'.[43] That much of this criticism was racially motivated was clear. In 1956 the American Civil Liberties Union (ACLU) declared that 'there is evidence that the objection to the music extends to and may be based upon the fact that it is largely the product of Negro bands'.[44] Interestingly, Hoover's intemperate language is not unlike that used by Adorno some years earlier when he criticized dancing to the jitterbug as being like 'the reflexes of mutilated animals'.[45]

In the 1930s, Hollywood had been able, in films like Warner Brothers' *Wild Boys of the Road* (1933) and *Angels With Dirty Faces* (1938), to 'explain' problems such as youth unemployment and urban deprivation within a wider discourse of environmentalism. Writing a review of Allied Artists' *Crime in the Streets* (1956), Bosley Crowther, the influential *New York Times* film critic, linked the wave of 1950s 'j-d' films to this earlier cycle of 1930s films, arguing that the only difference between them was that the current crop of delinquents 'talk a more lively jingo and dance to a rock and roll beat'.[46] It is certainly the case that one of the first of the 'new wave' j-d films, Universal's *City Across the River* (1949), perpetuates this link between the squalid Brooklyn environment and hoodlum behaviour, and offers reassurances that both can be contained.

New narratives of displacement and containment: *The Wild One, Rebel Without a Cause, The Blackboard Jungle*

Yet images of entrapment, of young people as victims of circumstances, were no longer possible in the films of the 1950s. Instead, the images which predominate centre around young people's mobility (in cars and on motorbike), conflict between rebellious teenagers and their uncaring and uncomprehending parents, the high school experience and rock'n'roll. *The Wild One* (Columbia 1954) and *Rebel Without a Cause* (Warner Brothers 1955) deal with, respectively, the implied threat that this new mobility represents to the older generation, and with the failure of that well-heeled older generation to prevent teenage angst and rebellion. What appeared to make this teenage rebellion so puzzling to older Americans was precisely the fact that it was taking place at a time of unprecedented affluence. This sense of bewilderment, in all its complexity, is a pervasive subtext in these two influential films.

In *The Wild One*, the motif of a disturbing, threatening enemy within, of a disruptive force which cannot be placed, located and therefore understood, is privileged in the opening frames. The static shot of a flat, open road is accompanied by the roar of motorbikes as the wild ones proceed to disrupt the Sage Valley races. As they leave, the policeman and the race official watch them disappear down the road:

'Where's that bunch from?'
'I don't know – everywhere. I don't even think they know where they're going. Termites. Nutty ... What are they trying to prove anyway?'
'Beats me. Looking for someone to push them around so they can show how tough they are.'

If in the cycle of earlier j-d films there were accessible explanations, here there are none. The sense of adult bewilderment is inverted within the film so that it is Johnny (Marlon Brando) and his 'bunch' who have no idea what it is they are rebelling against. Just as the narrative deliberately displaces the motorbike gang so that we never know where they have come from or where they are going, so it also displaces the anxieties and confusion of the older generation on to the supposed motiveless antisocial behaviour of the hoodlums. At the end of the film, though there is the hint that

Johnny has softened his attitudes as he hands back the stolen
trophy, the problem is displaced somewhere else, on to someone
else, as he rides off into an undefined elsewhere.

If, in *The Wild One*, young people's mobility is equated with
rebellion and the threat of social disruption, in *Rebel Without a
Cause* teenage mobility acts as the machinery which separates the
neurotic and criminal from those who can be redeemed. The car
duel between Jim Stark (James Dean) and Buzz Gunderson
(Corey Allen), which leads to the latter's death, epitomizes the
dangers of a life lived near the edge and of the quest for excite-
ment and meaning in what seems to Stark and his peers a mean-
ingless, bewildering existence. Let down by their weak, feckless or
absent families, Jim, Judy (Natalie Wood) and Plato (Sal Mineo)
seem adrift in a world devoid of direction and love. Yet, the narra-
tive insists, we need to recognize that there are good delinquents
and bad delinquents. As Staehling puts it, 'to the majority of
Americans, confronted with news of gang wars, Elvis, and drag-
racing, there were only two kinds of kids: the good ones and the
bad ones'.[47] Like Buzz, Plato is actually too rebellious, too beyond
adult control, and has to die. Jim and Judy, truly rebels without a
cause, are recuperated into adult society.[48]

Like these two films, *The Blackboard Jungle* (MGM 1955)
offers a narrative of social control, an older generation's discourse
on the 'youth problem'. Like them, it offers reassurance that,
whilst there is a problem, it is one that is capable of resolution.
And like them them, this reassurance is delivered through the
insistence that most – though not all – of the kids are all right.

Caged behind the bars of the North Manual High School gates,
the school students – black, Irish, Italian and Hispanic – are seen
by their long-serving teachers as 'animals', as a 'disorderly mob'.
The new teachers compare the experience with being in the
war; the 'rookie' teacher, Edwards (Richard Kiley), faced with his
first school meeting, says that 'the last time I felt like this was
when we hit the beach at Salerno', a comment which marks
out his generational difference from those he is asked to teach.
Another young teacher, Dadier (Glenn Ford), realizes the scale
of the task that confronts him, as a baseball is thrown at the
blackboard and they caricature his name as Daddy-o, but he
remains determined to reach the kids. Even when he is physically
attacked, he refuses to call in the police. In doing this, he rejects

the conservative, authoritarian strategy which most teachers at the school advocate, a strategy which has signally failed to solve the problem.

His resolve is strengthened by a visit to his old college and professor, optimistic icons of American youth and the value of education. Dadier's strategy is to win the redeemable delinquent, Miller (Sidney Poitier), to his side, isolating the irredeemable hoodlum West (Vic Morrow). As Dadier's pregnant wife puts it: 'Kids are people, and most people are worthwhile. We all need the same thing – patience, understanding and love.' The fact is, of course, in this narrative as in the wider social discourse, that not everyone is worthwhile and most of all this includes West, who smashes up Edwards' prized collection of jazz and swing records. This double encoding is significant. It reflects not just the point-less aggression and violence which West epitomizes, but also serves to equate this behaviour with rock'n'roll, with mindless rebellion. Ultimately, Dadier's liberal strategy is seen to succeed, and the problem of disruption in high school – and, by implica-tion, in society at large – is seen to be contained.

The Blackboard Jungle is not, of course, a musical, but its use of the Bill Haley number 'Rock Around the Clock' represents a significant moment in the development of American cinema. Whilst the narrative positions the film's spectators into condem-nation of juvenile delinquency and the rock'n'roll generation, as a commercial product it acknowledges the expediency of addressing the teenage market. As Martin and Segrave argue, the film 'marked the beginning of rock'n'roll's full breakthrough as a popular music form amongst the young'.[49] Exploitative as it is, *The Blackboard Jungle* points the way towards the power which the combination of popular music and the screen continues to exer-cise today.

Hollywood exploitation of rock'n'roll: musical performance and the spectacular

The success of *The Blackboard Jungle* was not lost on Hollywood executives, and a surge of films aimed at the youth audience followed. Not surprisingly, the success of Bill Haley and the Comets was one prime area for exploitation. Independent

producer Sam Katzman and his Clover production company placed Haley and his group at the centre of an otherwise wholly conventional narrative of showbiz success and heterosexual romance in *Rock Around the Clock*, distributed in 1956 by Columbia. Aware that his days as a manager of a big band are numbered, Steve Hollis (Johnny Johnston) stumbles across Haley playing music which ' ... isn't boogie, isn't jive, and isn't swing. It's a kind of all of that ... like hillbilly with a beat'. Apart from two of the six numbers performed by Haley and the band, 'See You Later Alligator' and 'Rock Around the Clock', the film is better known for the hysteria which marked its reception both in the United States and in Britain. Whilst such reactions only served to heighten the older generation's animosity towards young people and their music, the film is significant not only for being the first to acknowledge the role of Alan Freed in the promotion of rock n'roll, but also because it integrated and featured a number of black artists, notably the Platters.

Haley himself was bemused by what he considered to be youthful over-reaction to the film. His response was to offer reassurances about the new music and its teenage fans, both through such dire records as 'Teenager's Mother', and his next film, *Don't Knock the Rock* (Columbia 1956). Though featuring Alan Freed and exciting performances from Little Richard and the Upsetters ('Tutti Frutti' and 'Long Tall Sally') and black group the Treniers, together with choreographic routines which show little respect for furniture and other conventional materialist trappings, the film sets out to contain whatever oppositional potential the music has. Whilst some of the older citizens of Mellondale, singer Arnie Haines' home town, consider 'rock n'roll is for morons', the film's narrative argues that such views are unwarranted since, at bottom, the youngsters just want to enjoy themselves, as their parents before them did when they were young. Rock n'roll is, we are told, 'a business, just like any other business'.

Just as radio and records had rendered racial segregation based on geographical separation increasingly redundant, so too the presence of black performers and groups in Hollywood films represented a challenge to that fault line of race in American society. As an open acknowledgement of the influence of black artists and black music, such films contributed to a growing integration. Significantly, however, this elision of cultural spheres was

increasingly articulated through the discourse of business and entertainment. Though nobody had talked in the 1930s and 1940s in terms of rural black music as being 'authentic', the incorporation of black music into the mediated processes of screen performance was to have implications for later debates about the 'authenticity' of popular music in the 1960s.

This tension between wanting on the one hand to exploit rock n'roll in order to appeal to the youth market, and on the other to position the music and its cultural significance within mainstream popular showbiz in the attempt to minimize generational conflict, typifies the production strategy of the major Hollywood studios. Much of the time, the view towards the new music is far from benign, and often became emphatically anti-rock, as in Twentieth-Century Fox's *The Girl Can't Help It* (1956).

With the passage of time, *The Girl Can't Help It* has come to be seen by many as one of the most significant of all rock'n'roll films, largely because of its rota of acts and performances. Yet, from its opening title sequence, with Tom Ewell lamenting the changes experienced both by cinema and popular music, the film adopts a resolutely anti-youth and anti-rock'n'roll position, what Doherty describes as an 'imperial treatment of rock'n'roll'.[50] Enjoined by ageing mobster 'Fats' Murdoch to turn his platinum blonde girl-friend Jerry Jordan (Jayne Mansfield) into an overnight singing star, failing impresario Tom Miller (Ewell) sets about the task with initial reluctance. However, as Jerry reveals her deep-seated desire for domesticity and motherhood, Miller warms to her and his task, only to discover her total lack of singing ability. Undaunted, Miller propels Jerry into stardom with the help of Ray Anthony and his orchestra, together with 'Fats' Murdoch's success in the mafia-style jukebox warfare with long-standing mobster opponent Wheeler.

The knowingly appalling song which propels Jerry to stardom, 'Rock Around the Rockpile Blues', stands as explicit criticism of contemporary rock'n'roll, the more so since Jerry's sole contribution is the interjection of the high-pitched prison 'siren'. Coming from such a highly mediated product as a Hollywood film, this attack on the 'authenticity' of another highly mediated cultural process carries unintentional irony. This criticism of rock and its adherents is privileged throughout the film. Having pointed out to Murdoch that Jerry can't sing and that his mission is impossible,

Miller gets a phone call from Murdoch telling him to turn on the TV. After watching Eddie Cochran perform 'Too Tired to Rock' on 'The Peter Potter Show', Murdoch argues that if Cochran, who in his view patently can't sing, is a star, then Jerry can be so too. Yet, despite the film's mainly middle-aged protagonists, its overt misogynism and its parodic derision of young people and their music, it remains significant precisely because of the tension between exploitation and incorporation which sits uneasily throughout the narrative.

This tension is there in the very structure of the narrative. The insistence on placing rock'n'roll within the commercial mainstream of showbusiness, the appeal to a discourse of stardom of the kind enshrined in the classical Hollywood musical, simply cannot be resolved with the simplistic desire to exploit the popularity of the new music amongst young people. The result is an abandonment of the integrated narrative/number structure, and a return to the revue structure which characterized the very earliest film musicals. If the integrated narrative of the classical Hollywood musical implied ideological coherence, then the broken-backed, fractured narrative of films such as *The Girl Can't Help It* articulates the ideological, social and cultural tensions which surround rock'n'roll and the historical moment of its emergence.

Yet it is significant that the number of films which adopt this 'revue' structure are limited in number. Films like *Rock, Rock, Rock* (1956), *Mister Rock and Roll* (1957), both of which feature Alan Freed, *Jamboree* (1957) and *Rockin' the Blues* (1957), all unashamedly string a succession of numbers and acts together with barely a pretext of a plot, but they remain the exception rather than the rule. Like the musical genre in the late 1920s and early 1930s, Hollywood films of the late 1950s featuring rock, country and pop music, rapidly developed narrative structures and plotlines which displaced ideological conflict with images of implied sociocultural resolution. The oppositional resonance of the rock'n'roll performer is rapidly replaced by images of normative characters 'working' within a narrative.

Of course, the narrational condescension which wraps itself around the rock'n'roll numbers in *The Girl Can't Help It* was not likely to endear itself to a teenage audience, even if the music did. Moreover, whilst it seems reasonable to argue that the film

epitomizes mainstream Hollywood's attempt to maintain market share through the commercial exploitation of popular music, it is an oversimplification to suggest, as Doherty rather tends to, that these economistic determinants 'explain' the formation of youth subculture in the 1950s.[51] To argue that *The Girl Can't Help It* and the host of rock'n'roll teen-pics which emerged from small independent production companies and distributors at this time simply 'exploited' the increasingly affluent teen market is to misunderstand the complex processes of cultural formation, and in particular the development of youth subculture in the 1950s. As Negus, talking about the 'market' for music, argues:

> what becomes commercially successful on this market does not do so due to a spontaneous process in which 'the markets decide'. Neither does what is made available on the market simply coincide with what the public 'wants'.[52]

Whilst it is true that the entertainment industry, through a process of restructuring and precursory synergy, positioned itself to cater for and then drive the expanding teenage market, it is equally true that 'teenagers' used the cultural products they encountered in complex ways to accrue 'subcultural capital' which simultaneously differentiated them from, and incorporated them within, the commercial mainstream. Whilst the arguments in this book have sympathy for Peterson's rejection of 'talented individuals' or 'changes in the nature of the youth audience'[53] and his endorsement of what might be termed a 'production-of-culture' perspective, this is not to deny the complexity of cultural production, its use and appropriation, and the ways in which these interact. To understand these processes, we need to understand the emerging patterns of leisure and entertainment consumption amongst young people in the 1950s which was increasingly and largely based on images and sounds. Nowhere is this more apparent than in the career of Elvis Presley.

Elvis Presley and the exploitation of iconic excess

Presley's early career was constructed, as we have seen, through local and regional record sales, through radio play on local stations such as WHBQ in Memphis, through regional radio

stations such as KWKH from Shreveport (which broadcast
'Louisiana Hayride' across twenty-eight states) and, just as impor-
tantly, through live performances, beginning with his brief appear-
ances at the Bon Air club and Overton Park in Memphis in the
summer of 1954, leading on to the Grand Ole Opry in Nashville
and the Louisiana Hayride later that year. According to at least
one account, Presley's appearance at the Opry was criticized
because of his music was deemed 'unsuitable'.[54]

What was significant in Presley's early career was the extent to
which a taste culture amongst young people, based on radio play,
propelled him to attention, despite initial opposition from many
entrenched conservative figures across different levels in the
entertainment business. When Dewey Phillips first broke 'That's
All Right' and 'Blue Moon of Kentucky' on WHBQ in Memphis,
he was inundated with phone calls wanting to know more about
the singer and the still-to-be-released Sun acetates. Five thousand
orders for the record were placed in the week after the radio play.
Released on 19 July 1954, it reached number three on the
Memphis country and western chart by the end of the month. In
the same way, though billed way below Slim Whitman and Billy
Walker, the 'Tall Texan', both hillbilly singers performing to a
largely hillbilly crowd at the Overton Park Show in July 1954, it
was Elvis who drew screams from the teenage girls present and
who forced an encore.

Goldman argues that radio was the real foundation of Presley's
success:

> Radio put him before a large listening public at a time when he had
> only a few records. Radio broadcast these records far beyond the
> limited advertising and distribution powers of Sun Records. Radio
> inspired local bookers to engage Elvis.[55]

Whilst it is surely right to acknowledge the importance of radio in
developing Presley's early career, it is also right to emphasize
the extent to which local radio airplay was linked to, and partly
depended upon, his increasingly successful live performances,
initially in Memphis and later on tour. For example, in January
1955, he gave a number of performances around Corinth, Missis-
sippi, which led local WCMA DJ Buddy Bain to play 'Blue Moon
of Kentucky'. The point here is that, whilst the record sales
and radio play are acknowledged, the impact that Presley's visual

presence had upon young audiences at his live performances goes largely unacknowledged as an element which appealed to the emerging youth taste culture. It was the way he *looked*, just as much as how he sounded, that demanded attention and which created sensation. For young Americans trapped within the behavioural mores of domestic, high-school, suburban decorum, Presley's on-stage performative excesses were as liberating and intoxicating as the music itself. Significantly, local newspaper adverts for Presley's appearances at the Eagles Nest club at Memphis's Clearpool complex throughout September 1954 enjoined people to '*See* and hear Elvis singing "That's All Right" and "Blue Moon of Kentucky"'.[56]

Equally significantly, the conservative cultural backlash against Presley increasingly centred on his visual performance and persona. Criticisms of his 'downright obscene' stage performance, likening it to 'strip-tease with clothes on' and 'male burlesque' (truly a homophobic double horror), were commonplace. By June 1956, the magazine *America* was arguing that the negative influence of Presley's music on young people was containable, 'but unfortunately Presley makes personal appearances'.[57]

Of course, youthful exuberance and obsessive identification with popular singers was not new, as the early career of Frank Sinatra in the 1940s shows, not least in the 1944 'Columbia Day Riot' at New York's Paramount theatre. What made Presley different was the rapidity with which his visual persona was constructed, disseminated and consumed. What made the difference was television, and the growing ubiquity of its representational regime. As Greil Marcus argues, Elvis consciously set out to shatter the perceived 'limits of what Americans had learned to accept as shared culture'[58] in his early TV appearances.

Presley's early television appearances have been well documented. His first television appearance took place on 28 January 1956 on the CBS-networked *Stage Show*, produced by Jackie Gleason and hosted by bandleaders Tommy and Jimmy Dorsey. Earlier attempts to find him a slot on New York-based *Arthur Godfrey's Talent Scouts*, and to find a film role for him in a project proposed by Cleveland DJ Bill Randle, tentatively entitled 'The Pied Piper of Cleveland', came to nothing. Ironically, it was Bill Randle, more a celebrity name at this time than the young singer, who introduced Presley to the live television audience sitting in

CBS's New York studios. Contemporary accounts of Presley's performance emphasize the sheer visual impact he made rather than commenting on the numbers he sang. Indeed, there is anecdotal evidence that Presley was only booked for the show on the basis that he looked like 'a guitar-playing Marlon Brando'.[59]

Though losing out in the ratings to NBC's *The Perry Como Show*, Presley's performance led to further television appearances, both on *Stage Show* and, in April and again in June 1956, on *The Milton Berle Show*. It also led to a screen test and three-picture contract with Hollywood producer Hal Wallis, one of a number of film producers eager to tap into the growing market for 'teen pictures', an eagerness made more frenzied by the recent death of James Dean. Yet, if Presley's visual impact and performative presence were what inspired film and TV producers, these were precisely the qualities, rather than rock'n'roll per se, which alarmed the conservative critics. As Martin and Segrave point out, most reviews and comments about Presley were anatomical rather than musical. Many drew upon discourses of racism and delinquency to express their opposition, comparing Presley's performances with 'an aborigine's mating dance', suggesting that it was 'vulgar and suggestive', that it was inflected with a 'kind of animalism' associated with 'dives and bordellos'.[60]

Significantly, though Presley's growing number of television appearances commanded ever-larger fees and delivered much-needed improvements in ratings for flagging shows, the institution of television began to make its own demands, beginning to assert control over his performative exuberance and the cultural significance which surrounded it. Nowhere was this most apparent than Presley's appearances on *The Steve Allen Show* in the summer of 1956, and on *The Ed Sullivan Show*, hosted by Charles Laughton, in September of that year. In its press release of 20 June 1956, NBC stated that viewers would see a 'revamped, purified and somewhat abridged Presley' on the Allen show. What happened was a microcosmic cameo of cultural expropriation and incorporation, as Presley, dressed in formal shirt and dress jacket, sang 'Hound Dog' to a basset hound. Though the now infamous visual castration of Presley only occurred in the last of his Sullivan show appearances, his earlier performances on the show are subdued and unimpressive, even, in Goldman's view, 'amateurish'.[61] His presence on the show boosted its ratings, as did the appearance of

the Beatles on the show in 1964, but it foreshadowed some of the issues which still surround popular music and television. These issues range from the formal, aesthetic questions of how the musical performance is framed, shot and cut, to larger questions about institutional hegemony, symbolic significance and cultural meaning.

Television's apparently successful accommodation with rock n'roll and the most significant contemporary icon of teenage rebellion was replicated in Hollywood. Indeed, American network television and Hollywood can be seen as actively constructing synergistic alliances at this period, not least through Presley's performances across both media, in ways which were to become only more pronounced.

Presley and Hollywood: conservative ideology and the discourse of entertainment

Following his screen test for Hal Wallis and Paramount Pictures, Presley was initially set to appear in *The Rainmaker*, a film based on the wordy stage play by N. Richard Nash, starring Burt Lancaster and Katherine Hepburn. Whilst this may have suited Presley himself, who at this time publicly expressed aspirations to be taken as a serious screen actor, this was certainly not what his manager, Colonel Tom Parker, and Hollywood wanted from him. Uncertain as to what to do with Presley, Paramount loaned him to Twentieth-Century Fox to work on a western starring Richard Egan and Debra Paget, with whom Presley had first worked on *The Milton Berle Show* in June 1956. Originally entitled *The Reno Brothers*, the film is a Civil War melodrama in which Presley plays younger brother Clint to Richard Egan's Vance. Believing mistaken reports that Vance has been killed in the war, Clint marries Vance's sweetheart Kathy (Debra Paget). On Vance's return, it becomes clear that Kathy is still in love with the older brother, and driven by jealousy (and following Vance's arrest for stealing Union money) Clint shoots Vance and then is shot dead himself, appearing as a ghostly apparition at the end of the film, a scene shot hastily later in response to the preview protest at Presley's screen demise.

Both as product and text, the film exemplifies the processes by

which the symbolic challenges posed by the emerging youth subculture and its icons were effectively incorporated into socio-cultural norms by the dominant entertainment institutions. Significantly, four songs were added to the film and its release title was altered to *Love Me Tender*, the ballad sung by Presley. It was this number which Presley sang on the 9 September Sullivan show, where he introduced it as 'the title of our brand-new Twentieth-Century Fox movie and also my newest RCA Victor escape – er, release'.[62] Presley was given co-authorship credit along with Vera Matson for 'Love Me Tender' and the three other songs, 'Let Me', 'Poor Boy' and 'We're Gonna Move'. The contract with Twentieth-Century Fox also gave Colonel Parker credit as the film's technical adviser. This cross-media exposure paid handsome dividends. The Sullivan TV show got a 43.7 Trendex rating, reaching just over 82 per cent of the television audience. There were 856,327 orders for the RCA Victor single before it was available in the record stores. Twentieth-Century Fox's decision to print 575 copies of the film for a Thanksgiving Day release, more than for any other film in their history, was justified by a box-office gross of $3,750,000 by the end of the year. Within weeks, Parker had negotiated a new and highly lucrative deal with RCA, and had arranged for a marketing deal with Hank Saperstein worth an estimated $40 million in retail merchandising.[63]

Just as his presence had a huge commercial impact on what would otherwise have been a very routine western, Presley's appearance inflected the film's otherwise conventional narrative. Though he proves to be a competent actor, it is his four numbers which stand out. No attempt is made to motivate these performances at the level of either plot or characterization, but at least two of the numbers, 'We're Gonna Move' and 'Love Me Tender', do serve some expressive purpose within the narrative. The first unites the family which has been ripped apart by the experiences of Civil War and offers, ironically as it turns out, a declaration that things can only get better for them now the war is over. Presley's performance is interesting. Playing acoustic guitar, he occasionally breaks out into the physical gyrations which live and TV audiences had come to expect. Yet this physical exuberance is somehow contained by the familial setting in which the number is performed, with Ma (Mildred Dunnock) sitting in her rocking

chair, patting Presley's leg as he sings to her. Whilst it may lack the excessive schmaltz of Jolson in *The Jazz Singer*, the scene is uncannily similar to the 'Blue Skies' number in that film, arguably serving the same purpose of negating and containing the coded rebelliousness of the 'new' music whilst affirming the prospects of a better material future.

'Love Me Tender' also serves a narrative purpose, offering an ironic and emotional focus on the impossible romantic schisms which tear the Reno family apart in a more devastating way than the Civil War could ever do, the slow ballad perfectly suited to the melodramatic narrative. Yet the two most interesting numbers are 'Let Me' and 'Poor Boy', the ones which have little to do with plot or story but which show Presley performing to the audience at the County Fair. Elevated, in the best musical genre tradition, on a small stage and accompanied by a small backing group (though not by Bill Black and Scotty Moore, regular members of Presley's backing group, who had been rejected by the film's musical direc-tor on the grounds that they were not 'hillbilly' enough), he gives a performance which owes nothing to the context or codes of the western in which it is set, but rather replicates the Presley which was causing so much critical outrage amongst reviewers and the older generation. Interestingly, the shots acknowledge this extra-textual 'other' Presley through cutaways which show the front-row audience of young girls, albeit with western bonnets and dresses, standing and screaming up at him as he sings and moves. However, this acknowledgement sits alongside other shots of Ma glancing adoringly and approvingly at the performance, as well as of the older folk dancing, barn-dance fashion, in a coded construction of community which erases and transcends any generation conflict. The film eradicates race as an issue by ignor-ing it. Just as for an earlier generation, the new 'jazz' music was both acknowledged and made safe, so here rock'n'roll, through its most important icon, is both recognized and subsumed.

The conventional critical wisdom is that Presley's first four films, produced before he was drafted into the US army, epitomize the early rebelliousness of rock n'roll, marking out the dangerous subcultural territory which was so threatening to an older generation. Mark Kermode, for example, writing about *Jailhouse Rock* (MGM 1957), refers to the film as 'a cultural landmark'.[64] Perhaps the fact that the film was produced by

Pandro S. Berman, who also produced the Astaire–Rogers films for RKO from *Roberta* in 1935 to *The Story of Vernon and Irene Castle* in 1939, should give pause for thought. The argument here is that, whilst recognizing the importance of that taste culture which brought rock'n'roll and Presley himself to the attention of first local, then regional, and finally the national and international media, the simultaneous processes of dissemination and diffusion of this particular subcultural style where well under way by the time Presley had signed his Hollywood contract. Far from being in any real sense a radical departure from much that had gone before, what Presley's early films do is to provide clear textual evidence of those complex but specific processes through which subculture's symbolic challenge to the prevailing order is deflected and assimilated.

In his seminal study of subcultures and their meaning, Hebdige writes:

> Subcultures represent 'noise' (as opposed to sound): interference in the orderly sequence which leads from real events and phenomena to their representation in the media. We should therefore not underestimate the signifying power of the spectacular subculture not only as a metaphor for potential anarchy 'out there' but as an actual mechanism of semantic disorder: a kind of temporary blockage in the system of representation.[65]

This subcultural 'noise' ruptures the prevailing and 'authorized' codes through which the social world is organized and known, exposing their arbitrariness. Consequently, the normative world has to work hard to reassert the power of those codes which express and represent consensus, which give 'meaning' to social order. Influential as Hebdige's views on subcultures have been, it is probably a mistake to hold too romantic a concept of subcultures as being somehow divorced or insulated from mainstream commercial pressures. Arguably, we can see these commercial interests working to build a subcultural audience for their products across a range of historical moments. This 'work' is exactly what we see taking place in *Love Me Tender* (1956), *Loving You* (1956), *Jailhouse Rock* (1957), and *King Creole* (1958). Presley, his music, and all that they represent are incorporated within consensually validated norms specifically through the discourse of business and entertainment which, as we have seen,

sits at the centre of the Hollywood musical and which continues to be important in the late 1950s.

Jailhouse Rock

At one level in these films, incorporation is encoded within the narrative trajectory which turns Presley from a socially undesirable 'other', a victim of circumstances, into a regular guy who succeeds both in love and as a star performer. This is especially the case in both *Jailhouse Rock* and *King Creole*. In the former, Presley plays Vince Everett, a convict who becomes a rock'n'roll star and gets his own TV special. He is helped, in more senses than one, by his relationship with Peggy. As with so many self-reflexive classical Hollywood musicals, we see success operate across the dual axes of professional showbusiness and private, heterosexual romance, the two intertwined in that narrational 'double-helix' we noted earlier.

Presley, convicted of manslaughter, is encouraged to sing and play the guitar by his cellmate Hunk Houghton, himself a former professional country music artist. The sackful of fan letters following his prison-bound TV appearance singing 'I Wanna Be Free' is withheld from Vince who, in ignorance of the impact he has made, is persuaded by Houghton to sign a partnership contract. Released from prison, Vince meets and impresses Peggy, who works exploiting records for a major company. She pays for a studio session to record 'Don't Leave Me Now', only to find that a cover version by Golden Records' star Mickey Alba has been released without their knowledge. Twice victim of dubious business ethics, Vince opts literally for independence within the music industry by forming his own record label, Laurel Records, with Peggy and a lawyer who acts as a benign business manager. His first record, 'Treat Me Nice', gets plugged on radio and success leads first to a NBC TV extravaganza and then a contract in Hollywood with Climax Studios. However, this success makes Vince arrogant. He and Peggy drift apart and are only reconciled when a fight with his former cellmate threatens the loss of his singing voice. The film ends with Vince and Peggy back together, and with them agreeing to sell Laurel Records to a major company, Geneva Records. The figure that Vince is being offered,

$750,000, is mentioned more than once, as he is told, 'no artist has ever received an offer that big'. This is an interesting discursive treatment of many of the actual changes that were happening in the music industry and a useful articulation of those processes through which taste cultures are assimilated by business, If, throughout the film, there has been an emphasis on the 'work' involved in cultural production, by its conclusion Vince has been fully assimilated into the world of capitalist cultural production and the world of heterosexual romance. In this sense, there is a real continuity between these Presley vehicles and the earlier classical Hollywood musical.

Vince's move towards incorporation within the narrative is mirrored in the songs he sings. Whilst the film acknowledges the importance of country music and white gospel, 'One More Day', sung by his cellmate, contrasts with Vince's recognition of the importance of a newly emerging youth culture in his number 'Young and Beautiful'. 'I Wanna Be Free', the number which Vince performs at the televised prison show, has immediate resonance to his status as inmate, but equally has relevance for teenagers seeking to differentiate themselves from the mores of an older generation. Significantly, in the recording studio we are shown Presley rejecting the conformist balladeering treatment of 'Don't Leave Me Now' in favour of a treatment which reflects his youthful performer-based style. However, the cover version appropriated by Mickey Alba reverts to a sentimental ballad treatment. This coded implication of Alba's commercial insincerity is designed to serve as a contrast with Presley's supposed authenticity. The first – indeed only – number on their newly independent Laurel label, 'Treat Me Nice' is an upbeat rocker, and shares the insouciant confidence of 'Baby I Don't Care' which Vince performs at a poolside party in Hollywood. By acknowledging the new music and the necessity to move away from country ballads and white gospel, the film also reassures by intimating that the world of successful showbusiness is big enough to recognize and reward rock'n'roll.

Loving You

Very similar patterns are at work in *Loving You* (1957). Here, the significance of country music, 'the voice of our nation', is given even greater recognition, as is, by implication, Presley's own indebtedness to it. Persuaded to get up and sing with Tex Warner's country music outfit, Deke Rivers (Presley) performs 'Got a Lot of Livin' to Do' to the delight of the youngsters in the audience and the stony-faced indifference of the older generation. Encouraged by public relations impresario Glenda Markle (Lizabeth Scott), who tells him 'you've got something – I don't know what it is', Deke goes on tour with Tex Warner's 'Rough Ridin' Ramblers' band, which includes country singer Susan. At the Longhorn County Community Fair, and a host of small towns across the southern states, Deke sings 'Let's Have a Party', '(Let Me Be Your) Teddy Bear', 'Got a Lot of Living to Do', and 'Hot Dog' as a 'guest' spot invited out of the audience. Ironically, promoted as a full member of the band, Deke sings the showcased number 'Lonesome Cowboy', a number which reverts to the country music origins of rock. However, it is his appeal to teenagers and young women in particular which marks out his success, all helped by the fact that he is shot full-frame in ways that were denied on his TV appearances.

In this respect, *Loving You* more closely refers to Presley's own career path and the appeal to frenzied teenagers that so alarmed his critics. However, as Glenda says about the publicity surrounding a picture of Deke kissing a fan, 'sex is a healthy American commodity. It sells cold cream, steam engines, shampoo, real estate and toothpaste'. And, if sex is a commodity, so too is Deke Rivers and rock'n'roll. As Glenda reminds the governing citizens of Freegate who are objecting to his first coast-to-coast TV appearance, due to be broadcast from the town, rock'n'roll is nothing new. In fact, she links it to a long line of previous popular music fads, including the Charleston, the Black Bottom and jazz, by way of Stravinsky's *Rites of Spring* and even Debussy. Music, she reassures them, cannot be blamed for young peoples' behaviour. It is, after all, only entertainment. The appeal to democracy and publicity for Freegate wins the day and the TV show goes ahead, though not without some hitches. Deke realizes that he has been duped by Glenda, and not just over the matter of his

contract. Only when she puts the record straight and expresses her genuine belief in his talent does the show go on. In a parody of television production, the film concludes with a plethora of reassurances, direct to camera, not just about Deke, but about young people and rock'n'roll. Deke's songs, the sentimental ballad 'Lovin You' and the rocker 'Got a Lot of Living to Do', mark his success both professionally, as he is offered a TV contract, and romantically as, in 'the one deal I can handle myself', he embraces Susan. The measure of his success and of the incorporation of rock'n'roll is emphatically marked through that staple device of the classical musical, the on-screen 'internal audience' present at the TV show, where young and old alike are seen responding enthusiastically to Deke, his mannerisms and his music.

Far from representing a radical break with traditions depicting popular music on screen, it is clear that Presley's early films continue the stylistic and narrative conventions of the classical Hollywood musical, and perpetuate dominant ideologies, not least through the discourse of showbusiness and entertainment. Moreover, the way in which the numbers are shot remain firmly within that range of representational strategies employed by the classical musical. A review of a number of lesser-known films of the late 1950s such as *The Big Beat* (1957) and *Mister Rock and Roll* (1957) which involved either rock'n'roll acts, radio DJs, recording studio politics or high-school rebellion, would only serve to reinforce the sense of continuity with earlier cultural products. This is not to deny the distinctive cultural moment that was characterized by rock'n'roll, nor to negate the impact it was having upon Hollywood. In the popular fan annual *Preview* for 1959, actor John Saxon noted the extent to which cinema was catering for the teenage market:

> You guys and gals in your teens are sure shaking Hollywood up. You may not be old enough to vote, but you're old enough to dictate policy to Hollywood. ... Recent months have seen a spate of pictures with the stories centred around teenagers and filled with music that pleases younger ears.[66]

Arguably however, those who see in rock'n'roll a profound discontinuity with what had gone earlier are misreading the complex and powerful forces which were driving the entertainment business and cultural production throughout the 1950s and beyond. In this

sense, Presley's later films in the 1960s, so often criticized for their bland musical and filmic aesthetic, seem the logical outcome of Presley's assimilation into the dominant commercial mainstream which began with his very first films. By that time, of course, the dynamic of popular music and its place on our screens was coming from elsewhere.

Notes

1 T. Balio (ed.), *Hollywood in the Age of Television* (London, Unwin Hyman, 1990), pp. 13–23.
2 T. Schatz, *Old Hollywood/New Hollywood: Ritual, Art and Industry* (Ann Arbor MI, UMI Research Press, 1983), p. 178.
3 D. Webster, *Look a Yonder: The Imaginary America of Populist Culture* (London, Commedia/Routledge, 1988), pp. 174–208.
4 D. Gomery, *The Hollywood Studio System* (London, British Film Institute/Macmillan, 1986) and J. Izod, *Hollywood and the Box Office 1895–1986* (London, Macmillan, 1988).
5 For a more detailed account of the impact of the Paramount litigation upon the market structure of Hollywood through the 1960s to the 1980s, see G. Edgerton, 'American Film Exhibition and an Analysis of the Motion Picture Industry's Market Structure 1963–1980', unpublished PhD dissertation, University of Massachusetts, 1981.
6 For a wide-ranging account of HUAC and its activities, see L. Cepland and S. Englund, *The Inquisition in Hollywood: Politics in the Film Community 1930–1960* (Berkeley CA, University of California Press, 1983) and R. M. Friel, *The Red Menace: The McCarthy Era in Perspective* (New York, Oxford University Press, 1990). B. Neve, *Film and Politics in America: A Social Tradition* (London, Routledge, 1992) contains a study concentrating on specific individual experiences during this period in Hollywood.
7 J. Wasko, *Hollywood in the Age of Information* (London, Polity Press, 1994), pp. 11–15. For a more detailed case study see T. R. White, 'Hollywood's attempt at appropriating television: the case of Paramount Pictures', in Balio (ed.), *Hollywood in the Age of Television*, pp. 145-64.
8 S. Harvey, *Directed by Vincente Minnelli* (New York, Museum of Modern Art/Harper and Row, 1989), p.126.
9 C. Belz, *The Story of Rock* (New York, Oxford University Press, 2nd edn 1972), p. 54.

10 R. A. Peterson and D. G. Berger, 'Cycles in symbol production: the case of popular music', in S. Frith and A. Goodwin (eds), *On Record: Rock, Pop and the Written Word* (London, Routledge, 1990), p. 143.

11 Peterson and Berger, 'Cycles in symbol production', pp. 144–55.

12 Peterson and Berger, 'Cycles in symbol production', p. 145.

13 D. Hatch and S. Millward, *From Blues to Rock: An Analytical History of Pop Music* (Manchester, Manchester University Press, 1987), p. 18.

14 C. Escott with M. Hawkins, *Good Rockin' Tonight: Sun Records and the Birth of Rock'n'Roll* (London, Virgin, 1992), pp. 2–3.

15 D. Clarke, *The Rise and Fall of Popular Music* (London, Penguin , 1995), pp. 135–46.

16 Hatch and Millward, *From Blues to Rock*, p. 49.

17 D. Harker, *One for the Money: Politics and Popular Song* (London, Hutchinson, 1980), p. 56.

18 I. Chambers, *Popular Culture: The Metropolitan Experience* (London, Routledge, 1986), p. 142.

19 Clarke, *The Rise and Fall of Popular Music*, p. 283.

20 R. A. Peterson, 'Why 1955? Explaining the advent of rock music', *Popular Music*, 9:1 (1990) 97–116.

21 For more information on the ASCAP/BMI dispute and the American Federation of Musicians (AFM) strike in 1942, see Clarke, *The Rise and Fall of Popular Music*, pp. 250–60.

22 Clarke, *The Rise and Fall of Popular Music*, p.231.

23 C. Gillett, *The Sound of the City* (London, Sphere, 1971), p. 144.

24 D. Wade and J. Picardie, *Music Man: Ahmet Ertegun, Atlantic Records and the Triumph of Rock'n'Roll* (New York, W. W. Norton, 1990), pp. 31–3.

25 Escott with Hawkins, *Good Rockin' Tonight*, pp.18–19.

26 G. Marcus, *The Dustbin of History* (London, Picador, 1995), pp. 232–3.

27 Gillett, *The Sound of the City*, pp. 29–44. A summary is contained in B. Longhurst, *Popular Music and Society* (Cambridge, Polity Press, 1995), p. 95.

28 L. A. Lewis (ed.), *The Adoring Audience: Fan Culture and Popular Media* (London, Routledge, 1992).

29 D. Riesman, 'Listening to popular music', *American Quarterly*, 2 (Autumn 1950) 359–71, and cited in S. Frith and A. Goodwin (eds), *On Record*, p. 158.

30 L. Grossberg, *We Gotta Get Out of This Place: Popular Conservatism and Postmodern Culture* (New York, Routledge, 1992), p. 205.

31 P. Wicke, *Rock Music: Culture, Aesthetics and Sociology* (Cambridge, Cambridge University Press, 1990), pp. 16–17.
32 Grossberg, *We Gotta Get Out*, p. 173.
33 Grossberg, *We Gotta Get Out*, p. 179.
34 Peterson and Berger, 'Cycles in symbol production', p. 146.
35 P. Guralnick, *Last Train to Memphis: The Rise of Elvis Presley* (London, Little, Brown UK, 1994), p. 101.
36 L. Martin and K. Segrave, *Anti-Rock: The Opposition to Rock'n'Roll* (New York, Da Capo Press, 1993), p. 23.
37 Martin and Segrave, *Anti-Rock*, p. 46.
38 Gillett, *The Sound of the City*, p. 24.
39 S. Chapple, *Rock'n'Roll is Here to Pay* (Chicago, Nelson-Hall, 1977), pp. 35, 43–4. R. Shuker *Understanding Popular Music* (London, Routledge, 1994), p.43, also notes the market concentration enjoyed by the majors in the late 1940s and early 1950s, noting that in 1948 RCA, Columbia, Capitol and Decca released 81 per cent of all the records making the Top Ten.
40 H. Fordin, *The Movies' Greatest Musicals: Produced in Hollywood USA by the Freed Unit* (New York, Frederick Ungar Publishing, 1984).
41 F. Karlin, *Listening to Movies: The Film Lover's Guide to Film Music*, New York, Schirmer, 1994), p. 227.
42 For an overview of the relationship between Hollywood and television and its impact on colour production, see B. Chisholm, 'Red, blue, and lots of green: the impact of color television on feature film production', in Balio (ed.), *Hollywood in the Age of Television*, pp. 213–34.
43 T. Doherty, *Teenagers and Teenpics: The Juvenilization of American Movies in the 1950s* (London, Unwin Hyman, 1988), p. 51.
44 Martin and Segrave, *Anti-Rock*, p. 43.
45 K. Negus, *Popular Music in Theory* (Cambridge, Polity Press, 1996), p. 10.
46 Doherty, *Teenagers and Teenpics*, p. 119.
47 R. Staehling, 'From *Rock Around the Clock* to *The Trip*: the truth about teen movies' in T. McCarthy and C. Flynn (eds), *Kings of the Bs: Working Within the Hollywood System* (New York, E. P. Dutton, [1969] 1973).
48 P. Biskind, *Seeing is Believing: How Hollywood Taught Us to Stop Worrying and Love the Fifties* (New York, Pantheon, 1983), pp. 209–10.
49 Martin and Segrave, *Anti-Rock*, p. 7.
50 Doherty, *Teenagers and Teenpics*, p. 95.

51 J. Hay, 'You're tearing me apart! The primal scene of teen films', in *Cultural Studies*, 4:.3 (October 1990) 331–8 offers a useful critique of Doherty's position.
52 K. Negus, *Popular Music in Theory*, p.50.
53 Peterson, 'Why 1955?', pp. 97–116.
54 A. Goldman, *Elvis* (London, Allen Lane/Book Club Associates, 1982), p. 122.
55 Goldman, *Elvis*, p. 124.
56 Guralnick, *Last Train to Memphis*, p. 118.
57 Martin and Segrave, *Anti-Rock*, p. 59.
58 G. Marcus, *Mystery Train* (London, Penguin, 4th edn 1991), p. 241.
59 Goldman, *Elvis*, p. 176.
60 Martin and Segrave, *Anti-Rock*, p. 65.
61 Goldman, *Elvis*, p. 203.
62 Guralnick, *Last Train to Memphis*, p. 338.
63 Guralnick, *Last Train to Memphis*, p. 354.
64 M. Kermode, 'Twisting the knife', in J. Romney and A. Wootton (eds), *The Celluloid Jukebox: Music and Movies Since the 1950s* (London, British Film Institute, 1995), p. 9.
65 D. Hebdige, *Subcultures: The Meaning of Style* (London, Methuen, 1979), p.90.
66 J. Saxon, 'The cinema's becoming a teen screen', in E. Warman (ed.), *Preview* (London, Andrew Dakers, 1959), p. 76.

5

A very British coda

In New York, I saw my first talkie – *The Sidewalks of New York*. There-was a scratching sound throughout, but nevertheless artists were talking in synchronization, with their lips and movement. I caught the next train to Hollywood.

Twenty-Five Thousand Sunsets:
The Autobiography of Herbert Wilcox, 1967

We went on tour of the major American cities and I learned all about getting the American bird. They threw pennies at us in Detroit. In Pittsburgh they jeered and stamped, and in Philadelphia they opened their newspapers and read while the English actors and actresses performed.

Jesse Matthews, *Over My Shoulder: An Autobiography*, 1974

Rock'n'roll was still dubious music to these men who couldn't believe that the big band era was really over. They thought it was an American craze that would soon die out.

Steve Turner, *Cliff Richard: The Biography*, 1994

Of course, there were moments when I could cheerfully have strangled one or other of them, and no doubt the feeling was reciprocated, but my enduring memory of those times is the enormous fun it all was. We really did not think about material success and the fortunes that they were earning.

George Martin in Mark Lewisohn,
The Complete Beatles Chronicle, 1992

Whilst the musical genre has been called a quintessentially American cultural form, a synthesis of Broadway and Hollywood, those

'twin channels of twentieth century American popular culture',[1] it would be wrong to ignore the importance of the British film musical and the British contribution to popular music, both on and off the screen, in the twentieth century. The neglect of British popular music prior to the 1960s is matched by the lack of critical comment on British musicals and musical comedies, despite the fact that the genre formed a significant element within British film production from the 1930s onwards, often showcasing British popular music talent. This critical neglect is surprising given the rich vein of performed popular music in the music halls of the nineteenth and early twentieth centuries. British cinema produced some interesting if, judged by the conventions of the dominant Hollywood product, idiosyncratic musicals from the early 1930s onwards and British television has been supremely important in developing popular music since the late 1950s.

Of course, the impact of the Beatles and of their music, films and television appearances in the early and mid-1960s was to have a lasting inflection on the development of the global market for popular music and its visual representation on screen. However, long before the Beatles and the critical recognition of British popular music that developed from the 1960s onwards, there was a vibrant tradition in Britain of popular music on screen. As in the United States, British popular music also developed in collaboration with the broadcasting and film industries. Careers and star personas were constructed through cross-media sites, through records, radio and film, in ways which reflected the growing synergistic alliances within both the British and global entertainment industry. This chapter focuses on the role of cinema in this process. In the following chapter, we look at the role of television from the 1950s onwards in constructing the visual economy of popular music.

Arguably, one reason for the relative neglect of British musicals and popular musical talent reflects the wider critical neglect from which, until recently, British cinema as a whole has suffered. Much of this has been to do with the failure to recognize the tensions which have historically existed between wanting, on the one hand, to exploit indigenous popular cultural traditions and, on the other, to emulate dominant American cultural traditions. These tensions were inevitably translated into production and marketing strategies and were influenced by complex audience

reactions to the various cultural products on offer. Whilst there was often strong class-based and regional demand for British popular films, music and performers, the influence of American film and popular music was constantly present. If race was the structural fault line in the United States impacting upon the production and consumption of popular culture, in Britain class and class attitudes exercised similar influence. Whilst the importance of the economic struggles and tensions between British and American popular cultural production and distribution can never be underestimated, it is clear that complex class attitudes exercised enormous influence on the production and reception of, as well as attitudes towards, popular culture in Britain.

Anglo-American cultural exchange

This uneasy relationship between British and American popular culture is not new. Despite vexed copyright problems, the cross-fertilization between British and American popular culture was in evidence during the eighteenth century, most famously in productions of John Gay's *The Beggar's Opera*, but became pronounced in the late nineteenth century. Gilbert and Sullivan were very popular in the United States, although the first productions of *HMS Pinafore* in 1878 were pirated versions, illustrative of the complex copyright problems which surrounded cultural exchanges at this period. The composer and lyricist travelled to New York later in that same year to produce *The Pirates of Penzance*.[2] *Florodora*, a show with music written by Lancashire-born Leslie Stuart, most famous for 'Lily of Laguna' and a host of other music-hall songs, opened in London in 1899 and then successfully transferred to New York in 1900. The show was still being revived in the United States as late as 1931.[3] Stuart worked closely with white American 'coon' singer Eugene Stratton both in Britain and America, before a quarrel ended their partnership. In his account of his family's involvement in the history of the British music hall, Peter Honri describes his grandfather's appearances at the American vaudeville impresario Tony Pastor's theatres, as well as appearances on the Keith and Orpheum circuits.[4] One of the earliest and most significant American influences on British popular culture was the development of 'nigger' or blackface

minstrelsy, involving white artists offering impersonations of stereotypical Afro-Americans. Though minstrelsy became most popular in British music hall in the last twenty-five years of the nineteenth century, it had immediate appeal following its introduction in London in 1836. Designed as commercial entertainment, the success of minstrelsy owed much to what Pickering describes as 'the aesthetic values [of] the broad mass of the population'[5] and the complex class-based interpretations made of various blackface acts.

Just as popular culture crossed the Atlantic on a regular basis, so British popular singers and music-hall artists worked across a range of live and recorded media. *Florodora* was the first show to be recorded, in 1900, by its original cast. Music-hall artists like Dan Leno and Billy Williams, 'the man in the velvet suit', made early cylinder recordings. Williams, who died in 1915, made over 120 recordings on twenty different labels including Pathe, John Bull, Homochord, National and Colisseum.[6] George Formby Senior, who had a long career in the music hall, recorded on Sterling and Edison cylinders, and Perci Honri recorded at the Berliner Studios as early as October 1898, and for Edison Bell Studios in Peckham in 1904.[7] Honri was also involved in the early British film industry. At Frank MacNaghten's Palace Theatre in Blackburn in 1901, he saw some early film work by local filmmakers Mitchell and Kenyon and asked them to film his 'Mr Moon' act. He also used Charles Urban's early film *Quick Change Dressing Room* to cover an awkward scene change in his live onstage act. In 1909, he commissioned two film-makers, Foulsham and Banfield, to shoot a film of his act at the Euston Music Hall, intending to use it as a 'trailer' for the act, an interesting early example of an artist working in an existing cultural form seeing the potential promotional value of the moving image.[8] As we shall see, the value of music video in the mid-1970s was initially seen as residing in its potential as a promotional tool to boost record sales, rather than as a form in its own right.

Early British cinema, music hall and class

It is well known that prior to 1905, and even as late as 1914 and the start of World War One, the European film industry was as

vibrant and commercially successful as the early American indus-
try. As Musser indicates, Edison, Bioscope, Vitagraph and other
American companies faced severe competition in both equipment
and films from British and European companies as late as 1908.[9]
It has been argued that during the ten years from 1894, British
cinematographic equipment, particularly that developed by R. W.
Paul, was the most sophisticated in the world, not least because of
its portability.[10] However, British films were less successful in
America, partly because of Edison's efforts to stifle all European
competition, and partly because important and significant British
film-makers such as R. W. Paul, Birt Acres, G. Albert Smith, James
Williamson and Cecil Hepworth lacked the business acumen and
infrastructure to exploit their films successfully. However, film did
make an instant impact on British music hall, not least because
the music-hall theatres were the obvious site for exhibiting films.
As Medhurst records:

> The development of the music-hall institution ... demonstrates the
> growth of the first entertainment *industry*. The music-hall marks the
> first instance of the transformation of hitherto unregulated patterns of
> recreation into the profitable commodity of leisure.[11]

This is a view supported by Russell, who argues that music hall
represented the most organized aspect of the Victorian music
industry, being 'a prefiguration of the mass entertainment busi-
ness of the twentieth century'.[12] It is interesting to compare the
sophisticated commercial organization of the early-twentieth
century music hall with the business naïvety of many of the early
film-makers and exhibitors. R. W. Paul, having been asked by the
impresario Sir Augustus Hall to exhibit at the Olympia in March
1896, later commented, 'though I knew nothing of the entertain-
ment business I agreed to install the machine ... and was
surprised to find my small selection of films received with great
enthusiasm by the public who paid sixpence to see them'.[13]

As institutionalized sites of commodity leisure, the music halls
were, after all, where the audiences already were, though it is
important to stress that these audiences, certainly by the 1890s,
included the lower middle class as well as the better-off working
class. Russell points out that, certainly by the 1890s, there is
evidence to suggest that significant sections of the respectable
middle classes were attending music halls, and that much of the

music hall's earlier reputation for the bawdy had been eradicated, reflecting the fact that the industry was concerned to maximize profit by offering ever more grandiose features and comforts which appealed to those with money. Only in London, he argues, were halls able to cater for a stratified, differentiated audience. By 1910, the *Times* produced an article praising the refined morals and improved standards of music hall. All this reminds us, of course, of the lack of respectability with which music halls were regarded for so long, and which carried a cultural resonance into the twentieth century and British cinema.[14]

This emphasis on music hall as business has important implications for understanding more contemporary examples of commodified leisure, especially where attempts to read their significance ignore the extent to which structure and process inform the development of subcultures within a capitalist society. Summarizing the evolution of music hall in Britain, Bailey concludes that,

> The convergence of profit, morality and good order is assisted by an interventionist state via the localised input of the licensing system. In this schema music hall not only manufactures entertainment but a particular ideology which further assimilates its public to capitalism. Music hall fulfils a crucial role ... by enfolding ... workers in a 'culture of consolation' which, while far from soporific, is none the less socially conservative, aggressively patriotic and politically disabling. This is, then, hardly a success story for popular culture; it is culture for the people not of the people.[15]

Under the management of Felicien Trewey, a programme of Lumiere films was shown at the Empire Theatre, Leicester Square from March to July 1896, making the Empire the first music hall to show films. As John Barnes writes:

> it was these performances at the Empire which were largely responsible for establishing the early cinema as part of the regular repertoire of almost every major music-hall in the country. Contrary to popular belief, it was not until the following year [1897] that the 'animated pictures' began to infiltrate into the fairground and the village hall, and later still before they were being shown in converted shop premises which can be considered as the direct precursors of the cinema theatre. The latter began to appear only from 1907 onwards. The home of the cinema during 1896 was the music-hall.[16]

In a playbill for the Swansea Empire Palace of Varieties for 23 November 1896, R. W. Paul's 'animated photographs' share the bill with Spry and Austin in their 'Romantic Burlesques', the Clayton Twins with Wood and Willis in a 'comedy sketch', Clarke Glenny in the 'Laughable Haunted House', Haig and Haig the 'Comic Acrobats', with Arthur St George the 'Patriotic Vocalist', and with the 'celebrated Sisters Preston', 'the Premier Duettists and Dancers from the Gaiety Theatre London'.[17]

Of course, the early films exhibited at music halls and variety theatres were essentially actuality footage but, just as music-hall artists made sound recordings, so it was inevitable that their acts were recorded on film, as early film-makers discovered the potential in fiction and entertainment. Some early British films showed clear evidence of the comedic traditions which had been established in the music hall. Bamforth Films' *Winky* series, starring the comedian Reggie Switz, ran to thirty-nine pictures including *Winky Learns a Lesson in Honesty*, *Winky and the Gorgonzola Cheese*, and *Winky and the Leopard*. Slapstick clown Fred Evans was equally popular in the *Pimple* series, which ran to some 180 films between 1912 and 1922. Cecil Hepworth's comedy series *Tilly* made stars out of Alma Taylor and Chrissie White. However, it is significant that a number of directors and companies looked to literature for inspiration and, it is reasonable to assume, respectability. Examples include the Urban Trading Company's *A Canine Sherlock Holmes* (1912), the London Film Company's production of Trilby starring Sir Herbert Tree (1914), and their production of *The Prisoner of Zenda* (1915).[18]

In retrospect, the potential for crossover between established popular cultural forms such as the music hall and the newly emerging British cinema never fully materialized in silent British films. It is perhaps significant that Charlie Chaplin, who toured the music halls with Casey's Court in 1906 and then joined Fred Karno's London Comedians in 1907, first left for America in 1910 and built his subsequent film career there, having been made painfully aware of the depths of 'snobbish prejudice' in English society.[19] Arguably, the connection between music hall and cinema only became of any significance in the 1930s with the emergence of stars such as Will Hay, George Formby, Gracie Fields and, in the early 1940s, Arthur Askey and the lesser-known Frank Randle.

The reasons for this are many. Although there had been some early experiments with sound film as early as 1900, and a spate of them between 1906 and 1910 provided by Gaumont's Chronophone and Walturdaw's Cinematophone, the introduction of synchronized sound cinema technology was not successfully sustained until 1929, when the adoption of American technology enabled comic dialogue, music and singing to be properly articulated. Equally importantly, the relationship between existing popular entertainment forms and early British cinema was hampered by social attitudes emanating from the British class system, one manifestation of which was the very real disdain shown by theatre actors for the cinema. Cultural antipathy towards popular, mass entertainment carried over from the Victorian era into the twentieth century. As Chanan argues, 'film made its appearance in an entertainment world whose values were structured in several respects – behind the scenes and in front of them – according to a strong sense of social class'.[20]

Add to this the chronic lack of investment which characterized British film production from its beginnings and which militated against the formation of a major British production company comparable with Pathe or Gaumont, and it is little surprise that, by 1916, the promise of the early British film industry had largely evaporated. Ironically, by that time there had been a significant growth in the number of purpose-built cinemas in Britain. The *Kinematograph Year Book* survey of 1914 showed that there were 925 cinemas in the large towns and a further 242 cinemas in smaller county towns of Britain.[21] Increasingly, the films seen by British cinemagoers at this time were American. The Moyne Report of 1936, gathering evidence about the effectiveness of the 1927 Cinematographic Films Act which had restricted blind booking of American films and introduced a quota for British production, estimated that by 1914 only some 25 per cent of films shown in British cinemas were of British make. The American share of the British market, estimated to be 30 per cent in 1909, had increased to 60 per cent by 1914 and 95 per cent by 1926.[22] It was against this background that British cinema struggled to define itself and compete against American competition in the 1930s and beyond.

The BBC and popular music in Britain in the 1920s and 1930s

Though the institutional structure on which it was based differed radically from that of British cinema, the same social attitudes to popular entertainment were at work with the development of radio broadcasting in Britain in the early 1920s. Under its first Director General, John Reith, the BBC attempted to reconcile its sense of public service with the need to entertain, all within a culture which, as Frith argues, was 'first of all, a response to the fear of Americanization'.[23] Critical of mass popular culture and its supposed effects on people, Reith believed that radio had a duty to develop discriminating 'active' listeners through 'serious' programming. At the same time, he recognized the need for the BBC to entertain. The result, according to Frith, was the development of specific concept of 'light entertainment' which has been described as 'middle-brow', and involved a rejection of popular entertainment of the kind enjoyed by working-class people. This can be seen clearly in the BBC's attitude to popular music in the 1920s.

Whilst Reith's preference was for classical music, it was clear that the BBC needed to broadcast music, particularly dance-band music, which was currently popular. Thus, whilst a performance of Mozart's *The Magic Flute* had been broadcast live from the Royal Opera House Covent Garden in January 1923, Marius B. Winter's dance band was broadcast from the attic studios at Marconi House in London less than two months later, on 23 March 1923.[24] In April 1923, the first live broadcast of dance music from the Savoy Hotel was heard, featuring the American saxophonist Bert Ralton. When Ralton left at the end of the year, the band, now called the Savoy Orpheans Band and led by Debroy Somers (and from 1927 by Carroll Gibbons), began regular weekly live broadcasts. Others followed, including Henry Hall, who first broadcast live from the Gleneagles Hotel in 1924, and Jack Payne, who from 1928 led the BBC's own dance band.[25] *The BBC Year Book 1932* noted that, 'As a result of [the BBC Dance Band's] popularity with listeners, the band has built up a wider reputation with its gramophone records and in its periodical appearances on the music-hall stage'.[26] In 1932, of the 650 hours given over to broadcasting dance-band music, 50 per cent

of the tunes played were British, 40 per cent were American, with 10 per cent being described as 'continental'.[27]

In addition to betraying the BBC's concern not to be accused of being commercial by 'plugging' songs, the Year Book clearly articulates the parameters of what it regarded as acceptable popular music:

> The present style of dance playing is what in the USA, home of dance music, they term 'sweet' that is to say, it is quiet, melodious and subtly orchestrated, as opposed to the 'hot' style which held sway until recently, and which, in the strident eccentricity of its tone and rhythm, marked a step back to the native 'jazz' of the jungle. [Most of the bands] play in this style, which is suited to the sophisticated dance-audience in a small and fashionable London restaurant, while Bertini's Band affects a broader, simpler and noisier style, for it is playing in one of the world's largest ballrooms, to an audience of dancers that may number a thousand or more.[28]

As Frith points out, not only did this policy of broadcasting dance music from smart hotels or exclusive clubs offer listeners a vicarious experience of high living, it also served during the late 1920s and through the 1930s to define the difference between 'respectable' and disreputable' entertainment.[29] It was also, it should be noted, largely a metropolitan experience; with notable exceptions such as Henry Hall from the Midland Hotel in Manchester and Bertini's Dance Band from the Winter Gardens in Blackpool, the overwhelming majority of broadcasts were from London.

This separation, which reflected the power of class attitudes in Britain as well as the relation of London to the regions, was reinforced by the BBC's attitude towards popular live variety theatre. Though there were some early occasional broadcasts of variety, it was not a regular feature until the formation of the variety and vaudeville section of the BBC in 1930. This was partly because of the BBC's suspicion of what it termed 'the broader type of performance', of artists such as Will Hay, Wee Georgie Wood and Elsie and Doris Waters, and partly because of suspicion by performers, managers and impresarios about the role of the BBC and its potential detrimental effects on business. It was not until 1925 that the Society of West End Theatre Managers signed an agreement with the BBC which allowed more regular extracts from

shows to be broadcast. By 1931, the BBC was broadcasting just over 150 variety programmes a year, including series such as *Songs From the Shows*, *Music Hall* and *The White Coons' Concert Party*.[30] Significantly, the accommodation reached between live variety and the BBC did not extend to popular musical comedies on stage, which were jealously protected under copyright. As a result, the BBC began to commission and produce musical comedies of its own, including *Good Night, Vienna*, which was based on a radio play and had songs by George Posford and Eric Maschwitz, in 1932. The film rights were bought by Herbert Wilcox for his British and Dominion Film Corporation, and who produced the film starring Jack Buchanan and Anna Neagle for a budget of £23,000. One of the first British musical talkies, it ran for thirteen weeks at the Capitol Theatre in the Haymarket and proved commercially very successful. In Wilcox's view, the success of *Good Night, Vienna* and the other talkies that he produced, including the Aldwych farce *Rookery Nook*, provided a stimulus to British film production in 1932: 'I can say without fear of contradiction that these films, with cinemas installing sound as fast as they could get the equipment, truly represented the box office renaissance of British films.'[31]

If the BBC had an indirect role in stimulating British film production in the early 1930s, it also altered the relationship between popular music and its audiences. In effect, the experience of popular music became a much more highly mediated one, as the importance of listening to music on radio and on record outgrew the live experience of 'being there'. Consequently, the importance of the song publisher gave way to a system where radio and record company-based star performances were increasingly paramount. This shift towards an acceptance of the star performer, whether on radio, record or on film, was much in evidence as the 1930s unfolded, and was a crucial factor in the resurgence of popular British cinema in that decade.

British cinema and American dominance in the 1920s and 1930s

Though the British cinema of the 1920s had produced some interesting and critically acclaimed films such as *At the Villa Rose*

directed by Maurice Elvey in 1920, and *Reveille* directed by
George Pearson in 1924, the lack of a developed production and
distribution infrastructure meant that British films found it hard
to resist American competition even in the home market. This
American domination extended to exhibition, where the conflict
between the Kinematograph Renters' Society (KRS), which was
influenced by the American majors such as Paramount, and the
Cinematograph Exhibitors' Association (CEA) which represented
nearly four thousand members, many of them small independent
exhibitors, invariably favoured the big circuits when it came to
booking films. Even the influential British circuits which were
created in the late 1920s, Associated British Cinemas (ABC),
Gaumont-British (G-B) and, in the 1930s, Oscar Deutsch's
Odeon, in the main adopted booking practices which favoured
American films.[32]

Of course, there were very few British films being made and
therefore available for exhibition. As we have seen, in 1926 only
5 per cent of films shown in British cinemas were British made.
After some attempts to request a voluntary end to the practice of
block-booking, the Cinematographic Films Act was passed in
1927, which placed restrictions on blind and block booking, and
introduced a staged quota for British-produced films, intended to
rise to 20 per cent of films exhibited by 1935. Opinions about the
effects of the Act have differed. On the one hand, it did provide a
stimulus for production. In 1926 only twenty-six films had been
produced in British studios; a year later this had risen to 128,
more than was actually required under the Act. In the opinion of
George Perry:

> The Act was immensely successful ... Suddenly there, was money
> available for the cinema and new companies appeared ... What is
> more, there developed a tendency towards vertical integration,
> whereby the same company would produce, distribute and exhibit
> films thereby guaranteeing a showing for its own product.[33]

Sarah Street, echoing the findings of the 1952 Political and
Economic Planning Report, argues that the years 1927–30 were
of crucial importance to the British film industry, because of state
protection, the coming of sound and the formation of vertically
integrated British companies.[34] However, whilst it is impossible to
question the growth in the number of films produced and the

stimulus for improved business organization which the Act provided, the figures do disguise some complications. In the first place, some American firms developed a production strategy which technically supplied them with British quota films by opening production units in Britain, for example Warner Brothers First National at Teddington, and Fox-British at Wembley. In the view of many, the Quota Act did not end 'the predominance of the major American producers in the English market'.[35] The figures also ignore questions of quality. Whilst film renters did buy up some better quality British productions, there were too few British films to rent. In addition, renters often met their quota obligations by buying films which had been made cheaply and quickly, often with little intention of actually exhibiting them.[36] Interestingly, many producers turned to the music hall, making quick, low-budget films with minor music-hall stars such as the comic Ernie Lotinga who appeared in the 1932 British International Pictures (BIP) Elstree Studio production *Josser in the Army*.[37] This stimulus to reconnect cinema with live music hall was important however, and led to some longer-term consequences, in that it stimulated the production of a number of films which featured better-known music-hall stars with broad popular appeal. This process was in part driven by important variations in regional audiences and they films they preferred to see.

The situation was made more complicated because of the conversion to synchronized sound film which began in Britain in 1929. By the end of that year, 685 cinemas in the UK had been wired for sound, 2,523 by 1930 and 3,537 by the end of 1931. For British exhibitors, decisions about whether to opt for sound-on-disc or sound-on-film were further complicated by the wide choice of systems available, including the British Edibell and British Acoustic systems. Here again, however, American dominance was in evidence. Both RCA and Western Electric were initially more expensive than local systems, but agreement with American producers to inhibit rentals to exhibitors who did not have 'approved' systems tipped the balance in favour of the American companies. It was rumoured that as many as eighty-one American electrical engineers were working installing equipment in British cinemas in 1929.[38] Of the 215 sound films shown in 1929, twenty-three were British. Although Hitchcock's *Blackmail* (1929) is credited as being the first British talking picture, it was

the pioneer director George Pearson who had the first trade showing in March 1929 of a talking picture, *Auld Lang Syne*, featuring the singing of Sir Harry Lauder.[39]

Although the problems of 'quota quickies' was recognized in the Moyne Report and the subsequent Cinematograph Films Act of 1938, which replaced the 1927 Act, there is a strong argument for seeing the 1930s as a decade in which British cinema experienced a resurgence. The distinction between quality and quota was largely reflected in the production companies which were operating. BIP, Gaumont-British with Gainsborough, and British and Dominion (B&D), had been established in the silent period and, together with Ealing Studios and London Film Productions, were mainly responsible for what were seen as the quality British films. A host of smaller production companies such as Savana Films, Ensign Productions, Sound City, Cinema House and Basil Dean's Associated Talking Pictures (ATP) produced an enormous number of quota quickies up until 1937. Many of these, such as ATP's *The Bailiffs* (1932), based on a sketch by Fred Karno and starring Flanagan and Allen, made use of existing music-hall talent. Karno had his own production company, based in Hammersmith, and made *Don't Rush Me* (1936), again based on one of his own sketches and starring Robb Wilton. However, it was not only the smaller companies who made use of singers and performers already working in music hall. Stanley Lupino and Lupino Lane, who both belonged to a family with a long pedigree in music hall, made a series of musical comedies from *The Yellow Mask* (1930) to *Over She Goes* (1937). Writing of BIP's considerable output in the early 1930s, Low comments:

> As well as heavy drama in the German manner, there were music-hall comics, West End musicals, operettas, modern stage plays and some early films by Hitchcock. Will Kellino's 'typically British' comedy Alf's Carpet … began a stream of comedies featuring music-hall stars and aimed at lower-class audiences, which became a BIP staple.[40]

Despite the growing dominance of American dance bands and of American singing stars such as Bing Crosby in the British record industry, British dance bands such as those led by Ambrose, Roy Fox, Jack Harris and Maurice Winnick and British singers such as Al Bowlly were popular with dancegoers, record buyers and radio audiences. However, whereas American 'crooners' such as

Crosby, Rudee Vallee and 'Whispering' Jack Smith were known to British audiences as star performers, singers with British dance bands were, on the whole, expected to be much more anonymous, their voices being 'treated simply as one of the instruments in the band that had, like the others, its opportunity to do a solo'.[41] This conscious policy of the BBC of keeping British dance band singers relatively anonymous, based largely on the view that crooning was 'vulgar and common – in a word, American',[42] meant that British singers featured less prominently in early British sound films than they might have. As a result, and because of the proven popularity of live music-hall entertainment with audiences, it is perhaps not surprising that the resurgence in British sound film production in the 1930s should draw on the one area of important indigenous popular music, the music hall and its performers, and to a lesser extent variety and the West End.

Though, as Russell points out, the music performed in music halls was enormously varied, even encompassing a 'serious' repertoire such Rossini and Verdi, popular song as performed in the music halls had some basic salient features. These include a relatively simple melodic range which enabled lyrics to be grasped quickly so that the audience could join in when requested to, a verse/chorus rather than strophic structure, the common use of basic 3/4 time, together with the adoption of a persona by the performer which could be recognized by audiences as his or her 'trademark'. Though songs often referred to political or patriotic themes, many of them were characterized by a sense of engagement with the everyday, often given an ironic or comic inflection:

> music-hall songs deal far more directly with the conditions of daily existence than any form of English popular music apart from the industrial folk-song. They abound with allusions to current events and fashions and to real places.[43]

Though they shared elements of pathos and sentimentality with the more socially and geographically indeterminate Tin Pan Alley songs coming from America, music-hall songs and their performers were clearly rooted in specific British national and often regional identities, which was both a strength and, in the face of the growing saturation of American product, a weakness. However, it is significant that, from a commercial viewpoint, many

of the successful British films in the musical comedy genre in the
1930s starred performers whose identity with specific regions was
endorsed and accepted by British cinema audiences.

British cinema, music hall and sound technology: *Elstree Calling*

One of the very first sound films of the 1930s to exploit music-hall
and variety was BIP's *Elstree Calling* (1930), directed by Adrian
Brunel with sketches directed by Alfred Hitchcock. The bias
against popular cultural material which appealed to other than
intellectuals and the 'middle brow' is evident in contemporary and
subsequent critical opinions of the film. James Agate, reviewing
the film in the *Tatler* on 5 March 1930, called it 'unmitigated
footle, which would have bored an infants' school'.[44] Despite
Hitchcock's involvement, the extent of which remains in dispute,
Hitchcock commentators have called the film 'a truly dreadful
compendium of terrible stage variety acts'[45] and 'a mixed
pudding'.[46] Although as cinematic experience the film leaves
much to be desired, it remains an intriguing piece of early British
sound cinema. Within its revue structure, the film offers an array
of British variety, music-hall and radio talent, including Tommy
Handley, Will Fyffe, Jack Hulbert, Cecily Courtneidge, Donald
Calthorp, Gordon Harker, Anna May Wong and the Three Eddies.
Linked together by the comedy of Tommy Handley, who acts as
an increasingly disenchanted and misogynistic announcer, and by
a running comedy sketch in which Gordan Harker attempts to
perfect the reception on a prototypical television set, the film
showcases a rich and contrasting mixture of contemporary
popular entertainment, as well as an implicit critique of important
distinctions within that entertainment.

Some of the numbers emanate from a music-hall tradition
which reveals little accommodation with newer forms of
entertainment such as radio and film. The Three Eddies, 'the
black-faced trio from Blackburn' go through two dance routines,
including 'Dance Around in Your Bones', which have clear affini-
ties with a minstrelsy tradition which was to last into the 1960s
with the BBC's *The Black and White Minstrel Show*, first televised
in 1958 and winner of the Golden Rose award at Montreux in

1961. Lily Morris presents two numbers, 'Why am I Always a Bridesmaid' and 'Only a Working Man', which purport to be unmediated music hall, and the Scottish stand-up comedian Will Fyffe tells some unsavoury and anti-semitic jokes before launching into the music-hall song 'Twelve and a Tanner a Bottle', reinforcing stereotypes about drunken Scotsmen. These acts, like Jack Hulbert's comedy sketch about modern salesmanship, the Balalaika Chorus Orchestra, and Donald Calthorp's frequent attempts to interpolate Shakespeare into the show, are all shot in black and white.

Within the discourse of entertainment which the film constructs, it is significant that the numbers which come from the more respectable upmarket variety and West End shows are shot in colour, in contrast to the black and white music-hall sequences. In effect, a hierarchy of popular entertainment is established, one which differentiates, for example, Helen Burrell and 'the chorus ladies from the Adelphi Theatre review *The House That Jack Built* 'singing 'My Heart is Saying', from the more raucous and 'broader' entertainment provided by Will Fyffe. As with the number 'The Thought Never Entered My Head', featuring Helen Burrell and Jack Hulbert and again shot in colour, this is meant to be entertainment which can stand comparison and compete with the sophisticated American product, whilst preserving British decorum and taste. Both songs ape the romantic melodic structure of Tin Pan Alley and reinforce, through their lyrics, dominant heterosexual ideology. Unfortunately, these numbers, like those performed by the Charlot Girls and the more quirky and interesting 'I'm Falling in Love' performed by Cecily Courtneidge, fail to match their aspirations, not least because of some rather stodgy choreography and a general lack of 'pace'. Yet it is quite clear that these numbers are intended to occupy a privileged position within the film, not least because they are subjected to little, or certainly less, comic invective from Tommy Handley's introductions. This hierarchical positioning and differentiation of popular music and entertainment seems entirely consistent with those strategies which, as we saw earlier, were prevalent within the BBC at this period and articulate class-based attitudes towards the popular which were a determinant in British cultural production throughout the 1930s and beyond.

It is interesting that this discursive interpellation is reinforced

by the comic sequences in the film which revolve around Donald
Calthorp's attempts to 'do Shakespeare'. Mostly, these attempts
are thwarted by the closing of stage curtains or other interrup-
tions, but he does manage to occupy centre-stage on two
occasions 'in spite of the management', once whilst performing a
stage magician's act which has distinct overtones of early music
hall, and again in a scene purporting to be from *The Taming of the
Shrew*, though involving a comic motorcycle routine and a
slapstick, pie-throwing Anna May Wong. The surreal qualities of
the scene, its descent into comic routine, together with Tommy
Handley's bored introduction to the prospect of Shakespeare, not
only reinforce middle-brow suspicion of high culture, but serve to
valorize the 'sophisticated' variety entertainment coded through
the colour sequences. In fact, Calthorp is involved in one scene
which brilliantly realizes the comic potential of sound, lights and
camera as he apparently plays an organ under subdued lighting.
As the camera dollies across and the lights come up, he is actually
revealed to be seated in front of a piece of sound-stage equipment
labelled 'Danger Live Switches', pulling on his boots, the organ
music coming from elsewhere.

If the film is of interest because of the way in which it structures
a hierarchy of popular culture, coded through musical numbers
and formalist conventions, it is also significant in its concern to
foreground the technologies of entertainment. It does so in a way
which leaves in no doubt that we are watching and engaged with
the *business* of entertainment. The opening shot following the titles
is of two linked transmitter masts, with a soundtrack of crackling
airwave signals. The voice of Tommy Handley announces that this
is 'Elstree calling' and, as we cut to a shot of him in a studio with
its large box radio microphone and sound engineer's booth, we
are asked to think of broadcasting, 'if you can bear it'. Following
a pun on the words 'ether' and 'either', Handley continues:

> think of the cinema; pretty ladies, beautiful girls from ... um ... Holly-
> wood and ... er ... Shoreditch and ... Ashby-de-la-Zouch, all step right
> up to your door by this marvellous invention of television ... Now you
> in your theatre are privileged to hear and see for the first time an all-
> star vaudeville and revue entertainment televised from our studio at
> Elstree. Now hold tight to your cat's whiskers, I'm just about to switch
> you on to the largest movio studio in Eurovo.

The film then cuts to a rather unsteady external pan of the
BIP Elstree studio, followed by internal shots of the busy studio
at work, with film equipment and technicians clearly being
privileged. The *work* involved in film production and the repre-
sentation of the factory-like processes of production are carefully
inscribed into the film's visual and aural regime from the very
beginning. This is important in a film which privileges spectacle
and attraction at the total expense of narrative system; arguably,
the only pretence towards any narrative causation is precisely this
sense of the work involved in putting on the show.

This conflation of the technically disparate but increasingly
economically and culturally integrated technologies of entertain-
ment – music hall, revue, radio, cinema and television – all
designed to bring audiences in 'theatres' the best in vaudeville and
revue, is reinforced by the sketches with Gordon Harker which
show him struggling to tune in to the variety acts on a prototype
'television', some six years before the BBC began experimental
television broadcasts using the Laird and Marconi-EMI systems
on alternate weeks. Of course, the problems encountered by this
'television' are in sharp contrast with the efficiency of talking
pictures, which are themselves parodied by radio-star Handley,
when he introduces 'our latest hyper-super all-stereoscopic,
all-singing, all-dancing, all-talking and all-sneezing, all-thrilling
thriller'. There is a hesitation in all this, a recognition that
entertainment remains on the cusp of existent and emergent
technologies, but also a reassurance that, whatever the technology,
there is something seamless and enduring about the very nature
and business of entertainment, and of those dedicated to produc-
ing it. Although the film's formal devices construct a hierarchy of
entertainment, the text also elides distinction; whilst it acknowl-
edges both urban metropolitan sophistication and regional inflec-
tion, it combines the two in an ideological pot-pourri of
'entertainment'; whilst it acknowledges tensions between the
technologies of entertainment, based on genuine commercial
antipathies which operated between different sections within
showbusiness but which were never publicly acknowledged, it also
implies a cosy convergence and conflation between them.

The distinctions between different elements of popular culture
and popular music which are encoded within *Elstree Calling*
became increasingly significant during the 1930s and are evident

within British cinema, especially musicals and musical comedies, genres which were of real importance during this period. In particular, the strategic differences between those who attempted to produce films which appealed both to a national and overseas, largely American, market, and those who produced films designed to appeal solely to British and often specifically regional audiences, became both more pertinent and apparent.

British musical comedy in the 1930s: Jesse Matthews

In his rigorous and illuminating comparison between *Evergreen* (G-B 1934) starring Jesse Matthews, and *Sing As We Go* (ATP 1934) starring Gracie Fields, Andrew Higson contextualizes the films within the wider contemporary debate concerning British cinema, its relation to the dominance of American cinema, and appropriate production strategies to deal with that dominance:

> The two films thus involve different economies of scale and cultural aspirations, and are aimed at different, if overlapping, markets. They also relate very differently to the dominant formal paradigm of classical Hollywood cinema, and draw on relatively distinct, class-specific, and to some extent indigenous popular cultural traditions in their respective form and shape, their brands of comedy and song, and their modes of performance and address; in other words, they appeal to their audiences in often markedly different ways.[47]

The distinctions in cultural tradition and orientation which co-exist in *Elstree Calling* are here distilled and separated out. A product of the G-B policy of making films which had an 'international outlook', *Evergreen* was designed to have an impact on the American market, which it did. Higson cites an unsubstantiated claim that *Evergreen* was the largest-grossing British film in the States after Korda's *The Private Life of Henry VIII* a year earlier.[48] This success was the result of the deliberate decision to position the film within audience expectations conditioned by exposure to American film: '*Evergreen* takes on board the iconographic, thematic, discursive, and structural conventions of contemporary Warner Bros. backstage musicals.'[49]

This positioning also, of course, included the music and lyrics of Rodgers and Hart. If the film benefited from G-B's production strategy which launched its successful, though short-lived, assault

on the American market, it also drew upon a specific tradition of British, London-based, West End variety which, as we have seen in *Elstree Calling*, was itself was strongly influenced by American popular theatre and popular music. Jesse Matthews was herself a product of that entertainment tradition. She made her first professional stage appearance at the age of ten in *The Music Box Revue*, and appeared in the chorus of numerous other London revues. As a member of one of British impresario Andre Charlot's 'girls', she appeared on Broadway in 1924, and later starred in Charlot's 'international edition' of *Earl Carroll's Vanities* (1927) and *Wake Up and Dream!* (1930).[50] Her first record was released on the Columbia label in October 1926 and featured songs from *The Charlot Show of 1926* at the Prince of Wales Theatre in London. This was the first musical play record ever made at a British theatre during a performance. In 1930 she starred in the C. B. Cochran London production of Richard Rodgers and Lorenz Hart's show *Ever Green*. Following appearances in a number of British films including *Out of the Blue* (BIP 1931), *There Goes the Bride* (G-B 1932), *The Man From Toronto* (Gainsborough 1933) and *The Good Companions* (G-B 1933), before making the film version of Rodgers and Hart's *Evergreen*, with additional numbers, including 'Over My Shoulder', written by another American, Harry Woods.

The concern about the 'Americanization' of popular culture which influenced debates within both BBC radio and the British film industry extended to popular music. Matthews herself was criticized for being influenced by transatlantic trends, but defended herself:

> My films had more of a gloss than most English films of that time, because they were international ... I had a lot of American composers for my songs and the English writers picked on me for preferring them. I'd said 'I simply choose the best songs'.[51]

Though the stage show had given British bandleader Jack Hylton a big American record hit with 'Dancing On the Ceiling' earlier in 1932, Matthews' implied preference for American popular music echoed contemporary debates concerning British film. Michael Balcon's comment about British cinema – 'There is no British style. Or if there is, it is a bad one'[52] – must have seen to some to be equally applicable to British popular music. Certainly, the

success of Matthews' next two musicals, *First a Girl* (G-B 1935) and *It's Love Again* (G-B 1936), both directed by Victor Saville, appeared to confirm the wisdom of incorporating both the conventions of classical Hollywood and of Tin Pan Alley within British production strategies. So successful did this approach appear to be that both films were given their premiere in America before they were shown in Britain.[53]

Certainly, these musicals do stand favourable comparison with those being produced in Hollywood. Like many of them, they are essentially backstage musicals, though here the backstage is distinctly British. *Evergreen* is set firmly within the milieu of early twentieth-century music hall and its continuing traditions, though the modernism which characterizes the contemporary scenes is clearly meant to be admired. *First a Girl* is, with its gender-crossing and intimations of homoerotic desire, in many ways a more deeply interesting film, sufficiently so for the film to be banned in Maryland. Based on a German play by Reinhold Schunzel and made into the film *Viktor und Viktoria*, and with songs written by Sigler, Goodhart and Hoffman, the film offers a narrative exposition of precisely those tensions between different class and cultural traditions seen in *Elstree Calling*.

Unable to return to her job at an expensive fashion house, Elizabeth (Jesse Matthews) agrees to work with Victor (Sonnie Hale) who, as an actor with aspirations to play Shakespeare, 'fills in' as a female impersonator in the music halls. At Crufts Music Hall, Elizabeth substitutes for Victor as a female impersonator, though not without problems as she tries to change in the 'gentlemen's changing room'. In a beautifully realized sequence which points to the role of sound in the construction of cinematic space, we are treated to a music-hall bill that includes a goose tamer (played by 'Monsewer' Eddie Gray), and Atlas the strong man. As we see Elizabeth attempt to change into her costume, the soundtrack carries tap dancing, followed by 'Tripe', a characteristic verse/chorus music-hall song praising the qualities of that firmly class-specific food, all accompanied by noises from a very raucous audience.

All this is in contrast with the melodic, sentimental and rhythmically sweet number that 'Victor' begins to sing, 'It's Written All Over Your Face'. At first, the orchestration is tidy and controlled. However, though we are shown enough of Matthews singing

to establish her talent, the number soon descends to comic slap-stick, complete with a faster-tempo, cruder orchestration, much to the delight of the audience and promoter McLintock who, recognizing that 'many a good pearl has been cast before these ... audiences', immediately hires the act. When Victor worries about the unintended slapstick of the act, McLintock replies that 'low comedy is alright for these sort of audiences, but the audiences you're going to play are more refined. How do you fancy Paris, Berlin, Rome, Vienna ... ?'

In rejecting what are inscribed as the comic and musical limitations of British music hall, and opting for the more cosmopolitan cabaret scene across Europe, the film's narrative offers a curious echo of the production strategy of G-B itself. What follows are a series of numbers, including 'Half and Half', 'I Can Do Everything But Nothing With You', 'Close Your Eyes' and 'Everything in Rhythm (With My Heart)', which are accom-panied by staging, chorus work, choreography and orchestrations of the highest order, and which clearly adopt the dominant paradigm of the Hollywood musical, including dominant musical conventions. Above all, the film integrates the spectacle of the numbers with the narrative, rejecting the episodic series of turns which characterize the earlier music-hall sequence, and indeed, *Elstree Calling*. However, though most of what Higson says about *Evergreen* also applies to *First a Girl*, including 'the ever-present problem of forming the right couples',[54] it is perhaps significant that at the end of the film we revert to the traditions of comic routine, as the real Victor parodies Elizabeth's earlier elaborate number performed in the setting of a giant birdcage. Whilst this clearly has a plot function, enabling the 'right' couples to be with each other and heterosexuality to triumph, it acknowledges a specifically British comic cultural tradition which had been important in British cinema throughout the 1930s in musicals that were radically different from *Evergreen* and *First a Girl*.

The wave of success in the American market proved short-lived, as G-B's strategy of 'internationalism' was stymied by a combination of factors, not least opposition from the vertically integrated American companies who made it difficult to get exten-sive distribution for British films. By 1936, G-B had curtailed their attempts on the American market, and by 1937 British production was in crisis, in what has become for the British film

industry a familiar cycle of success and subsequent retrenchment. What was left were those films which, though deemed 'inexportable' because of their use and promotion of indigenous cultural traditions and icons, had been popular with British audiences throughout the decade. Like *Evergreen* and *First a Girl*, these films bid for popularity through the exploitation of established star images and through the use of accepted generic conventions but, unlike those films, restricted the appeal to the domestic and even, in some cases, regional market. Many of the stars of these films, including Gracie Fields, Tommy Handley, Flanagan and Allen and George Formby, were already firmly established in music hall, records and radio, providing what Tom Ryall has referred to as 'a formidable array of music hall talent which crystallised into a distinctive category of British film production in the 1930s'.[55] Broad comedy of this kind, with and without the music, was an element of British film production which was to continue for decades, most notably with the films of Norman Wisdom and the later *Carry On* series, commercially successful films roundly condemned by British film critics.

George Formby and a cinema of attractions

The two most important British stars during the 1930s were Gracie Fields and George Formby, both signed by Basil Dean at ATP. In his analysis of *Sing As We Go*, Andrew Higson argues that whilst the film shares many of the generic conventions of the musical, its roots are firmly in the tradition of music hall and variety, and that it is Fields' 'performance and charisma which hold the film together, not the principles of narrative continuity'.[56] Drawing upon Tom Gunning's work on early film form and the 'cinema of attractions', Higson argues that:

> *Sing As We Go* is an impressive instance of the emergence of the cinema of attractions within the field of narrative cinema. Indeed, it makes more sense to see *Sing As We Go* not as a narrative film in which music and comic gags feature as interruptions or inserts, but as a film which is organised around its various attractions ... The attractions are the point of the film, not its flaws ... The narrative is merely the excuse for a carnival, a licence for the transgressions of the cinema of attractions.[57]

The foundations of these 'attractions' and of Fields' charisma lay elsewhere than cinema of course, having been built by her career, beginning in 1911, in music hall, records and radio.[58] Moreover, like Formby, her career had a quite specific regional and class resonance, both of which are exploited in the film, not least through the carnivalesque use of the pleasures of Blackpool, and the songs that she sings. In particular, the title song, which serves as an important framing device at the beginning and end of the film, does as much as anything to 'reproduce the participatory community audience of pre-cinematic modes of entertainment' noted by Higson.[59]

Whilst the films of George Formby can be said to be more formulaic than those starring Gracie Fields, they too rely for their pleasures less on their narrative systems than on the highly idiosyncratic 'attractions' of Formby, and particularly his music. Following the death of his father, Formby began a career in the music hall, initially reproducing his father's 'Silly John Willie' act in 1921. Having learnt to play the ukelele, though unable to read music, Formby signed his first recording contract in 1926 and subsequently made over 200 records.[60] In 1932 he signed a contract with Decca Records and, with their ability to promote their products on a large scale, 'Chinese Blues' sold over 100,000 copies and brought him to the attention of Manchester cinema owner and producer John Blakeley. His Blakeley's Production Ltd, later to become Mancunian Films, specialized in filming music-hall stars and their routines. In Formby's first film, *Boots! Boots!* (1934), he plays the John Willie character from his stage act, singing 'Why Don't Women Like Me?'. Shot in fourteen days at a cost of £3,000 and using the British Marconi Visatone sound recording system, the film struggled for distribution, receiving its premiere at Burslem, Stoke-on-Trent, where, as Formby himself experienced first hand, it played to packed audiences.[61] The response from northern audiences encouraged Mancunian to produce a second Formby film, *Off the Dole* (1935), which cost £8,000 and netted £30,000. Though this film was extremely popular with regional audiences, not least because it addressed in its oblique comic manner the experiences of the unemployed during the depression, the critical reaction to it from the London-based film establishment was unsurprisingly hostile, with *Kino Weekly* finding Formby's song 'With My Little Ukelele in My

Hand' gratuitously vulgar.[62] Despite his personal dislike of
Formby, Basil Dean recognized his commercial potential, and
signed him him for a seven-year contract with ATP. Though Dean
brought in writers J. B. Priestley and Walter Greenwood to add
respectability to these popular vehicles, it was the comic personas
of Fields and Formby, together with their songs, that delivered the
pleasures audiences were seeking.

Though many of Formby's songs were written by established
British writers and lyricists such as Noel Gay ('Leaning On a
Lamp-post'), Harry Gifford and Fred Cliffe (I'm Shy') and Roger
MacDougal ('The Emperor of Lancashire', 'Ukelele Man'), it was
his delivery which gave them mass appeal: 'His songs, mild and
mocking, were delivered crisply in a nasal voice and with a broad
Lancashire accent, with an innocent stare as he accompanied
himself with brisk toe-tapping rhythm on his ukelele.'[63] The
suggestiveness of Formby's lyrics, which *Kino Weekly* found so
offensive, are transcended by the ability of the performance to
suggest an imagined community in which the cinema audience is
implicated.

For all their lack of sophistication judged by standards of
classical realism, Formby's films often spoke directly to concerns
which were exercising British audiences. For example, in *Spare a
Copper* (1940), where British warship-building in Birkenhead is
being threatened by saboteurs, Formby manages to create consen-
sus through his singing, whether in the music shop where he
performs 'Ukelele Man' to a group of young children and elder
citizens, or in the police concert where 'On the Beat' serves to
position those on screen and those watching the film to accept the
important role of authority in stopping 'the enemy within'. The
song is reprised at the end of the film when the saboteurs have
been defeated. Whilst the pleasures of narrative resolution are
important, so too are the pleasures of spectacle provided by the
motorcycle trials, Formby performing 'I Wish I Was Back On the
Farm' during amateur hour at the variety theatre, the comic car
chase, and the final 'wall of death' sequence set in the fun fair.
Affirmation of working-class pleasures sit alongside affirmations
about the importance of Merseyside ship-building and reassur-
ances about wartime victory, all allied with the pleasures of
Formby's music and its defiance of 'middle-brow' culture.
Between 1938 and 1943 Formby was the top British male

box-office star, his persona constructed across records, radio, newspaper columns and comics such as *Film Fun*. His decision to leave ATP at Ealing and sign for Columbia in 1941 signalled a slow decline in his popularity.

The influence of music-hall and radio stars on the British film industry continued throughout the years of World War Two. As Andy Medhurst argues:

> clearly variety artists were fulfilling a particular ideological role during the war; offering a sense of community with pre-war times, attempting to defuse threats with humour, and most importantly reaffirming a notion of community ... The music hall offered a sense of community to an urban proletariat involved in repetitive labour ... and it did so primarily through song and later comedy.[64]

The shift from song to comedy that Medhurst identifies is important. Though in the late 1930s artists such as Flanagan and Allen, in their revue *Okay For Sound* (1937), were able to showcase songs with a distinctly British tone, including the jingoistic 'The Fleet's Not in Port Very Long', films of the early 1940s starring radio and variety artists such as Arthur Askey and Tommy Trinder placed more reliance on comedy than on music. By the 1950s Norman Wisdom, the only British film star to rival the earlier popularity of George Formby, was better known for his comedic routines than his singing, even though he enjoyed some pop chart success in the mid-1950s.[65] This shift reflects a number of important factors which operated during the war years of the early and mid-1940s and the period of austerity which followed.

In the first place, it is clear that the BBC had changed its attitude towards light entertainment and comedy as the 1930s progressed. Competition from Radio Luxembourg was an influence in this, no matter how much Reith loathed the 'monstrous stuff' it broadcast. By 1939, the new comedy revue *Band Waggon*, with Arthur Askey and Richard Murdoch, had outstripped the more traditional show *Music Hall* in popularity. Though Askey signed a six-picture deal with G-B, radio now had an unprecedented appeal to the popular audience, an appeal which only grew during the war years. At the outbreak of the war, as Scannell and Cardiff put it, 'Radio had learnt to relax'.[66]

Significantly, *Band Waggon* was based on an American radio show of the same name, even if it did develop distinctively British

inflections. As the war in Europe intensified, genuine material shortages, including a shortage of shellac for records, led to the increased dominance of American trade and culture. With American entry into the war and the influx of American troops based in Britain, this process became even more pronounced, especially in the field of popular music where American bands, singers and records became even more dominant. More importantly, the fact that so much of the British film industry was, in Robert Murphy's phrase, 'fully mobilised for war' led to an aesthetic suffused with nostalgia.[67] Though comedians such as Gert and Daisie and Arthur Lucan could star in films which often dealt humorously with the effects of wartime bureaucracy and deprivation, song was now used for the nostalgic construction of community and nationhood, as when, towards the end of Askey's film *I Thank You* (1941), the ageing music-hall star Lily Morris sings 'Waiting at the Church' in the underground air-raid shelter.

British musicals and popular music: issues of commercial dominance and national identity

This tendency to recreate community through nostalgia is clearly in evidence with films such as *Champagne Charlie* (1944), starring Tommy Trinder, and *I'll Be Your Sweetheart* (1945), starring Margaret Lockwood and Vic Oliver, both of which have music-hall settings. However, the latter is particularly interesting in that it looks at the fight to establish music publishing copyright law at the beginning of the twentieth century. For Robert Murphy, the film is 'too wordy to be a proper musical, not funny enough to be a comedy, and not dramatic enough to be a melodrama.[68]

This is actually too harsh a judgement on a film that is directed with pace by Val Guest, which has some imaginative camera work, good performances from Michael Rennie and Vic Oliver, and numbers which are imaginatively staged and choreographed. True, in the numbers written specially for the film by Manning Sherwin and Val Guest the production is more lavish 1940s modernist than music hall, and at other times the orchestrations have a distinct hint of swing, but all the numbers relate to the central concerns of the plot. Moreover, despite being set between 1900 and 1905, when music copyright laws were finally

introduced, the film clearly has contemporary resonance in its attack on the illegal activities of the music pirates, echoing concerns about the extent of the black-market economy which had prevailed during the war and which was a subject of considerable anger and debate. A later, more free-market, reading of the activities of the pirates might be more charitable, but in 1945 the film positions its audience to regard the pirates as distinctly antisocial. As Bob Fielding (Michael Rennie) puts it, the attempt to stamp out pirated sheet music is an attempt to give the British public 'honest melodies at honest prices', to provide 'music for the masses'. After all, he tells the gentlemen of the press, 'these songs are part of the life-blood of the people'. Intriguingly, given the film's relevance for the postwar project of social reconstruction, Wallace (Garry Smith), the 'crook' behind the illegal printing of sheet music, is played as an East End 'spiv'. In contrast, the street sellers of the cheap song copies are presented as 'ordinary people', simply trying to earn a living. In a key scene in which Edie (Margaret Lockwood) talks to Bob Fielding at the top of Blackpool Tower, she comments on the lights below, and tells him 'when you see a dark space, it means they've given up, been beaten', adding that they are 'Just ordinary people, but they're not going to let go'. Drawing upon the significance of Blackpool as coded reference to the nation as it exists outside of cosmopolitan middle-class London, the scene implicates ordinary people, including the northern working class, in this project of social reconstruction. The power of song to create this consensual, participatory community is reiterated throughout the film and is strong enough to survive Edie's political exhortation to the audience 'never to buy another sheet of stolen music'. At the end of the film, with victory over the pirates assured, Edie makes the value of collaboration and consensus explicit: 'We've won this fight because we were all united, songwriters, publishers and artists.'

It was more usual for films made during the war period to make direct reference to the war effort. Typical of such rather routine morale-boosters was Columbia British Productions' *Rhythm Serenade* (1943), starring Vera Lynn. Having been a band singer in the early 1930s, Lynn made her first radio broadcast in 1935 with Joe Loss and his orchestra, and in the same year made her first record, 'I'm in the Mood for Love' on the Crown label. With Ambrose

and his orchestra, she had a major hit with 'The Little Boy That Santa Clause Forgot' in 1937, followed by 'Red Sails In the Sunset'. Her radio series, *Sincerely Yours*, in which she sang and passed on messages to the forces serving overseas, was hugely popular with both listeners in Britain and the troops, something which the BBC Controller of Programmes Basil Nicholls, whose musical preference was for waltzes and stirring marches and who disliked her sentimental numbers, could not ignore. By 1943 and *Rhythm Serenade*, Lynn was known as 'the force's sweetheart'.

In *Rhythm Serenade*, Lynn plays a woman desperate to join the WRENS, but who comes to realize the importance of work in the munition factories, and of providing nurseries so that more women could work in them. With Jimmy Jewel and Ben Warris as her unlikely brothers providing some comedy routines, Lynn's singing is largely confined to snatches of her well-known songs as she tends wounded soldiers or paints the furniture for the nursery school, though we are treated to a fuller-length version of 'It Doesn't Cost a Dime' as she gets ready to go out for the evening. War-damaged John Drover is recuperated by her singing, and eventually returns from duties with the Merchant Navy to, we are led to believe, marry her. Wrapped as they are around exhortations to 'think of the army behind the limelight, the ones you can't see, without glory, without uniforms, without bands and bits of ribbons stuck on their chests', the musical numbers only serve to punctuate narrative business, though admittedly with real emotional impact. Only towards the end of the film, at the factory concert party, is Lynn given privileged space in which to sing and perform. Here, the two numbers '(I Love You Dear) With All My Heart' and 'I Love to Sing', are given direct to camera, creating a performance space which is only eventually related to narrative concerns when the film cuts to the factory audience, who join in the singing of the second number. The film ends with an indirect reference to Lynn's radio programme *Sincerely Yours*, as John Drover picks up a workers' lunchtime broadcast from the BBC on his stricken oil-tanker, and we cut to Lynn singing 'Hear That Song of Freedom', a reference to the 'music' of armament production. Though the film makes full use of Lynn's iconic status, and the affective power of her music, it is the dictates and demands of propaganda which dominate.

The growing dominance of American popular culture is much

in evidence in Arthur Askey's *Miss London Ltd* (1943), directed by
Val Guest. Though the film carves out a privileged performance
space for Askey to go through his concert-party routine, the film
has a distinctly American frame of reference, not least through the
presence of American Evelyn Dall as Terry Arden. The concept of
an escort agency designed to 'help the boys when they come home
on leave' is a clear indication of British determination to do every-
thing to reassure its new wartime ally that its soldiers will be made
at home. Though the agency donates some of its profits to the
Prisoners of War Fund, it is also designed, as Terry Arden says, 'to
do for the English girl what Ziegfeld did for the American girl'.
References to American music and film stars abound, through
Jack Train's impersonations of, amongst others, Rochester and
W. C. Fields, the Marx brothers sketch with Askey as a credible
Harpo, and the acknowledgement of his debt to Abbott and
Costello.[69] When the business is failing, Askey jokes that he is
working out a 'lend-lease' agreement. In the number 'I'm Only
Me', Askey regrets not being Clark Gable or Fred Astaire. Though
there are some distinctly British songs in the film, including Askey
as 'Arthur Bowman' pretending to be the real Arthur Askey, as he
does his song 'The Moth', and the brilliantly executed opening
number where Anne Shelton sings the '8.50 Choo Choo to Water-
loo-Choo', most of the numbers have a decidedly transatlantic
swing to them, including 'A Fine How Do Ya Do' and Evelyn
Dall's solo number 'Keep Cool, Calm and Collect'. Anne
Shelton's two other songs stand out, the duo with Peter Graves
sung over dinner, 'If You Could Only Cook' and the romantic 'You
Too Can Have a Lovely Romance', which serves to unite a
number of people in the hotel in the prospect – and importance –
of love and romance. Like Vera Lynn, Anne Shelton was closely
associated with the British war effort, she went on to sing with the
Glenn Miller band in 1944, and had some hit records on the
Decca label in the United States in the late 1940s, including 'Be
Mine' (1949) and 'Galway Bay' (1949). Like Lynn, she was one
of the few British female vocalists to challenge the American
domination of the popular music charts in Britain in the early and
mid-1950s.

Though *Miss London Ltd* has a pace and verve which are char-
acteristic of Val Guest's direction, it failed to match the box-office
popularity of George Formby's films. By the end of the war, the

British musical had lost its way. There were attempts to compete with the American product, not least as a result of Rank's ambitious assault on the American market which began in 1945. The strategy involved using American talent to star or direct, as when Associated British Pictures teamed David Niven with Vera-Ellen in *Happy Go Lovely* (1951) and Rank brought in American director Wesley Ruggles to shoot *London Town* (1945), starring the comic Sid Field, Kay Kendall and child star Petula Clark.

With a very large budget which included Technicolor photography, *London Town* follows the attempt by Jerry Sandford (Sid Field) to break into London showbusiness. Significantly, the opening shot of the film has Jerry and his daughter Peggy (Petula Clark) on their way by train from Wigan to London. The cultural gulf between London and the north is alluded to several times, as when Jerry is hired by Mrs Barry as a 'threat' to her existing comic Charley (Sonnie Hale). When he protests that he thought he would be appearing in the show, she tells him to sit and observe, to 'feel the pulse' of the West End audience, as it is 'quite different from from those in the provinces'. Charley tells Jerry that he 'has no place in London theatre'. Jerry is on the verge of packing things in and 'going back to the provinces' when, thanks to Peggy's intervention, he gets his big break and is an immediate success. It is the displaced Charley who ends up working in a show in Newcastle, banished to the purgatorial fringes of provincial showbiz from where Jerry has escaped.

With its lavish sets and songs by American composer Jimmy Van Heusen and lyricist Johnny Burke – who had worked with Tommy and Jimmy Dorsey, Artie Shaw and Benny Goodman, written for Frank Sinatra and, in the *Road* series of films, for Bing Crosby – Rank must have expected the film to do well in Britain and the United States. They were disappointed – film was a box-office disaster on both sides of the Atlantic. Explaining the difficulties that Jesse Matthews was having in getting film parts in the mid- and late 1940s, Malcolm Thornton says that producers saw Matthews,

> exclusively in the category of musicals. And song-and-dance was the one thing the British film industry didn't want to know about in 1947. The previous year Rank's lavish *London Town* had been a dismal disaster which retarded Kay Kendall's career, as well as the English film musical, by a decade.[70]

The reasons for the film's poor reception are not too difficult to analyse. Apart from some touchingly effective scenes between him and the young Petula Clark, Field's performance is unable to carry the weight of the money spent on the production. His singing voice, though it works well in 'You Can't Keep a Good Dreamer Down' which is sung to Clark to help her sleep, lacks sufficient tone and range for the stage-set numbers. Moreover, his comic routines, shot without the benefit of any cut-aways to the theatre audience or even soundtrack laughter, are bounded by precisely the sense of provincial music-hall and variety comedy which the film purports to leave behind. Though the sets are lavish, involving a boating lake for the number 'So Would I', they too fail to create a distinctly cinematic space, so that we remain too firmly locked within the theatrical space of the diegesis. What remain are some rather tacky attempts to appeal to the American audience, involving location shots of the River Thames, Windsor Castle, Eton College schoolboys in uniform and cockney community singing aboard the Thames pleasureboat 'Britannia', as well as the inexecrable ''Ampstead 'Eath' sequence involving Pearly Kings and Queens, followed by a dire attempt to launch the song as a new dance craze. What is left are some effective sets, including a giant piano for eight pianists, and some well-sung swing vocal arrangements to the show's main numbers. Finally, the film simply ends, falling off the screen with no sense of resolution, romantic denouement or even celebration of the spectacular.

The failure of *London Town* to compete in the American market and the declining popularity of the idiosyncratic and inexportable British musical comedies epitomized by films such as *Miss London Ltd* and the 1943 G-B production *It's That Man Again*, meant that both elements of the British film industry's production strategy were exhausted, at least so far as the musical was concerned. Whilst there were other British musicals during this period – including Two Cities' *Trottie True* (1949), starring Jean Kent and directed by Brian Desmond Hurst which, despite its music-hall setting manages to say something about class mobility in postwar Britain – British audiences expressed a clear preference for musicals made in Hollywood.

The growth of the record industry in Britain

In the same way, the late 1940s and early 1950s saw the growing domination of American popular music. When the *New Musical Express* (NME) published its very first 'Hit Parade' on 14 November 1952, only two British artists, Vera Lynn and Max Bygraves, had records in the top twelve best-selling singles. By the mid- 1950s, a number of British singers, including David Whitfield, Ruby Murray, Alma Cogan, Dickie Valentine and Ronnie Hilton, were enjoying chart success, but the popular music charts remained under American domination. At this period, the influence of songwriters and of sales of sheet music were still important to the music industry and, although the sales of 78 r.p.m. records increased rapidly after 1951, it was still common for one or more cover versions of the same song to make the hit parade. As we have seen earlier, the development of roc'n'roll swept away this dependence on songwriters, sheet music and music publishers, in Britain as much as in the United States, and coincided with the development of record sales as the prime indicator of popularity, based on a performance style which was both musically and visually distinctive, often using songs written by singers or groups themselves.

Noting important changes in record technology and domestic equipment to play records on, the growing availability of portable transistor radios and the development of TV in the 1950s, Bradley comments:

> We can thus see clearly that the period of rock'n'roll was also a period of great change and accelerating development for the techniques of the music industry and their social dissemination ... A music industry employing new media of sound to sell a new type of product (singles, LPs and small radios), and to sell these goods to a market comprising mainly the working people and their families within the producing nations, on a scale never previously approached – this is the musical infrastructure of the 1950s.[71]

In Britain, the attitude of the BBC made the impact of these changes less immediate, partly because of its continuing resistance to American popular culture, and partly because of a residual resistance to any excessive use of gramophone records.

Though the BBC had used gramophone records since the 1920s, they only accounted for 1.29 per cent of programme time

in 1927.[72] Following the merger of the Columbia Gramophone Company and the Gramophone Company to form EMI in 1932, and under the strictures of wartime broadcasting, the number of programme hours using records increased, the *BBC Year Book 1946* noting that 'During the past few years the Gramophone Department has made a virtue of necessity, so to speak, and built up an extensive and individual repertory of its own in radio entertainment, which there is no reason for peacetime conditions to alter'.[73] However, as Briggs puts it, 'By current standards, even gramophone-record programmes, strictly limited in hours, had a strong British flavour. The America (and continental) reliance on gramophone records as the "staple diet" of broadcasting was never copied by the BBC.'[74]

Before the 1950s, the overwhelming use of gramophone records was for classical or light orchestral music. Even at the beginning of the 1950s, there was still an attitude of deep suspicion towards British popular music on record. Though Radio Luxembourg plugged David Whitfield's 1953 record 'Answer Me', which rose to number one on the NME chart that December, the record was banned on the BBC.[75] Given that in 1955 Radio Luxembourg began a series of half-hour and one-hour record programmes sponsored directly by record companies such as Decca, it was an attitude that was under considerable pressure for change.

In December 1956, the BBC broadcast its first 'Radio Record Week' under producer Philip Slessor, who had previously worked for G-B and Radio Luxembourg. As if suddenly waking up to the important changes in domestic entertainment technologies, Slessor wrote in justification for the idea:

> Do you realise that 60 million records are sold in Britain every year? That making discs is a £15 million business – one of the most thriving in the country? That the gramophone is as popular an entertainment-giver as the TV, radio and cinema?[76]

In Slessor's view, modern pop-star careers were made almost entirely by records. Whilst Slessor was promoting the importance of records as opposed to radio and sheet music, of equal significance, as we saw in the previous chapter, was the response by the film industry to the developments in the music industry and the increasing importance of cinema in creating the visual economy of

the modern music industry. The enormous popularity of Bill
Haley and the Comets' records in Britain was matched by the
over-zealous reaction to the film *Rock Around the Clock* when it
opened in Britain in late 1955. The popularity of this and other
rock'n'roll films, including *The Girl Can't Help It* (1956),
prompted a number of British films featuring British singers.

British popular music in the 1950s and the business of entertainment

British rock'n'roll singers initially modelled themselves on the
American stars, with Bill Haley and the Comets leading the
way. Haley's popularity was greater and longer-lasting in Britain
than it was in the United States, and his music was central to the
development of a new youth-orientated phase in British popular
music. As Bradley argues:

> Haley and the Comets ... set a new pattern of music-use among
> British teenagers: music became much more central to their leisure
> style than previously ... It was the excitement of an encounter with a
> startling new style, and also the rejection of the principal pop styles of
> the immediate past.[77]

The influence of Buddy Holly and the Crickets was also
pronounced, not least in the encouragement they provided for the
development of small-group music which prided itself on a
certain kind of 'virtuosity' in singing and playing. Within a year or
two, the influence of Elvis Presley was to have even greater
impact, as British singers imitated his performance style.

However, British popular music of this period, influenced as
it was by American singers and records, was also influenced
by calypso and skiffle, the latter a musical style which grew from
within the British 'trad' jazz tradition and which was promoted
by the success of records by Lonnie Donegan, fusing 'white Amer-
ican folk styles, together with a dash of music-hall and George
Formby.'[78] In fact, it is important to place the development of
British rock'n'roll within the wider tradition of British popular
entertainment and culture, rather than seeing it as in any sense a
radical departure. In Britain, as in the United States, the develop-
ment of the teenage market for differentiated cultural product did

have specific and distinctive features but, as was argued in the previous chapter, it was located within the wider context of the business of entertainment. As rock'n'roll made an impact in the media and amongst young people, established artists such as the Beverley Sisters, Ruby Murray and Dickie Valentine made cover versions of rock'n'roll records, and established pre-rock bands including Ted Heath and Ken Mackintosh appeared on the BBC's 'youth' programme *Six-Five Special*.[79] In late 1956, 'Bloodnok's Rock'n'Roll Call', recorded by the stars of the BBC's radio programme *The Goon Show*, reached number three in the hit parade. Early in his career, a young Cliff Richard found himself on a variety bill at three London theatres playing alongside a roller-skating tap dancer, a puppeteer, comedians and an act that consisted of a man miming to records.[80]

This sense of showbusiness continuity is exemplified in the films, music and career of Tommy Steele, who was promoted by showbiz impresario Larry Parnes as Britain's first rock'n'roll star.[81] His first single, 'Rock With the Caveman', co-written with Lionel Bart, made a brief appearance in the charts in December 1956. In January 1957 he reached number one with his version of 'Singing the Blues', following his appearance on Jack Payne's TV show *Off the Record* on October 1956. His first film, *The Tommy Steele Story* (1957) reiterates the story of his success as constructed by his manager Parnes, from guitar-playing merchant seaman to coffee-bar success to record star. The sense of musical continuity is reinforced in a film which features, alongside numbers such as 'Elevator Rock' and 'Doomsday Rock', slower ballad numbers such as 'Water Water' and 'A Handful of Songs' which, as a double-sided record, entered the British charts on 17 August 1957. Lionel Bart, the film's songwriter, recalls that the film company insisted that there were a variety of songs, including some cockney and calypso numbers.[82] In featuring Humphrey Lyttleton, the Chas McDevitt Skiffle Group with Nancy Whiskey, and Chris O'Brien's Caribbeans, the film reflected the contemporary pop scene in Britain which was characterized by a fusion of musical codes and styles. Far from being a radical departure, *The Tommy Steele Story* represents an attempt to place the 'new' music and its young singers within an established discourse of popular music and entertainment. As Medhurst argues, the film 'was seeking to negotiate a space between its specific topic of British

pop and two established film genres, the rags-to-riches biopic and the Hollywood musical.'[83]

Steele's subsequent films, *The Duke Wore Jeans* (1958), *Tommy the Toreador* (1959) and *Half a Sixpence* (1968) make it clear where that space is, as they position him firmly within that discourse of the 'all-round entertainer' of mainstream showbusiness. As McAleer states, the number 'Little White Bull' from *Tommy the Toreador* is 'closer to George Formby than Elvis'.[84]

Traditions of entertainment: Cliff Richard and *Expresso Bongo*

This concern to exploit the commercial potential of the new rock'n'roll singers was also evident in the film career of Cliff Richard. Following his chart success in September and October 1958 with 'Move It' and appearances on ATV's *Oh Boy!*, he was signed to Eros Films' 1958 production *Serious Charge*, later referred to by one of the cast as 'a poor man's *The Wild Ones* set in Stevenage'.[85] In the film, Richard plays the part of the delinquent Curly, a part not in Philip King's original stage play. His presence in the film was acknowledged by director Terence Young as pure market exploitation, since he 'thought that if we put a few kids in it would draw a younger audience'.[86] A reworked version of one of the three Lionel Bart numbers written for the film, 'Living Doll', stayed at number one in the charts for six weeks in August and September 1959.

In *Expresso Bongo* (1959), based on a West End play intended to satirize the phenomenon of Tommy Steele's success and with a screenplay written by Wolf Mankowitz, Richard plays Bert Rudge, aka Bongo Herbert, a young rocker devoted to his music who is discovered in a coffee bar and becomes a big star. Cliff Richard got the part in preference to Marty Wilde, his co-star on the television show *Oh Boy!*, in part because of a decision by producer/director Val Guest. Norrie Paramor, who had signed Richard to the Columbia label in 1958, is credited with contributing to some of the songs in the film, and the number Richard sings at the Tom Tom Club, 'A Voice in the Wilderness', entered the chart in January 1960. The film mirrors Paramor's real-life concern to turn Richard into an 'all-round entertainer'. For his

second album, *Cliff Sings*, released in November 1959, Paramor had him singing orchestrated classics including 'As Time Goes By' as well as rock numbers.

In fact, the film works hard to position Richard and, by implication, young people and their new music, firmly within mainstream entertainment. Here, the spectrum of entertainment runs from the strip joints of Soho, through conventional pop, the 'new' music represented by the Shadows and Cliff, to the classical music which Mr Meier, the boss of Garrick Records, plays on an office gramophone to sooth his ulcer. The film is doubly interesting in that, as well as eradicating distinction between different styles of entertainment, it also suggests an important synergy between the channels which disseminate that entertainment. Apart from the aspiring agent Johnny Jackson (Laurence Harvey), the mechanism which links Maisie and the strip joint to contemporary youth culture, via the record industry and West End variety and revue, is BBC Television, in the unlikely guise of the real-life Gilbert Harding and his 'Cosmorama' documentary on teenage rebellion. This connection between filmic text and the wider entertainment context is reinforced not simply through the presence of Cliff Richard and Gilbert Harding, but by the appearance of Jimmy Henney, then the well-known presenter of the television programme *Oh Boy!*

This discourse of entertainment is reinforced through the juxtaposition of the different numbers in the film, combining the original songs from the West End play with those written specially for the film. Though 'spectacular' privileged diegetic space is created for Richard's performance of numbers such as 'Love is a Fever' and 'A Voice in the Wilderness', other numbers sung by Meier, Johnny Jackson or Maisie obey the generic conventions of the classical musical, and arise out of and comment upon preceding narrative events. Having been persuaded to hear Bongo Herbert sing at the Tom Tom Club, Meier responds to the experience by making comparisons between Herbert and classical composers in the song 'Nausea', which has lines such as:

> Years ago they would have been failures,
> Now they're cutting out Sibelius.

Though it is hard not to see Richard as central to the film, in fact the narrative focus is on Johnny Jackson. At the end of the film,

having lost control of Bongo, who is about to disappear on his American tour, we return to Johnny's struggle to establish himself in the entertainment business, as he tries to strike yet another deal. It is Johnny's immersion in the business of entertainment, his reiterative patter using the language of business, which sits at the heart of the film. From the beginning, when he 'borrows' copies of the trade papers *Variety*, *Disc* and *Melody Maker*, Johnny attempts to survive in what he calls 'the jungle of showbusiness'. From his awareness of Maisie's vocal limitations, to the failed struggle to get Bongo's parents to sign a contract (a failure which renders his management and control illegal), to the well-worn device of the faked phone call supposedly from major label HMV as he tries to interest Garrick Records in signing Bongo, Johnny constantly pitches for deals which will advance his career in management. He has some successes too, not least in getting himself on BBC Television where he plugs Bongo's new single unmercifully, to the evident discomfort of Gilbert Harding and the BBC he here represents. In aligning Bongo with fading American star Dixie Collins, he propels him into transatlantic stardom.

However, this contact with Dixie sows the seeds of his own hubristic downfall, though this is due in part to the greed exemplified in the terms of the contract with Bongo, something which scandalizes even hard-nosed businessman Meier. For Johnny, Bongo is only ever a 'property', something which will further his own aspirations within the entertainment business. His cynicism towards his property and the youth market is evident. In trying to persuade Mrs Rudge to put her signature on the contract, he tells her 'Our boy is going to be the idol of teenagers everywhere' as he will get 'recordings, variety bookings, even open shoe shops for cash'. As Bongo's career begins to take off, Johnny realizes how crucial his forthcoming TV appearance will be: he tells Bongo, 'Eight million telly-hugging imbeciles are going to fall in love with you simultaneously'. He is painfully aware that in this business, you need to 'cultivate the right people', and that 'All you need to succeed is one success after another'.

Within this discursive framework, failure figures as much as success, as we are confronted not just with Dixie's growing inability to attract headline bookings, but with the rejection and dismissal of Johnny as Bongo's manager. It is Meier who twists the knife. In a business where there is no room for sentiment, Meier

not only out-flanks Johnny's aspirations for Bongo's northern variety tour, but is the one who breaks the good and bad news about the American tour to Bongo and Dixie respectively. Given the spectre of failure which haunts the business, the lengthy discussions with Bongo about his future have a certain logic to them; as Dixie tells him, 'You can't go on being a teenage singer very far beyond your teenage, you know'. This attempt to promote Bongo's business career longevity, to position him within the commercial mainstream with its appeal to the largest audience, is helped by his apparent contempt for the teenagers who have made his career, calling them 'grimy yobs'.

This discursive treatment of showbusiness has remarkable resonance with events surrounding Cliff Richard's real career, and with the hierarchal structure of the British entertainment business. It is clear that the role of Johnny Jackson was modelled to some extent on Larry Parnes, a manager who represented a host of British pop stars in the late 1950s and early 1960s. Though he was successful in arranging important provincial tours of his singers and bands, often using the old music-hall twice-nightly format, as well as booking them on to TV shows like *Six-Five Special* and *Oh Boy!*, Parnes never had access to the premier entertainment circuit owned and controlled by Leslie Grade and Bernard Delfont, which included the prestigious London Palladium. As a result, many of his singers fell into obscurity. Richard's career path, on the other hand, was constructed so as to enable him access to the important mainstream circuits. As Tremlett argues:

> Cliff Richard owed much to skilled management and an agent who kept [him] working when new trends were catching fans attention … As a stage performer he was no better than Billy Fury or Marty Wilde, but the business liked him … He became a star in the sense that the old timers understood.[87]

Given this resonance, *Expresso Bongo* can be meaningfully placed with that wider aesthetic of social realism which characterized British cinema in the late 1950s and early 1960s.[88] This helps to explain the explicit nature of the scenes at the strip club, which resulted in the film being given an 'X' rating. Far from being an anti-rock statement in the way that the stage play had been, or a fantasy on the career of rising young pop star, the film offers a

construction within a realist framework of the workings of the
entertainment industry in a treatment which, whilst it acknowl-
edges rough justice, roundly endorses the industry.

Despite its realist aesthetic, it is important to reiterate that,
like the Hollywood musical, *Expresso Bongo* is essentially a self-
reflexive film, concerned to show the 'backstage' workings of
showbusiness. Richard's next film *The Young Ones* (1961) could
not have been further removed from the black and white cine-
matic realism of *Expresso Bongo*, though it too shares many of the
ideological concerns of the classical Hollywood musical. For
Marshall Crenshaw, *The Young Ones* 'is where Cliff Richard's
screen career took off – and went wrong'.[89] By 1961 Richard was
being backed by the resources not only of EMI's Columbia, but of
the Grade Organisation which had bought the option for his next
film. He had already appeared in pantomime, had topped the bill
on *Sunday Night at the London Palladium*, had starred in an
extended six-month show at the Palladium and, under the musical
direction of Norrie Paramor, had increasingly concentrated on
singing pop ballads. He had also undertaken a tour of the United
States but, like the vast majority of other British singers, had failed
to make any more impact live than his records had done.

British pop musicals and the American market

Given his success in Britain and lack of it in the United States, *The
Young Ones*, produced by Associated British Pictures, was
designed to make an impact on the American market, where it
was issued as *Wonderful to be Young*. As with earlier musicals, it
was decided that the presence of American personnel on the film
might help. Canadian director Sidney Furie was appointed,
and the American songwriting team of Sid Tepper and Roy
Bennett wrote the title song, as well as 'When the Girl in Your
Arms is the Girl tn Your Heart', much to the annoyance of British
songwriters Peter Myers and Ron Cass who were already working
on the film.

Revolving round a plot unashamedly borrowed from the
Mickey Rooney and Judy Garland *Babes* series of films produced
by MGM in the 1940s, a group of youngsters whose youth club is
threatened by property development put on a show in an effort to

save it. The plot is complicated by the fact that property developer Hamilton Black (Robert Morley) is the father of Nicky (Cliff Richard), a leading light at the youth club. With dance numbers produced by Broadway choreographer Herb Ross and some effective songs, *The Young Ones* comes closest of any British musical to the conventions of the classical Hollywood musical at its best. It has energy, optimism, romance and a sense of community, all the generic elements associated with the backstage musical, bound within a double-helix narrative which sees professional showbiz success matched by success in romance. Whilst it expresses an older generation's alienation from youth culture, it also neutralises that threat as the young people are incorporated within capitalism. Literally so, since the property development goes ahead, but with a privileged space in the middle of the development reserved for a brand-new youth club. The structural barriers that are part of the British social formation, class, gender, age and economics dissolve within the construction of imagined community, reified through the show. Though the film did well in Britain, it was at least ten years too late for the American market.

The Young Ones and *Summer Holiday* (1963) confirm the transition of Richard into the commercial mainstream of the British entertainment industry, though, like *The Young Ones, Summer Holiday* made no more impact on the American market than his records or live tours did. In this, he followed a pattern during the late 1950s and early 1960s, when a number of British pop films, including *Rock You Sinners* (1957), *Six-Five Special* (1957), Terry Dene's *The Golden Disc* (1958), *Play it Cool* (1962) and *What a Crazy World* (1963), did reasonable business in the British market, but failed to make any impact in America. In that sense, British pop films of this period should be seen as a continuation of that tradition of the 'inexportable' British film, even if occasionally, as with *The Young Ones*, the intention was to break in to the important American market. This indifference to British popular music and the films in which it appeared was to change radically in 1964, with the success of the Beatles.

The interest in and popularity of the Beatles and their records in Britain had begun slowly in 1962, building to a crescendo in November 1963 following the Royal Command performance and an appearance on *Sunday Night at the London Palladium*, both of which were televized, and helped to create the frenzy of

'Beatlemania' which was fuelled by the British popular press. Christmas 1963 was 'Beatlemania' Christmas, when the group sold almost as many records as the rest of the British market combined. The single 'I Want to Hold Your Hand' went straight to number one on 7 December of that year, having accrued 950,000 advance orders. In that same week, sales of the LP 'With the Beatles' were so strong that it reached number eleven in the top thirty NME chart.

Initially, the response to the Beatles in America was one of indifference. As Philip Norman puts it:

> America up to now [late 1963] had regarded the Beatles as it regarded every British Pop performer – an inferior substitute for a product which, having been invented in America, could only be manufactured and marketed by Americans. The view was reinforced by the half-century in which American artists, through every musical epoch, had dominated the English market as against only one or two freakish incursions by English acts travelling the other way.[90]

Despite the fact that EMI (who issued the Beatles record on the Parlophone label in Britain) owned the Capitol label in America, Capital refused to issue the early British hits 'Please Please Me' and 'From Me to You', both of which were instead released on the Chicago-based Vee Jay label. Capitol also refused 'She Loves You', which was issued on the Swan label. Before Capitol did agree to release 'I Want to Hold Your Hand' in January 1964, two important decisions had been made. The first arranged for the Beatles to tour America, including a live appearance at Carnegie Hall in New York City and two appearances on *The Ed Sullivan Show*. The second decision was made by George Ornstein, European production head of United Artists, who arranged for independent producer Walter Shenson to negotiate a film deal with the group's manager Brian Epstein. It is clear that United Artists, who owned their own record label, saw a film as a means to obtain some rights over the growing interest in the United States in the Beatles music, since their contract with EMI excluded soundtrack album rights. As Neaverson puts it:

> the project was initially envisaged by the American-owned company as little more than another low budget exploitation picture which would capitalize on the group's fleeting success with the teenage market and, more importantly, provide its record label with a lucrative tie-in

soundtrack album. Indeed, as Shenson later revealed, the company was only interested in making a Beatles film 'for the express purpose of having a soundtrack album'.[91]

Whatever disclaimers EMI's George Martin may subsequently have made, the fact remains that the Beatles' first film came into being as a result of some far-sighted, hard, and American, business decisions. Moreover, as Alexander Walker makes clear, United Artists had limited ambitions for the film itself, anticipating that distribution and exhibition within northern Europe and the Commonwealth would suffice to cover costs plus a small profit.[92]

Richard Lester, born in Philadelphia but based in London, already had considerable experience directing for television advertising and had directed *It's Trad Dad* (1962) for Columbia. Under his direction, it has been argued that *A Hard Day's Night* (1964) broke new ground in rejecting the conventional format of pop musicals which had grown since the mid-1950s. John Lennon himself was concerned not to replicate what he considered to be the rather tired format of young people ultimately proving to be acceptable to an initially suspicious older generation:

> we weren't interested in being stuck in one of those typical nobody-understands-our-music plots where the local dignitaries are trying to ban something as terrible as the Saturday Night Hop. The kind of thing where we'd just pop up a couple of times between the action, all smiles and clean shirt-collars to sing our latest record.[93]

Influenced by the British 'Free Cinema' documentary movement and the 'kitchen sink' realist aesthetic of films like *Saturday Night and Sunday Morning* (1960) and *The Loneliness of the Long Distance Runner* (1962), *A Hard Day's Night* certainly acknowledged the 'documentary feel' wanted by scriptwriter Alun Owen, though its realist aesthetic is punctured by Lester's knockabout surrealism. The film also represents a departure from the conventional representational regime which privileged performance through the construction of an illusory diegesis, with its inevitable connotations of 'authenticity'. There is a marked contrast between the Cliff Richard number 'Love is a Fever' in *Expresso Bongo* which, whilst set in the 'authentic' context of the coffee bar, clearly relies on the artifice of non-diegetic musical backing, mediated through the post-production process, and 'I Should

Have Known Better' in *A Hard Day's Night*, which is shot in the
'non-musical' setting of the baggage-car and where the opening
verses are set against visuals of the Beatles playing cards. The
dislocations which mark the performance of the number, with
musical instruments suddenly appearing from nowhere, clearly
anticipate some of the central stylistic elements and representa-
tional strategies of music video. Given the genesis of the film and
United Artist's prime concern with a soundtrack album, it is only
to be expected that the quality of the sound-track is privileged
over the visuals. Though Lester's use of multi-camera set-ups
created a visual frenzy and 'playfulness' which owes something to
the French *nouvelle vague* and which was vastly different from any
contemporary television aesthetic, the number still makes use of
lip-synching, a technique which was commonplace on television
pop shows.

Neaverson argues that the film is groundbreaking in rejecting a
number of ideological conventions associated with the pop music
film, not least the 'simple-minded morality tales in which a ficti-
tious conflict between youth and old age is resolved by mutual
understanding and co-operation'.[94] It is certainly the case that the
film interpellates its audience in a more knowingly complicit
manner than had been usual, presenting the Beatles as 'real'
people rather than fictional constructs within a narrational device,
itself a complex layering of textual devices which anticipates
aspects of the postmodern text. Rather than seeing the young
musicians from the perspective of the older generation, the 'hand-
held' aesthetic implicates its young audience within a world which
seems occupied as much by themselves as by the Beatles. In this
sense, the film adopts an almost ethnographic approach to a
phenomenon which was central in a reconstruction of British
national identity in the mid-1960s, centred around the display of
'swinging London'.

Yet, whilst it can be argued that *A Hard Day's Night*, like the
Beatles second film *Help!* (1965), anticipated and helped develop
an aesthetic which has come to be associated with music video, it
would be wrong to ignore the sense of connectedness and conti-
nuity which link the film to earlier British musical productions.
Arguably, Owen's script and dialogue, as delivered by the Beatles,
has a lineage dating back to *Elstree Calling*, *Okay For Sound*
and *It's That Man Again*, with its quick-witted, near-scatological

surrealism. To an extent, it is this humour and sense of irreverence which distinguishes the film from *Expresso Bongo* and *The Golden Disc*, films which owe as much, if not more, to the British realist aesthetic of the late 1950s and 1960s.

In much the same way, *A Hard Day's Night* both absorbs and perpetuates the issue of provincialism and its connection with the British entertainment industry. Whilst the film's setting is determinedly metropolitan, the influence of a northern provincial entertainment tradition is evident. Whilst this tradition no longer, in the 1960s, has connotations of exotic otherness, it still provides tension between the 'ordinary' and 'unaffected' working-class northerners and middle-class metropolitan insincerity and pretentiousness. Of course, this tension is inflected by contemporary concerns, so that the targets for criticism are the affectations of television directors and fashion trend-setters. At bottom, like George Formby and Gracie Fields, the Beatles are presented as 'the salt of the earth', unchanged by fame, fortune and success, though also like them the economic dictates of the entertainment business compelled them to enjoy their success well away from their iconic origins.

Despite the initial limited ambitions which United Artists had for the film, its critical and commercial impact was extraordinary. The final figures for the film's budget vary between £175,000 and £189,000, but the returns were phenomenal. Capitalizing on the huge interest generated by the Beatles American tour, United Artists decided to undertake distribution on a global scale, promising that the film would have 'more prints in circulation than any other pic in history', and anticipated a UK gross in excess of £1,000,000.[95] *A Hard Day's Night* opened simultaneously at 500 cinemas across North America, earning $1,300,000 in the first week and reaching $5,800,000 at the end of six weeks. Worldwide receipts were double that, and sales to the American NBC television network brought in a further $2,500,000.[96] United Artists scheduled a run of 500,000 copies of the soundtrack album, but rapidly increased the run to cope with the advance orders totalling over two million copies. Critical reaction was epitomized by Andrew Sarris, for whom the film was

the *Citizen Kane* of jukebox musicals, a brilliant crystallization of such diverse cultural particles as the pop movie, rock'n'roll, cinema verite,

the nouvelle vague, free cinema, the affectedly hand-held camera, fren-
zied cutting, the cult of the sexless adolescent, the semi-documentary,
and studied spontaneity.[97]

Whilst it would be wrong to ignore the British context in which
the Beatles and their films developed, it is clear that their success
signified the increasingly global nature of the entertainment
industry, in which convergence between the music and the screen
industries became even more pronounced. The success of *A Hard
Day's Night* and of *Help!* in the following year was not lost on the
entertainment conglomerates. Though, as we have seen, the
importance of title or theme songs and the synergistic potential of
the soundtrack album had long been recognized by Hollywood
and understood by the music industry, the sheer global scale of
the Beatles' success cemented the alliance between the music and
screen industries, confirming the crucial importance of the visual
economy of popular music. Of course, this visual regime was not
solely constructed by cinema. Improvements in print technology
in the late 1950s and early 1960s had ensured that record covers
made an important contribution to the look of popular music,
much the way that sheet music had done between the 1920s and
1950s. In the next chapter, the role of television in constructing
the visual economy of popular music is examined.

Notes

1 R. Matthew-Walker, *From Broadway to Hollywood: The Musical and
 the Cinema* (London, Sanctuary Publishing, 1996), p. 11.
2 D. Clarke, *The Rise and Fall of Popular Music* (London, Penguin,
 1995), p. 97.
3 P. Hardy and D. Laing, *The Faber Companion to 20th-Century
 Popular Music* (London, Faber and Faber, 1992), p. 765.
4 P. Honri, *Working the Halls: the Honris in One Hundred Years of
 British Music Hall* (London, Futura Publications, 1974), p. 99.
5 M. Pickering, 'White skin, black masks: 'nigger' minstrelsy in Victo-
 rian England' in J. S. Bratton (ed.), *Music Hall: Performance and
 Style* (Milton Keynes, Open University Press, 1986), p. 70–91.
6 Honri, *Working the Halls*, pp.139–40.
7 Honri, *Working the Halls*, p. 142.
8 Honri, *Working the Halls*, pp. 107–9. See also D. Mayer, 'Learning
 to see in the dark', *Nineteenth Century Theatre*, 25:2 (Winter 1997)

92–114 and M. Chanan, *The Dream That Kicks* (London, Rout-ledge, 2nd edn 1996), pp. 129–30. Chanan comments that R. W. Paul found that many music-hall stars were quite willing to appear in films, often for no payment, since they regarded it as good publicity. Marie Lloyd's first appearances were in actualities, rather than in reconstructions of her stage acts.

9 C. Musser, *Thomas A. Edison and his Kinetographic Motion Pictures* (New Brunswick NJ, Rutgers University Press, 1995), p. 43.

10 J. Barnes, *The Beginnings of Cinema in England* (Newton Abbot, David and Charles, 1976), p. 196.

11 A. Medhurst, 'Music hall and British cinema', in C. Barr (ed.), *All Our Yesterdays* (London, British Film Institute, 1986), p. 169.

12 D. Russell, *Popular Music in England 1840–1914: A Social History* (Manchester, Manchester University Press,1987), pp. 72–3.

13 Chanan, *The Dream That Kicks*, p. 128.

14 D. Russell, *Popular Music in England 1840–1914*, pp. 83–6. For further commentary on music-hall audiences, see D. Hoher, 'The composition of music hall audiences 1850–1900', in P. Bailey (ed.), *Music Hall: The Business of Pleasure* (Milton Keynes, Open University Press,1986), pp. 73–92.

15 Bailey, *Music Hall*, p. xv.

16 Barnes, *The Beginnings of Cinema in England*, pp.89-90.

17 Barnes, *The Beginnings of Cinema in England*, p.217.

18 P. Warren, *The British Film Collection 1896–1984* (London, Elm Tree Books, 1984), pp.11–17.

19 C. Chaplin, *My Autobiography* (London, Penguin, 1966), p.133.

20 Chanan, *The Dream That Kicks*, p.155.

21 Warren, *The British Film Collection*, p.9.

22 T. Ryall, *Alfred Hitchcock and the British Cinema* (London, Croom Helm, 1986), pp.37–8. See also M. Chanan, 'The emergence of an industry', in J. Curran and V. Porter (eds), *British Cinema History* (London, Weidenfeld and Nicholson, 1983), pp.39–58.

23 S. Frith, 'The pleasures of the hearth: the making of BBC light entertainment', in S. Frith (ed.), *Music For Pleasure: Essays in the Sociology of Pop* (Cambridge: Polity Press, 1988), p. 25.

24 D. Parker, *Radio: The Great Years* (Newton Abbot, David and Charles, 1977), pp. 35–6.

25 Parker, *Radio*, pp.36–9.

26 BBC, *BBC Year Book 1932* (London, British Broadcasting Corporation, 1932), p.201.

27 *BBC Year Book 1932*, pp. 201–2.

28 *BBC Year Book 1932*, p. 204.

29 Frith, 'Pleasures of the hearth', p.38.

30 Parker, *Radio*, pp. 41–2.
31 H. Wilcox, *Twenty-Five Thousand Sunsets: The Autobiography of Herbert Wilcox* (London, Bodley Head, 1967), p. 88. On Wilcox's significance in British cinema, see R. Low, *Film Making in 1930s Britain* (London, George Allen and Unwin,1985), pp. 143–8.
32 Low, *Film Making in 1930s Britain*, pp.3–5.
33 G. Perry, *The Great British Picture Show* (London, Paladin,1975), p.54.
34 S. Street, *British National Cinema* (London, Routledge, 1997), p. 8. A more extensive consideration of the 1927 Act and its consequences is contained in M. Dickinson and S. Street, *Cinema and State: The Film Industry and the British Government 1927–1984* (London, British Film Institute, 1985).
35 S. Hartog, 'State Protection of a Beleagured Industry', in J. Curran and V. Porter (eds), *British Cinema History* (London, Weidenfeld and Nicholson, 1983), p.73.
36 Low, *Film Making in 1930s Britain*, pp.33–5.
37 Ernie Lotinga made a series of films based on the character of Josser, including *Josser Joins the Navy*, *Josser on the Farm*, *Josser on the River* and *PC Josser*. See Low, *Film Making in 1930s Britain*, pp. 338–9.
38 Low, *Film Making in 1930s Britain*, pp. 75–6.
39 Low, *Film Making in 1930s Britain*, p.77.
40 Low, *Film Making in 1930s Britain*, pp. 117–8.
41 P. Scannell, *Radio, Television and Modern Life* (Oxford, Basil Blackwell, 1996), pp. 63–4.
42 Scannell, *Radio, Television and Modern Life*, p. 64.
43 Russell, *Popular Music in England*, p. 89.
44 J. Agate, *Around Cinemas* (London, Home and Van Thal, 1946), p. 59.
45 J. R. Taylor, *Hitch: The Life and Work of Alfred Hitchcock* (London, Faber and Faber, 1978), p.103.
46 D. Spoto, *The Art of Alfred Hitchcock* (London, W. H. Allen, 1977), p.26.
47 A. Higson, *Waving the Flag: Constructing a National Cinema in Britain* (Oxford, Oxford University Press, 1997), p. 99.
48 Higson, *Waving the Flag*, p. 121.
49 Higson, *Waving the Flag*, p.135.
50 M. Thornton, *Jesse Matthews: A Biography* (London, Hart-Davis, McGibbon, 1974).
51 J. Kobal, *Gotta Sing, Gotta Dance: A History of Movie Musicals* (London, Hamlyn, 1983), p. 58.
52 Higson, *Waving the Flag*, p. 123.

53 Higson, *Waving the Flag*, p. 121.
54 Higson, *Waving the Flag*, p. 135.
55 Ryall, *Alfred Hitchcock and the British Cinema*, p. 74.
56 Higson, *Waving the Flag*, p. 148.
57 Higson, *Waving the Flag*, pp. 145-6.
58 C. Winchester (ed.), *The World Film Encyclopedia: A Universal Screen Guide* (London, The Amalgamated Press, 1933), p. 80. The biography by M. Burgess and T. Keene, *Gracie Fields* (London, Star Books, 1980) outlines her life and career, whilst an article by S. Frith, 'Northern soul – Gracie Fields', in his *Music For Pleasure*, pp. 67–71, offers some explanation for her continuing attraction.
59 Higson, *Waving the Flag*, p. 165.
60 Warrington Borough Council, *Turned Out Nice Again: The George Formby Story*, catalogue of the Formby exhibition at Warrington Museum and Art Gallery, 26 April – 27 July 1991.
61 Filmed interview with Formby on *The South Bank Show*, 8.11.92.
62 Low, *Film Making in 1930s Britain*, p. 162.
63 Low, *Film Making in 1930s Britain*, p. 163.
64 Medhurst, 'Music hall and British cinema', pp. 179–80.
65 R. Murphy, *Realism and Tinsel: Cinema and Society in Britain 1939–49* (London, Routledge, 1989), p. 195.
66 P. Scannell and D. Cardiff, *A Social History of British Broadcasting Vol. 1, 1922–1939, Serving the Nation* (Oxford, Basil Blackwell, 1991), p. 273.
67 Murphy, *Realism and Tinsel*, p. 18.
68 Murphy, *Realism and Tinsel*, p. 202.
69 Train's impressions are well to the fore in the 1943 G-B film *It's That Man Again*, based on the BBC Tommy Handley radio show. Interestingly, for all its British humour, the film has songs which are decidely transatlantic, including 'Oh Mr Crosby'. However, at the climax of the film, 'C. B. Cato's' lavish and genteel production 'Princess For Tonight' is invaded by the more raucous cast of Handley's stage school/radio show, including 'Mrs Mopp', a clear clash of two prevailing traditions within British musical comedy.
70 Thornton, *Jesse Matthews*, p.186.
71 D. Bradley, *Understanding Rock'n'Roll: Popular Music in Britain 1955–1964* (Buckingham, Open University Press, 1992), p. 82.
72 A. Briggs, *The History of Broadcasting in the United Kingdom Vol. II: The Golden Age of Wireless* (Oxford, Oxford University Press, 1965), p. 35.
73 BBC, *The BBC Yearbook 1946* (London, British Broadcasting Corporation, 1946), p. 75
74 Briggs, *The History of Broadcasting Vol. II*, p. 110.

75 P. Murray, *One Day I'll Forget My Trousers* (London, Everest Books, 1976), p. 88.
76 P. Slessor, 'The story behind radio's record week', *Picturegoer*, 8 December (1956) 16–17.
77 Bradley, *Understanding Rock'n'Roll*, p. 57.
78 Bradley, *Understanding Rock'n'Roll*, p. 63.
79 D. McAleer, *Hit Parade Heroes: British Beat Before the Beatles* (London, Hamlyn, 1993), pp. 46–7.
80 S. Turner, *Cliff Richard: The Biography* (Oxford, Lion, 1994), p. 131.
81 That title probably belongs to Tony Crombie, a jazz drummer who played with Ronnie Scott. As *New Musical Express* reported in August 1956, Crombie had left be-bop to form a rock'n'roll band, Tony Crombie and the Rockets. Crombie was also the first British rock artist to gain a record contarct when he was signed by Norrie Paramor for Columbia. Crombie's record 'Teach You to Rock' coupled with 'Shortnin' Bread Rock' entered the NME chart on 20 October 1956, a week before Tommy Steele's 'Rock With the Caveman'.
82 McAleer, *Hit Parade Heroes*, p. 90.
83 A. Medhurst, 'It sorted of happened here: the strange, brief life of the British pop film', in J. Romney and A. Wootten (eds), *Celluloid Jukebox: Popular Music and the Movies Since the 50s* (London, British Film Institute, 1995), p. 62.
84 McAleer, *Hit Parade Heroes*, p. 91.
85 Quote by Andrew Ray, cited in Turner, *Cliff Richard*, p. 141.
86 Turner, *Cliff Richard*, p. 140.
87 George Tremlett, *Rock Gold: The Music Millionaires* (London, Unwin Hyman, 1990), p. 49.
88 J. Hill, *Sex, Class and Realism: British Cinema 1956–63* (London, British Film Institute, 1986).
89 M. Crenshaw, *Hollywood Rock: A Guide to Rock'n'Roll in the Movies* (London, Plexus, 1994), p. 257.
90 P. Norman, *Shout! The True Story of the Beatles* (London, Corgi, 1982), pp. 213–14.
91 B. Neaverson, *The Beatles Movies* (London, Cassell, 1997), p. 12.
92 A. Walker, *Hollywood England: The British Film Industry in the Sixties* (London, Michael Joseph, 1974), p. 235.
93 R. Carr, *Beatles at the Movies* (New York, HarperCollins, 1996), p. 30.
94 Neaverson, *The Beatles Movies*, p. 20.
95 Carr, *Beatles at the Movies*, p. 47.
96 A. Yule, *The Man Who Framed The Beatles: A Biography of Richard Lester* (New York, Donald I. Fine, 1994), pp. 18–19.
97 Yule, *The Man Who Framed the Beatles*, p. 17.

6

Popular music and the small screen

In the opinion of this writer the question of televising musical performances has received scant attention from the television programme chiefs. This is remarkable in the BBC, which has always taken music seriously, and has done so much for musical standards of taste.

Kenneth Baily, *Here's Television*, 1950

The introduction of consumer television coincided with the emergence of rock'n'roll and provided a medium for beaming the image of the performer into homes across the United States.

Keith Negus, *Producing Pop:
Culture and Conflict in the Popular Music Industry*, 1992

These days it's impossible to convey the excitement that built from one week to the next in the fifties and sixties when you knew that Elvis, the Beatles – or even Pat Boone – were going to appear live on *The Ed Sullivan Show*. Of course, you had to sit through Topo Gigio and an elephant act to see them, but that only heightened the fun.

Penny Stallings, *Rock'n'Roll Confidential*, 1984

Whilst cinema has constituted a major force in promoting, reflecting and defining the meanings of popular music, the introduction of television and developments in video technology have also had a profound impact on popular music and the music industry. From an initial reluctance to programme popular music, television and, later, music video have come to occupy a central place in the visual economy of popular music, constructing complex patterns of use of the products of a highly integrated entertainment industry, in ways which resonate beyond traditional notions of leisure consumption.

In his seminal study of popular music, Middleton argues that:

> To some extent the history of records since the 1930s can be seen in
> terms of a struggle between this dominant model – mass transmission
> and individual reception ... – and the possibilities of alternative insti-
> tutions, arrangements and users. There was some upheaval around
> the middle of the century. New kinds of music (rhythm and blues,
> rock'n'roll) appeared ... There was a real possibility here of a whole
> new pattern of musical communication. By the late 1950s, however, a
> new symbiosis, recognizably related to the old dominant model was in
> place.[1]

Whilst this 'new symbiosis' was in part due to developments in
music technology and to structural changes in the record indus-
try, as well as to changes in radio programming and audience
construction, this chapter examines the influence of television in
the reassertion of institutionally defined patterns of consumption
of popular music in the 1950s and beyond.

The growth of television in Britain and the USA

The growth in television ownership contributed to and reflected
important changes in patterns of domestic leisure consumption
in the early 1950s. In North America, Britain and Western
Europe, the home increasingly became the dominant arena for
leisure activities, as the radio, the gramophone and the television
challenged the supremacy of cinema as the prime source of enter-
tainment. In the United States, there were 14,000 TV sets in use
in 1947. By 1950 the number had risen to four million, and to
thirty-two million in 1954. Though TV ownership in Britain
lagged behind, with only 0.2 per cent of families having a TV set
in 1947, this had risen to 7 per cent in 1950. Television ownership
in the UK received a major boost with the televizing of the 1953
coronation and for the first time, in 1953, the number of televi-
sion sets being manufactured in Britain was greater than the
number of radios being made. By the mid- to late 1960s, televi-
sion had penetrated 90 per cent of households in the United
States and Britain.

 In the United States, reaction to the development of television
from existing interests within the commercial entertainment busi-
ness was ambivalent. Although initially regarded with suspicion by

Hollywood, a process of commercial accommodation rapidly followed. As Balio points out: 'During the early fifties, nearly all prime-time programming emanated from New York and was broadcast live. By the late fifties, nearly all prime-time programming emanated from Hollywood on film.'[2] The proportion of live television programming on the American networks fell from 81.5 per cent in June 1953 to 26.5 per cent in 1961, as Hollywood increased its production of television material. The Federal Communication Commission's approval in February 1953 of the takeover of ABC by United Paramount Theaters signalled the end of commercial hostility between the American film and television industries, and opened the way for the growing convergence between the sectors.[3]

Audiences were attracted to television because of its relative cheapness and the variety of its programming. Adults in particular appreciated the convenience of being able to watch it in the home. Hollywood, as we saw in a previous chapter, relied increasingly on product differentiation, particularly in responding to the youth market, though it also proved very efficient at providing programming material for the American television networks, so much so that *Television Magazine* for September 1963 reported that 'For all practical purposes motion pictures have been shoved aside and Hollywood has become a television production town'.[4]

Though American and British television had a radically different structure and institutional orientation, both were heavily influenced by prior experiences in radio broadcasting, particularly in regard to programming. This was especially pronounced in America with NBC, itself a subsidiary of RCA, the chief manufacturer of TV sets and recipient of 3.5 per cent royalties of every set sold in the US, and CBS, who had strengthened its radio network in the 1950s. Of the three American networks, it was ABC who relied most on Hollywood, signing, for example, a deal with Disney in 1954. The commercial nature of American television clearly depended on successful advertising, as did radio:

> Of chief concern to the leaders of the new television industry was the challenge of integrating television programming into the routines of the housewife's daily chores as radio had done. The development of television on the model of commercial radio – widespread receiver

sales to the private home with programming supported by direct advertising – was seen to depend on the housewife as 'household purchasing agent' and as target of advertising messages.[5]

In Britain, television emerged from within the BBC and its public service monopoly of radio broadcasting, and was subject to policies and cultural attitudes which had prevailed within that context. Though the British cinema industry had some concerns which it expressed to the Hankey Committee, which had been set up to look at the reinstatement of television after the war, J. Arthur Rank was convinced that a television service operated by the BBC would be helpful to the cinema industry, not least in its capacity to show films which had not been 'fully exploited'.[6] Following the resumption of the BBC's television service on 7 June 1946, the influence of radio on television programming was evident, including, for example, a television version of *It's That Man Again* (*ITMA*), dance-band music from Harry Roy, *Late Joys*, a programme of music-hall entertainment, a magazine programme called *Picture Page*, *Composer at the Piano* and *Guest Night*. According to the judgement of Asa Briggs, programmes were more varied than those found on American television, and there was little public criticism of programming policy.[7]

However, Paulu notes that in the first ten years following the resumption of the television service, there was a notable bias within the BBC against television, itself a product of the class-based suspicion of the new medium:

> During the first decade of the post-war service, there were frequent charges that the BBC was essentially a radio-oriented organisation, whose leadership lacked interest in television ... If the limited amount and kind of space devoted to television in the BBC yearbooks between 1947 and 1955 is any indication of the Corporation's regard for the medium, the conclusion must be drawn that the new service did indeed have a low priority.[8]

Whether programming was aimed at that 'agent' of consumption, the American housewife, or whether it reflected the more varied though safe programming policy prevalent within the BBC, it was clear that it offered little for young adults, a view confirmed by the 1952 audience research conducted by the BBC, which showed that interest in television was lowest amongst twenty- to twenty-four-year-olds.[9] Some contemporary commentators noted

the allure of television and the threat it offered to the cinema, but explained why it appeared less appealing to young people:

> To the cinema, for instance, [television] has become a serious rival; people will not go out so readily when they can have hours of entertainment at home for the cost of a licence. On the other hand there is evidence that after the first spell has worn off, in a year or so, younger people like to go out because they get away from the home circle, and because the feeling of 'going out' to see something in company with an audience gives a different kind of sensation.[10]

Yet, like the film industry, within a matter of a few years American and British television were forced to rethink their programming strategies in response to the emergence of a distinctive youth culture and an equally distinctive, identifiable and burgeoning market which that culture signified.

Television, popular music and youth in the 1950s

American television programming was always more expansive than programming on British television which was, by contrast, severely and deliberately curtailed. As a result, it was much easier in the early expansionist years of American television for American stars and formats to make the crossover from radio to television. Texaco switched its *Star Theater*, eventually hosted by Milton Berle, from radio to television in 1948, followed shortly by *The Toast of the Town* fronted by Ed Sullivan. Music programmes also crossed over from radio, notably *Your Hit Parade* in 1950, and radio and record stars like Perry Como and Dinah Shore hosted their own shows. American television provided a rich showcase for virtually every major recording artist, singer and bandleader including, improbably, Paul Whiteman in a show called *The TV Teen Club*, which ran from 1949 to 1954. The importance of television to the music industry at this period was such that, by 1957, it was estimated that more than 42 per cent of ASCAP's payments came from television networks.[11]

Other popular music shows on American television included *The Peter Potter Show* (1953–54), *Upbeat* (1955), *The Music Shop* (1959) and *The Big Record* (1957–58), the latter hosted by middle-of-the-road singer Patti Page. Though these and the variety shows did showcase some rock'n'roll music and singers

(including, as we saw in a previous chapter, Elvis Presley), they were catering for what was still regarded within the entertainment business as a largely undifferentiated audience, and served to perpetuate a definition of popular music which, whilst it included country music as well as black artists like Nat King Cole, was essentially targeted at white, northern, urban tastes. Whilst popular music programming was a significant element in American television in the early 1950s, for much of the time the music seen and heard reflected the homogeneity of musical style which dominated the products of the record industry. However, the extent to which television was important in introducing the music enjoyed by teenagers to a wider audience, and making it acceptable to that wider audience, should not be underestimated. As Gillett comments on American television:

> Most of the shows that included rock'n'roll singers were all-purpose entertainment shows, among them, Arthur Godfrey's talent-spotting show, Jackie Gleason's show, and the Ed Sullivan and Steve Allen shows. Godfrey played an important part in presenting rock'n'roll (and rhythm and blues) to an audience that still hadn't heard the music much on the radio.[12]

Arguably, American television in the early and mid-1950s played an important role on two fronts. By parading rock music and its performers before a wider audience, it increased the commercial potential of the record industry by actively promoting its products, often in ways which bordered on the corrupt. However, the fact that rock music was located within the context of 'entertainment' effectively rendered the music 'safe'. The increase in commercial potential was at a price, as whatever potentially distinctive meanings rock'n'roll may have had transmuted, both musically and ideologically, into pop, incorporated within the mainstream of the entertainment industry. As Frith puts it: 'The effect of fitting rock'n'roll into a medium like television is to make it safe, to deprive it of some of its significance – an undifferentiated audience can't be a rock audience.'[13]

This seems incontrovertible but, in the light of historical precedence, hardly surprising. As we have seen, this process of accommodation and incorporation is perhaps the defining characteristic of the relationship between popular music and the screen, the prime purpose and effect of the commercial,

industrial, cultural and ideological convergence which has operated at varying levels since the beginning of the century. It is certainly true that the emergence of rock and the beginning of the rock formation represents one distinctive historical juncture, such that strong claims have been made, with some justification, for its distinctiveness. This is usually articulated through distinctions which are said to exist between rock and pop:

> Rock, in contrast to pop, carries intimations of sincerity, authenticity, art – noncommercial concerns. These intimations have been muffled since rock became the record industry, but it is the possibilities, the promises which matter.[14]

However, it can be argued that claims to the 'authenticity' said to be represented by rock are themselves an appropriation of the ideology of authenticity which was attached to a range of musics and other signifying and cultural practices long before the emergence of rock'n'roll, and which continues to have cultural currency through its ability to mark out distinctions within social formations at historical moments. As Wicke comments:

> it is really ironic that the ideology of rock should amount to anti-capitalism, even though this is only illusory, since more than any other this music is inextricably linked to the basic mechanisms of capitalism and itself became an industry organised along capitalist lines[15]

Arguably, claims to notions of 'authenticity' are an expression of the relationships between the centre and the margins, and the affective expressions of people who occupy at one time or another these distinctive spaces of identity, with all the complex dynamics which operate upon them including, crucially in societies such as ours, powerful economic and commercial determinants. Though the notion of 'authenticity' had a distinct resonance within the rock formation, it served to disguise the actual material trend towards increasing corporate domination which characterized the popular music industry. Whilst those at the social and cultural margins during the 1920s, 1930s and early 1940s were largely ignored by the dominant commercial media, in the 1960s marginal tastes were increasingly catered for by these media, with the result that claims to cultural and musical 'authenticity' became at once more focused, articulated and spurious.

In fact, from the perspective of a television industry executive

it must have been hard to make a strong case in the mid-1950s for there being such a thing as a 'rock audience'. Audience research into American radio programming at this time revealed that, even during what were thought to be peak listening periods for teenagers, they actually only accounted for some 12 per cent of the listening audience. Billboard, concluding that a significant proportion of the five million copies of Presley's 'Don't Be Cruel' must have been bought by older people, questioned the wisdom of targeting music play policy at the 12 per cent, given that it appeared not to bring additional sales benefits to advertisers.[16] From this perspective, the variety format epitomized by *The Ed Sullivan Show*, where 'guest' rock artists could appear on occasions, must have made more sense, especially in a television system driven by the commercial concerns of sponsors and advertisers.

American Bandstand and the appropriation of pop music

Yet, like Hollywood, American television's response to rock'n'roll and to the evident growth of the teenage market was often clothed in the discourse of controversy which characterized debate about young people and their lifestyle. One significant indication of the need to make a specific response to the burgeoning purchasing power of teenagers was the national syndication of *American Bandstand* in August 1957. Having started broadcasting locally in Philadelphia five years before, the show had been sufficiently successful for ABC to network it. Initially fronted by local DJ Bob Horn, *Bandstand* had made use of a series of short made-for-TV films featuring singers and bands when it began in 1952. Forerunners of music video, these films proved unpopular, as Dick Clark recalled: 'The "Snaders" [after producer George Snader] were considered a bore, certain death, so within a few weeks, they changed the show to something that seemed more interesting – having real live kids in the studio dancing to the latest pop hits.'[17]

As hosted by Dick Clark, the show featured white teen idols miming to their records, many of them records and songs produced and published by companies in which Clark had a more or less direct financial interest. The House of Representatives subcommittee investigating corruption within the music industry

noted that 'Mr Clark managed to keep an average of 4.1 records owned by [his] publishing, manufacturing or artist management firm in the charts every week between October 1957 and November 1959 ... When Mr Clark pushed songs in which he had an interest ... Mr Clark manipulated these plays to the fullest advantage'.[18] The subcommittee also heard – and dismissed – accusations that Alan Freed had been asked by ABC to promote records on the Am-Par label, owned by the ABC-Paramount company, and to book his live rock'n'roll shows into Paramount theatres. Within a few years, such strategies would become an accepted part of marketing and promotion, and continue to be so.

Whilst the ethics may have been highly questionable, here was clear evidence of the influence which television was able to have over record sales. The American trade paper *Billboard* reported a representative of the record dealers of Greater St Louis as saying that *American Bandstand* was 'the greatest stimulant to the record business we as dealers have ever known. Many dealers have installed TV sets in their record departments and extend teenagers an invitation to see the show in their stores.'[19] Clark's enormous success in promoting rather mediocre and, on the whole, white singers such as Frankie Avalon and Fabian was not lost on record retailers, sponsors or ABC themselves. The fact that Clark survived the investigation of the House subcommittee into his dubious business interests and connections clearly had something to do with the fact that the show had brought in over twelve million dollars for ABC. The popularity and longevity of the programme also says something about the way in which rock-'n'roll was positioned into the commercial mainstream, not least by *American Bandstand* itself.

It is clear that, just as early MTV was denounced for racial bias in the 1980s, accusations that Clark perpetuated racism by promoting white singers at the expense of black artists – accusations which later informed John Waters' parodic film *Hairspray* (1988) – carry weight. However, it is clear that Clark was ultimately motivated and driven by economic imperatives and opportunities; as he put it, 'I don't make culture. I sell it'.[20] In 1958, Clark had sat on the Silhouettes' record 'Get a Job' not because the group were black, but because the record, which he thought had great potential, was issued on the Junior label with no national distribution. After it was transferred to Ember, a label

which did have national distribution, Clark programmed the
record and it became a major hit selling over two million copies.[21]
Clark's commitment to commercial profitability was such that
some years later, as he revealed to the American publication *TV
Guide* in 1970, his business interests had consolidated and grown,
and he boasted that he had 'one of the best organizations in the
country for reaching the youth market'. Clark told his interviewer
that

> We own 16 companies in Los Angeles alone ... The television arm has
> two regular shows on the air right now, *American Bandstand* and *Get It
> Together* ... as well as my *Music Bag Special* which is still in syndication.
> We have completed three motion pictures, and another is scheduled
> for immediate production. We have the largest production-promotion
> company for concerts anywhere, and we own three radio stations.[22]

The article also listed Clark's other interests, which included
teenage magazines, drive-in restaurants, radio commercials,
promotions for soda and guitars and a hot-rod racetrack.

American Bandstand clearly indicated television's increasingly
powerful role in constructing and determining the directions in
which youth culture would develop. Though record sales were
heavily influenced by the show, it also helped construct the *look* of
teenage subculture, not least through its ability to parade fashion
and dance before the nation:

> by going national, it was giving American teens a standard, a ritual that
> was performed every day to confirm their membership in the secret
> society. Dick Clark's dancers became celebrities in their own right.
> They set fashion. They did the latest dances, so that teens and their
> friends could try them before they went to record hops ... Hairstyles,
> slang, tie widths – all those critical concerns of adolescence – the
> *Bandstand* regulars set the tempo.[23]

Though Hollywood had attempted to construct an imagined
community through its influence on patterns of consumption,
television programmes such as *American Bandstand* were
constructing an imagined and specific community through the
insistent visualization of the *processes* of consumption itself,
targeted at commodities which were both associated with and
signified youth culture.

Clear evidence of this increasing commodification of youth

culture extended across a range of media and ancillary commer-
cial interests, came in 1960 when *American Bandstand* promoted
Chubby Checker's version of 'The Twist', originally recorded
with some chart success by Hank Ballard and the Midnighters.[24]
Though he had featured Ballard lip-synching to his minor hit
'Finger Poppin' Time' in June 1960, Clark used his extensive busi-
ness holdings, which included TV production, music publishing,
part-ownership of the Jamie and Swan record labels, a record-
pressing plant, and a talent management company, to promote
Checker's cover version of 'The Twist' on the Philadelphia-based
Cameo-Parkway label. Though he played the record regularly on
American Bandstand, Clark also showcased Checker and the dance
on his influential Saturday night prime-time programme *The Dick
Clark Show* in August 1960. By 19 September the record was at
number one on both the *Billboard* Hot 100 and the *Cash Box* pop
chart. At the end of that month, Clark presented Checker with his
gold record on *American Bandstand*. By the end of 1961, four low-
budget 'twist' films had been produced, including *Twist Around the
Clock* (1961) and *Don't Knock the Twist* (1961), both produced by
Sam Katzman for Columbia. As Dawson points out, '*Don't Knock
the Twist* was barely more than a shill for Cameo-Parkway, which
controlled most of the artists and the movie's thirteen songs, and
for the dozen or so merchandisers who had signed lucrative
deals.'[25] Amongst these deals were commercial tie-ins with the
Fred Astaire Dance Studio franchises and with the 900 coast-to-
coast Thom McAn shoe stores, 'exclusive retailers of "Chubby
Checker Twisters"'. A soundtrack album from the film, issued by
Parkway in the United States and Columbia in Britain, achieved
respectable sales. A sequence featuring Checker performing 'Lose
Your Inhibitions Twist' found its last-minute way into Richard
Lester's film *It's Trad Dad* (released in the US as *Ring a Ding
Rhythm*), and Checker made a number of British television
appearances including the BBC's Monday night *Television
Dancing Club*, hosted by veteran strict-tempo bandleader Victor
Sylvester.[26]

What this promotion of 'The Twist' revealed was the power
of television to privilege commercial considerations above all
others. Though it would be an exaggeration to say that, by 1960,
opposition to black music and singers had been eradicated, social
attitudes which had prevailed even five years before no longer

prevented black artists from regular appearances on networked television. The pace and significance of this change can be gauged from the earlier controversy just two years earlier which had surrounded Alan Freed's *Rock'n'Roll Dance Party*, networked by ABC. Freed championed black artists and when, in 1958, the programme showed black singer Frankie Lymon dancing with a white girl, thirteen ABC affiliates cancelled the show and the series was dropped.[27] The same racial attitudes were a factor which prevented networking of local television shows such as *Jocko's Rocket Ship* hosted by black radio DJ Doug 'Jocko' Henderson from Newark in 1958. By the 1960s, however, American television, with *American Bandstand* and a host of variety shows which featured rock and then pop artists, had become a rather sanitized proving ground for promoting mostly, but not exclusively, American popular music.

The influence of variety entertainment shows in showcasing rock and pop continued throughout the 1960s and provided further evidence of the power of television to determine commercial success in the music industry. The appearances by the Beatles on *The Ed Sullivan Show* on 9 and 16 February 1964, which attracted audiences variously estimated at between seventy and seventy-three million, made the group and their music acceptable to a public beyond the teenage audience which made up live-performance audiences.[28] Sullivan's personal endorsement of this 'group of fine youngsters' indicated the extent to which youth and pop music had become, in Grossberg's words, 'inserted into the dominant system of economic and social relationships'.[29]

The role of television in the visual economy of popular music

Throughout this book, the contention has been that the visual regime has been important in constructing and inflecting the meanings of popular music, that the screen media have exercised a powerful mediating influence on audience reception and understanding of popular music. Arguably however, the appearances by the Beatles on both British and American television represent a key moment when the *look* of popular music achieved a new threshold of significance. Writing about the documentary *In Bed*

With Madonna based on her 'Truth or Dare' tour some twenty-five years later, Lawrence Grossberg makes the point that

> while Madonna's music is the sign of her investment and the vehicle of her success, it is neither the sign nor the vehicle of her popularity. While a number of critics have recently argued against readings which focus on her image rather than her music, it is worth pointing out that the music is entirely taken for granted, its production erased.[30]

It is clear that both the success and the commercial popularity of Madonna in the 1980s were as much dependent on the exploitation of herself as visual commodity through music video as on the records themselves. Arguably, a point was reached where it became impossible to hear a new release by Madonna without operating some interior visualization of her as performer, visualization which was rapidly reinforced by the latest video which accompanied the record release, as well by a welter of carefully controlled visual images circulated in the print media. This process, perhaps inevitable as the power of television and video grew, became significant in the early 1960s. Whilst the Beatles' music, like Madonna's, was the vehicle of their success, its overdetermining significance lessened as their exposure through film and television increased, as their image assumed increased importance in defining their meaning as cultural icon and commodity.

These same processes of ideological 'insertion', increasingly constructed through the regime of the visual, were clearly at work in those American television shows which purported to address a specifically youthful audience. Following the folk music and folk-rock boom in the early 1960s, ABC began broadcasting its weekly show *Hootenanny* from different college campuses in 1963. Though the music industry had successfully promoted the new, mainly white, folk music, the broadcasting institutions tended to promote singers and groups such as the New Christy Minstrels, who exemplified an America of clean-cut, nice-looking white kids, but whose commitment to the political undertones of contemporary folk music was at best tenuous. Following the refusal to let Pete Seeger appear on the show because of his reluctance to sign a loyalty oath to the American government, *Hootenanny* rapidly lost what little credibility it had with the youth audience. Ideology and ratings were sometimes compatible.

Dick Clark's success on *American Bandstand* led to him

fronting two additional television shows, *Where the Action Is,* which ran from 1965 to 1967, and his *Saturday Night Show* which, as mentioned previously, occupied an ABC network prime-time slot on Saturday evening. *Where the Action Is* was particularly interesting, since it took the *Bandstand* format into location settings where bands were filmed 'in performance', a style imitated by *Malibu U,* fronted by ex-*Ozzie and Harriet* TV star and pop singer Ricky Nelson at the height of the California beach and surf craze. These were unusual, however, and two of the most successful American music television shows of the mid-1960s were studio-bound programmes. *Shindig!* started as a once-a-week, half-hour programme on ABC in September 1964, produced by Jack Good. By the end of the year, ratings were so good that the show was extended to one hour and, for a brief period, ran twice a week. Like its NBC rival, *Hullabaloo,* which started in January 1965, the show relied mainly on artists miming to records in the studio, supported by professional dancers and a strictly limited number of teenagers in the studio audience. This was in spite of the fact that an increasing number of artists and bands were making promotional films which were being sent to the TV shows. However, as Shore argues, 'American TV, more rooted in the straight performance idea, rarely, if ever, showed them. British and European rock shows did.'[31]

If American television remained resistant to promotional film clips through the 1960s, it is clear that sections of the industry recognized its power in establishing the look of popular music, and its ability to promote record sales. Clearly influenced by the global record, film and television success of the Beatles, TV producers Bert Schneider and Bob Rafelson sold the concept of a television series based on the adventures of a pop group to NBC producer Don Kirshner. *The Monkees* was first broadcast in September 1966, proved an immediate success and was broadcast in Britain from January 1967. In the next two years, the group had significant record success in both the American and British charts. However, by the time their feature film *Head* was released in 1968, their popularity had diminished and the film was a commercial failure, despite a bold style which both looked back to *A Hard Day's Night* and forward to the aesthetics of music video. The fact that the group were constructed primarily for a television series, which was then used to promote the music, represented a

clear and unambiguous attempt to construct an audience for a particular pop product. As Durant puts it, the group were 'devised to embody an image of an already calculated social demand'.[32] As such, the series represents a clear example of television's powerful role in the reassertion of institutionally defined patterns of consumption of popular music, a process which continued spasmodically in the United States through the 1970s and 1980s with shows such as *The Music Scene, Don Kirshner's Rock Concert, Midnight Special* and *Soul Train.*

BBC television and popular music: *Six-Five Special*

Though not driven by the overt commercial imperatives which characterized American television, British television's construction of popular music and its meanings has been no less important. Given the suspicion and resistance which marked British television's treatment of popular music in the early 1950s, underpinned as it was by a hostility towards 'Americanism' deeply engrained within the organization, it is perhaps surprising that it eventually established a significant number of programmes privileging popular music.

When the BBC reopened its television service in 1946, it broadcast for an average of twenty-eight hours a week. This had risen to forty-one hours by 1954, and reached the maximum of fifty hours permitted by government legislation following the introduction of competition from the commercial channels in 1955.[33] Limitations on programme hours necessarily constrained schedules and the variety of programming. Whereas New York television stations were devoting 53.3 per cent of their air time to 'light entertainment' by 1955, less than 16 per cent of BBC television output that year was light-entertainment programming.[34]

Not surprisingly, given the importance of the BBC within the musical life of Britain, 'serious' music was given an increasingly high priority on television by the mid-1950s, though, as Briggs points out, 'British musical tastes inside and outside the BBC were assured, if not completely rigid, and there was less interest in the new than in the familiar'.[35]

Given the attitude to 'pop music' within the BBC which, as Briggs argues, 'was subject to almost as many controls as the

British economy',[36] it is perhaps not so surprising that popular music of even the most mainstream kind was under-represented on BBC television in the early 1950s. In part, this reflected the continuing debate within the organization about the influence of 'Americanism'. The BBC was not unreceptive to the lobbying by the Songwriter's Guild of Great Britain (whose vice chairman was ex-BBC variety chief Eric Maschwitz, soon to return to the BBC) who were calling for the creation of 'a specifically British contemporary culture in the realm of the Popular Song'. Maschwitz complained that the BBC was 'spilling out' American pop music 'to the semi-Americanised "teen-age" listener who in these times of high wages and full employment, has an excess of pocket money to spend upon foolish, often vulgar, musical fads'.[37] Consequently, when BBC television introduced the programme *Hit Parade* in 1952, it followed the format of the radio show of the same name, with a team of British resident singers who performed the current best-selling songs, mixed with one or two 'standards'. Responding, like the BBC 'Radio Record Week', to the significant increase of record sales, *Off the Record*, a magazine programme which looked at the record industry, was first broadcast in May 1955. Introduced by veteran bandleader Jack Payne, it featured British singers such as Max Bygraves, Lita Roza, Ronnie Hilton, David Whitfield and Alma Cogan singing numbers which largely reflected the British version of Tin Pan Alley mainstream popular music.

The growing consumption of American popular music on record, and the dominance of these within the fledging attempts to chart record success, was acknowledged by *Cool for Cats*, a series of fifteen-minute programmes broadcast in the London region by Associated-Rediffusion from December 1956 and hosted by Canadian Kent Walton. The success of the show, which highlighted dancing to the latest record releases, led to it being networked from June 1957 until December 1959. However, the popularity of the show was overshadowed by the BBC's *Six-Five Special*, which was first broadcast nationally on Saturday 16 February 1957.

Until 1957, both the BBC and the comparatively new commercial channel had closed down their programmes between 6.00 and 7.00 p.m., ostensibly so that children could be put to bed without the distraction of television. Pressure from the commercial

companies had persuaded the Postmaster General, who had responsibility for the allocation of broadcasting hours under the 1954 Television Act, to end the so-called period of 'toddler's truce'. The BBC filled the 6.00–7.00 p.m. slot on Mondays to Fridays with *Tonight*, a news magazine programme, with *Six-Five Special* filling the Saturday slot following a five-minute news bulletin. As Hill comments:

> Although the programme soon became a cornerstone of the BBC's Saturday evening schedule, its appearance was largely fortuitous. The Corporation had actively opposed the ending of the 'toddler's truce' and, when it became clear that the ban would end anyway, sought to delay its implementation. Failing to do so, their response was to look for stop-gap programmes which could be mounted both quickly and cheaply. Thus, *Six-Five Special* was intended to run for only six weeks (on a budget of £1,000 per show), and was still at a relatively early stage of planning at the end of January 1957.[38]

Within a short time, the programme was attracting a regular audience in excess of six million, though this was probably due in part to the rapid growth of the social habit of watching weekend, early evening and prime-time television as the show itself. The programme was important in featuring a number of British rock singers, including Marty Wilde, Terry Dene and Adam Faith. Importantly, it also showcased American rock singers such as Presley, Little Richard and Jerry Lee Lewis in film clips from movies not yet released in Britain, so that their popularity was promoted without them having to undertake costly and often arduous live tours. However, these 'rock'n'roll' acts were not typical of the show as a whole, which was intended to appeal to both teenagers and older viewers, those whom the *Radio Times* called 'the young in spirit of all ages'.[39] The programme adopted a magazine format, mixing filmed items of supposed educational interest, occasional outside broadcasts, comedy acts and sporting items presented by ex-boxer Freddie Mills, as well as a range of music. Pete Murray, one of the presenters of *Six-Five Special*, recalled that

> the best thing about the show was the musical mixture. On the very first show we had my old chum Denis Lotus, Lonnie Donegan and Tommy Steele. Like the show itself, nothing was 'typical'. You just didn't know what to expect … The musical spectrum ranged from the

great blues singer Big Bill Broonzy, then a very old man, to classical guitarist Julian Bream.[40]

Whilst the show clearly served the same function as American television shows in bringing rock'n'roll and contemporary pop to a wider audience, it is important to realize the essential conservatism of the programme's musical policy, itself a reflection of attitudes prevalent within the BBC. Though Don Lang and his Frantic Five featured regularly, so did more established bands like the Ted Heath Orchestra and the Ken Mackintosh Band. As Murray indicates, the very earliest programmes included classical music, a clear indication of the class attitudes which prevailed within the BBC and which had influenced, as we saw earlier, music programming since the 1920s. As with American pop shows, the new music was enveloped within a wider musical discourse situated firmly within established notions of acceptable entertainment and musical styles.

The tensions between wanting to appeal to both young and old, between the need to reflect the powerful and growing influence of American popular music and culture and the desire to promote British talent, were not only implicit in the show's musical policy, but were articulated by the two main presenters Pete Murray and Jo Douglas. Whereas the former would refer to the studio audience as 'cats jumping' and 'real cool characters' and implore the television audience to 'get with it and have a ball', the more staid, demure and 'square' Jo Douglas translated this into language older viewers would be more at home with.[41] There was considerable concern amongst senior executives at the BBC about the music being played and the behaviour of and clothes worn by the young people in the studio audience. Briggs cites an internal memorandum which complained that 'Apart from the general chaos, there were too many girls who wore very abbreviated skirts, and several who wore practically no skirts at all'.[42] There was also concern about the music, not least a skiffle group singing a 'terrible phoney spiritual', and a skiffle contest which, since it featured some amateur skiffle groups, brought the BBC into conflict with the Musicians' Union.[43]

Like *American Bandstand*, the show made a feature of young people dancing in the studio audience, much to the initial concern of senior BBC executives, despite the fact that inducements were

offered to the most extrovert dancers by the show's producers. As with *Bandstand, Six-Five Special* and other programmes which followed proved highly influential in constructing and influencing consumption patterns amongst young people in areas such as fashion and dance styles, the beginnings of a public iconography directly related to popular music. Record buying was often directly related to appearances on the show; Terry Dene, Marty Wilde and Don Lang were amongst those who had chart success following sustained appearances on *Six-Five Special*.

This connection was readily recognized by the BBC in the *BBC Handbook 1959*. Whilst clearly taking pride in the range of broadcast light music featured on television, which included 'straight dance music, jazz and skiffle, to old-time dancing and guitar music', it made particular note of the success of *Six-Five Special*:

> Perhaps the most remarkable innovation of the last year was the introduction of *Six-Five Special*. This programme was planned at short notice to cover the period from 6 to 7 p.m. on Saturdays. It was immediately a great success: recording companies have taken up many of the young singers who make their debut in this programme. It also provides an opportunity for small bands and ensembles to be presented to regular audiences of some seven million adults. Primarily designed for a teen-aged audience, the programme has become a national institution equally enjoyed by the parents.[44]

Given the BBC's historical paranoia about songplugging and other activities which denoted commercialism, this was a tacit and significant recognition of the growingly powerful liaison between television and the record industry, prompted in part from the long-standing competition from Radio Luxembourg and the new commercial television network which began broadcasting in 1955.

British commercial television and pop music: *Oh Boy!*

Whilst the new commercial television companies in Britain were working to what was essentially a public service remit overseen by the Independent Television Authority (ITA) whose duty it was, amongst other things, to ensure that programmes were 'as far as possible' British 'in tone and style',[45] they were also propelled by commercial incentives. Indeed, the first contracts awarded went to groups whose business credentials in other areas of the

entertainment industry were already well established. What eventually became known as Granada was a wholly owned subsidiary of Granada Theatres Ltd which, under Sidney and Cecil Bernstein, had considerable interests in cinema and theatre. ABC Television was formed as a subsidiary company of the Associated British Picture Corporation in whom, by 1954, Warner Brothers had a 37½ per cent share, and ABC Television had the backing of Warner executives in America.[46]

The mid- to late 1950s was a period of intense interest by the British media in young people themselves. Documentary film-makers such as Karel Reisz and Tony Richardson revealed this growing obsession with the lifestyle and mores of teenagers in films such as *Momma Don't Allow* (1956) and *We are the Lambeth Boys* (1959) and other British feature-film directors projected this interest through films such as *I Believe in You* (1952) and *Violent Playground* (1958), both directed by Basil Dearden, *It's Great to be Young* (1956) directed by Cyril Frankel and *My Teenage Daughter* (1956) directed by Herbert Wilcox.[47] The new independent television companies proved eager to provide programming which reflected the interests of young people and their perspective on the world. An earnest desire to understand the attitudes of young people was in evidence in television programmes such as Granada's *Youth is Asking*, a series of thirty-two programmes first transmitted in May 1956, and *Youth Wants to Know*, which began a longer series of sixty-one programmes in February 1957, but the independent companies were equally keen to develop programming based on the clear appeal of pop music. As Sendall argues: 'It is probably true to say that ITV, with its ear closer to the ground than the BBC, understood the 'pop' sub-culture better than its older rival and was able to make better programmes in that area.'[48]

One of the earliest of these programmes was the *ABC Music Shop*, which featured 'popular recording stars from both sides of the Atlantic'. The most successful was ABC's *Oh Boy!* which, following two trial programmes shot live at London's Wood Green Empire, was broadcast regionally in the Midlands from June 1958 and then nationally from 13 September that year. Produced by Jack Good, *Oh Boy!* shifted its venue to the Empire Theatre in Hackney, and was shot live each week in front of an enthusiastic and highly audible young audience. The show dispensed with the

magazine format which had characterized *Six-Five Special* and presented live non-stop music for the entirety of the programme, apart from appearances from presenters Tony Hall and Jimmy Henney at the beginning and end of the show. Back-to-back acts were introduced by voice overs from Hall and Henney in the attempt to maintain a breathless, frenzied pace:

> whereas *Six-Five Special* had tried to create a party atmosphere, *Oh Boy!* sought to generate the excitement of a live show. Its central tactic, in this regard, was speed. Billed in the *TV Times* as 'an explosion of beat music', the programme aimed to pack as many musical numbers into the show as possible.[49]

Against the ABC Television logo and accompanied by the sound of the audience screaming, an opening voice over announced in a distinctly transatlantic accent 'OK, come and get it, it's *Oh Boy!*'. Following a cut to the audience, with the show's title superimposed, the non-stop music begins. In one show which survives on tape, the opening number of a medley of rock'n'roll' songs is 'At the TV Hop', sung by a solo member of the Dallas Boys, the show's resident male group:

We're at the TV Hop,
That's where we're gonna bop,
At the TV show,
That's where we're gonna go,
So put your books away,
And come along with me.

This chorus, with its mimicry of that rejection of 'high school' which was so central to the lyrical rhetoric of American rock'n'roll, is repeated, this time supported by a backing line-up of the young stars appearing in the show, including Cliff Richard, Marty Wilde, Billy Fury and Cuddly Duddly. This is cut short to make way for truncated versions of '(Rock it Up) at the Ball Tonight' and 'Lonesome Traveller', culminating in a big 'showbiz' finale. Not unlike the opening medley of songs played over the title sequence of most Hollywood musicals, this opening serves the purpose of announcing what's on offer both in terms of the stars appearing and of the music to expect, all delivered with a pace which represented, at that time, a highly innovative television style. This was not lost on BBC executives who noted that *Oh*

Boy!'s 'formula is better, more punchy, its camera work simpler and faster than [*Six-Five Special*]'.[50]

Tensions between musical and cultural codes, between ballads and rock, between British pop and the American product, are inscribed in the script of the show's two presenters. Jimmy Henney, speaking with a clear British accent, launches into the ballad 'Come Prima', a hit for Marino Marini and his Quartet in October 1958, only to be energetically interrupted by Tony Hall, announcing in his American accent 'Thank you very much boys and girls – and hi!'. Hall then introduces the Rockingham XI and 'their latest release, "Ra Ra Rockingham"'. This tension between cultural and musical styles continues through the show. Songs from Billy Fury, Dicky Pride, Marty Wilde and Cliff Richard follow in quick succession, though there is a slow number 'When I Grow Too Old to Dream' by balladeer Peter Elliot, and a version of 'When the Saints Go Marching In' sung by Richard, Wilde, the Dallas Boys and the Vernon Girls. Following the commercial break, the music continues with a choreographed number which owes more to variety than rock, before switching to a sultry Cliff Richard singing 'Turn Me Loose'. In total, as Jimmy Henney confides to Tony Hall at the end of the show, there have been seventeen songs during the programme, an indication of the pace Good and director Rita Gillespie brought to the show.

Broadcast on Saturday evenings between 6.00 and 6.30 p.m. the show did well in the competition for ratings. It attracted considerable comment not just in specialist British music papers such as the *New Musical Express* (*NME*) and *Melody Maker*, but also in the weekly and daily press, clear evidence of the power of television to provoke and position people in relationship to youth music. The *Daily Sketch* was concerned that in his appearances on *Oh Boy!* Richard came across as dangerously sexy, and the later row between Larry Parnes, who managed Marty Wilde, and Good made the front page of the *Daily Mirror*.[51]

The last edition of *Oh Boy!* was broadcast on 30 May 1959. It was replaced in September by *Boy Meets Girls*, which relied on many of the same basic personnel including Marty Wilde and the Vernon Girls, and introduced Joe Brown. However, as John Hill notes, the show was designed to have an appeal that went beyond teenagers, and its music policy reflected this:

In a self-conscious retreat from the freneticism of *Oh Boy!*, the idea
was feature more ballads and quieter numbers as well as introduce a
greater variety ... Ironically, this dilution of the original formula
appears only to have lessened the show's appeal without appreciably
expanding its following amongst adults.[52]

Boy Meets Girls, like a number of other rock and pop shows such
as *Wham!* (ABC-TV) and *Drumbeat* (BBC), with its resident
singer Adam Faith, failed to build an audience and soon ceased
transmission.

Whilst the impact of *Oh Boy!* undoubtedly stimulated other
television programmes devoted to British rock and pop music,
its frenetic pace and emphasis on live performance was not copied
by them. The personal conflicts between producer Jack Good
and impresario Larry Parnes epitomized the problematic issue
of control, behind which lay wider questions of institutional
relationships between different branches of the cultural and enter-
tainment industries. It also raised the question of how television,
situated as it was within its specific institutional framework and
determinants, was going to deal with that articulation of 'authen-
ticity' which was circulated by rock in the 1950s and 1960s. Put
simply, when considered on the one hand in its relationship with
the music and record industry and, on the other hand, with the
teenagers who bought the products of the industry and had strong
affective investments in what the music represented for them,
what was television for?

Whilst the live performances on *Oh Boy!* resonated 'authentic-
ity' and clearly appealed to a teenage audience, there was too
much potential commercial slippage involved. For reasons which
were partly different and partly coincident, both television and the
music industry preferred control, preferred to obey what Laing
has called 'the higher objectivity of the market'.[53] Though the
tensions between the 'authenticity' of youth culture and its music
and the commodification of the products associated with that
culture consistently reveal themselves in television music
programmes, the institutional preference for the ideologically safe
and the commercially successful was always visible. The institu-
tion of television was there to direct and encourage the direction
of that commercial success. Throughout the 1960s, 1970s and
1980s, the discourse of authenticity was to be articulated in a
series of television shows which claimed to speak directly to the

youth audience. Usually, despite their often considerable appeal to the youth audience and their cultural significance, such programmes attracted what were in television terms small audiences and were taken off the air, whilst the more avowedly commercial shows continued to attract large audiences, ensuring their televisual longevity.

Television and the public iconography of pop in the 1960s

One of the most important television pop shows to negotiate its way between the subcultural appeal to 'authenticity' and the commercial imperatives of the institutional apparatus was *Ready, Steady, Go! (RSG!)*. Produced by Rediffusion for the independent network, *RSG!* began transmissions in August 1963. Whilst it is right to argue, as Hill does, that the show marked a swing 'back in favour of the youth audience',[54] the series was instrumental in conflating popular music with commodified fashion and style and, at the same time, promoting the growing power of mediated pop music through film and television. George Melly remarked how the influence of television on teenage fashion was visible at this period, noting that when touring in the 1950s, 'fashions took an almost incredible time to spread … *RSG!* changed all that. It made pop work on a truly national scale.'[55] Again, the influence of television in helping to construct the importance of a public iconography, of the look of popular music, is evident. For Chambers, *RSG!* was a national showcase for youth culture in early 1960s Britain:

> Nicknamed the 'Mecca for Mods', *RSG!* seemed the unique television programme, both then and since, to have had its finger on the pulse of an important part of teenage Britain. The bland greyness of the adult world so obviously in control of *Juke Box Jury* was temporarily displaced by the imposition of a decisive youth style.[56]

Writing elsewhere, Chambers argues that one of the effects of the programme was that 'British youth culture went public':

> Pop culture and images of youth began to enter areas from which they had previously been excluded: the 'quality' press and Sunday colour supplements; later, 'high brow' late-night viewing on BBC-2. More obvious class and cultural lines, such as those which had excluded the

Teds and rock'n'roll music in the 1950s, were blurred in an expanding taste for the catchy songs of the Beatles and the more fashionable icons of the moment, Biba, Mary Quant, Twiggy.[57]

Many of the performances on *RSG!* were live, an approach actively demanded by Musicians' Union policy, and the programme's format emphasized an apparent spontaneity. Compères Cathy MacGowan and Keith Fordyce spoke live and direct to camera and conducted interviews with studio guests who discussed music and fashion. All this took place amongst a live studio audience who surrounded compère, guest and performers, and who booed and hissed loudly when, for example, on one show Keith Fordyce announced that American star Brenda Lee would not be appearing.

However, not all performances were live, even after the temporary success of the Musicians' Union in April 1965, and artists such as Lulu, Dusty Springfield and Them mimed to records. Moreover, many of the interviews were clearly designed primarily to promote new record releases. For example, P. J. Proby was asked briefly about making the demonstration tapes for Elvis Presley films, before his newest release, 'Hold Me', was played on air; the record entered the charts at number fifteen some weeks later on 20 June 1964. In the same edition of *RSG!* live performances from Jerry Lee Lewis and the Rolling Stones were preceded by a four-minute promo feature for United Artists' *A Hard Day's Night*, featuring what the narrational voice in the promo termed those 'whimsical wonders' the Beatles. Like *RSG!* itself, where television cameras were often deliberately in shot, the promo foregrounded the technologies of contemporary pop production, implicating the audience in the increasingly mediated world of popular music, fandom and consumption. As with the Hollywood musical, where the 'work' of cultural production – 'putting on the show' – is acknowledged and accommodated within its textual strategies, here the 'work' of musical and television production and of 'stardom' is also foregrounded. Transmitted on early Friday evenings, *RSG!*, with its opening announcement 'The weekend starts here', served an important function in delineating, at a time of nearly full employment, that 1960s prime cultural space for teenage consumption, whether of records, clothes or the media themselves.

Whilst the differences in format, style and address between
RSG! and the BBC's long-running *Juke Box Jury* are evident,
the rationale for their existence share much in common. In their
different ways, both programmes helped position rock and pop
within a wider and growingly complex discourse of commodified
entertainment, a process evident even in children's programmes
of the period such as *Crackerjack!* and *Pops and Lenny,* which
regularly had chart singers and bands in guest appearances. Based
on an American format, *Juke Box Jury* was originally transmitted
on Monday evenings at 7.30 p.m. from June 1959, but switched
to an early Saturday evening slot in August that year. The show
rapidly built a large audience, which by early 1962 had reached
twelve million, clear vindication of the desire to offer a pop-music
programme which appealed both to a teenage and family
audience. During the programme's relatively long life, until it
ceased being broadcast in 1967, the records reviewed by the panel
of guests increasingly played second place to the personalities of
the panel members themselves, many of whom proved wholly
unsympathetic to popular music. As an entertainment format,
it worked well. Its insistent coding of those conflicts which were
being experienced on a daily basis by teenagers and their families
spoke in different ways to the various constituencies which
made up the audience. In this sense, *Juke Box Jury* exercised a
crucial influence in implicating not just those teenagers who
were already disposed to the cultural economy of popular music
and the habits of record purchase, but also an older generation
whose resistance was overcome precisely through the process
of offering a cultural space in which that resistance could be
articulated and then, because the same process occurred week
after week, accommodated. For younger viewers, the apparent
random nature of the records which were reviewed, together
with the pleasures associated with the appearance of a guest
celebrity artist whose identity was revealed to viewers but not,
until they had cast their verdict, to the panel, created a state of
anticipated, impending and unsated satisfaction long before the
advent of MTV.

In a sense, this process of anticipating success or failure
was more radical and less controlled than the format which came
to dominate one subgenre of music television in programmes
such as *Top of the Pops* and, in the 1980s and 1990s, *The Chart*

Show (Yorkshire TV) and *The Pepsi Chart Show* (Channel 5). In a statement which revealed the tensions between the appeal to 'authenticity' which *RSG!* seemed to represent and the demands for good television ratings, the first producer of the BBC's *Top of the Pops*, Johnnie Stewart, dismissed the appeal of *RSG!* because it was 'a kid's show for what is really a minority audience':

> Although the BBC had a variety of popular shows, like *Juke Box Jury* for instance ... there was nothing with the regularity of Ready, Steady, Go! operating at that time ... We decided that it was time that we had a pop show to reflect the most popular records of the day.[58]

Originally broadcast from the BBC's Manchester studios, *Top of the Pops* was given an initial trial run of six programmes, beginning on 1 January 1964. Its obvious success with viewers and with the record industry, who recognized its promotional value, ensured the continuation of the programme, and in 1967 it relocated to the BBC studios in London. More sophisticated graphics notwithstanding, the programme has retained its basic format and is still being broadcast.

In his autobiography, Pete Murray recounts a phone call from Decca's Beecher Stevens asking to play Decca's version of 'Volare' sung by the McGuire Sisters. He refused, and although there were four versions of the song (by Dean Martin, Domenico Modugno, Charlie Drake and the Marino Marini Quartet) in the *NME* chart in October 1958, the McGuire Sisters and Decca did not have a hit with their version.[59] Whilst there is thus some evidence that record companies applied pressure on BBC radio presenters to play their records, the commitment through *Top of the Pops* to reflect and reify commercial popularity deflected the need for outright and obvious commercial pressure, something which, as we have seen, the BBC had traditionally regarded with deep suspicion. This commitment to 'reflect the most popular records of the day' presented some problems for the show, but stimulated the demand for filmed clips and taped performances. Whereas appearances on *Oh Boy!* had usually been determined through negotiated contracts with artist managers such as Larry Parnes whether or not that artist was currently enjoying chart success, the formula adopted by *Top of the Pops* meant that appearances on the programme were determined by record success in that week's chart. To ensure that current chart success was reflected

in the programme, it was necessary to think of ways in which to visualize artists and bands who were not available for 'live' appearances. Producer Stewart explained his formula for choosing which artists and bands to present on the programme:

> It was so simple – rule Number One was that we only put a record on the show if it went up the charts that week. If a record was going down, to me it was dead. And rule Number Two, we always, and I mean always, ended up with the No. 1 record. If we couldn't get the act in the studio then we'd show a film or a still – anything in fact as long as we played the No. 1 record. For instance, in the first show The Beatles were in America, so I put their No. 1 'I Want To Hold Your Hand' over some news clips – there's always a way.[60]

In addition to the news compilation used for the Beatles, the first show used film of Cliff Richard and the Shadows, as well as of Freddie and the Dreamers. Whilst the show coincided with the dominance of British singers and bands in the charts in the early and mid-1960s, making 'live' appearances more likely, increasing use was made of film clips, shot either when an act was on tour, or prepared especially in anticipation of chart success.

New technology and the growth of promo clips in the visual economy of popular music

This growing use of promotional clips in the mid-1960s, not just on *Top of the Pops* but on other television shows eager to reflect and exploit chart popularity, represents a significant moment in the visual economy of popular music and clearly anticipates the development of music video from the mid-1970s onwards. It occured at a time when both film and video technology made significant advances, with a reduction in cost and increase in availability. Noting the development by Ampex in 1956 of the first broadcast-standard video recorder and subsequent technological developments by Japanese manufacturers, Armes writes that 'Within broadcasting, video's role largely parallels that of sound tape within radio. It has served to turn ... television programmes into commodities to be bought and sold between networks and across national boundaries.'[61]

This facilitation of visual material as commodity was to have a profound effect on the market for popular music. Though it

become evident in the 1980s with the advent of sell-through video for domestic consumption as well as being important as programming material, it enabled sales of prerecorded performances to television to become increasingly significant from the mid-1960s onwards.

This shift towards the use of promo clips was clearly signalled in the early career of the Beatles. Their television debut was on Granada TV's regional magazine programme *People and Places* on 17 October 1962, singing 'Some Other Guy' and 'Love Me Do' live. On subsequent regional television shows such as Granada's *Scene at 6.30*, Television Wales and the West's (TWW) *Discs a Gogo*, and Scottish Television's magazine programme *Roundup*, they mixed live and live-but-mimed appearances, until demand for their appearances proved too great. In fact, they had taped two songs prior to transmission for their second appearance on Granada's *People and Places* in October 1962, and by the time they appeared on nationally networked TV for ABC's *Thank Your Lucky Stars* in January 1963, taping in advance was becoming the norm within television pop shows.

Following their experience filming for the BBC documentary *The Mersey Sound*, directed by Don Haworth in 1963, the success of *A Hard Day's Night* and *Help!*, and the taping of *The Music of Lennon & McCartney* for Granada in November 1965, the group decided to produce and videotape a series of promotional video clips with the effect, as Lewisohn puts it, of 'heralding the dawn of pop's promo-video age'.[62] Both *Top of the Pops* and *Thank Your Lucky Stars* made use of the promos, which were also first used in the United States on *Hullabaloo* in January 1966. Neaverson considers that the promos

> occupy a unique position in television history for a number of reasons. They were the first independently produced pop films to be made and distributed specifically for the international market, anticipating the beginning of contemporary pop video. Moreover, while their ultimate *raison d'être* (to allow the Beatles total control over their image and to be seen simultaneously all over the world) closely mirrors the group's move into feature films, so too does their form.[63]

Whilst the promos were significant in breaking with the dominant performance aesthetic which prevailed in the majority of contemporary television pop programmes and for the way in which they

explore the relationship between diegetic and non-diegetic perfor-
mance, they were far from being original in this, as we have shown
in earlier chapters looking at the Hollywood musical and the
Soundies of the 1940s. However, they clearly did offer liberation
from the limited set of codes and conventions which television
had developed in its attempt to offer visual representation of
popular music and its performers, 'authentic' or otherwise.

Arguably, much of the significance of the promos lies in their
dawning recognition of the increasingly global reach of the market
for pop product and their awareness of the power of television and
film to define, construct and position product for this market.[64] It
could be argued that even as late as the mid-1960s, the pop
product was still essentially the audio experience delivered either
on record or radio. However, what the Beatles' attempt to exercise
both artistic and commercial control over their image signified
was a recognition that pop product increasingly implied and relied
upon the realm of the visual, whether through live performance or
the mediating processes of film and television.

Consolidation of commercial interests in the 1960s and 1970s

Moreover, the attempt to 'author' and control promotional mate-
rial does reflect a profound shift in the business complexity of the
music industry in the 1960s. Though independent labels had
taken a significant share of the market in America between 1956
and 1959 and had encouraged musical innovation, the major
labels, including Warner and MGM, reasserted their market share
between 1959 and 1963 as they acknowledged rock was more
than a passing fad and signed a growing number of artists and
bands. The convergence between the film industry and the music
industry was consolidated at this period as Warner bought
Reprise, United Artists bought Liberty and Paramount bought
Dot. However, both in America and Britain, the mid-1960s were
marked by the presence of a growing number of different labels
which enjoyed commercial success. In America in 1956, twenty
firms had Top Ten hits, with ten of them having only one hit; in
1962, forty-one firms had Top Ten hits, with twenty of them
having only one hit. By 1970, however, the dominance of the

major firms had been reasserted with, in 1971, only twenty-one firms enjoying Top Ten commercial success, and only five of those having one hit.[65]

Songwriter-performers such as the Beatles attempted to combat established power relationships and to redress imbalances in the financial rewards generated by the industry during this period of relative commercial turbulence. The creation of Apple Corps Ltd was intended to overcome what was for the group the painful lessons learnt following the sale of Northern Songs Ltd to ATV Music in 1967, backed as it was by the big City financial institutions. As Tremlett argues, 'in the creation of Apple Corps Ltd [the Beatles] intended to alter the shape of the music industry. In that they failed'.[66]

In fact, the process of industrial convergence was intensifying through the 1960s, as the relationship between small independent companies and the corporates was increasingly symbiotic rather than oppositional. Simon Frith argues that even by the 1950s the word 'independence' had lost much of its meaning for the record industry, given the dependence of small companies on major companies to press and then distribute their products.[67] Whilst the large companies looked to small companies for innovatory product, through the late 1960s and 1970s the power of the major companies increased considerably. Writing in 1980, Dave Harker could look back on the growth of EMI (Electrical and Musical Industries) during this period through the interests of one of its directors, Bernard Delfont:

> if you read the *TV Times*, buy Pye, Marble Arch, Regal, Columbia, Parlophone, HMV, Pathe, Music for Pleasure, or Odeon records; if you watch ATV or Thames Television, go to The Talk of the Town, the London Palladium, Victoria Palace, Hippodrome, Her Majesty's, Globe, Lyric, Apollo, or Prince of Wales theatres; if you go to one of ABC's 270 cinemas or twelve bowling alleys or one of Ambassador's ten bowling alleys, then Bernard Delfont has an interest in what you are doing.[68]

Though the ITA were able to take regulatory action in 1971 to redress what it saw as an imbalance of ownership power, for over two years EMI had effective control over Thames Television, itself a product of the merger of Rediffusion and ABC Television in 1968, when EMI acquired a majority shareholding in ABC's

parent company, the Associated British Picture Corporation, in 1969. Throughout the 1970s, when it was taken over by Thorn to form Thorn-EMI, the company had extensive and growing interests across the range of the entertainment business, including extensive record and music publishing interests.[69] It is against this background that the attempt by the Beatles to establish control over their output and image, and the failure of that attempt, needs to be read.

Television and the youth audience in the 1970s and 1980s

Whilst it is clear that the business priorities of the major entertainment companies with interests in music and records were best served by strategies which exploited the commercial potential of the popular, it was also the case that the limitations in the number of available broadcasting hours in Britain and elsewhere militated against innovation and diversity. However, both the regional nature of the companies which made up the Independent Television (ITV) network and the opening of BBC2 in 1964 and Channel 4 in 1982 did provide some opportunities to provide programming which appealed to young people who were interested in popular music not represented on more mainstream shows. The creation of BBC2 not only provided additional broadcasting hours, but was intended to speak to a different, less mainstream, less metropolitan audience. For a period in the 1970s following its first broadcast on 21 September 1971, *The Old Grey Whistle Test*, presented by 'Whispering' Bob Harris, managed partially to reflect the growing diversity of popular music and fragmentation of audience tastes, addressing those who took their music seriously and saw rock as essentially anti-commercial. It was a requirement that artists appearing on the show must have had at least one album to their credit, reflecting the programme's intended appeal to those for whom album-orientated rock connoted an 'authenticity' which was in sharp contrast with pop chart success. As Longhurst puts it:

> Pop was singles and chart success, rock was albums and serious. It is important to recognize that the distinction was not necessarily built around the size of the audience. The rock groups sold lots of albums, but their 'serious' intent and content seemed to protect them from the criticism of 'selling out'.[70]

To an extent, the format and content of *The Old Grey Whistle Test* built upon the success and appeal of late 1960s films such as *The Graduate* (1967) and *Easy Rider* (1969) which had used rock soundtracks to mark out that soft-political territory of the counter-culture, to code a specific cultural 'authenticity' for educated young people grappling with issues of personal and cultural identity during a period when the public face of corporate capital was increasingly visible, not least through the products they themselves wished to purchase most.

Regional ITV companies also managed to address a youth audience whose interests in music lay outside the commercial, chart-orientated mainstream, in programmes such as Tyne Tees' *Alright Now* and Granada's *So It Goes*, the latter a series of nineteen programmes first transmitted in July 1976 and presented by Anthony Wilson, who owned the independent Factory Records based in Manchester. Exploiting the franchise obligation to provide regional programming, *So It Goes* was one of a tiny minority of television programmes to present punk rock in anything other than alarmist terms, and provided an additional forum to challenge the commercial assumptions about the meaning of popular music by showcasing bands in the ten *So It Goes Concerts* broadcast by Granada in 1977.

Such programmes were the exception within an institutional regime which, when it did pay attention to youth and popular music, perpetuated the popular and the commercial and failed to address issues of commodified lifestyle through which young people were increasingly defining their own sense of difference. Ironically, though television had contributed to the creation and importance of a public iconography of youth, with few exceptions including *So It Goes*, it proved largely unable to cope with those signifying excesses which marked punk music in the mid-1970s. As Savage makes clear, the origins and development of punk are complex and still a matter of critical dispute.[71] However, whether punk is regarded as an attempt to return to musical and cultural 'white roots', or as some playful and ironic expression of the icons of authenticity, it is clear that it represented a turning point in the relationship not just between different musical styles and genres, a blurring between mainstream and margin, but also between young people and the channels of contemporary representation. As Chambers puts it, punk 'turned the attention of subsequent

youth culture to the actual mechanisms of representation: the codes themselves'.[72]

Although this significant shift in the relationship between young people and the channels of representation and discourse was not fully understood in the late 1970s, there was clearly pressure for change in the ways in which television dealt with young people and the place of popular music in their lifestyle:

> Pressure for distinctive youth programmes had grown in the late 1970s; essentially this came from a radical perspective that argued that television presented a limited view of young people and their everyday experience. The arguments for change focussed on two factors ... it was argued that the existing presentation of young people and their concerns on television was inadequate. Programmes like *Top of the Pops* and *The Old Grey Whistle Test* were out of touch, reflecting conservative assumptions about audience interests, and new programmes were badly needed. This feeling was accompanied by a nostalgia for old programmes such as *Ready Steady Go!*.[73]

This was to lead to programmes such as *Reportage* (BBC) and *Network 7* (Channel 4) which located music within the wider context of lifestyle, and which refused notions of rock and pop, of the 'authentic' and the 'commercial', as being in opposition. For a brief though significant period in the 1980s, *The Tube*, produced by Tyne Tees for Channel 4, revealed television's ability to address a youth audience in terms which that audience itself recognized and understood. The Annual Report for the Independent Broadcasting Authority (IBA) for 1982–83 noted the specific appeal of the programme in terms of its 'authenticity' and 'spontaneity', terms which had been used earlier about *Ready, Steady Go!*:

> *The Tube*, produced by Tyne Tees Television, and going out live on Friday evenings for one-and-three-quarter hours, has been topical and popular. The fact of being live has been a considerable attraction, giving it an authenticity and spontaneity to which the programme's presenters have also contributed a great deal. In musical terms the series has been concerned not simply to feature the most popular bands, but also to introduce up-and-coming groups, something which a weekly research exercise ... has shown to have been appreciated by the audience.[74]

Despite its popularity, *The Tube* was temporarily replaced in early 1983 by an hour-long live programme, *Switch*, which proved less

popular. Noting its return, the Annual Report of the IBA for 1983–84 acknowledged the ability of *The Tube* to address a youth audience but issued a veiled warning about the show:

> The Tube has consolidated its deserved success as a lively and entertaining rock show, something which was convincingly demonstrated by its ability to hold a large audience for five hours in a special show, *A Midsummer Night's Tube* on 24 June. At times *The Tube* has appeared to be uncomfortably scheduled at 5.30–7 p.m. and there have on occasions been problems about the programme's suitability for family viewing. Placed where it is, the show must reconcile itself to these requirements.[75]

It is quite clear that whilst Malcolm Gerri and other producers responsible for *The Tube* understood the sea change that was underway, the IBA did not. In much the same way, though it aroused considerable hostility from the British press, *The Word*, first broadcast in 1990, placed music within a magazine format which itself addressed issues of concern to the audience it spoke to, before controversy proved too much and the series was wound up. More recent attempts by terrestrial television to address specific audiences through music television, such as Channel 4's *Flava* (which began broadcasting in 1997), have met with little success. At the end of the century, popular music on British terrestrial television remains dominated by the chart-oriented formats epitomized by *Top of the Pops* and *CDUK*, appealing to the new demographics of the audience for popular music.

In a sense, it would be surprising if this was not the case. Much of the argument here so far has been to suggest the role of the screen media in erasing distinction and difference, and those agencies which wish to promote these. There is clearly justification for maintaining, as Shuker does, that

> A contradictory relationship has traditionally existed between television and rock. Television is traditionally a medium of family entertainment, collapsing class, gender, ethnic and generational differences ... Rock, in contrast, has traditionally presented itself as being about 'difference', emphasising individual tastes and preferences.[76]

The argument here is that the relationship between television and rock is no longer in any sense contradictory. The ability of television and its mediation of popular music to construct imagined

global communities was apparent in the 1985 Live Aid concert, in which TV linked Wembley Stadium in London and the JFK Stadium in Philadelphia, and in the 1988 Nelson Mandela concert. The institution of television has changed profoundly, not least in its transformation from broadcasting to narrowcasting. Moreover, as I shall argue further in the concluding chapter, notions of a rock formation which connotes opposition or difference seem no longer valid. Of course, many young people continue to regard *Top of the Pops* as 'domestic, familial and tame', but this does not indicate a wider antagonism to contemporary television itself. In analysing British rave culture and its relationship to the media, Sarah Thornton argues:

> British youth subcultures aren't 'antitelevision' as much as they are against a few key segments of TV that expose subcultural materials to everybody else. The general accessibility of broadcasting (as opposed to narrowcasting) is at odds with the esotericisms and exclusivities of club and rave culture. It too widely distributes the raw material of youth's subcultural capital.[77]

Interestingly, Thornton argues that MTV and ITV's *The Chart Show* do not have the same negative connotations as *Top of the Pops* because they are 'sufficiently narrowcast to escape negative symbolization'[78] and because they rely on music video for their content (although note that *The Chart Show* finished broadcasting in 1998).

Whilst wishing to avoid a crude teleological determinism, I would argued that film and television have done their work. They have proved the point that they are inextricably bound up with defining the meaning of popular music, that they are structurally and ideologically bound up with the popular music industry and those commercial enterprises through which we receive, interpret, delight in or reject our music. This reiterative process, the all-embracing pervasive nature of entertainment consumption, has eradicated even the central notion of 'youth-as-difference', eradicated that ideological platform which used to define 'youth'. As Redhead puts it, '"Youth television" … is fast becoming the new international pop style created by television and advertising discourses for the whole potential audience, irrespective of age'.[79]

Whilst this process is complex, it owes much to the technological developments which have resulted in an increasingly

sophisticated manipulation and exploitation of what I want to term the musical commodity. In attempting to analyse the contemporary state of 'rock', Grossberg reiterates the point that what he terms 'the rock formation' has always depended on popular music's location within a specific set of social and cultural practices. In this sense, the rock formation has a specificity fashioned by particular conditions, opportunities and responses. As Grossberg argues:

> These conditions not only enabled rock, but also constrained it, setting limits on its shapes and effects. But if the rock formation has a beginning, it is also possible that it has an end or at least, a trajectory of disappearance.[80]

My argument is that the transformations in the media economy, most powerfully and significantly in its visual regime, have altered not just the market for the musical commodity, but the very nature of that musical commodity. In discussing the contemporary reconfiguration of the music industry, Grossberg detects a profound shift:

> I do want to suggest that the ratio of sight and sound has already changed significantly. The visual (whether MTV, or youth films or even network television, which has, for the first time since the early 1960s, successfully constructed a youth audience) is increasingly displacing sound as the locus of generational identification, differentiation, investment and occasionally even authenticity ... As a result, the rhythms of both visual imagery and music have changed, the music as it were having adapted to television's beat.[81]

Whilst Grossberg is surely right in asserting that the balance between sound and sight has been profoundly altered in recent years, specifically with the growth and significance of film, television and video, the overall argument of this study is that sight and sound have co-existed throughout the twentieth century, and that any consideration of the meanings of popular music from the late 1920s onwards necessitates a consideration of its articulation through the visual regime, in particular the moving images we see on film and the small screen.

In the concluding chapter, I want to examine the transformation of the musical commodity through an examination of music video, MTV and the use of popular music in contemporary film.

Whilst the argument here is that popular music throughout the twentieth century has to an extent relied for its meaning on what Grossberg terms 'other mattering maps', it is important to take note of the specific configurations and alliances which characterize the business of popular entertainment and its consumption at the end of the century. In considering the development of music video in the 1980s, the institutional and commercial determinants which have influenced this development, its reliance on technological innovation and the enthusiasm which has characterized its public reception, it is important to recognize not just specific differences, but also significant continuities with the history of popular music on screen.

However, whilst arguing for its distinctiveness as cultural form, it seems important to recognize that the development of music video during the 1980s and 1990s represents a continuation in the growth of the visual economy of popular music, drawing upon and extending those representational strategies which have been employed in screening popular music throughout the twentieth century. Significantly, the rapid evolution in the ways in which music video clips were used and packaged by television offers curious echoes of the rapid changes in the public exhibition of early film in the late nineteenth and early twentieth centuries. Arguably, the dedicated television channels, notably MTV, represent the institutional changes. Equally, the reception of music video by viewers, excited by its freshness and novelty, offer echoes of the public reception of early cinema over a hundred years ago.

Notes

1 R. Middleton, *Studying Popular Music* (Milton Keynes, Open University Press 1990), p. 85.
2 T. Balio (ed), *Hollywood in the Age of Television* (London, Unwin Hyman, 1990), p. 17.
3 J. L. Baughman, 'The weakest chain and the strongest link: the American Broadcasting Company and the motion picture industry 1952–60', in Balio (ed.), *Hollywood in the Age of Television*, pp. 91–114. Baughman states that 'By the late 1950s, all of the major motion picture studios produced television programs. The movie colony had become television town.'

4 Balio, *Hollywood in the Age of Televsion*, p. 37.
5 W. Boddy, '"The shining centre of the home": ontologies of television in the "golden age"', in P. Drummond and R. Paterson (eds), *Television in Transition: Papers from the First International Television Studies Conference* (London, British Film Institute, 1985), p. 132.
6 Parts of the British cinema industry involved in Scophony, the business concern which had installed large-scale television apparatus in cinemas during the war years, were naturally opposed to the BBC's operation of a television service.
7 A. Briggs, *The History of Broadcasting in the United Kingdom Vol. IV: Sound and Vision* (London, Oxford University Press, 1979), p. 213.
8 B. Paulu, *Television and Radio in the United Kingdom* (London, Macmillan, 1981), p. 55.
9 Briggs, *The History of Broadcasting Vol. IV*, p. 263.
10 M. Crozier, *Broadcasting: Sound and Television* (London, Home University Library, Oxford University Press,1958), p. 93.
11 A figure given in evidence at the House subcommittee investigation into 'payola' and cited by Donald Clarke, *The Rise and Fall of Popular Music* (London, Penguin, 1995), p. 421.
12 C. Gillett, *The Sound of the City* (London, Sphere, 1971), p. 238.
13 S. Frith, *Sound Effects: Youth, Leisure, and the Politics of Rock'n'Roll* (London, Constable, 1983), p. 153.
14 Frith, *Sound Effects*, p. 11.
15 P. Wicke, *Rock Music: Culture, Aesthetics and Sociology* (Cambridge, Cambridge University Press, 1990), p. 114.
16 E. Ward, G. Stokes and K. Tucker, *Rock of Ages: The Rolling Stone History of Rock and Roll* (London, Penguin, 1987), p. 156.
17 Unattributed quote in M. Shore, *The Rolling Stone Book of Rock Video* (London, Sidgwick and Jackson, 1985), p. 27.
18 D. Wade and J. Picardie, *Music Man: Ahmet Ertegun, Atlantic Records and the Triumph of Rock'n'Roll* (New York, W. W. Norton, 1990), p. 91.
19 Ward *et al.*, *Rock of Ages*, p. 160.
20 Wicke, *Rock Music*, p. 117.
21 E. Ward *et al.*, *Rock of Ages*, p. 167.
22 D. Diehl, 'The oldest living teenager' (*TV Guide*, February 1970), in J. S. Harris, *TV Guide: The First Twenty Five Years* (New York, Simon and Schuster, 1978), p. 164.
23 Ward *et al.*, *Rock of Ages*, p. 155.
24 Ballard was a member of the Royals, who first recorded in 1952. Their record 'Work With Me, Annie' was denounced by both *Billboard* and *Variety* for its suggestive lyrics and was actually banned by a number of black radio stations, including the influential WDIA

in Memphis. Ballard's version of 'The Twist', on the King label, entered the *Billboard* R&B chart on 6 April 1959.

25 J. Dawson, *The Twist: The Story of the Song and Dance that Changed the World* (Boston MA, Faber and Faber, 1995), p. 111.

26 Dawson, *The Twist*, pp. 119–20.

27 P. Hardy and D. Laing, *The Faber Companion to 20th-Century Popular Music* (London, Faber and Faber, 1992), p. 286.

28 M. Lewisohn, *The Complete Beatles Chronicle* (London, Chancellor Press, 1992), pp. 144–7. The Beatles never appeared in person on Dick Clark's *American Bandstand*, though they recorded a filmed interview for the 'all-Beatle program' which went out on 10 October 1964.

29 L. Grossberg, *We Gotta Get Out of This Place: Popular Conservatism and Postmodern Culture* (New York, Routledge, 1992), p. 177.

30 Grossberg, *We Gotta Get Out*, pp. 227–8.

31 M. Shore, *The Rolling Stone Book of Rock Video*, p. 30.

32 A. Durant, *Conditions of Music* (London, Macmillan, 1984), p. 192.

33 Paulu, *Television and Radio in the United Kingdom*, p. 170.

34 Briggs, *The History of Broadcasting Vol. IV*, p. 718.

35 A. Briggs, *The History of Broadcasting in the United Kingdom Vol. V: Competition* (Oxford, Oxford University Press, 1995), p. 228.

36 Briggs, *The History of Broadcasting Vol. V*, p. 760.

37 Briggs, *The History of Broadcasting Vol. V*, p. 758.

38 J. Hill, 'Television and pop: the case of the 1950s', in J. Corner (ed.), *Popular Television in Britain: Studies in Cultural History* (London, British Film Institute, 1991), p. 91.

39 *Radio Times*, 22 February 1957, p. 4, cited in Hill, 'Television and Pop', p. 105.

40 P. Murray, *One Day I'll Forget My Trousers* (London, Everest Books, 1976), p. 119.

41 Hill, 'Television and pop', p. 93.

42 Briggs, *The History of Broadcasting Vol. V*, pp. 203–4.

43 Briggs, *The History of Broadcasting Vol. V*, p. 204.

44 *BBC Handbook 1959* (London, British Broadcasting Corporation, 1959), p. 99. Ironically, by the time the *Handbook* was available, *Six-Five Special* had been replaced by a new programme aimed at young people, *Dig This*, in January 1959. The latter show was discontinued in March that year.

45 B. Sendall, *Independent Television in Britain Vol. 1: Origin and Foundation, 1946–1962* (London, Macmillan, 1982), p. 33. The recommendation was that not less than 80 per cent of the programmes transmitted by any television station should be British.

46 Sendall, *Independent Television Vol. 1*, pp. 73–84.

47 For further critical comment, see J. Hill, *Sex, Class and Realism: British Cinema 1956–1963* (London, British Film Institute, 1986), pp. 68–126 and A. Lovell, 'Free cinema', in A. Lovell and J. Hillier, *Studies in Documentary* (London, Secker and Warburg in association with the British Film Institute, 1972), pp. 133–67.

48 Sendall, *Independent Television Vol. 1*, p. 321.

49 Hill, 'Television and pop', p. 96.

50 Briggs, *The History of Broadcasting Vol. V*, p. 205.

51 S. Turner, *Cliff Richard: The Biography* (Oxford, Lion, 1994), p. 130.

52 Hill, 'Television and pop', p. 101.

53 D. Laing, *The Sound of Our Time*, 1969, quoted in I. Chambers, *Urban Rhythms: Pop Music and Popular Culture* (London, Macmillan, 1985), p. 53.

54 Hill, 'Television and pop', p. 103.

55 G. Melly, *Revolt Into Style* (London, Penguin, 1970), p. 170.

56 Chambers, *Urban Rhythms*, p. 76.

57 I. Chambers, *Popular Culture: The Metropolitan Experience* (London, Routledge, 1986), p. 159.

58 S. Blacknell, *The Story of* Top of the Pops (Wellingborough, Thorsons in association with the BBC, 1985), p. 16.

59 Murray, *One Day I'll Forget My Trousers*, p. 128.

60 Blacknell, *The Story of* Top of the Pops, p. 18.

61 R. Armes, *On Video* (London, Routledge, 1988), p. 83.

62 Lewisohn, *The Complete Beatles Chronicle*, pp. 206–8. The group recorded ten promos, including 'Day Tripper', 'Help!', 'Ticket to Ride' and 'I Feel Fine', on two-inch, black-and-white video tape at a total cost of £750.

63 B. Neaverson, *The Beatles Movies* (London, Cassell, 1997), p. 40.

64 It is important to remember that whilst American and British television occupied the foreground, popular music television was in the process of development elsewhere. For a concise account of developments in music television in Australia from the mid-1950s on, see S. Stockbridge, 'Programming rock'n'roll: the Australian version', *Cultural Studies*, 3:1 (January 1989) 73–88.

65 See B. Longhurst, *Popular Music and Society* (Cambridge, Polity Press, 1995), p. 31 and R. Shuker, *Understanding Popular Music* (London, Routledge, 1994), pp. 46–7.

66 G. Tremlett, *Rock Gold: The Music Millionaires* (London, Unwin Hyman, 1990), p. 129.

67 S. Frith, *Sound Effects*, p. 138. For further discussion on the relationship between industrial stucture and musical product, see Keith Negus, *Popular Music in Theory* (Cambridge, Polity Press, 1996), pp. 39–50.

68 D. Harker, *One for the Money: Politics and Popular Song* (London, Hutchinson, 1980), p. 91.
69 For further details of the formation of Thames Television and other companies see Jeremy Potter, *Independent Television in Britain Vol. 4: Companies and Programmes 1968–80* (London, Macmillan, 1990).
70 Longhurst, *Popular Music and Society*, pp. 109–10.
71 J. Savage, *England's Dreaming: Sex Pistols and Punk Music* (London, Faber and Faber, 1991).
72 Chambers, *Popular Culture*, p. 172.
73 M. Dunford, 'Organisational change and innovation in youth programming' in G. Mulgan and R. Paterson (eds.), *Reinventing the Organisation* (London, British Film Institute, 1993), p. 60.
74 IBA, *Annual Report and Accounts 1982–83* (London, Independent Broadcasting Authority, 1983), p. 22.
75 IBA, *Annual Report and Accounts 1983–84* (London, Independent Broadcasting Authority, 1984), pp. 21–22.
76 Shuker, *Understanding Popular Music*, p. 171.
77 S. Thornton, 'Moral panic, the media and British rave culture', in A. Ross and T. Rose (eds), *Microphone Fiends: Youth Music and Youth Culture* (London, Routledge, 1994), p. 180.
78 Thornton, 'Moral panic', p. 181.
79 S. Redhead, *The End-of-the-Century Party: Youth and Pop Towards 2000* (Manchester, Manchester University Press, 1992), p. 9.
80 L. Grossberg, 'Is anybody listening? Does anybody care? On 'the state of rock', in Ross and Rose (eds), *Microphone Fiends*, p. 41.
81 L. Grossberg, 'Is anybody listening?' pp. 54–5.

7

I want my MTV …
and my movies with music

I have a very large television in my bedroom and the first thing I do
when I wake up at 7.30 a.m. is switch on MTV. Then I switch over to
the news …

<div align="right">Jean-Paul Gaultier</div>

MTV … brings a rock sensibility to television … it makes television
musical.

<div align="right">Andrew Goodwin, Dancing in the Distraction Factory, 1993</div>

The MTV concept has become an international institution of youth
culture … The network's unique programming elements, innovative
graphics and irreverent on-air presentation have left an indelible
imprint on movies, television, advertising, music and fashion.

<div align="right">MTV UK press dossier 1994</div>

The filmmakers assembled spectacular images that evoked the story
rather than telling the story in and of itself; indeed, images jumped
from high point to high point with crucial causal connections left
unarticulated.

<div align="right">Charles Musser, The Emergence of Cinema, 1994</div>

As we have seen, popular music has enjoyed a long, if evolving,
relationship with the screen media for over a hundred years.
Beginning with pre-cinematic illustrated songs and with musical
accompaniment to so-called 'silent' film, through to the develop-
ment of short film clips of musical performers which in turn led
to the complex and powerful interaction between popular music
and moving image in the Hollywood musical, followed by the
exploitation of popular music both on television and in the cinema

from the 1950s onwards, producers and directors have developed textual strategies for representing and incorporating popular music and its performers within the visual regime.

Driven by an over-riding concern to maximize the profit potential of successive new technologies of leisure and entertainment, companies and organizations throughout the twentieth century have consistently sought ways in which to promote what might be termed 'hardware delivery systems' through the exploitation of relevant and appealing 'software'. Again, as we have seen, the specific pleasures delivered by popular music on film, television and video have been an important commercial platform for promoting the social consumption and domestic appropriation of these technologies of leisure and entertainment, whether they be synchronized sound cinema – the 'talkies' – and its improved, upgraded Dolby widescreen modern equivalent, the domestic television set, the video cassette recorder or, more recently, cable, satellite and digital television. Of course, it needs to be remembered that throughout the twentieth century attempts by corporations and companies to buy into, maintain or increase control of the market have often been aided – and occasionally hindered – by legislative changes.

In all this, the development of what I have termed the visual economy of popular music has both helped to define the social meanings of popular music and positioned the consumption of that music firmly within the discourse and ideology of entertainment. Though, as we have seen, specific musics at specific historical and social moments often connoted 'rejection', 'rebellion', 'opposition' or 'authenticity' for their devotees, the totalizing effect of the specific institutional practices which placed popular music on screen has been to fuse popular music within the dominant system of economic and social relationships. Ragtime, jazz, rock'n'roll, punk, disco and, more recently, dance and house music remind us of the important, essential and dynamic relationship between the centre and the margins, remind us of the ideological issues which are at stake, not least around constructions of race and class, but also offer evidence of the power of capitalist cultural production to erase structural and cultural dissonances through their incorporation. They also serve to remind us that the relationship between textual production and consumption, between the 'machine' of industrial cultural

production and the individuated pleasures we gain from their products, is a highly complex one which neither the cultural pessimism associated with Adorno nor the excesses of the carnivalesque fully explain.

Given this relationship between popular music and the screen media, its long history and the abundance of documentary evidence for its existence, it is sometimes difficult to understand the ways in which the development and emergence of music video in the late 1970s and early 1980s was treated by those who wrote about it. The sheer amount of academic and journalistic writing about music video throughout the 1980s and into the early 1990s indicated the widespread interest in and impact of what were seen alternatively as 'perfect movie miniatures' or 'mind-rotting pap'.[1] For a period, music video and music television received almost unprecedented levels of attention from academic theorists, generating what Frith described as 'more scholarly nonsense than anything since punk'.[2] Whilst noting that music television had become the locus for the latest in a long line of moral panics organized around cultural forms, Grossberg expressed surprise about the speed with which interest in music video and music television had grown:

> unlike previous forms of post-World War Two popular culture (especially youth culture), music television has been rapidly incorporated into the canon of legitimated topics. In these debates, music television is rarely offered as just *another* example; it is the *ultimate* example: of the commodification of culture, of the capitalist recuperation of 'authentic' forms of resistance, of textual and subjective schizophrenia, of the postmodern disappearance of reality, or orgasmic democracy, etc.[3]

Some ten or so years later, it has become possible to question the importance of music video, as the initial excitement which surrounded it has ebbed and it has become an accepted part of a complex mediascape. Whereas a great deal of 'quality' journalism was preoccupied during the mid- and late 1980s with explaining the significance of music video, contemporary commentators are as likely to want to dismiss it as a passing fad:

> It is not hard, nowadays, to write music video off as the eight-track of the eighties pop world. Great claims were made for them, they were hugely popular for a while, and then they came to seem oddly pointless.[4]

Although it is significant that music video attracted comment which often blurred the distinction between academic writing and journalism, much of it has located music video within the broader excitement over the emergence of postmodernism as theoretical construct, or within the specific locus of MTV and its significance as dedicated non-terrestrial television. Moreover, much academic criticism about music video privileged screen and film theory, often at the expense of analytical consideration of the music and its ideological role. More significantly, it often examined music video in a context which refused historical and materialist commentary, a critical myopia which, in a strange way, echoes and replicates critical misreadings of so-called 'silent' cinema.

A music video aesthetic

In this concluding chapter, although I want to take issue with the approach and tenor of much of the writing about music video and MTV which has appeared in the last ten or fifteen years, I also want to refute any suggestion that music videos and music television channels which exploit and promote them are in any sense 'pointless'. Whilst acknowledging those differences which mark out music video from earlier cultural forms such as the classical Hollywood musical, I want to suggest that music video and music television 'make sense' when they are seen as part of a larger continuity, a process of aesthetic, ideological, technological and industrial convergence between popular music and the screen which has been underway throughout the century. From this perspective, music video can be seen as a further development in the visual economy of popular music.

In fact, far from being 'pointless', it is quite possible to see what might be termed a 'music video aesthetic' at work across a range of contemporary cultural forms, including television, cinema and advertising, even if much of the original enthusiasm for music video as a distinct cultural form itself has lessened. One measure of the primacy of pop music across all media has been the growing use of a music bed for radio news, particularly prevalent in British commercial radio. In the screen media, this music video aesthetic has been increasingly evident in contemporary commercial cinema. For Brown, 'one of the most interesting and indicative

aspects of film music in the nineties lies not in the evolution of its styles and sounds, but in the redefining and resiting of the very role of music in the imaged world of the cinema'.[5]

In 1985, Madonna's single 'Into the Groove' was featured in and helped to promote *Desperately Seeking Susan* (Orion, 1985). This was one of a number of films in the post-MTV years – including *An Officer and a Gentleman* (Lorimar, 1982) which won an Academy Award for the song 'Up Where We Belong' and *The Breakfast Club* (A&M, 1985) – which made use of a pop soundtrack as a key marketing tool. *The Bodyguard* (Warner Brothers, 1992), starring Kevin Costner and singer Whitney Houston, not only exploited and promoted Houston's chart popularity within the narrative as Costner protects singer Rachel Marron (Houston) at the Academy Awards, but adopted an economic visual style and editing pace – referred to by one reviewer as 'cheap-jack MTV burnish'[6] – which owes much to music video. Whilst critics judged the film harshly, Houston's soundtrack album from the film was a best-seller with, in a blurring of boundaries between construct and showbiz reality, two of the songs being nominated for Academy Awards.

Even before then, the influence of music video and MTV was evident. Though, as we have seen, there has always been some level of synergy between Hollywood and the music industry, the influence of pop music specifically as a marketing tool became more pronounced in the 1980s, a point acknowledged by Bones Howe, Senior Vice President of Music at Columbia Pictures in 1989:

> Basically [the film companies] are looking for additional exposure for the movie; a pop soundtrack is just another way of promoting and marketing the film ... the video that's showing on MTV is like a three-minute commercial for the movie ... A hit single is a great way of setting up the movie.[7]

Though music as a marketing tool was aimed predominantly in the 1980s at the younger demographic, this is no longer the case. In the late 1990s, it is difficult to find films that do not have a music soundtrack. Often, as with the 1993 film *Sleepless in Seattle* whose soundtrack featured amongst other songs Gene Autry singing 'Back in the Saddle Again' and Nat King Cole singing 'Stardust', the music is culled from both pop and popular music.

In making a case for a degree of continuity within the screen media, it is important to recognize that this situation in which soundtracks for contemporary films are increasingly a mixture of existing songs and performances, together with numbers written expressly for a particular film, is not altogether far removed from those two principal methods of film scoring, compilation and original composition which Marks identified as central to early 'silent' cinema.[8] Yet this is not the only element of continuity which links contemporary cinema and music video with popular music and the screen media earlier in the century.

Music video and cinematic spectacle

Though a great deal of useful and incisive analysis about specific music video texts exists, there has been little comment on the connection between music video and the strong tradition of the spectacular in cinema. The work of Tom Gunning and others has been influential in reassessing the importance of spectacle in early cinema, what Gunning terms the 'cinema of attractions',[9] and attention has shifted to the re-examination of the aesthetic of the spectacular within so-called 'classical' Hollywood cinema. One of the primary sites for the cinematic spectacular has been, of course, the Hollywood musical, not least because of the importance it grants to both visual and auditory representational regimes, and to the power of performance directly attached to music and singing. But, as we have seen, British musicals and musical comedies from the 1930s onwards also privilege the spectacular through musical performance and its excesses, often at the expense of narrative continuity, and the spectacular remains an important element in both television pop shows and pop musicals.

As Musser's comments on early cinema quoted at the beginning of this chapter might indicate, there is room for further consideration of the formal connections and continuities between what appear to be distinct cultural forms, separated at either end of the twentieth century. Like much early cinema, music video texts have often been described as 'evoking the story rather than telling the story', of being concerned with implicit narratives rather than making clear the causal connections which realist cinema demands. In developing a history of screen practice which

both embraces and subsumes specific historical moments such as 'pre-cinema', Musser has argued that screen practice 'has always had a technological component, a repertoire of representational strategies, and a socio-cultural function, all of which undergo constant, interrelated change'.[10] What is significant about the Hollywood musical, music on television, pop musicals and music video, for all their distinctive differences, is that they employ specific representational strategies which in part draw upon music and musical performance, and that they make specific appeal to an audience precisely because of the way in which music and singing are privileged. What is doubly interesting is the way in which these specific representational strategies are, as we have seen, being incorporated within contemporary realist Hollywood cinema through the growing use of pop music soundtracks and the impact this has upon film style.

This was evident in the 1986 film *Top Gun* directed by Tony Scott, a director with 'a background in commercials and a flashy visual style'.[11] The credits include 'record company consultants' and a string of songs, many of them specially written by Giorgio Moroder and Tom Whitlock, as well as established pop classics such as 'Dock of the Bay' and 'You've Lost That Loving Feeling'. 'Take My Breath Away', a song from the film performed by the band Berlin, first entered the British charts in October 1986 and got to number one; it re-entered the charts in February 1988 and again in October 1990. Perhaps more important than being yet more evidence of the mutuality of commercial exploitation is the impact the music exerts on film style. With a rather bare storyline, what the film offers is the spectacular, whether in the extensive shots of in-flight combat or in sequences such as the beach volley-ball game. It is a prime example of the contemporary 'cinema of attractions' based on both visual and audio seductions.

The power of contemporary commercial synergy

Behind this pervasive aesthetic lies a continuing process of commercial and industrial convergence which determines the cultural products audiences are able to enjoy and gain an array of pleasures from, even if they have little or no interest in the commercial institutions and structures which shape those

pleasures. This is neither an endorsement of Adorno's model of a passive and manipulated audience, nor of models of subcultural autonomy and resistance, merely a recognition that being active and gaining pleasure is not the same thing as having power and influence. Though talking about the audience for television, Morley's view that the ability to 'reinterpret meanings is hardly equivalent to the discursive power of centralised media institutions to construct the texts that the viewer then interprets'[12] applies equally well to our relationship with all the contemporary media.

The 1989 merger of Time-Warner and the subsequent acquisition of Turner Broadcasting (CNN) in 1995, the merger of Paramount Communications and Viacom (then owners of MTV) in 1993, and the rather more more complicated buying into Hollywood by Japanese corporations Sony and Matsushita, all indicate the importance of creating corporate structures powerful enough to compete successfully in the global entertainment market. If the entertainment we enjoy is increasingly shaped by fewer but larger industrial conglomerates, it is also determined by developments in technological convergence which are rendering tradition distinctions between different media forms increasingly irrelevant. As Barker suggests, the advantages for transnational corporations of synergy and convergence are evident:

> The preoccupation with combining software and hardware is well illustrated by the recent film *Last Action Hero*. This Schwarzenegger 'blockbuster' was made by Columbia Pictures, owned by the Sony Corporation. The soundtrack came from CBS, also owned by Sony and it was screened in cinemas with digital sound systems made by Sony. In addition, Sony produced virtual reality and video games based on the film.[13]

Michael Schulhof, Vice Chairman of Sony America, argues that the company consciously developed a business strategy based upon 'computing plus entertainment', in which movies and music are regarded as the key software.[14] This concentration is evident in the music industry, where the six major companies – Sony, Polygram, EMI, BMG, MCA and Warner – all themselves part of larger corporations – now account for between 70 to 80 per cent of worldwide record, cassette and CD sales. Arguably, at the end of the twentieth century, screen culture, whether the big screen of

the cinema with its Dolby SurroundSound, the increasingly technologically refined domestic television screen with its Nicam stereo speakers, or the computer screen with its growing capacity to present moving pictures and improving audio channels, is as equally about sound – and in particular music – as it is about vision. But then perhaps cinema and television have always been as much about sound as vision, had we but analysed them properly.

The rise of global television

Whilst cinema has enjoyed a resurgence towards the end of the century and offers an important arena for the alliance of music and moving images, television is even more important. It is already possible to look back and see the increased importance of television in our lives since the 1980s and to understand the reasons for this. Television is bound up with economic activities and wider social forces which characterize late twentieth-century capitalism and which have focused on developments in the telecommunications and information industries. Technological opportunities and the political determination to appropriate them for specific social uses have dramatically altered the conventional television landscape. Whilst these changes may be experienced in a specific country like Britain as a challenge to the conventional terrestrial broadcast television's distribution monopoly and to a long-standing, non-commercial, class-influenced, public-service broadcasting ethos, with the consequent emergence of dedicated television channels such as MTV, Sky Movies and Eurosport, delivered by cable and satellite, they are part of a wider process creating what is increasingly termed 'global television'.

The process of telecommunications deregulation, begun in the United States under President Reagan in the 1980s and taken up enthusiastically in Britain and across Europe, amounted to the reregulation of enabling legislation to favour and promote the growth of the commercial potential of both television and related digital telecommunications, often driven by powerful companies with existing media interests eager to enter and supply the growing market for television and other digital communications, both in terms of hardware and software. Whilst the scale of

corporate activity is different and more complex, taking place on a global scale, the process of corporate repositioning in the 1990s echoes the industrial restructuring that took place during the transition to sound cinema, as well as the initial growth of television in the late 1940s and 1950s, when companies sought vertically integrated control over specific entertainment sectors, as well as convergence between separate though related areas of the entertainment business. What characterizes all these moments are the determination of major companies to reposition themselves in order successfully to exploit and promote new technologies, to capitalize on the synergy of hardware and software sales. As we have seen, the result of this restructuring has a profound impact on the daily lives of vast numbers of people, as these new technologies become fully social technologies, available at a price most are willing to pay. New cultural forms such as the musical or music video emerge which, whilst owing something to earlier cultural forms, also bring something distinct.

Whilst the importance of cinema to corporate profits is openly acknowledged here, it is television which has been regarded as central to global economic power. The erosion of the public sphere and the commercialization of television has placed the medium at the heart of corporate marketing strategies, the prime site for advertising and promotion. As Barker puts it, 'the rise of transnational television as a commercial phenomenon has made advertising both a core source of revenue and a major component of the flow of television'.[15] At those times when the concept of 'global television' is most easily felt and understood, during the Olympic Games or the World Cup for example, global brand names such as Coca-Cola, Pepsi, Nike and McDonalds are very much in evidence, not just in the advertising slots, but often intruding into programme content, often as 'official sponsors'. Pop music is invariably an essential element of such advertising, often leading to renewed sales and chart success for rapidly re-released past hits.

It has long been recognized that we need to understand television in terms of its flow across programme content, trailers and adverts.[16] With deregulation and the growing commercialization of television, advertising has increased its potential not simply in terms of revenue, but also in terms of the meaning of television. Television provides information and entertainment through

programmes and through promotion. Arguably, it is increasingly difficult and, for many, perhaps increasingly irrelevant, to separate the two within the flow that is contemporary television.

Music video, postmodernism and popular culture

This blurring of boundaries was also characteristic of music video, as was recognized some years ago by Peter Wollen in an early attempt to think critically about music video within the context of postmodernism:

> the most significant hybridisation brought about by music video is the breakdown between programme and ad. In origin and, from the point of view of the music industry, in function, music videos are an advertising vehicle, promoting the sale of records ... In form, too, music videos have much in common with the more sophisticated ads, and there has been a rapid crossover between the two.[17]

Thus, if television has come to be seen as central to the production and reproduction of what many see as a 'promo-culture' which itself partly defines postmodernity, then it is no surprise that music video has assumed an important place within television, nor that academics write about it with such enthusiasm. As Cubitt argues, 'music video ... finds a natural home in the "segmented flow" of televisual images, sounds and events'.[18]

Whilst televisual flow has conventionally been talked about in visual terms, this emphasis on music video rightly reminds us that sound – and in particular pop and popular music – is also an integral, if more problematic, element of that flow, and has become more so as both the use and importance of pop music on television has increased. Though sound was often conceptualized as interrupting visual flow, the increasing presence of pop music across programmes and promotional segments – adverts and trailers – has changed this. Whilst the axis between sophisticated visuals, pop music and advertising is increasingly dominant, as might be expected within the commercialized global television industry, the 'music video aesthetic' is frequently put to use for magazine, news, current affairs and sports items on television, even on the still nominally commercial-free BBC. One recent example of this is what was in effect the 'music video' of England's experiences in the 1998 football World Cup.

As we have seen, whatever antagonisms may have existed between young people and television in the 1950s, 1960s and 1970s were, by the early 1980s, redundant. From the beginning of the 1980s, television, cinema, advertising and pop music existed in a discursive alliance which helped define a contemporary lifestyle being literally and symbolically bought into by what I would characterize as 'young people of all ages'. Music remained central to this lifestyle, but in ways which were different from earlier decades. The ubiquity of the visual regime and the musical commodity meant that their appeal was no longer confined to a narrow age band, to that postwar construction, the 'teenager'. 'Youth', as the subject of conflicting historical discourses in specific cultural formations, no longer existed, and the notion of an ideology of 'rock', with its connotations of 'authenticity' and 'opposition', had become meaningless. Though the Monkees had been criticized for the way in which the band was put together and for their perceived lack of musical credibility, such issues no longer mattered with Take That and Spice Girls. Arguably, their very artificiality was part of their appeal. Though Milli Vanilli had their 1990 Grammy Award for Best New Artist taken away from them when it was disclosed that they did not actually sing on 'their' record, in a way nobody actually *cared*, since so much of their appeal had been based on the way they looked, on an attractive visual quality they undoubtedly possessed. The importance of the visual was evident in the growth of music video as cultural and commodity form through the 1980s and into the 1990s, constructing and representing a major shift away from those conventional discourses which had defined the earlier rock formation and its meaning. In trying to account for these changes in the sensibility of rock, Grossberg argues that rock's

> public and discursive existence has been transformed from a crisis of social rhetorics and shared historical events to a powerful and pervasive popular sensibility, infiltrating many of the spaces of social and everyday life, rearticulating many of the possibilities of people's cultural investments.[19]

The argument here is that this 'popular sensibility' has in large part been created by television, cinema and their specific use of pop and popular music. The ways in which music has been used have resulted in a popular sensibility which is increasingly equated

with the processes and pleasures of commodification, so that the concept of 'cultural investment' resonates with more than one meaning, and at more than one level. The cultural and the commercial have become increasingly inseparable.

This shift away from the earlier cultural meanings of rock and its defining sense of 'authenticity' has in part been due to techno-logical developments. In one of those paradoxical conjunctions which mark the dynamics of popular culture, the emergence of punk rock and its symbolic affront to the commercial 'insinceri-ties' of the music industry coincided with the growing displace-ment of the skills of the musician, as new computer-based technologies of musical production made it possible to produce and replicate sounds both in the studio and on stage, rendering the distinction between 'live' and 'recorded' music and perfor-mance problematic. The opportunities presented by these new technologies were taken up enthusiastically by British bands in the early 1980s such as Duran Duran, ABC and Wham! in what became known as 'New Pop'. As Goodwin argues:

> the new music-making technologies demonstrated to musicians, critics, and audiences more forcefully than ever before that pop perfor-mance is a visual experience ... New Pop openly acknowledged pop performance as a visual medium with a sound track.[20]

For Goodwin, the emergence of an avowedly visual New Pop, combined with the global increase in the quantity of television programming and the music industry's crisis in profitability, gave the impetus to the commercial exploitation of music video and the development of what he terms music television. As Frith demonstrates, the crisis in profitability for the record industry took place between 1978 and 1982, proving a powerful stimulus in the development of music video.[21] The crisis for the major corporations who owned the record companies was resolved precisely by recognizing and investing in new areas of opportunity within the entertainment and leisure market, includ-ing the expansion in television programming. This expansion was not just an expansion in programme hours and channels, but also an expansion in televisual style and in new televisual forms.

New technology and the development of MTV

In addition to developments in the technologies of musical production, there were also significant developments in film and video technology in the late 1970s and throughout the 1980s which, whilst making production costs and schedules more accessible and therefore attractive to those who valued the promotional potential of music video, also problematized notions of 'authentic' performance. In addition, this increased dependence on a range of visual technicians, on the director, art director and cameraperson, was often at the expense of the musicians involved. Contemporary trade papers were full of excited articles about Chromakey, Magicam and the Ampex Digital Optics (ADO) system which could rotate, resize and reposition images with ease:

> Music videos provide the perfect context for this high-tech magic. Like them or not, they are here to stay, and the illusions are limited only by the imaginations of their creators. Using computer animation, an Ultimatte system, the ADO, the paint box and a few sets, jarring images of a rock star's head attached to a fly's body glide by effortlessly (*The Cars*), while Paul McCartney plays eight different instruments in a single scene to the tune of *Comin' Up*.[22]

Such developments in both audio and visual technologies and their specific deployment within the televisual apparatus played their part in rendering notions of 'rock authenticity' redundant, at least in the ways that had been used previously, and helped construct that new 'popular sensibility' talked about by Grossberg.

For most commentators, the most significant expression of these technological, political and economic determinants was the development of MTV, which began on cable television in the United States in August 1981 and which now broadcasts across five continents. Like music video itself, MTV has been overprivileged in terms of the attention given to it by academic writers. As a result, the general movement towards increased convergence between entertainment corporations and, in particular, the drive by record companies to establish their own video departments, has been rather neglected. For example, EMI established EMI Music Video in 1981, later to be known as Picture Music International. Polygram Music Video was started in 1982. Both were recognition by the music industry of the importance of the visual

regime in the promotion of musical product, and both were responses by major companies to the growth in independent music video production companies in the late 1970s and very early 1980s, companies such as Limelight, formed by Steve Barron in London in 1979. This situation to some extent echoed the relationship between the majors and independents which existed in the record industry itself.

Although, as we saw in the previous chapter, pop music shows on terrestrial television were making some use of video clips, the problem of an appropriate distribution network was awaiting a solution. EMI had plans to market compilation video albums featuring bands such as Duran Duran, Kim Carnes and Kajagoogoo in a series to be called *Picture Music*. In both Britain and the US a number of dance clubs began to feature video from early 1980 onwards, showing full-length video albums by commercial bands such as Blondie, as well as more avant-garde video material from bands such as Devo and the Residents. Some attempts were made to structure this club circuit into a commercial subscription service, but the distribution outlets for music video failed to keep pace with the exponential growth in music video production, as the number of independent production companies multiplied.

The solution to the problem of an appropriate distribution channel had begun in 1980 in Carmel, California, where ex-Monkee Mike Nesmith's production company Pacific Arts produced a half-hourly series called *Popclips*. Part financed by Warner Cable and shown on their Nickleodeon cable service, *Popclips* provided the initial formula for MTV. In early 1981, USA Cable Network had launched *Night Flight* which, interestingly in the light of the move to mixed-formula programming which MTV has undertaken, presented music video clips within a magazine format. By then, Warner executives had tried and failed to buy out *Popclips*. Following a merger with American Express to form Warner-Amex Satellite Entertainment Corporation, the company launched MTV as a 24-hour music channel on cable on 1 August 1981. Other dedicated music television channels followed, including Much Music in Canada, Music Video in Australia, Music Box and Sky Trax in Europe. In 1987 MTV, now owned by Viacom, launched MTV Europe, capable of reaching a potential forty-seven million homes in thirty-one countries. Using licensing

agreements with, amongst others, Pioneer Electronics, TDK Electronics and Abril, the Brazilian publishing group, MTV now transmits across all continents.

For many commentators, MTV is significant not so much for its audience figures, which remain small in comparison with many conventional terrestrial broadcasters, as for its symbolic place within a contemporary cultural landscape increasingly dominated and defined by the power of mediating images, within a specific cultural formation neatly characterized by Redhead as 'the times of the signs'.[23] It has been argued that MTV represents a different kind of television, one that attempts to incorporate a rock-music aesthetic, and which reflects profound changes in the cultural formation. In an important comment which anticipated the growing convergence of pop music and the music video aesthetic across a range of media, Kaplan wrote, 'If MTV is enmeshed in discourses about rock music, it is the insertion of these discourses in the specifically *televisual* apparatus that produces a result drastically different from prior organizations of rock'.[24]

Throughout the 1980s commentators like Kaplan argued that MTV, with its programming strategies heavily reliant on music video and its specific mode of televisual address, could only be understood within the context of postmodern culture:

> MTV reproduces a kind of decenteredness, often called 'postmodernist', that increasingly reflects young people's condition in the advanced stage of highly developed, technological capitalism evident in America ... MTV arguably addresses the desires, fantasies and anxieties of young people growing up in a world in which all the traditional categories are being blurred and all institutions questioned – a characteristic of postmodernism.[25]

It is not difficult to understand the enthusiasm for discussing music video and music television within the wider context of postmodernism. Within the over-consumptionist dynamic which characterizes multinational capitalism, it is not surprising that postmodernism has come to be seen by many as the cultural dominant, whether viewed as a new social theory, a new social formation or a new aesthetic. The relative complexity of the visual component of music video texts, their complex referentiality, the apparent lack of coherent temporal and spatial structures,

fragmentation and displacement, the lack of closure or resolution, the emphasis on pastiche, that 'neutral practice of mimicry',[26] all these seemed at one stage to justify the enthusiasm for discussing music video in what were essentially conceptually isolationist terms.

Postmodernism and its limitations

However, in trying to understand something of the long-standing relationship between the screen media and popular music, it does seem clear that many of the claims which attempt to understand music video as a distinct cultural and commodity form through the perspective of postmodern theory appear willfully to misread the relationship between the production of popular culture and those who experience it. This seems particularly the case with those who confine their analysis to isolated textual examples, with little or no reference to the material conditions in which those texts are produced and consumed. In celebrating the 'polysemic' nature of the music video text, commentators such as Fiske have argued for reading positions which render meaning and signification irrelevant in the face of the liberating physical pleasures which, it is argued, are engendered by music video. Going beyond notions of subcultural resistance, this is an argument for the autonomy of an active audience which seems hard to sustain and for which no empirical evidence exists.

Admittedly, in the face of the usual conflation of political economy and cultural pessimism, the concepts of resistance and opposition implicit in that particular kind of analysis deriving from postmodernism seem attractive. Certainly, an argument can be made for the existence of complex reading positions which exist in response to the multi-discursive material we encounter on an everyday basis, but this does not take us further in understanding the aesthetic and its relation to modes of production. Nor does it shed much light on the social context in which audiences make use of the products made available to them. As Tetzlaff argued some years ago when writing about MTV,

> Escape is a form of resistance, but it is a weak one if it is only temporary. And the time comes when the viewer has to turn off MTV and

again become a subject of the social system to go about the business of securing food, shelter and enough cash to make the next payment on the TV set ... the politics of postmodern popular culture tends to be sealed, self-contained. *The resistance it engenders does not touch the arenas of power.*[27]

There are further problems involved in focusing analysis of music video and music television too narrowly on postmodern theory. In his analysis of MTV, Goodwin identifies three distinct stages in MTV's history and notes that it is the earliest of these three phases, from 1981 to 1983, which 'represents the peak of the postmodern claim on MTV ... when the MTV schedule most closely resembled the arguments advanced by academics'.[28] Goodwin argues that the relative scarcity of video clips led to high repetition in a continuous 'flow' which blurred generic categories, together with the neglect of narrative within individual clips themselves, meant that MTV came the closest to being what academics were defining as 'postmodern television'.

For Goodwin, there is a problem in arguing for postmodernism as the dominant paradigm through which to understand MTV, since this initial phase in MTV's history was also the most insignificant, in the sense that the channel struggled to find an audience. Furthermore, given academic claims that post-modernism represents an 'end of ideology' and the erasure of structural distinctions, it is significant that during this period MTV was consistently accused of racism in its programming policy. Though Goodwin argues that in this MTV was simply following the music industry which, as we have seen earlier, itself tended to define 'rock' in essentially racist terms, the willingness to replicate that fault line of racism in American society does little to suggest that MTV marked a radical departure, in these terms at least.[29] In this, Warner-Amex were following an established pattern of US corporate anxiety about confronting racial issues, preferring to privilege commercial viability over social and ethical concerns.

Nor are the claims for MTV's cultural radicalism any more true using different criteria. As Goodwin shows, the channel moved progressively away from a rolling format of repeated clips towards more conventional segments and discrete programmes, many of them reflecting different pop and rock genres:

> While heavy metal acts are still prevalent, MTV now screens a wider
> variety of rock and pop music than ever before. The question of racism
> has been resolved by two developments: the emergence of rap
> crossover music that combines black and white musical forms ... and
> the success of black heavy metal act Living Colour.[30]

MTV's repositioning within the television landscape was evident
when it carried programming material which had previously been
broadcast on terrestrial TV, including shows such as *The Monkees*
and *The Tube*. At the same time, a number of non-music shows
were introduced, including *MTV at the Movies*, a 'daily fifteen
minute slot providing up-to-the-minute information on film and
home-video releases' and Real World, 'the youth soap opera with
a difference'.[31] The traffic has become two-way, with series such
as *Beavis and Butthead* and *MTV Unplugged* being broadcast on
terrestrial TV.

Though far from dismissing postmodernism, it is clear that to
try to understand music video and what I have termed the music
video aesthetic purely through that conceptual paradigm has its
limitations. Collins, for example, takes issue with what he sees
as the assumptions made by Lyotard and Baudrillard about narra-
tive, arguing that 'that the power of narrative not only has
persisted, but intensified, can be seen in the narrativisation of
non-narrative discourses. The most striking example is, of course,
rock music, especially in video form.'[32] Collins goes on to distin-
guish between what he terms the performance mode of presenta-
tion, which he says characterized the presentation of pop music in
the 1960s, with the narrative mode of the 1980s, maintaining that
a 'significant percentage of rock videos have either done away with
outright performance, or placed it entirely in narrative context, so
that very few videos maintain anything like a "concert"
aesthetic'.[33]

Developments in music videos in the 1990s suggest that we
need to treat this statement with caution. Arguably, much of the
distinction between performance and narrative has been fused in
the drive to what I want to term the spectacular. For example,
the recent Madonna video 'Substitute for Love' (1998) certainly
has nothing of performance which connotes the live concert, but
it remains performance, linked to an implied though distinct
narrative, using a mode of representation which privileges the
spectacular, not least through the impressive computer-generated

facial distortions of the guests at the showbiz party, the grotesque which she rejects in favour of the love she has found in motherhood.

Mercifully, both the utility and the limitations of postmodernism in analysing popular culture, popular music and the screen media are now being recognized. As Mitchell points out,

> By the beginning of the 1990s, there was an almost unilateral retreat from postmodernism within the broad field of Cultural Studies ... The concept of postmodernism began to be questioned as a useful theoretical tool and as an all-embracing, non-specific 'condition' ... A major problem was that postmodernism itself had become a 'master-narrative that was loosely applicable to almost any form of social or cultural practice.[34]

However, to recognize the limitations of one conceptual tool is to accept the need for others. As this book has argued, we perhaps need an awareness of the long-standing relationship between popular music and the screen if we are to understand and contextualize its latest developments. Moreover, in trying to understand the ways in which texts work, we need analysis that connects texts to the material processes of their production and consumption.

Though we need to treat the audience impact of MTV itself with caution – Viacom claims to reach 320 million households in 90 countries on 5 continents for 24 hours a day – the channel epitomizes the importance of visual imagery to contemporary pop and rock. As music journalist Jon Pareles argues, the power of the music television has changed the balance between sound and image: 'in a visual culture like ours, MTV has amplified the importance of image over sound, which has repercussions in everything from stage shows to who gets a chance to record ... MTV favours pretty people.'[35] However, whatever weight this statement carries, it does not excuse the tendency to discuss and analyse music video solely from the perspective of the visual. We need to remind ourselves in all this that music video remains, whatever else it is, a musical event.

Music genres and visual coding

Any analysis of individual music videos will reveal the extent to which the music genre influences, if not determines, the visual

iconography wrapped around the sound. Whatever its limitations, Kaplan's early attempt to establish a critical taxonomy of music video reflected important differences based on generic distinctions,[36] though these distinctions were more to do with the visual media than with generic distinctions in the music.

Yet, it does seem clear that the different genres within popular music do influence choices about structure, form and visual style. For example, in his article on country music videos, Fenster notes that they tend to avoid the more fragmented, disjointed narratives associated with music videos drawing upon other genres of popular music. Whilst in general country music videos valorize performance, it is also the case that

> 'traditional' values and small towns have been a major set of themes and locations for recent country videos ... Traditional values and romantic emotions in the country music lyric are visually translated in videos that focus on the family and the rituals associated with it.[37]

Too often, discussion of music videos which has concentrated on their visual aspects has ignored the the ideological loadings associated with specific music genres. Most noticeably, there has been considerably more discussion of issues of gender based on screen concepts of the 'male gaze' and much less based on gender constructions implicit within the music. Refreshingly, in his discussion of heavy metal and gender, Walser reminds us that 'It is not only lyrics or visual imagery, but the music itself which constructs gendered experiences'.[38]

As argued in Chapter 3, we need an analytical methodology which, in considering music video, recognizes that in their different ways sight and sound articulate different aspects of the social process, one which acknowledges that both remain resolutely social. It is equally clear in looking at the Hollywood musical that musical difference influences visual coding, as we saw in the 'Heavenly Music' number and Garland's 'Get Happy' finale in *Summer Stock*. An analysis of music video which considers music and lyrics, which considers the song and the ideological work it undertakes, is not really advanced by being mesmerized by narrow conceptions of postmodern theory applied only to visual images.

Throughout this book, we have emphasized the importance of the visual regime in understanding the meanings of popular

music. However this reminder that music video is, whatever else it may be, a musical event is central to one of the key themes of this book, which has argued that important continuities are visible across the layered phases of cultural development during the twentieth century. Whilst not wanting to deny the differences which mark out music video, such as the sophistication and economy of its visual imagery and its ability to imply or infer narrative, there is a strong argument for regarding music video less as a radical departure and more as a continuation and development of previous cultural forms which attempted to visualize popular music and song. What we need to understand is that the imaging of popular music implies conditions which construct a quite specific set of representational practices. It is striking, for example, that just as we saw the 'work' involved in constructing professional success in *The Jazz Singer*, a process replicated across a range of so-called backstage musicals including Presley's *Loving You*, many early music videos also offered visual representations of the 'work' involved either in musical production or in the production of the video itself. An example would be Soft Cell's *Non-Stop Exotic Video Show*, directed by Tim Pope in the early 1980s, which makes ironic use of a range of showbusiness iconography, from circus acts, snake charmers, torch singers and a proscenium arch stage to the video studio itself.

Precisely because it is rooted in *musical* performance, music video privileges specific visual performance in much the same way that numbers in the Hollywood musical, filmed Soundies clips, or segments of *Oh Boy!* and other television shows do. Whilst there are important differences in shot and editing styles, such that there is a level of visual excess and ironic play around that excess which is sometimes absent from the musical genre or early TV performances, what continues to predominate is that direct mode of address which musical performance demands. The processes of identification and implication, either within the emotional world established by the singer, or within that wider community referenced by the singer and the musical style, remain the same.

Though for a period claims were made for certain authorial voices said to be at work within some music videos, including Tim Pope mentioned above, as a cultural form they remain essentially authorless texts. What matters is the presence and the persona of the musical performer(s). As with numbers in the Hollywood

musical, these performers exist both within and outside the text, so that the performance in a specific text draws upon, amplifies and resonates with all those performances by that artist which exist in one form or another elsewhere. Writing about this process, Frith comments that

> This move in and out of the imaginary is equally significant for our construction as viewers. The object is to turn us into fans, into consumers, to identify not so much with the performers themselves as with their audience, the community they create.[39]

This attempt through music video to implicate us within a constructed community has similarities to the attempts by the Hollywood musical to locate us within what are presented as sustainable utopias. Both make their appeal through the emotional power of popular music and rely on the affective investments which we all, at different times and in different ways, make in popular music and popular culture.

Continuity and the construction of the visual economy of popular music

Whilst recognizing its distinctiveness as cultural form, it seems important also to recognize that the development of music video during the 1980s and 1990s represents a continuation in the growth of the visual economy of popular music, drawing upon and extending those representational strategies which have been used to in showing popular music on screen throughout the twentieth century. Just as it would be foolish to maintain that contemporary Hollywood cinema is the same as early American cinema, to argue that British television in the late 1990s is no different from British television in the 1950s, or that British popular culture simply mirrored or imitated American popular culture, it would be equally foolish to deny differences between music video and earlier cultural forms which made use of popular music on screen. However these specific differences, located within and dependent on specific historical and social moments, should not blind us to the real continuity of commercial, ideological and cultural practice which characterizes the relationship between popular music and the screen media.

From the earliest attempts by Edison and others to perfect and exploit technologies which combined image and sound, the development of the visual economy of popular music has had a profound impact on popular culture in the United States, in Britain and across the globe. This visual economy has been characterized by a mass of individual texts across film, television and video which have drawn upon a repertoire of representational practices and strategies which are distinctive to the process of imaging popular music on screen, which reflect specific socio-cultural concerns and construct specific ideological effects. At the same time, this visual economy has been driven by an over-riding concern with economics, with business and commerce. In particular, the concern to develop and exploit the technologies of entertainment has made good use of the pleasures associated with popular music, with moving images, and with the powerful affective combination of the two. As we have seen, the exploitation of these technologies has often taken place within legislative and regulatory regimes which attempt to favour this specific and partial use of 'new' technologies by corporations and organizations who are in a position both to invest in and profit from them.

Though this was not predetermined, it has largely been American and, to a lesser extent, British corporations which have been in the forefront in developing the popular music and moving image industries and in reaping the commercial benefits from them. At certain historical moments, as we have seen, the central role of popular culture in constructing aspects of national identity has led to localized skirmishes and battles between British and American commercial interests, though these have been subsumed by the development of transnational organizations dealing in the the global market. Their products bring us complex pleasures and, like other elements of popular culture, help define our sense of who we are, but they come to us, it has been argued, ideologically pre-loaded.

The Hollywood musical, films featuring rock'n'roll and pop artists, pop shows on television and contemporary Hollywood films using pop soundtracks have exercised powerful mediating influences over the social circulation, consumption and meaning of popular music. Though there is enormous scope for further research into the relationship between popular music and the screen media, and though screen theorists, historians and

musicologists have only recently begun talking to and working with each other, it seems clear that the pervasive nature of the music video aesthetic and contemporary patterns of leisure and consumption offer conclusive evidence of an ineluctable relationship between popular music and moving image culture. This relationship is not a static one nor, despite the emphasis we have placed on understanding its historical development, is it possible to predict its shape in the future. It is clear that the computer screen is already a site where popular music and the moving image are forming new configurations and where new patterns of use and perhaps new pleasures are being experienced. All the indications suggest that we are prepared to invest as substantial amounts of time to this form of pleasurable consumption as we already do to watching television, going to the movies and listening to music.

That this investment – and the pleasures which result – is in commodified products manufactured and disseminated by organizations and institutions which make it their business to entertain us is perhaps not, in the final analysis, something which we can alter. But perhaps it is not something we should forget either.

Notes

1 B. Thompson, 'Lights! Camera! Cliche!', *Independent on Sunday* (19 July 1992) 18–19. Thompson's piece was written as a responsive commentary on the exhibition of music video at London's Museum of the Moving Image in 1992.

2 S. Frith, 'Making sense of video: pop into the nineties', *Music For Pleasure: Essays in the Sociology of Pop* (Cambridge, Polity Press, 1988), p. 205.

3 L. Grossberg, 'MTV: Swinging on the (Postmodern) Star', in I. Angus and S. Jhally (eds), *Cultural Politics in Contemporary America* (New York, Routledge), 1989, p. 255.

4 A. Beckett, 'Videos go to the wall ... ', *Guardian* (16 May 1998) 4.

5 R. S. Brown, *Overtones and Undertones: Reading Film Music* (Berkeley CA, University of California Press, 1994), p. 239.

6 J. Pallot and J. Levich (eds), *The Fifth Virgin Film Guide* (London, Virgin), 1996, p. 76.

7 M. Cooper, 'Heard any good films lately?', *Q*, 35 (August 1989) 17–18.

8 M. M. Marks, *Music and the Silent Film: Contexts and Case Studies*

1895–1924 (New York, Oxford University Press), 1997.

9 T. Gunning, 'The cinema of attractions: early film, its spectator, and the avant garde', in T. Elsaesser and A. Barker (eds), *Early Cinema: Space, Frame, Narrative* (London, British Film Institute, 1990).

10 C. Musser, *The Emergence of Cinema: The American Screen to 1907* (Berkeley CA, University of California Press), 1994.

11 *Monthly Film Bulletin*, 53:633 (October 1986) 319.

12 D. Morley, 'Active audience theory: pendulums and pitfalls', *Journal of Communication*, 43:4 (1993) 13–19.

13 C. Barker, *Global Television: An Introduction* (Oxford, Basil Blackwell, 1997), p. 25.

14 R. Burnett, *The Global Jukebox: The International Music Industry* (London, Routledge, 1996), p. 20.

15 Barker, *Global Television*, p. 153.

16 The concept of 'flow' was first usefully developed in R. Williams *Television, Technology and Cultural Form* (London, Fontana/Collins, 1974).

17 P. Wollen, 'Ways of thinking about music video (and postmodernism)', *Critical Quarterly*, 28:1/2 (1986) 168.

18 S. Cubitt, *Timeshift: On Video Culture* (London, Routledge, 1991), p. 46.

19 L. Grossberg, *We Gotta Get Out Of This Place: Popular Conservatism and Postmodern Culture* (New York, Routledge, 1992), p. 209.

20 A. Goodwin, *Dancing in the Distraction Factory: Music Television and Postmodern Culture* (London, Routledge, 1993), p. 33.

21 S. Frith, 'Video pop: picking up the pieces' in S. Frith (ed) *Facing the Music: Essays on Pop, Rock and Culture* (London, Mandarin, 1990), p. 92.

22 *American Cinematographer* (September 1986) 84.

23 S. Redhead, *The End-of-the-Century Party: Youth and Pop Towards 2000* (Manchester, Manchester University Press, 1990), p. 40.

24 E. Ann Kaplan, *Rocking Around the Clock: Music Television, Postmodernism, and Consumer Culture* (London, Methuen, 1987), p. 3.

25 Kaplan, *Rocking Around the Clock*, p. 5.

26 F. Jameson, 'Postmodernism and consumer society', in E. A. Kaplan (ed.), *Postmodernism and its Discontents: Theories and Practices* (London, Verso, 1988).

27 D. Tetzlaff, 'MTV and the politics of postmodern pop', *Journal of Communication Inquiry*, 10:1 (1986) 89.

28 A. Goodwin, 'Fatal distractions: MTV meets postmodern theory', in S. Frith, A. Goodwin and L. Grossberg (eds), *Sound and Vision: The Music Video Reader* (London, Routledge, 1993), p. 50.

29 Accusations about MTV's racism continued up to 1986, though Goodwin argues that in recent years MTV has played a major role in promoting black music, particularly through its programme *Yo! MTV Raps*.

30 Goodwin, *Dancing in the Distraction Factory*, p. 137.

31 These and all the other programmes are listed in the 1993 edition of the MTV press pack.

32 J. Collins, *Uncommon Cultures: Popular Culture and Postmodernism* (London, Routledge, 1989), p. 120.

33 Collins, *Uncommon Cultures*, p. 120.

34 T. Mitchell, *Popular Music and Local Identity: Rock, Pop and Rap in Europe and Oceania* (London, Leicester University Press, 1996), p. 14.

35 J. Pareles, cited in Burnett, *The Global Jukebox*, pp. 96–7.

36 Kaplan's taxonomy also reflected the fact that her analysis was very much based in screen theory, but at least the attempt to differentiate between five main types of video – romantic, socially-conscious, nihilist, classical and postmodernist – opened up the way for further consideration of the relationship between specific images and specific music. Kaplan, *Rocking Around the Clock*, p. 55.

37 M. Fenster, 'Genre and form: the development of the country music video', in Frith *et al.* (eds), *Sound and Vision*, p. 118.

38 R. Walser, 'Forging masculinity: heavy metal sounds and images of gender', in Frith *et al.* (eds) *Sound and Vision*, p. 157.

39 Frith, 'Making sense of video', p. 216.

Bibliography

Adorno, T. W. with Simpson, G., 'On popular music' in S. Frith and A. Goodwin (eds), *On Record: Rock, Pop and the Written Word*, London, Routledge, 1990.

Agate, J., *Around Cinemas*, London, Home and Van Thal, 1946.

Allen, R. C., 'From exhibition to reception: reflections on the audience in film history', *Screen*, 31:4 (Winter 1990) 347–56.

Altman, R. (ed.), *Genre: The Musical*, London, British Film Institute, 1981.

——, *The American Film Musical*, London, British Film Institute, 1989.

—— (ed.), *Sound Theory Sound Practice*, London, Routledge, 1992.

American Cinematographer, September (1996) 84.

Angus, I., 'Circumscribing postmodern culture', in I. Angus and S. Jhally (eds), *Cultural Politics in Contemporary America*, New York, Routledge, 1989.

Angus, I. and Jhally, S. (eds), *Cultural Politics in Contemporary America*, New York, Routledge, 1989.

Armes, R., *On Video*, London, Routledge, 1988.

Attali, J., *Noise: The Political Economy of Music*, Manchester, Manchester University Press, 1985.

Aufderheide, P., 'The look of the sound', in T. Gitlin (ed.) *Watching Television*, New York, Pantheon, 1986.

Bailey, P. (ed.), *Music Hall: The Business of Pleasure*, Milton Keynes, Open University Press, 1986.

Baily, K., *Here's Television*, London, Vox Mundi, 1950.

Balio, T. (ed.), *The American Film Industry*, Madison WI, University of Wisconsin Press, 1976.

—— (ed.), *Hollywood in the Age of Television*, London, Unwin Hyman, 1990.

Barker, C., *Global Television: An Introduction*, Oxford, Basil Blackwell, 1997.

Barnes, J., *The Beginnings of Cinema in England*, Newton Abbot, David and Charles, 1976.

Barrios, R., *A Song in the Dark: The Birth of the Musical Film*, New York, Oxford University Press, 1995.

Baughman, J. L., 'The weakest chain and the strongest link: the American Broadcasting Company and the motion picture industry 1952–60', in T. Balio (ed.) *Hollywood in the Age of Television*, London, Unwin Hyman, 1990.

BBC, *BBC Year Book 1932*, London, British Broadcasting Corporation, 1932.

——, *BBC Year Book 1946*, London, British Broadcasting Corporation, 1946.

——, *BBC Handbook 1959*, London, British Broadcasting Corporation, 1959.

Beckett, A. 'Videos go to the wall ...', *Guardian*, 16 May (1998) 4.

Belz, C., *The Story of Rock*, New York, Oxford University Press, 2nd edn, 1972.

Biskind, P., *Seeing is Believing: How Hollywood Taught Us to Stop Worrying and Love the Fifties*, New York, Pantheon, 1983.

Blacknell, S., *The Story of Top of the Pops*, Wellingborough, Thorsons in association with the BBC, 1985.

Boddy, W., '"The shining centre of the home": ontologies of television in the "golden age"', in P. Drummond and R. Paterson (eds) *Television in Transition: Papers From the First International Television Studies Conference*, London, British Film Institute, 1985.

Bordwell, D. and Thompson, K., *Film Art: An Introduction*, New York, Alfred Knopf, 2nd edn 1986.

Bordwell, D., Staiger J. and Thompson, K., *The Classical Hollywood Cinema: Film Style and Mode of Production to 1960*, London, Routledge, 1985.

Bowers, Q. D., *Nickelodeon Theaters and Their Music*, New York, Vestal Press, 1986.

Boyne, R. and Rattansi, A. (eds), *Postmodernism and Society*, London, Macmillan, 1990.

Bradley, D., *Understanding Rock'n'Roll: Popular Music in Britain 1955–64*, Buckingham, Open University Press, 1992.

Briggs, A., *The History of Broadcasting in the United Kingdon Vol. II: The Golden Age of Wireless*, Oxford, Oxford University Press, 1965.

——, *The History of Broadcasting in the United Kingdon Vol. IV: Sound and Vision*, Oxford, Oxford University Press, 1979.

——, *The History of Broadcasting in the United Kingdon Vol. V: Competition*, Oxford, Oxford University Press, 1995.

Brown, K., *Adventures with D. W. Griffith*, London, Faber and Faber, 1988.

Brown, R. S., *Overtones and Undertones: Reading Film Music*, Berkeley CA, University of California Press, 1994.

Brownlow, K., 'An introduction to silent film: the Peter Le Neve Foster Lecture, 23rd November 1983', *Journal of the Royal Society of Arts*, March (1984) 261–70.

Burgess, M. and Keene, T., *Gracie Fields*, London, Star Books, 1980.

Burnett, R., *The Global Jukebox: The International Music Industry*, London, Routledge, 1996.

Carr, R., *Beatles at the Movies*, New York, HarperCollins, 1996.

Carringer, R. L., *The Jazz Singer*, Madison WI, University of Wisconsin Press, 1979.

Casper, J. A., *Vincente Minnelli and the Film Musical*, Cranbury NJ, A. C. Barnes and Company, 1977.

Cepland, L. and Englund, S., *The Inquisition in Hollywood: Politics in the Film Community 1930–1960*, Berkeley CA, University of California Press, 1983.

Chambers, I., *Urban Rhythms: Pop Music and Popular Culture*, London, Macmillan, 1985.

——, *Popular Culture: The Metropolitan Experience*, London, Routledge, 1986.

Chanan, M., 'The emergence of an industry' in J. Curran and V. Porter (eds), *British Cinema History*, London, Weidenfeld and Nicholson, 1983.

—— *The Dream That Kicks*, London, Routledge, 2nd edn 1996.

Chaplin, C., *My Autobiography*, London, Penguin, 1966.

Chaplin, S., *The Golden Age of Movie Musicals and Me*, Norman OK, University of Oklahoma Press, 1994.

Chapple, S., *Rock'n'Roll is Here to Pay*, Chicago IL, Nelson-Hall, 1977.

Chisholm, B., 'Red, blue, and lots of green: the impact of color television on feature film production', in T. Balio (ed.) *Hollywood in the Age of Television*, London, Unwin Hyman, 1990.

Clarke, D., *The Rise and Fall of Popular Music*, London, Penguin, 1995.

Coe, B., *The History of Movie Photography*, London, Ash and Grant, 1981.

Collins, J., *Uncommon Cultures: Popular Culture and Postmodernism*, London, Routledge, 1989.

Cohen, S., *Rock Culture in Liverpool: Popular Music in the Making*, Oxford, Oxford University Press, 1991.

Cook, D., *A History of Narrative Film*, New York, W. W. Norton, 2nd edn 1990.

Cooper, M., 'Heard any good films lately?', *Q*, 35, August (1989) 16–19.

Crenshaw, M., *Hollywood Rock: A Guide to Rock'n'Roll in the Movies*, London, Plexus, 1994.

Cordova, R., 'The emergence of the star system in America', in C. Gledhill, *Stardom: Industry of Desire*, London, Routledge, 1991).

Croce, A., *The Fred Astaire and Ginger Rogers Book*, New York, Dutton, 1987.

Crozier, M., *Broadcasting: Sound and Television*, London, Home University Library, Oxford University Press, 1958.

Cubitt, S., *Timeshift: On Video Culture*, London, Routledge, 1991.

Curran, J. and Porter, V. (eds), *British Cinema History*, London, Weidenfeld and Nicholson, 1983.

Dawson, J., *The Twist: The Story of the Song and Dance that Changed the World*, Boston MA, Faber and Faber, 1995.

Diehl, D., 'The oldest living teenager' (*TV Guide*, February 1970), in J. S. Harris, *TV Guide: The First Twenty Five Years*, New York, Simon and Schuster, [1970] 1978.

Doherty, T., *Teenagers and Teenpics: The Juvenilization of American Movies in the 1950s*, London, Unwin Hyman, 1988.

Dickinson, M. and Street, S., *Cinema and State: The Film Industry and the British Government 1927–1984*, London, British Film Institute, 1985.

Dranov, P., *Inside the Music Publishing Industry*, New York, Knowledge Industry Publications, 1980.

Drummond, P. and Paterson, R., *Television in Transition: Papers from the First International Television Studies Conference*, London, British Film Institute, 1985.

Dunford, M., 'Organisational change and innovation in youth programming' in G. Mulgan and R. Paterson (eds), *Reinventing the Organisation*, London, British Film Institute, 1993.

Durant, A., *Conditions of Music*, London, Macmillan, 1984.

Dyer, R., 'Is Car Wash a black musical?', in M. Diawara (ed.) *Black American Cinema*, New York, Routledge, 1993.

——, 'The colour of entertainment', *Sight and Sound*, 5:11, November (1995) 28–31.

Edgerton, G., 'American Film Exhibition and an Analysis of the Motion Picture Industry's Market Structure 1963–1980', unpublished PhD dissertation, University of Massachusetts, 1981.

Escott, C. with Hawkins, M., *Good Rockin' Tonight: Sun Records and the Birth of Rock'n'Roll*, London, Virgin, 1992.

Eyman, S., *The Speed of Sound: Hollywood and the Talkie Revolution*, New York, Simon and Schuster, 1997.

Fenster, M., 'Genre and form: the development of country music video', in S. Frith, A. Goodwin and L. Grossberg (eds) *Sound and Vision: The Music Video Reader*, London, Routledge, 1993.

Feuer, J., *The Hollywood Musical*, London, British Film Institute, 1982.

Finch, C., *Rainbow: The Stormy Life of Judy Garland*, London, Michael Joseph, 1975.

Fischer, L., 'The image of woman as image: the optical politics of *Dames*', in R. Altman (ed.) *Genre: The Musical*, London, British Film Institute, 1981.

Fiske, J., *Television Culture*, London, Methuen, 1987.

——, 'The cultural economy of fandom', in L. A. Lewis (ed.), *The Adoring Audience: Fan Culture and Popular Media*, London, Routledge, 1992.

Fordin, H., *The Movies' Greatest Musicals: Produced in Hollywood USA by the Freed Unit*, New York, Frederick Ungar Publishing, 1984.

French, P., *The Movie Moguls: An Informal History of the Hollywood Tycoons*, London, Penguin, 1971.

Friel, R. M., *The Red Menace: The McCarthy Era in Perspective*, New York, Oxford University Press, 1990.

Frith, S., *Sound Effects: Youth, Leisure, and the Politics of Rock'n'Roll*, London, Constable, 1983.

—— (ed.), *Music For Pleasure: Essays in the Sociology of Pop*, Cambridge, Polity Press, 1988.

——, 'The industrialization of music', in S. Frith (ed.), *Music For Pleasure: Essays in the Sociology of Pop*, Cambridge, Polity Press, 1988.

——, 'Making sense of video: pop into the nineties', in S. Frith (ed.), *Music For Pleasure: Essays in the Sociology of Pop*, Cambridge, Polity Press, 1988.

——, 'Northern soul – Gracie Fields', in S. Frith (ed.), *Music For Pleasure: Essays in the Sociology of Pop*, Cambridge, Polity Press, 1988.

——, 'The pleasures of the hearth: the making of BBC light entertainment', in S. Frith (ed.), *Music For Pleasure: Essays in the Sociology of Pop*, Cambridge, Polity Press, 1988.

——, 'Why do songs have words' in S. Frith (ed.), *Music For Pleasure: Essays in the Sociology of Pop*, Cambridge, Polity Press, 1988.

——, 'Video pop: picking up the pieces', in S. Frith (ed.) *Facing the Music: Essays on Pop, Rock and Culture*, London, Mandarin, 1990.

——, 'Frankie said: But what did they mean?', in A. Tomlinson (ed.), *Consumption, Identity and Style: Marketing, Meanings and the Packaging of Pleasure*, London, Routledge, 1990.

Frith, S., Goodwin, A. and Grossberg, L. (eds), *Sound and Vision: The Music Video Reader*, London, Routledge, 1993.

Geduld, H., *The Birth of the Talkies: From Edison to Jolson*, Bloomington IN, Indiana University Press, 1975.

Gelatt, R., 'Music on records' in P. H. Lang (ed.), *One Hundred Years of Music in America*, New York, Schirmer, 1961.

Gendron, B., 'Theodor Adorno meets the Cadillacs' in T. Modleski (ed.),

Studies in Entertainment: Critical Approaches to Mass Culture, Blooming-ton IN, Indiana University Press, 1986.

Gillett, C., *The Sound of the City*, London, Sphere, 1971.

Gitlin, T, 'Postmodernism: roots and politics', in I. Angus and S. Jhally (eds) *Cultural Politics in Contemporary America*, New York, Routledge, 1989.

Gledhill, C. (ed.), *Stardom: Industry of Desire*, London, Routledge, 1991.

Goldberg, I., *Tin Pan Alley: A Chronicle of American Popular Music*, New York, Frederick Ungar Publishing, 1961.

Goldman, A., *Elvis*, London, Allan Lane/Book Club Associates, 1982.

Gomery, D., 'Writing the history of the American film industry: Warner Bros. and sound', *Screen*, 17: 1, Spring (1976) 40–53.

——, *The Hollywood Studio System*, London, British Film Institute/ Macmillan, 1986.

Goodwin, A., 'Popular music and postmodern theory', *Cultural Studies*, 5:2 (1991) 174–90.

——, *Dancing in the Distraction Factory: Music Television and Popular Culture*, London, Routledge, 1993.

——, 'Fatal distractions: MTV meets postmodern theory', in S. Frith, A. Goodwin and L. Grossberg (eds) *Sound and Vision: The Music Video Reader*, London, Routledge, 1993.

Gorbman, C., *Unheard Melodies: Narrative Film Music*, Bloomington, IN Indiana University Press/British Film Institute, 1987.

Grossberg, L., 'MTV: swinging on the (postmodern) star', in I. Angus and S. Jhally (eds), *Cultural Politics in Contemporary America*, New York, Routledge, 1989.

——, *We Gotta Get Out of This Place: Popular Conservatism and Postmod-ern Culture*, New York, Routledge, 1992.

——, 'Is anybody listening? Does anybody care? On 'the state of rock', in A. Ross and T. Rose (eds), *Microphone Fiends: Youth Music and Youth Culture*, London, Routledge, 1994.

Gunning, T., 'The cinema of attractions: early film, its spectator, and the avant garde', in T. Elsaesser and A. Barker (eds), *Early Cinema: Space, Frame, Narrative*, London, British Film Institute, 1990.

Guralnick, P., *Last Train to Memphis: The Rise of Elvis Presley*, London, Little, Brown UK, 1994.

Hardy, P. and Laing, D., *The Faber Companion to 20th-Century Popular Music*, London, Faber and Faber, 1992.

Harker, D., *One for the Money: Politics and Popular Song*, London, Hutchinson, 1980.

Harris, J. S., *TV Guide: The First Twenty Five Years*, New York, Simon and Schuster, 1978.

Hartog, S., 'State protection of a beleagured industry', in J. Curran and

V. Porter (eds), *British Cinema History*, London, Weidenfeld and Nicholson, 1983.

Harvey, A. C. H., 'Holy yumpin' yiminy: Scandinavian immigrant stereotypes in the early twentieth century American musical', in R. Lawson-Peebles (ed.), *Approaches to the American Musical*, Exeter, University of Exeter Press, 1996.

Harvey, S., *Directed by Vincente Minnelli*, New York, Museum of Modern Art/Harper and Row, 1989.

Hatch, D. and Millward, S., *From Blues to Rock: An Analytical History of Pop Music*, Manchester, Manchester University Press, 1987.

Hay, J., 'You're tearing me apart! The primal scene of teen films', *Cultural Studies*, 4: 3, October (1990), 331–8.

Hebdige, D., *Subcultures: The Meaning of Style*, London, Methuen, 1979.

Heslem, D. (ed.), *The NME Rock'n'Roll Years*, London, Reed International, 1992.

Higson, A., *Waving the Flag: Constructing a National Cinema in Britain*, Oxford, Oxford University Press, 1997.

Hill, J., *Sex Class and Realism: British Cinema 1956–63*, London, British Film Institute, 1986.

——, 'Television and pop: the case of the 1950s', in J. Corner (ed.), *Popular Television in Britain: Studies in Cultural History*, London, British Film Institute, 1991.

Hirschhorn, C., *The Hollywood Musical*, London, Pyramid Books, 2nd edn 1991.

Hitchcock, H. W., *Music in the United States: A Historical Introduction*, New York, Prentice-Hall, 1969.

Hoher, D. 'The composition of music hall audiences 1850–1900', in P. Bailey (ed.), *Music Hall: The Business of Pleasure*, Milton Keynes, Open University Press, 1986.

Honri, P., *Working the Halls: The Honris in One Hundred Years of British Music Hall*, London, Futura Publications, 1974.

Huntley, J. and Manvell, R., *The Technique of Film Music*, London, Focal Press, 1957.

IBA, *Annual Report and Accounts 1982–83*, London, Independent Broadcasting Authority, 1983.

IBA, *Annual Report and Accounts 1983–84*, London, Independent Broadcasting Authority, 1984.

Izod, J., *Hollywood and the Box Office 1895–1986*, London, Macmillan, 1988.

Jameson, F., 'Postmodernism and consumer society', in E. A. Kaplan (ed.), *Postmodernism and its Discontents: Theories and Practices*, London, Verso, 1988.

Kaplan, E. A., *Rocking Around the Clock: Music Television, Postmodernism and Consumer Culture*, London, Methuen, 1987.

Karlin, F., *Listening to Movies: The Film Lover's Guide to Film Music*, New York, Schirmer, 1994.

Kermode, M., 'Twisting the knife', in J. Romney and A. Wootton (eds), *The Celluloid Jukebox: Music and Movies Since the 1950s*, London, British Film Institute, 1995.

Kerr, P., *The Hollywood Film Industry*, London, British Film Institute/Routledge Kegan Paul, 1986.

Kobal, J., *Gotta Sing Gotta Dance: A History of Movie Musicals*, London, Hamlyn, 1983.

Lang, P. H. (ed.), *One Hundred Years of Music in America*, New York, Schirmer, 1961.

Langer, S., *Philosophy in a New Key*, Cambridge, MA, Harvard University Press, 1942.

Laing, D., 'Making popular music: the consumer as producer'. in A. Tomlinson (ed.), *Consumption, Identity and Style: Marketing, Meanings and the Packaging of Pleasure*, London, Routledge, 1990.

Lash, S., *Sociology of Postmodernism*, London, Routledge, 1990.

Lewis, L. A. (ed.) *The Adoring Audience: Fan Culture and Popular Media*, London, Routledge, 1992.

Lewisohn, M., *The Complete Beatles Chronicle*, London, Chancellor Press, London, 1992.

Longhurst, B., *Popular Music and Society*, Cambridge, Polity Press, 1995.

Lovell, A., 'Free cinema', in A. Lovell and J. Hillier, *Studies in Documentary*, London, Secker and Warburg in association with the British Film Institute, 1972.

Low, R., *Film Making in 1930s Britain*, London, George Allen and Unwin, 1985.

Mc Aleer, D., *Hit Parade Heroes: British Beat Before the Beatles*, London, Hamlyn, 1993.

McCarthy, T. and Flynn, C. (eds) *Kings of the Bs: Working Within the Hollywood System*, New York, E. P. Dutton, 1973.

Mabey, R., *The Pop Process*, London, Hutchinson, 1971.

Marcus, G., *Mystery Train*, London, Penguin, 4th edn 1991.

——, *The Dustbin of History*, London, Picador, 1995.

Marks, M. M., *Music and the Silent Film: Contexts and Case Studies 1895–1924*, New York, Oxford University Press, 1997.

Matthews, J., *Over My Shoulder*, London, W. H. Allen, 1974.

Matthew-Walker, R., *From Broadway to Hollywood: The Musical and the Cinema*, London, Sanctuary Publishing, 1996.

Martin, L., and Segrave, K., *Anti-Rock: The Opposition to Rock'n'Roll*, New York, Da Capo Press, 1993.

Martland, P., *Since Records Began: EMI the First 100 Years*, London, Batsford, 1997.

Mayer, D., 'Learning to see in the dark', *Nineteenth Century Theatre*, 25: 2, Winter (1997) 92–114.

Medhurst, A., 'Music hall and British cinema', in C. Barr (ed.), *All Our Yesterdays*, London, British Film Institute, 1986.

——, 'It sort of happened here: the strange, brief life of the British pop film' in J. Romney and A. Wootton (eds), *Celluloid Jukebox: Popular Music and the Movies since the 50s*, London, British Film Institute, 1995.

Melly, G., *Revolt into Style*, London, Penguin, 1970.

Middleton, R., *Studying Popular Music*, Milton Keynes, Open University Press, 1990.

Mitchell, T., *Popular Music and Local Identity: Rock, Pop and Rap in Europe and Oceania*, London, Leicester University Press, 1996.

Monthly Film Bulletin, 53:633, October (1986) 319.

Mordden, E., *The Hollywood Musical*, Newton Abbot, David and Charles, 1982.

Morley, D., 'Active audience theory: pendulums and pitfalls', *Journal of Communication*, 43:4 (1993) 13–19.

Murphy, R., *Realism and Tinsel: Cinema and Society in Britain 1939–49*, London, Routledge, 1989.

Murray, P., *One Day I'll Forget My Trousers*, London, Everest Books, 1976.

Musser, C., *The Emergence of Cinema: The American Screen to 1907*, Berkeley CA, University of California Press, 1994.

——, *Thomas A. Edison and his Kinetographic Motion Pictures*, New Brunswick NJ, Rutgers University Press, 1995.

Neaverson, B., *The Beatles Movies*, London, Cassell, 1997.

Negus, K., *Producing Pop: Culture and Conflict in the Popular Music Industry*, London, Edward Arnold, 1992.

——, *Popular Music in Theory*, Cambridge, Polity Press, 1996.

Neve, B., *Film and Politics in America: A Social Tradition*, London, Routledge, 1992.

Norman, P., *Shout! The True Story of the Beatles*, London, Corgi, 1982.

Norris, C. (ed.), *Music and the Politics of Culture*, London, Lawrence and Wishart, 1989.

Pallot, J. and Levich, J. (eds), *The Fifth Virgin Film Guide*, London, Virgin, 1996.

Parker, D., *Radio: The Great Years*, Newton Abbot, David and Charles, 1977.

Paulu, B., *Television and Radio in the United Kingdom*, London, Macmillan, 1981.

Perry, G., *The Great British Picture Show*, London, Paladin, 1975.

Peterson, R. A., 'Why 1955? Explaining the advent of rock music', *Popular Music*, 9:1 (1990) 97–116.

Peterson R. A. and Berger D. G., 'Cycles in symbol production: the case of popular music', in S. Frith and A. Goodwin (eds), *On Record: Rock, Pop and the Written Word*, London, Routledge, 1990.

Pearsall, R., *Edwardian Popular Music*, Newton Abbot, David and Charles, 1975.

Pickard, R., *Fred Astaire*, London, Deans International Publishing, 1985.

Pickering, M., 'White skin, black masks: 'nigger' minstrelsy in Victorian England', in J. S. Bratton (ed.), *Music Hall: Performance and Style*, Milton Keynes, Open University Press, 1986.

Potter, J., *Independent Television in Britain Vol. 4: Companies and Programmes 1968–80*, London, Macmillan, 1990.

Prendergast, R. M., *Film Music: A Neglected Art – A Critical Study of Music in Films*, New York, W. W. Norton, 2nd edn 1992.

Quain, K. (ed.), *The Elvis Reader: Texts and Sources on the King of Rock'n'Roll*, New York, St. Martins Press, 1992.

Redhead, S., *The End-of-the-Century Party: Youth and Pop Towards 2000*, Manchester University Press, Manchester, 1992.

Riesman, D., 'Listening to popular music', in S. Frith and A. Goodwin (eds), *On Record: Rock, Pop and the Written Word*, London, Routledge, [1950] 1990.

Robinson, D., Buck E. and Cuthbert, M. (1991) *Music at the Margins: Popular Music and Global Cultural Diversity*, London, Sage, 1991.

Ross, A. and Rose, T., *Microphone Fiends: Youth Music and Youth Culture*, London, Routledge, 1994.

Rubin, M., *Showstoppers: Busby Berkeley and the Tradition of Spectacle*, New York, Columbia University Press, 1993.

Russell, D., *Popular Music in England 1840–1914: A Social History*, Manchester, Manchester University Press, 1987.

Russell, T., *Blacks, Whites and Blues*, London, Studio Vista, 1970.

Ryall, T., *Alfred Hitchcock and the British Cinema*, London, Croom Helm, 1986.

Salt, B., *Film Style and Technology: History and Analysis*, London, Starword, 1983.

Sandahl, L. J., *Rock Music on Film*, Poole, Blandford Press, 1987.

Savage, J., *England's Dreaming: Sex Pistols and Punk Music*, London, Faber and Faber, 1991.

Saxon, J., 'The cinema's becoming a teen screen', in E. Warman (ed.) *Preview*, London, Andrew Dakers, 1959.

Schatz, T., *Old Hollywood/New Hollywood: Ritual, Art and Industry*, Ann Arbor, UMI Research Press, 1983.

Scannell, P., *Radio, Television and Modern Life*, Oxford, Basil Blackwell, 1996.

Scannell, P. and Cardiff, D., *A Social History of British Broadcasting Vol. 1, 1922–1939: Serving the Nation*, Oxford, Basil Blackwell, 1991.

Sendall, B., *Independent Television in Britain Vol. 1: Origin and Foundation, 1946–1962*, London, Macmillan, 1982.

Sendall, B., *Independent Television in Britain Vol. 2: Expansion and Change, 1958–68*, London, Macmillan, 1983.

Shepherd, J., *Music as Social Text*, Cambridge, Polity Press, 1992.

Shipman, D., *Judy Garland*, London, HarperCollins, 1992.

Shore, M., *The Rolling Stone Book of Rock Video*, London, Sidgwick and Jackson, 1985.

Shuker, R., *Understanding Popular Music*, London, Routledge, 1994.

Slessor, P., 'The story behind radio's record week', *Picturegoer*, 8 December (1956) 16–17.

Spoto, D., *The Art of Alfred Hitchcock*, London, W. H. Allen, 1977.

Staehling, R., 'From *Rock Around the Clock* to *The Trip*: the truth about teen movies', in T. McCarthy and C. Flynn, C. (eds) *Kings of the Bs: Working Within the Hollywood System*, New York, E. P. Dutton, [1969] 1973.

Staiger, J. 'Seeing stars', in C. Gledhill, *Stardom: Industry of Desire*, London: Routledge, 1991.

Stallings, P., *Rock'n'Roll Confidential*, London, Vermilion Hutchinson, 1984.

Stockbridge, S., 'Programming rock'n'roll: the Australian version', *Cultural Studies*, 3:1, January (1989) 73–88.

Street, S., *British National Cinema*, London, Routledge, 1997.

Tawa, N. E., *The Way to Tin Pan Alley: American Popular Song 1866–1910*, New York, Schirmer, 1990.

Taylor, J. R., *Hitch: The Life and Work of Alfred Hitchcock*, London, Faber and Faber, 1978.

Tetzlaff, D. 'MTV and the politics of postmodern pop', *Journal of Communication Inquiry*, 10:1 (1986) 89.

Thomas, T., *Music for the Movies*, London, Tantivy Press, 1973.

Thompson, B., 'Lights! Camera! Cliche!' *Independent on Sunday*, 19 July (1992) 18–19.

Thornton, M., *Jesse Matthews: A Biography*, London, Hart-Davis, McGibbon, 1974.

Thornton, S., 'Moral panic, the media and British rave culture', in A. Ross and T. Rose (eds), *Microphone Fiends: Youth Music and Youth Culture*, London, Routledge, 1994.

Tomlinson, A. (ed.), *Consumption, Identity and Style: Marketing, Meanings and the Packaging of Pleasure*, London, Routledge, 1990.

Tremlett, G., *Rock Gold: The Music Millionaires*, London, Unwin Hyman, 1990.

Turner, S., *Cliff Richard: The Biography*, Oxford, Lion, 1994.

Wachhorst, W., *Thomas Alva Edison: An American Myth*, Cambridge MA, The MIT Press, 1982.

Wade, D. and Picardie, J., *Music Man: Ahmet Ertegun, Atlantic Records and the Triumph of Rock'n'Roll*, New York, W. W. Norton, 1990.

Walker, A., *Hollywood England: The British Film Industry in the Sixties*, London, Michael Joseph, 1974.

——, *The Shattered Silents: How the Talkies Came to Stay*, London, Harrap, 1986.

Walser, R., 'Forging masculinity: heavy metal sounds and images of gender', in S. Frith, A. Goodwin and L. Grossberg (eds), *Sound and Vision: The Music Video Reader*, London, Routledge, 1993.

Ward, E., Stokes, G. and Tucker, K., *Rock of Ages: The Rolling Stone History of Rock and Roll*, London, Penguin, 1987.

Warren, P., *The British Film Collection 1896–1984*, London, Elm Tree Books, 1984.

Warrington Borough Council, *Turned Out Nice Again: The George Formby Story*, Catalogue of the Formby exhibition at the Warrington Museum and Art Gallery, 26 April – 27 July, 1991.

Wasko, J., *Hollywood in the Age of Information*, Oxford, Polity Press, 1994.

Webster, D., *Looka Yonder: The Imaginary America of Populist Culture*, London, Comedia/Routledge, 1988.

Wenden, D. J., *The Birth of the Movies*, London, Macdonald, 1975.

Whitcomb, I., *After the Ball*, London, Penguin, 1972.

——, *Irving Berlin and Ragtime America*, London, Century Hutchinson, 1987.

White, T. R., 'Hollywood's attempt at appropriating television: the case of Paramount Pictures', in T. Balio (ed.), *Hollwood in the Age of Television*, London, Unwin Hyman, 1990.

Wicke, P., *Rock Music: Culture, Aesthetics and Sociology*, Cambridge, Cambridge University Press, 1990.

Wilcox, H., *Twenty-Five Thousand Sunsets: The Autobiography of Herbert Wilcox*, London, Bodley Head, 1967.

Williams, L. R., 'Nothing to find', *Sight and Sound*, 6:1, January (1996) 28–30.

Williams, R., *Television, Technology and Cultural Form*, London, Fontana/Collins, 1974.

Willis, P. with Jones, S., Canaan, J., and Hurd G., *Common Culture: Symbolic Work at Play in the Everyday Cultures of the Young*, Milton Keynes, Open University Press, 1990.

Winchester, C. (ed.), *The World Film Encyclopedia: A Universal Screen Guide*, London, The Amalgamated Press, 1933.

Wollen, P., 'Ways of thinking about music video (and postmodernism)', *Critical Quarterly*, 28:1/2 (1986) 168.

Yule, A., *The Man Who Framed the Beatles: A Biography of Richard Lester*, New York, Donald I. Fine, 1994.

Zukor, A., *The Public is Never Wrong*, London, Cassell, 1954.

Select filmography

The Blackboard Jungle (MGM 1955)

Director	Richard Brooks
Screenplay	Richard Brooks
Producer	Pandro S. Berman
Music	'Rock Around the Clock', Bill Haley and the Comets on soundtrack
Starring	Sidney Poitier, Anne Francis, Glenn Ford, Vic Morrow

The Bodyguard (TIG Productions/Kasdan Pictures 1992)

Director	Mick Jackson
Producer	Lawrence Kasdan
Screenplay	Lawrence Kasdan from his story
Music	David Foster, Jud Friedman and others
Lyrics	Linda Thompson, Allan Rich and others
Starring	Kevin Costner, Whitney Houston, Gary Kemp, Bill Cobbs

Elstree Calling (British International Pictures 1930)

Directors	Adrian Brunel, Alfred Hitchcock
Screenplay	Adrian Brunel
Music	Ivor Novello and others
Starring	Tommy Handley, Jack Hulbert, Cicely Courtneidge, Will Fyffe, Donald Calthrop, Teddy Brown, Anna May Wong

Expresso Bongo (Britannia/Conquest 1959)

Director	Val Guest
Producer	Val Guest
Screenplay	Wolf Mankowitz.
Starring	Cliff Richard, Laurence Harvey, Sylvia Sims, Yolande Donlan, Gilbert Harding, Meier Tzelniker

First a Girl (Gaumont-British 1935)

Director	Victor Saville
Producer	Michael Balcon
Screenplay	Marjorie Gaffney from the film *Viktor and Viktoria*
Musical direction	Louis Levy
Starring	Jesse Matthews, Sonnie Hale, Griffith Jones, Anna Lee

Footlight Parade (Warner Brothers 1933)

Director	Lloyd Bacon
Choreography	Busby Berkeley
Music/lyrics	Harry Warren, Al Dubin, Sammy Fain, Irving Fahal
Starring	James Cagney, Joan Blondell, Ruby Keeler, Dick Powell

The Girl Can't Help It (Twentieth Century Fox 1956)

Director	Frank Tashlin
Screenplay	Frank Tashlin and Herbert Baker
Music	Lionel Newman
Musical performers	Little Richard, Fats Domino, the Platters, the Treniers, Eddie Cochran, Gene Vincent and the Bluecaps and others
Starring	Tom Ewell and Jayne Mansfield

A Hard Day's Night (United Artists 1964)

Director	Richard Lester
Producer	Walter Shenson
Screenplay	Alun Owen
Musical direction	Robert Freeman
Starring	The Beatles, Wilfred Brambell, Norman Rossington, John Junkin, Victor Spinetti, Deryck Guyler, Anna Quayle

I'll Be Your Sweetheart (Gainsborough 1945)

Director	Val Guest
Executive producer	Maurice Ostrer
Screenplay	Val Valentine and Val Guest
Music	Robert Nesbitt
Orchestration	Bob Busby, Ben Frankel
Musical direction	Louis Levy
Starring	Margaret Lockwood, Vic Oliver, Michael Rennie, Peter Graves, Moore Marriott

It's Always Fair Weather (MGM 1955)

Director	Gene Kelly and Stanley Donen
Music/lyrics	Betty Comden and Adolph Green
Starring	Gene Kelly, Dan Dailey, Michael Kidd, Cyd Charisse

Jailhouse Rock (MGM 1957)

Director	Richard Thorpe
Producer	Pandro S. Berman
Musical direction	Jeff Alexander
Musical score	Jerry Leiber and Mike Stoller
Starring	Elvis Presley, Judy Tyler, Micky Shaughnessy

The Jazz Singer (Warner Brothers 1927)

Director	Alan Crosland
Scenario	Alfred A. Cohn from the story 'The Day of Atonement' by Samson Raphelson and its stage adaptation *The Jazz Singer* (1925)
Photography	Hal Mohr
Orchestral Score	Louis Sivers
Starring	Al Jolson, May McAvoy, Warner Oland, Eugenie Besserer

London Town (Rank 1945)

Director	Wesley Ruggles
Producer	Wesley Ruggles
Screenplay	Elliot Paul and Sigfried Herzig
Music/lyrics	Jammy Van Heusen and Johnny Burke
Musical direction	Salvador Camarata
Starring	Sid Field, Greta Gynt, Tessie O'Shea, Sonnie Hale, Kay Kendall, Petula Clark

Love Me Tender (Twentieth Century Fox 1956)

Director	Robert D. Webb.
Screenplay	Robert Buckner
Musical direction	Lionel Newman.
Starring	Richard Egan, Debra Paget, Elvis Presley.

Loving You (Paramount 1957)

Director	Hal Kanter
Producer	Hal Wallis
Screenplay	Herbert Baker, Hal Kanter
Starring	Elvis Presley, Lizabeth Scott, Wendell Corey, Dolores Hart

Meet Me in St Louis (MGM 1944)

Director	Vincente Minnelli

Screenplay	Irving Brecher, Fred Finklehoff
Music/lyrics	Hugh Martin and Ralph Blane
Starring	Judy Garland, Margaret O'Brien, Leon Ames, Mary Astor, Lucille Bremer, Tom Drake

Miss London Ltd (Gainsborough – Gaumont British 1943)

Director	Val Guest
Executive producer	Maurice Ostrer
Producer	Edward Black
Screenplay	Marriott Edgar and Val Guest
Musical direction	Louis Levy
Music/lyrics	Manning Sherwin and Val Guest
Starring	Arthur Askey, Evelyn Dall, Anne Shelton, Richard Hearne, Max Bacon, Jack Train, Jean Kent, Peter Graves

Rebel Without a Cause (Warner Brothers 1955)

Director	Nicholas Ray
Producer	David Weisbart
Director of photography	Ernest Haller
Screenplay	Stewart Stern, from a story by Nicholas Ray
Music	Leonard Rosenman
Starring	James Dean, Natalie Wood, Sal Mineo, Jim Backus, Corey Allen

Rhythm Serenade (Columbia British Pictures 1943)

Director	Gordon Wellesley
Producer	Ben Henry
Associate producer	George Formby
Screenplay	Basil Woon and Majorie Deans
Musical direction	Harry Bidgood
Starring	Vera Lynn, Peter Murray Hill, Julien Mitchell, Charles Victor, Jimmie Jewell, Ben Warriss, Jimmy Clitheroe, Irene Handl

Summer Stock (MGM 1950)

Director	Charles Walters
Screenplay	George Wells, Sy Gomberg
Musical direction	Johnny Green
Starring	Judy Garland, Gene Kelly, Phil Silvers, Gloria de Haven

Top Hat (RKO 1933)

Director	Mark Sandrich
Choreography	Hermes Pan and Van Nest Polglase
Music/lyrics	Irving Berlin
Starring	Fred Astaire, Ginger Rogers, Edward Everett Horton, Helen Broderick

The Wild One (Columbia/Stanley Kramer 1956)

Director	Laslo Benedek
Script	John Paxton from the story 'The Cyclists' Raid' by Frank Rooney
Music	Leith Stevens
Starring	Marlon Brando, Lee Marvin, Mary Murphy

The Young Ones (Associated British Pictures Corp.1961)

Director	Sidney J. Furie
Producer	Kenneth Harper
Screenplay	Peter Myers and Ronald Cass
Music/lyrics	Peter Myers and Ronald Cass, with Roy Bennett, Sid Pepper, Shirley Wolfe, Sy Soloway, Peter Gormley, Bruce Welch, Hank B. Marvin, Norrie Paramor
Musical direction	Stanley Black
Dances and musical numbers	Herbert Ross
Starring	Cliff Richard, Robert Morley, Carole Gray, the Shadows, Richard O'Sullivan, Melvyn Hayes, Robertson Hare, Annette Robertson

Index

Adorno, Theodore 3, 104, 223, 228

After The Ball 34

Ager, Milton 33

A Hard Day's Night 171–4, 203

Altman, Rick 54, 56, 68–9, 76

American Bandstand 186–90

American Broadcasting Company (ABC) 35, 181, 187, 191–2

American Federation of Musicians (AFM) 89

American Society of Composers, Authors and Publishers (ASCAP) 34, 42, 78, 92, 102, 183

Ampex 206, 234

Anglo-American cultural exchange 129–30, 146–9, 157, 168–71

Apple Corps Ltd 209

Askey, Arthur 133, 153, 154, 157

Associated British Cinemas (ABC) 138

Astaire, Fred 63–8, 87, 118, 189

Atlantic Records 95

'authenticity' 26, 90–2, 185, 201, 202, 205, 210–12, 222, 232–4

Bamforth Films 133

BBC
 and British films 165–6
 and gramophone records 135, 160–1, 163
 radio and popular music 135–7, 141, 153, 160
 television and popular music 182, 193–7, 210–12, 231
 variety theatre 136–7
 see also under individual programme titles

Beatles, the 115, 128, 169–74, 190, 203, 206, 207–9

Berkeley, Busby 58–9

Berlin, Irving 22, 34, 48, 60, 63, 86

Berliner, Emile 19, 130

black artists, 90–8 *passim*, 100–1, 108–9

Blackboard Jungle, The 98, 106–7

Blackpool 136, 151, 155

BMG 228

Bodyguard, The 225

Brigadoon 86–7

British cinema
 American market for 146, 169
 comedy films 133
 critical neglect of 128
 decline in market share 134, 149